THE COLLECTIONS OF THE ROMANOVS

European Art from the
State Hermitage Museum, St Petersburg

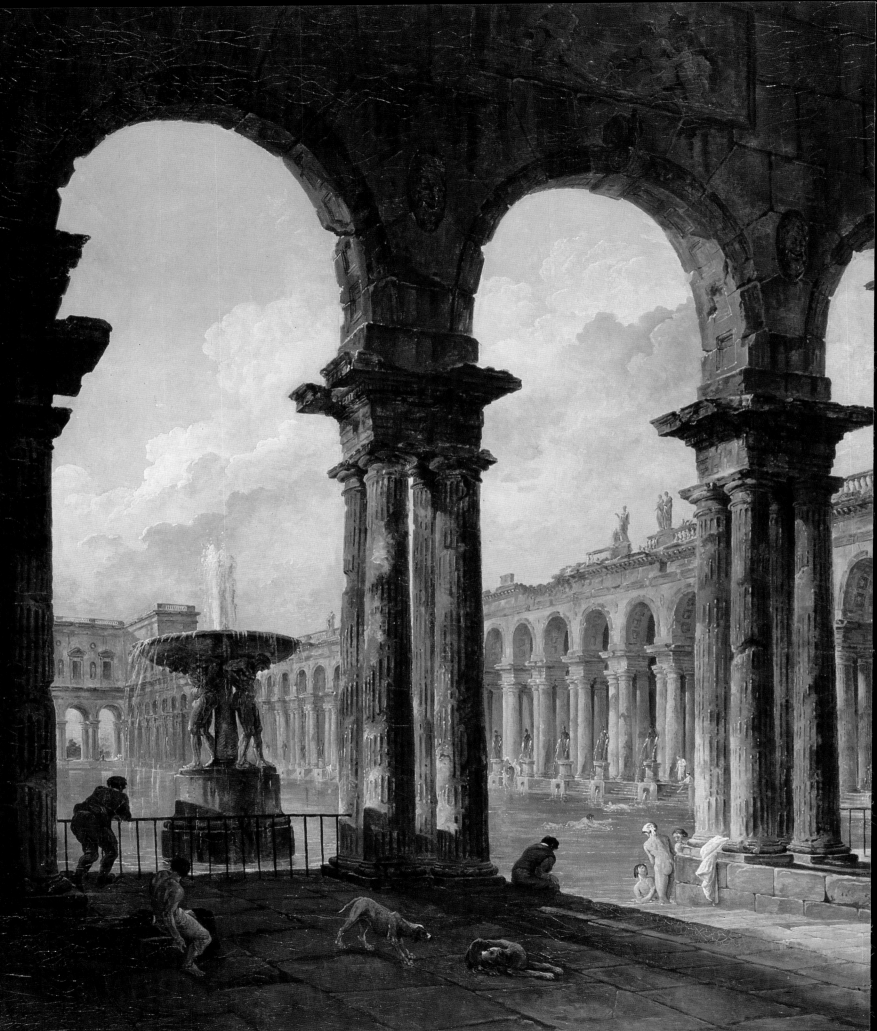

THE COLLECTIONS OF THE ROMANOVS

European Art from the
State Hermitage Museum, St Petersburg

James Christen Steward, *Editor*
with Sergey Androsov

MERRELL
LONDON · NEW YORK

in association with
The University of Michigan Museum of Art
and the State Hermitage Museum

First published 2003 by
Merrell Publishers Limited

Head office:
42 Southwark Street
London SE1 1UN

New York office:
49 West 24th Street
New York, NY 10010

www.merrellpublishers.com

in association with

The State Hermitage Museum, St. Petersburg, and The University of Michigan Museum of Art

Produced to coincide with the exhibition *The Romanovs Collect: European Art from the Hermitage*, held at the University of Michigan Museum of Art from 21 September to 23 November, 2003, as part of the festival *Celebrating St. Petersburg: 300 Years of Cultural Brilliance. Celebrating St. Petersburg* Honorary Chairs: Dr. Mary Sue Coleman, President, University of Michigan; The Honorable Jennifer M. Granholm, Governor, State of Michigan; His Excellency Yuri V. Ushakov, Ambassador of the Russian Federation to the United States

100 YEARS

This exhibition and catalogue are made possible by Ford Motor Company.

Additional support has been provided by the University of Michigan Office of the Provost, the Samuel H. Kress Foundation, the Trust for Mutual Understanding, and the University of Michigan Office of the Vice President for Research.

Library of Congress Control Number 2003104196

British Library Cataloguing-in-Publication data:
 The collections of the Romanovs : European art from the State Hermitage Museum, St. Petersburg
 1.Romanov (House of) – Art collections – Catalogs
 2.Gosudarstvennyi Ermitazh (Russia) – Catalogs 3.Art, European – Catalogs
 I.Steward, James Christen II.University of Michigan. Museum of Art
 708.7'21

ISBN 1 85894 221 7

Front jacket: R. & S. Garrard, Silver centerpiece of a knight on horseback, detail (see cat. 83)
Frontispiece and pages 50–51: Hubert Robert, *Ancient Ruins Used as a Public Bath*, detail (see cat. 27)

Volume editor: James Christen Steward, D.Phil., with Dr. Sergey Androsov
Translation of original Russian texts by Catherine Phillips
Photography by Leonard Heifetz, Yury Molodkovets, Svetlana Suyetova, Vladimir Terebenin, and Sergey Pokrovsky

Produced by Merrell Publishers
Designed by Tim Hervey
Copy-edited by Richard Dawes
Indexed by Laura Hicks
Printed and bound in Italy

NOTES ON THE TEXT
This book follows the Library of Congress system of transliteration. The only exception concerns the transliteration of personal names, where soft signs are avoided, and at the end of which -y is used to express -й, -ий and -ый. Russian rulers are referred to by their Anglicized names (thus Catherine and Nicholas, rather than Ekaterina and Nikolai). Certain standard transliterations of Russian names are also followed, for example Alexander, Yuri, Julia, Soloviev, and Yusupov.

CONTENTS

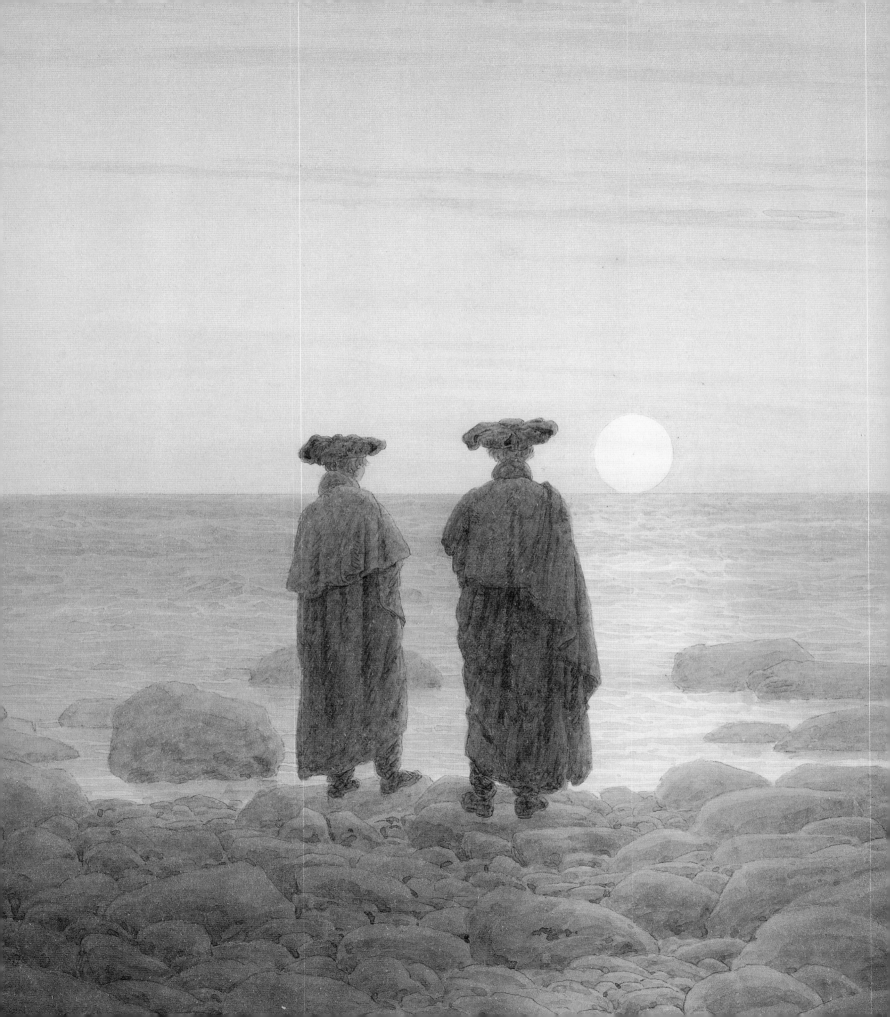

SPONSOR'S STATEMENT

Ford Motor Company is pleased to continue its support of the University of Michigan Museum of Art through the sponsorship of *The Romanovs Collect: European Art from the Hermitage*. Drawing upon masterworks of European art from the collection of the State Hermitage Museum, the exhibition illuminates the history of collecting in Imperial Russia, and reveals St. Petersburg as Russia's window on the West.

The Romanovs Collect is part of a three-year series of exhibitions organized by the University of Michigan Museum of Art and supported by Ford. The series began with *Albert Kahn: Inspiration for the Modern*, was followed by *Women Who Ruled: Queens, Goddesses, Amazons 1500–1650*, and culminates with *The Romanovs Collect*. These exhibitions have provided important new scholarly insight, and offered the Museum's visitors a diverse range of new programs.

At Ford we believe that cultural programs serve and enrich us in positive ways, as individuals, as communities, and as a society. In recognition of the vital role the arts play in our lives, Ford is committed to supporting cultural and educational programs like *The Romanovs Collect*, and we are proud of our continuing partnership with the University of Michigan Museum of Art.

SANDRA E. ULSH
President
Ford Motor Company Fund

Caspar David Friedrich, *Two Men on the Seashore (Moonrise Over the Sea)*, detail (see cat. 55)

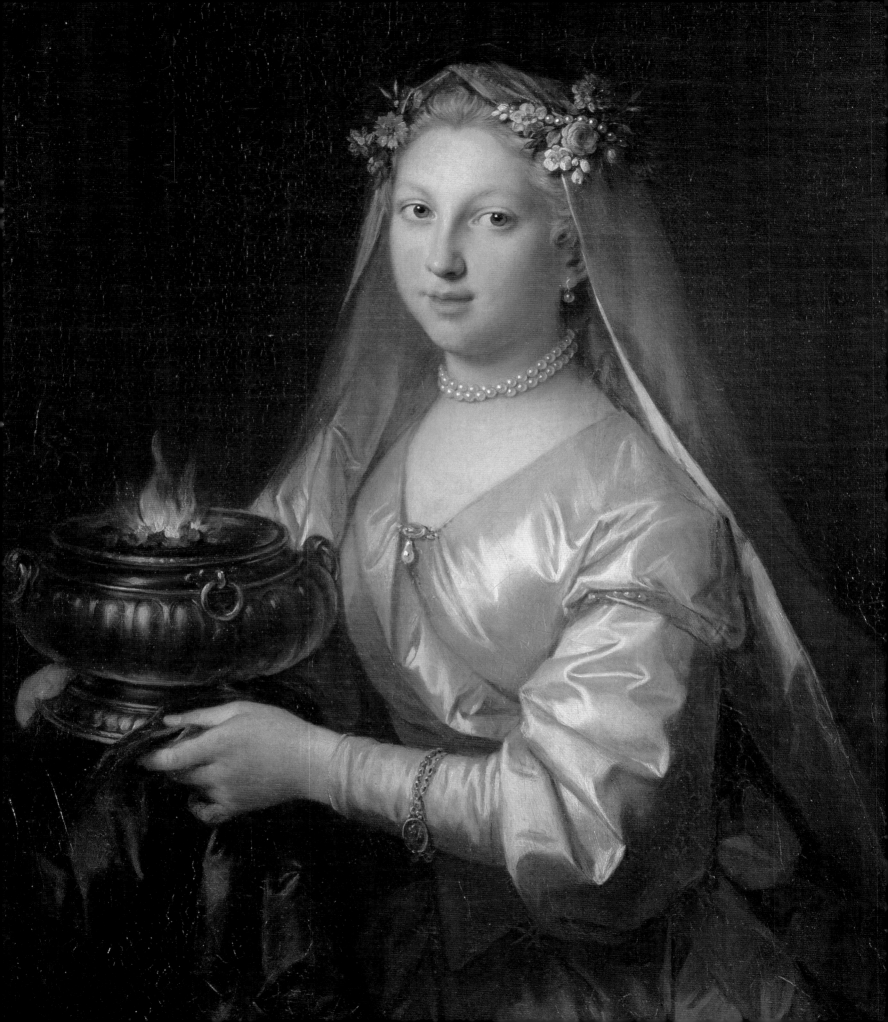

whom has brought important intellectual and practical talents to bear on exhibition research generally, and this catalogue in particular. Curator for Education Ruth Slavin has done her usual masterful job in devising exciting educational programs to accompany the exhibition itself, as well as helping to shape its interpretation. Registrar Lori Mott has played a critical role in ensuring that the Hermitage's priceless loans could travel safely and efficiently from St. Petersburg to Ann Arbor and back; Preparator Brendnt Rae has taken the creative lead in devising a handsome installation for the exhibition, in partnership with his colleagues Kevin Canze and Katie Carew. Beyond the Museum of Art's own staff, numerous individuals have contributed in essential ways, from Catherine Phillips in St. Petersburg who has translated the texts of all our Russian authors; to Eugenia Bell in Ann Arbor who has provided essential editorial support; to Anne Odom, Curator Emeritus at the Hillwood Museum in Washington, D.C., who has provided wise counsel on many issues of content and interpretation.

Clearly, a project involving a partner museum as distinguished as the State Hermitage Museum, and a publication as ambitious as this, has required the support of many. Both exhibition and publication have been generously supported by the Ford Motor Company, without whose exceptional philanthropic leadership a project of this scope would not have been possible. My special thanks go to John Rintamaki, Group Vice President and Chief of Staff at Ford Motor Company (as well as a member of this Museum's National Advisory Board). John's friendship and advocacy on behalf of the Museum of Art have brought enormous value to museum-goers throughout our region, and to all who have benefited from Ford Motor Company's visionary leadership in arts and culture. Thanks as well are due to Sandra Ulsh, President of the Ford Motor Company Fund, who has warmly advised the Museum of Art on this project and numerous other issues.

Additional essential support has come from many sources. The Samuel H. Kress Foundation has given generously through its "Old Masters in Context" program, while the Trust for Mutual Understanding has supported the international scholarly exchange occasioned by this exhibition and Festival. Both are to be congratulated for sharing our vision of scholarship surrounding the visual arts to broad audiences encompassing both the specialist and the novice. The University of Michigan's Office of the Provost and Office of the Vice President for Research have made a critical difference in our ability to sustain such a vision. The Friends of the Museum of Art continue to support the Museum in essential ways, including both financial support and outreach to our regional audiences. I can only hope that the results—as embodied in this exhibition catalogue—merit the confidence, faith, energy, and commitment of so many.

James Christen Steward
Director
University of Michigan Museum of Art

HISTORICAL OVERVIEW

1689	Peter the Great (1682–1725) becomes Tsar
1697	The "Great Embassy," headed by Peter the Great, embarks for Europe
1700–21	Great Northern War
1703	Foundation of St. Petersburg by Peter the Great
1712	St. Petersburg becomes official capital of the Russian Empire
1724	Peter the Great issues decree founding the Academy of Sciences
1725–27	Reign of Catherine I
1727–30	Reign of Peter II
1729	Birth of Sophia Frederika Augusta of Anhalt-Zerbst, later Catherine the Great
1730–40	Reign of Anna Ioannovna
1740–41	Reign of Ivan VI
1741–61	Reign of Elizabeth
1744	Sophia arrives in St. Petersburg, adopts the Russian Orthodox religion, taking the name Catherine (Ekaterina Alekseevna). Catherine marries Grand Duke Peter, heir to the Russian throne
1754–62	Construction of the Winter Palace commissioned by Catherine II from the architect Bartolomeo Rastrelli
1756–63	Seven Years War
1757	Foundation of the Imperial Academy of Arts
1761–62	Reign of Peter III
1762	Overthrow of Peter III after reign of six months; Catherine II (1762–96) seizes the throne; Peter is assassinated by a group of Catherine's friends
1764–75	Construction of the Small Hermitage by the architect Jean-Baptiste Vallin de la Mothe
1764	Catherine II acquires Johann Ernest Gotzkowski's collection, first of the Hermitage collections
1767	Catherine issues her "Instruction," a philosophical and legal treatise presented to a Legislative Commission set up to compile a new Code of Laws (which was never issued)
1768–74	Russo-Turkish war
1769	Acquisition of Count Heinrich von Brühl's collection
1771–87	Construction of the Large (Old) Hermitage by the architect Yury Velten
1772	Acquisition of Baron Pierre Crozat's collection
1779	Acquisition of Sir Robert Walpole's collection
1781	Acquisition of Count Badoin's collection
1783–87	Construction of the Hermitage Theater by the architect Giacomo Quarenghi
1796	Death of Catherine the Great; her son, Paul I, becomes Emperor (1796–1801)
1801	Coup and assassination of Paul I; Alexander I becomes Emperor (1801–25)
1807	Russian alliance with Napoleon
1812	Napoleonic invasion of Russia; Battle of Borodino
1813–14	Alexander's pursuit of Napoleon to Paris
1814	Napoleon is defeated and abdicates; acquisition of Empress Josephine's collection by Alexander I
1825	Death of Alexander I; Emperor Nicholas I (1825–55) accedes to the throne. Decembrist Revolt
1830–40	Creation of Hermitage interiors to designs by Alexander Briullov
1833	Creation of the Field Marshals' Hall and Peter I's Room (Small Throne Room) by the architect Auguste Montferrand

1837	Fire in the Winter Palace
1839–52	New Hermitage constructed by the architect Leo von Klenze
1840	Reconstruction of the state halls of the Winter Palace by Vasily Stasov
1850	Acquisition of the collection from the gallery of Cristoforo Barbarigo
1852	Opening of the New Hermitage as the Imperial Museum
1853–56	The Crimean War
1855	Alexander II becomes Emperor (1855–81)
1860	Creation of state rooms in the Large Hermitage by the architect Andrei Stakenschneider
1865	Acquisition of the painting *Madonna and Child (Litta Madonna)* by Leonardo da Vinci
1881	Assassination of Alexander II; Alexander III becomes Emperor (1881–94)
1885	Acquisition of the collection of the former Tsarskoe Selo Arsenal for the Hermitage
1895–17	Reign of Nicholas II
1904–05	Russo-Japanese War
1914	Acquisition of the painting *Madonna with a Flower (Benois Madonna)* by Leonardo da Vinci
1914	Beginning of World War I; state rooms of the Winter Palace turned over for use as a hospital; St. Petersburg renamed "Petrograd"
1917	February Revolution; Nicholas II abdicates
1917	Winter Palace and the Hermitage become state museums
1918	Execution of Nicholas II and his family
1920	Hermitage transfers 460 items to the Pushkin Museum of Fine Arts, Moscow
1924	Lenin's death; Petrograd renamed "Leningrad"
1920–30	Many private collections are nationalized into the Hermitage holdings
1932–34	Numerous Hermitage objects are sold to raise funds for the Soviet Union; many other works are transferred to other museums around the USSR
1941	Entry of USSR into World War II; Hermitage collections are evacuated to storage in the Ural Mountains
1945	Reopening of the Hermitage Museum after World War II
1991	Break-up of the USSR; establishment of the Russian Federation; Leningrad renamed "St. Petersburg"
1996	By decree of Russian President Boris Yeltsin, the State Hermitage Museum is placed under direct patronage of the President of the Russian Federation

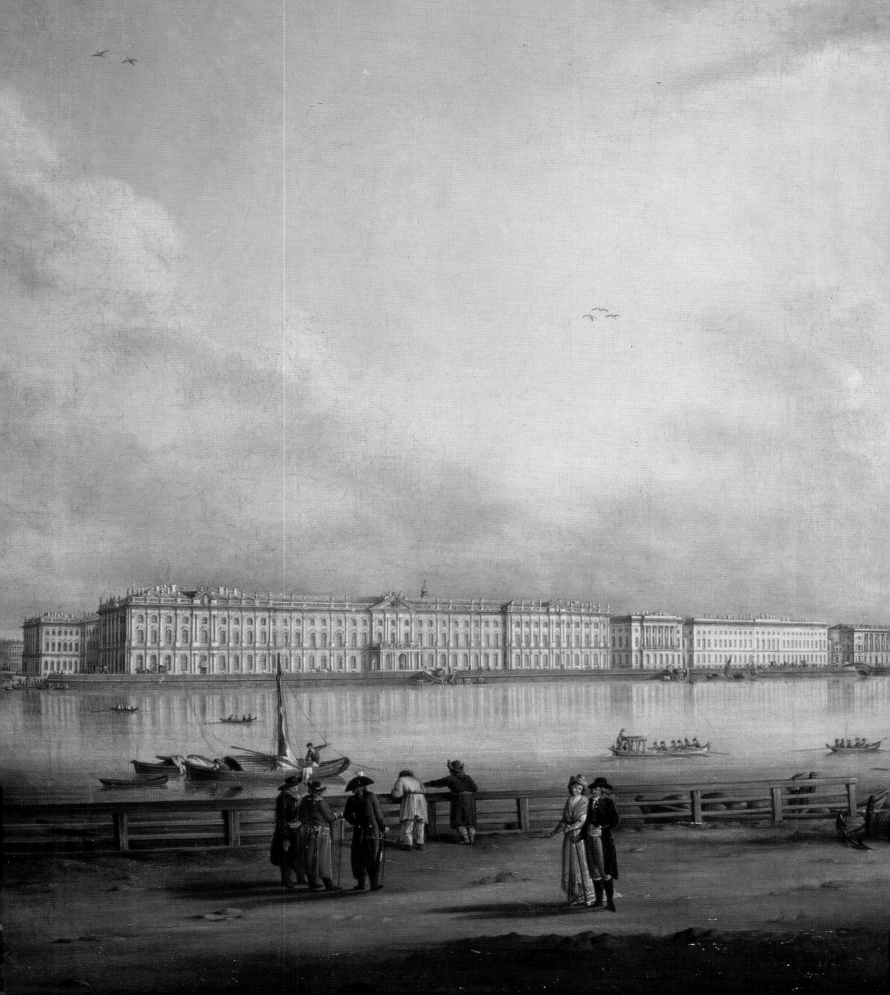

JAMES CHRISTEN STEWARD

The Private Taste of the Romanovs in Eighteenth-Century Russia

When Peter the Great founded St. Petersburg in 1703, during the Northern War with Sweden, the swampy site must have seemed to hold little potential beyond its strategic presence on the eastern shore of the Gulf of Finland. But his ambition and vision of establishing a great European capital were in line with vanguard European tastes of the day, and his new capital—from its first ceremonial buildings at the Peter and Paul Fortress, in the historic heart of the city, to the pleasure palaces he built in what are now the suburbs—was assembled by craftsmen from throughout Europe. Peter's express goal was to create a modern capital that would rival, or exceed, the capitals of Europe. And in this he quickly succeeded: by 1722, foreign observers were commenting on the success of the new city. Friedrich Weber, the Hanoverian Resident in Russia, contended that "at Present Petersburg may with Reason be looked upon as a Wonder of the World, considering its magnificent Palaces, sixty odd thousand Houses, and the short time that was employed in the building of it."[1]

But beyond importing talented craftsmen and European styles, Peter began also to introduce objects that spoke to the progressive tastes of the time. The first merchant vessels from Holland and England were reported to have arrived in St. Petersburg in 1703, carrying snuffboxes and table silver, clocks and watches, cloth and furniture. These and more exotic objects ultimately formed the core of Peter's collections, from the diverse examples of natural history that would be housed at the Kunstkammer on the north bank of the Neva River, to the objects of fine and decorative arts that were the origins of the imperial art collections in St. Petersburg and, ultimately, the Hermitage itself.

The Kunstkammer was the first museum in Russia, and was opened to the public by Peter the Great in 1719—only seven years after the capital was formally moved to St. Petersburg. This was the age of the first European museums—in the sense in which we generally understand the term today, as distinct from the purely private, princely collections—from the British Museum in London to, much later in the century, the Wadsworth

Atheneum in the new American Republic. The Kunstkammer's aim was the improvement and education of Peter's subjects, and the collection incorporated scientific specimens, skeletons, anatomical abnormalities, found objects, minerals, rare jewels, and even works of applied art. Made part of the Academy of Sciences when the Academy was founded in 1724, the Kunstkammer also received Peter's personal collection of curiosities upon his death in 1725. As both public museum and private collection, the Kunstkammer derived from the European tradition of the *kunstkabinet*, or cabinet of curiosities, a phenomenon that was part of the Enlightenment impulse toward the ordering of knowledge, toward its discovery through material objects and artifacts.

Peter collected in the fine arts as well, and in many ways set the tone for the Romanovs to follow. During his first tour abroad, in 1697–98, and on his second visit to Holland, in 1717, he often attended art auctions personally and bought out of them directly. His favorite artists were thought to be Rembrandt, Rubens, van Eyck, Steen, Wouwerman, Brueghel, and Ostade.[2] During this same period his emissaries bought a further 280 paintings for him, at sales in The Hague, Amsterdam, Antwerp, and Brussels, for the palace of Monplaisir at Peterhof. One of these, Rembrandt's *David's Farewell to Jonathan*, was the first work by the Dutch master to arrive in Russia. From the outset of the eighteenth century, Peter sent young men to study fine art and craftsmanship in England and Holland, setting a taste for the decorative arts (primarily English) that dominated Russian imperial and noble tastes well into the nineteenth century. In the fine arts Peter's personal tastes favored the Dutch (especially landscapes, seascapes, and genre scenes) for his first palace at Peterhof, but as he built the Great Palace there it expanded to place French painting before all else. It was Peter, too, who established the longstanding Romanov interest in collecting Italian sculpture, a taste that ran from the chaste works of the Renaissance to the flamboyance of the Baroque and Rococo periods.

Johann Georg de Mayr, *View of the Palace Embankment, St. Petersburg, from the Vasil'evsky Island*, 1796. Oil on canvas, 76 × 117 cm (29⅞ × 46 in.). The State Hermitage Museum, St. Petersburg

early years of the twentieth century. She continued Peter's purchases of Dutch and Flemish painting, filling the picture galleries at the palaces of Oranienbaum and Tsarskoe Selo with such pictures by the 1750s. The successful establishment in 1745 of a gold mine near Ekaterinburg in the Ural mountains did much to improve the Russian economy during the last years of Elizabeth's reign; it also led to a revival of extravagant jewelry after some years of stagnation, and to the increased use of both Russian and European artisans working in Russia in an elaborate guild system. Equally, it seems likely that the Imperial Porcelain Factory was established during Elizabeth's reign with the explicit intent of rivaling the factories of England and France. Masters there were first able to make pieces of "hard" porcelain in 1744, but it was not until after Elizabeth's death that the factory began to work primarily for the imperial court. The need to rely on foreign manufacturers was thus diminished in more than one area, but in fact the taste for them was not.

Despite the important acts of patronage carried out by her Romanov predecessors, it was Catherine the Great who transformed both the Russian nation and the imperial Russian collections, and who stands at the center of any discussion of Romanov taste in the eighteenth century. It was during her reign that Russia realized Peter's dream and became a truly great European state, a rich and powerful land of which the capital, court, army, and art collections amazed foreign visitors. That Catherine had not a drop of Russian blood in her veins mattered not, so long as her actions, including her voracious collecting activities, were seen as being for the good of the Russian nation.

Admired (usually at more than arm's length) by the French *encyclopédistes*, Catherine was an enlightened monarch. From an early age she favored the writings of Voltaire and Diderot. Indeed, when she gave birth to her eventual heir, Paul, he was immediately taken from her by her mother-in-law, the Empress Elizabeth, and Catherine later recounted in her memoirs that she comforted herself by reading Tacitus' *Annals*, Voltaire's *Essay on the Customs and Spirit of Nations*, and Montesquieu's *Spirit of the Laws*. In 1766 she bought Diderot's personal library when he was in financial difficulties, leaving it in his Paris home and paying him to act as its "librarian." Diderot proved to be one of her most influential advisors on matters of art collecting, although early on he had himself been skeptical about the prospects of building a major collection in St. Petersburg. On Voltaire's death, in 1778, Catherine bought his library as well, and shipped the seven thousand volumes to St. Petersburg to occupy a purpose-built library in the Winter Palace. Catherine

could be seen as attempting to embody and realize many of her enlightened views, to the point that she had herself inoculated against smallpox with great public pomp in 1768, to serve as a model for the rest of the country in her belief in advanced medicine. Her art collecting must certainly be seen in the Enlightenment context, a marker of her desire (however unevenly applied) to modernize her country, bring it fully into the West, and elevate the tastes of her people. She was not universally admired by writers of the Enlightenment: the English connoisseur and writer Horace Walpole (son of the first British Prime Minister, Sir Robert Walpole) described her as a "philosophic tyrant," and he deeply resented the fact that she was able to acquire his father's art collection, an act he saw as the equivalent of pillage. Ultimately Catherine's taste for Enlightenment ideals was dealt a serious blow by the French Revolution, which revealed to her the dangerous possibilities of true intellectual freedom. Abstract virtue was thus tempered by a strong (and strong-willed) understanding of practical realities and the need to control her people.

It was most probably from Frederick the Great (Friedrich II) of Prussia that Catherine learned that an art collection of the first rank could serve her imperial ambitions almost as effectively as an imperial army. Indeed, her first major purchase, in 1764, consisted of 225 Old Master paintings that had been gathered for Frederick, Russia's enemy in the recent Seven Years War, who was unable to pay for them. This had the simultaneous effect of launching Catherine into the highest ranks of European collectors and humiliating a fellow monarch. It also set what became a standard practice for Catherine, buying in bulk out of collections gathered by others, often in other countries. Her acquisition of 198 works from the collection formed by Sir Robert Walpole in 1779 even allowed her to stake a claim to ascendancy over the British, then known for being among the greatest collectors (and perhaps the most stable nation) in Europe.

By contrast with the exuberant Baroque tastes of the Empress Elizabeth, Catherine's tastes were restrained, occasionally to the point of severity. She had strong Neo-classical preferences, which became simpler as her reign progressed, relying on classically balanced forms for their visual impact—even when richly ornamented with precious stones. She overthrew the tradition of sending craftsmen to England and Holland to study, and instead sent many of her students—who were required to be graduates of the Academy of Arts—to Italy. In all other cases Catherine's personal permission had to be sought by the artist.

Rembrandt van Rijn, *The Return of the Prodigal Son, c.* 1668–69. Oil on canvas, 262 × 205 cm (103¹⁄₈ × 80³⁄₄ in.). The State Hermitage Museum, St. Petersburg

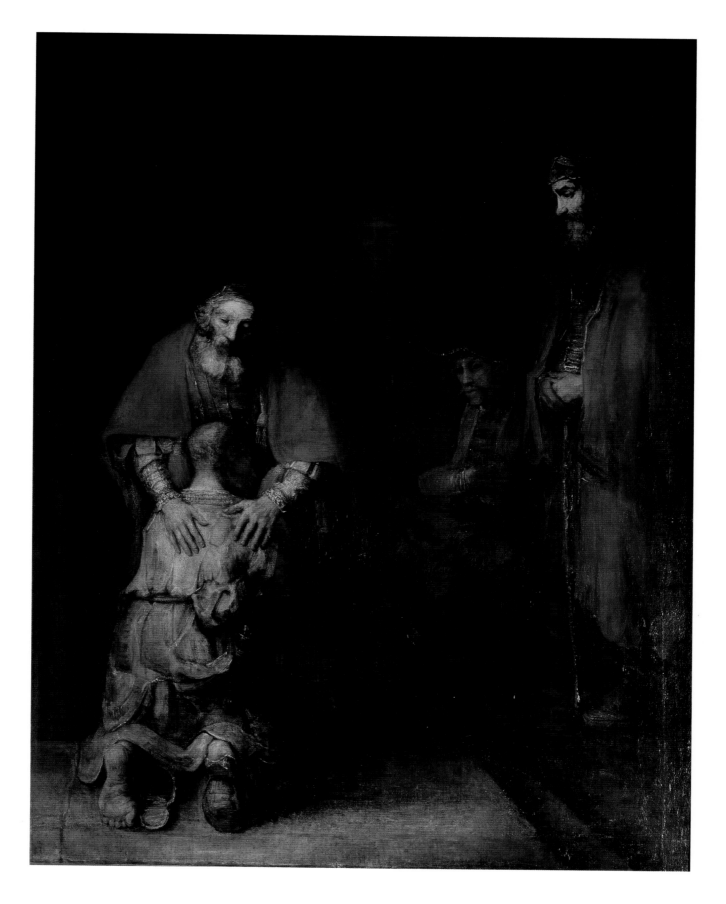

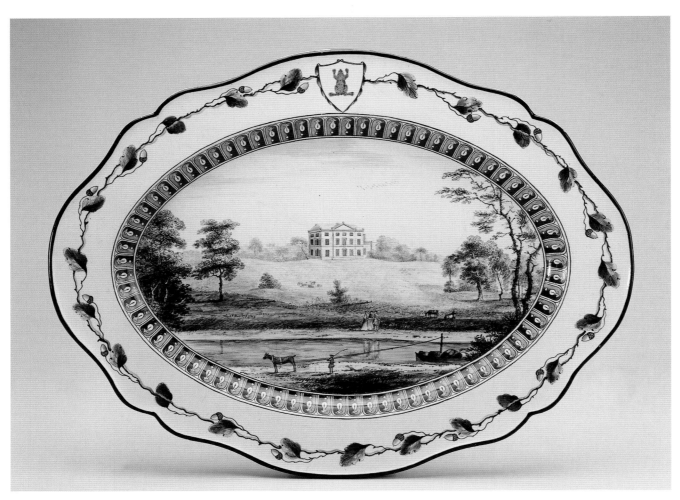

Josiah Wedgwood, Oval dish decorated with a view of Etruria Hall, Staffordshire, 1773–74. Creamware, 38.5 × 29 cm (15⅛ × 11⅜ in.). The State Hermitage Museum, St. Petersburg

While her collecting activities may have grown out of the tradition begun in Russia by Peter the Great and modeled for her by Frederick, Catherine transformed these through both the quality and the quantity of her acquisitions. She initially followed Peter's practice of concentrating on "the universal museum," but then rejected this approach and turned over her natural history collections to other museums, such as the Kunstkammer and the Academy of Sciences, retaining in this area only her mineral collections within the Winter Palace itself. From an early date Catherine's collections and their impact on the city were attracting notice from distinguished European visitors. The Reverend William Coxe, who visited in 1779, noted that "The richness and splendour of the Russian court surpasses all the ideas which the most elaborate descriptions can suggest. It retains many traces of its antient Asiatick pomp, blended with European refinement."[4] Observers often particularly noted the collections of jewelry, including "boxes and

caskets of silver wire, marvellously woven, partly gilded, some laid with stones and pearls ... also salt cellars of precious stones ... pockets watches of previous Sovereigns and their families ... snuffboxes also very different in time, size, appearance, material, others with precious stones and pearls,"[5] many of them made by European master craftsmen often in Catherine's employ, either in Russia (whose manufacturing traditions in the decorative arts Catherine inherited from Peter but then entirely restructured) or abroad.

In 1790, six years before her death, Catherine wrote to her friend and agent Melchior Grimm that, in addition to her four thousand paintings and the paintings of the Raphael Loggia, "my museum in the Hermitage contains 38,000 books; there are four rooms filled with books and prints, 10,000 engraved gems (and another 34,000 casts and pastes),[6] roughly 10,000 drawings and a natural history collection that fills two large galleries"[7] —without mentioning her sixteen thousand coins and

medals, or her decorative arts collections. One aspect of Catherine's collecting could relate to another: the growth of her collection of engraved gems, for example, led her to commission the favored furniture maker David Roentgen to produce five extraordinary mahogany cabinets, each with one hundred drawers, to house the gems. Catherine herself referred to her collecting as "a bottomless pit"; her passion for collecting gems she saw as gluttony: "gluttony of this kind is as infectious as gall."[8] The sheer scale of Catherine's collecting was such that it could only weaken the influence of her individual taste. From an early date she acquired large collections in their totality, one of the earliest of which was the purchase of the drawings collection assembled by Count Cobenzl in Brussels in 1768, containing some three thousand Old Master drawings (see cat. 53, 56, 61, 62).[9] This was almost immediately followed by her purchase of the Brühl collection in 1769, adding some six hundred paintings and fourteen folio albums containing 1020 drawings of consistently high quality (e.g. cat. 57). The acquisition of the collection of Count Crozat de Thiers from the Paris art market in 1772 was one of the qualitatively most significant of her collecting career, for this contained some 427 paintings including masterworks by Rembrandt (notably the *Danäe* and *The Holy Family*), Rubens, Van Dyck, Jordaens, Teniers, and others.[10] Subsequent acquisitions of large collections—such as Sir Robert Walpole's (two-thirds of which were paintings by either Rubens or Van Dyck),[11] the Casanova gem collection from Dresden, and a variety of French collections made available after the French Revolution— led to an exponential increase in her holdings. Such acquisitions were often complex negotiations, involving vast correspondence, indecision, doubt, and competition with rival bidders. And they resulted in the purchase of collections that substantially challenge our understanding of Catherine's personal tastes, absorbing out of necessity the tastes of other collectors—including several generations of the House of Orléans in France. Yet even here her subsequent desire to impose on many of these collections a rigorous cataloguing system—undertaken at her behest in the 1780s and largely accomplished (at least in some areas, such as gems and cameos) by 1795[12]— conformed to her personal desire for the ordering of knowledge and to Enlightenment tastes for the structuring of knowledge.

Catherine's collecting habits, voracious as they were, were profoundly personal as well as political. She greeted with passion the arrival of new paintings—works that were acquired for her, and which she never saw until they were unpacked in one or another of her palaces in and around the Russian capital. Her emissaries included artists and antiquarians, envoys and diplomats, travelers and members of the Russian and European aristocracy. Catherine exhibited the habits of the connoisseur, spending happy hours personally examining her albums of prints and drawings (three of which are to be seen in the present exhibition) or her collections of cameos and intaglios (engraved gems). Clearly, she saw collecting and connoisseurship, through personal handling of her treasures, as a source of daily pleasure, "an endless source of all kinds of knowledge."[13] A typical day saw her spend three hours with her collections after lunch, and she took favorite pieces with her as she moved from residence to residence through the year, including the engraved gems that went with her to her summer palace at Tsarskoe Selo.

Catherine's pleasure extended to the receipt of opulent gifts, including the extraordinary "Berlin Dessert Service" (cat. 86) made for Frederick the Great of Prussia as a gift to her in 1772—a service from which 470 pieces still survive in the Hermitage. Many of her best-known commissions combined personal taste with state function, as in the case of the dinner service she commissioned from Josiah Wedgwood in 1773 for her Chesme Palace, built in Gothic style between 1774 and 1777 on a site with the Finnish name Kekerekeksinen, or Frog Marsh.[14] Each of this service's 50 covers and 944 pieces bears the whimsical element of the green frog that has given the service its colloquial name. Their views of English palaces, castles, and abbeys in natural landscapes (with no view ever repeated) reflected Catherine's Anglophile tastes and were intended to inspire diners with the development of newly fashionable landscape features. Here, too, the taste was profoundly personal, as Catherine herself admitted in a letter to her friend Voltaire: "I love English gardens to the point of folly: Serpentine lines, gentle slopes, marshes turned into lakes, islands of dry ground, and I deeply despise straight lines … ."[15] Yet Catherine never personally visited an English garden, and knew them first only through the accounts of friends who had visited them, such as her Polish favorite, Stanislas Poniatowski, later through the gardeners and architects she dispatched to England, and finally from prints—of English gardens such as Stowe, Kew, and Wilton—that she acquired. Art was here a way for Catherine to access the world.

Catherine's tastes in English art, ranging from painting, to prints, engraved gems, ceramics by Wedgwood (cat. 43), and sculptures by Joseph Nollekens (cat. 88, 89), were in turn related to her interest in English culture in general and English literature in particular. Early conversations with the English envoy to Russia, Sir George Macartney, may have initially

stimulated these tastes, through his own interests in poetry, theater, and art. Catherine's letters bear testament to her knowledge and love of English literature, including Henry Fielding's *Joseph Andrews* and Laurence Sterne's *Tristram Shandy*, of which she wrote in 1779 "Je trouve une grande analogie entre sa tete et la mienne … ." ("I find a great similarity between his head and mine … .")[16] She was known to have read Richard Brinsley Sheridan's fashionable play *School for Scandal* in a German translation, as well as ten volumes of Richardson's *Clarissa*. Her support of English artists was such that she even paid off the private debts of the painter Richard Brompton, then in England in a debtors' prison, so that he might be free to move to Russia to enter her employ.[17] Brompton's double portrait of the empress's two eldest grandsons (cat. 1), painted in 1781, is replete with references to her policies in the East and her victories in the war with Turkey (1768–74). This she termed "un tableau charmant … . Ce tableau dans ma galerie n'est pas de figure par les Van Dyck." ("a charming painting … . This painting in my gallery isn't out of place in the company of Van Dyck.")[18] Brompton may have been an artist of limited talent, but he could certainly give the empress what she wanted in portraits of her family.

Catherine was perhaps the only leading collector outside England to collect English painting in the eighteenth century, a period when English art was without recognition on the Continent and not sought out.[19] Her first identifiably English painting was Joseph Wright of Derby's *The Iron Forge from Without*, acquired directly from the artist on her instructions in 1773, a painting of monumental modernity in depicting a scene of the Industrial Revolution. Through this purchase, Wright achieved more renown in St. Petersburg than he had then achieved in his own country town in the north of England. Yet, adventurous as Catherine's tastes could be, her personal views were often tempered by the political meanings she recognized could be found in the works she collected. Most famous in this regard, perhaps, was her response to the work she had commissioned from the leading English portraitist Sir Joshua Reynolds, a commission the subject of which she left to the artist. When she saw the finished product, *The Infant Hercules*, in 1789, she resented the symbolic relationship of the infant Hercules to the Russian empire and the implication that "her empire was still in its leading strings"—reins used to control the behavior of young children.[20] Even so, she admired Reynolds and, in particular, the discourses he gave to the Royal Academy in London, which she avidly read. Here, and in regard to the painting itself, she claimed in 1790, "in each of his own works one sees the progress of a distinguished genius"[21]—genius she

rewarded with the personal gift of a jewel-encrusted snuffbox, a not uncommon sign of the empress's particular goodwill.[22] Through the international relationships Catherine rebuilt and expanded, she had given the arts of Russia by the end of her reign "the fruits of a European education," giving birth to "taste" and "an attachment to the merits of the Russian name," in the words of the diarist Filipp Vigel.[23]

Catherine's personal collecting impulses first exhibited themselves through her collections of jewels and precious objects. Even the crown jewels were treated privately, kept in Catherine's private apartments where she often gathered friends for an evening of cards. These evening gatherings in her apartments or the Hermitage for conversation and cards outwardly appeared sober, often ending early to allow her to be in bed by eleven. Such regimented habits, even in pleasure, strongly contrasted with the court of Peter the Great, whose work she saw herself as completing. Peter's court was fluid, and he himself was known to have little taste for formality. Indeed, Peter's practice, even in more private settings such as the first palace-cum-hunting lodge he erected at Peterhof, was known for its excesses. He would ply visiting ambassadors with extraordinary quantities of alcohol as a test of their fortitude, and many were known to pass out on the lawns and gardens from complete excess. By contrast, Catherine's preference for an evening of cards with her intimates, in purpose-built suites of rooms, was typically the close to a highly structured day. This seemingly simple practice was equally informed by the fact that Catherine played cards for diamonds, and kept large stores of these on the card tables in special boxes, which today, like her private dinner services, are considered masterpieces of the applied arts. And such card games often had political implications, involving the fates of individuals or love affairs.

Catherine's private apartments were the precursor to the "Hermitage," a suite of private rooms each ornamented in a different style and open to Catherine's guests, where they could move among the worlds (and tastes, as Catherine and her court understood them) of China, Persia, and then Turkey. These had been preceded by her construction at the imperial palace of Oranienbaum, where she had spent much of her time as Grand Duchess, of the Chinese Palace, to designs by Antonio Rinaldi. Caravans sent to China throughout the 1770s brought back vast quantities of lacquered tables, chairs, textiles, wallpaper, dolls, and other pieces. In this way Catherine again inherited Peter's interests in the East, but took these—and the taste for chinoiserie, the adaptation of Asian influences to objects made in the West—to new heights, seemingly inspired both by the

Sir Joshua Reynolds, *The Infant Hercules Strangling the Serpents*, 1786. Oil on canvas, 303 × 297 cm (119¼ × 116⅞ in.).
The State Hermitage Museum, St. Petersburg

English passion for China and chinoiserie, and by the belief of Voltaire and others that enlightened rulers were to be found in China.[24]

The word "Hermitage" had already been used by Catherine's predecessors to characterize rooms or freestanding pavilions where the monarch could escape the formality of the court and engage in something approaching a private life. Catherine, however, extended the meaning to apply to the site where she held informal gatherings and where she housed her growing art collections, first named "Hermitage" in a manuscript inventory compiled in 1789 that referred to "the 'Armitazhe' of her Majesty."[25] The term was extended equally to a whole range of events, from performances to

card games, to receptions, to viewings of the collections. From the initial suite of private apartments the imperial museum grew, starting with a Hanging Garden where a dining pavilion contained tables that could be raised and lowered mechanically, allowing guests to be served while avoiding the presence of servants, and thus further ensuring the private function of the Hermitage gatherings. To this were eventually (but still within Catherine's lifetime) added the Large Hermitage, the Hermitage Theater (as a true embodiment of her theatrical leanings), and the Raphael Loggias.

Catherine followed the expansion of the Hermitage, and the subsequent movement of her collections, with great pleasure. When the Small Hermitage was opened, and her collection of cameos was moved there from the Winter Palace, she wrote Melchior Grimm in April 1785: "My little collection of engraved stones is such that yesterday four men had difficulty in carrying it in two baskets filled with drawers containing roughly half of the collection; so that you should have no doubts, you should know that these baskets were those used here in the winter to carry wood to the rooms … ."[26]

In the 1770s Catherine had a set of rules of conduct drawn up and posted within her Hermitage, rules that were both tongue in cheek and a sly reference to the loose behavior of Peter the Great's era. The rules themselves draw attention to her desire to carve out a fundamentally private domain, even if one that still had rules of conduct, and thus reflected her ordering outlook:[27]

1 All ranks shall be left outside the doors, similarly hats, and particularly swords.
2 Orders of precedence and haughtiness, and anything of such like which might result from them, shall be left at the doors.
3 Be merry, but neither spoil nor break anything, nor indeed gnaw at anything.
4 Be seated, stand, or walk as it best pleases you, regardless of others.
5 Speak with moderation and not too loudly, so that others present have not an earache or headache.
6 Argue without anger or passion.
7 Do not sigh or yawn, neither bore nor fatigue others.
8 Agree to partake of any innocent entertainment suggested by others.
9 Eat well of good things, but drink with moderation so that each should be able always to find his legs on leaving these doors.
10 All disputes must stay behind closed doors; and what goes in one ear should go out the other before departing through the doors.

The rules thus insist that in this quasi-private domain, a distinct set of conducts was required in which the formal pretensions and ranks of the court system would be set aside. In practice, however, this was not entirely the case, for the Hermitage functioned as an adjunct to the formal practices of the court—much as the Hermitage was itself attached physically as a series of extensions to the Winter Palace, the official residence of the monarch and center of the court system. This tug of war between private and public could be seen embodied in the collections enjoyed and displayed within the rooms of the Hermitage. Perhaps more so than was the case for her Western European counterparts, the public and political statement of the collections was an extension of Catherine's personal preferences. Her twin desires, for sumptuous private spaces and a museum that would make a statement about her and the Russian nation to all of Europe, existed side by side, and are to a great extent inseparable. Such a statement was, of course, made to a highly defined and limited audience: it was the empress's friends, courtiers, and guests who would see the museum, not the public at large. The modernization and westernization of Russia as represented by Catherine's collections could not arguably have had a direct effect on any of her people except those who operated at the highest levels. And this group, in Catherine's day and for many years to come, was very small when compared with the mass of the Russian populace.

Catherine's heirs followed her practices, and often her tastes, and were in some cases directly inspired by them. They were particularly active in regard to the Picture Gallery at the Hermitage, whereas other aspects of the imperial collection—such as the Cabinet of Drawings—languished, apart from works that entered the collection via other private collectors. Catherine's son Paul Petrovich, later Tsar Paul I, and his wife were profoundly interested in art and traveled extensively in France and Italy, acquiring works of both contemporary art and ancient sculpture. Together, Paul and his wife took on, from about 1780, the construction of the imperial palace at Pavlovsk, "inheriting" Catherine's favored Scottish architect, Charles Cameron, to create there the most thoroughly Palladian of the imperial residences, complete with a temple-filled "English" park across nearly a thousand acres. Paul thus continued the imperial strain of Anglophilia, and took Catherine's taste for the Neo-classical to one of its purest expressions. He also continued his mother's pattern of buying art *en masse*. At the very end of the eighteenth century, after becoming Tsar, Paul seems to have personally undertaken negotiations to acquire the sculpture collection assembled by the Farsetti family in Italy and

Konstantin Andreevich Ukhtomsky, *The New Hermitage: Voltaire's Library*, 1859.
Watercolor, 42.1 × 26.4 cm (16½ × 10⅜ in.).
The State Hermitage Museum, St. Petersburg

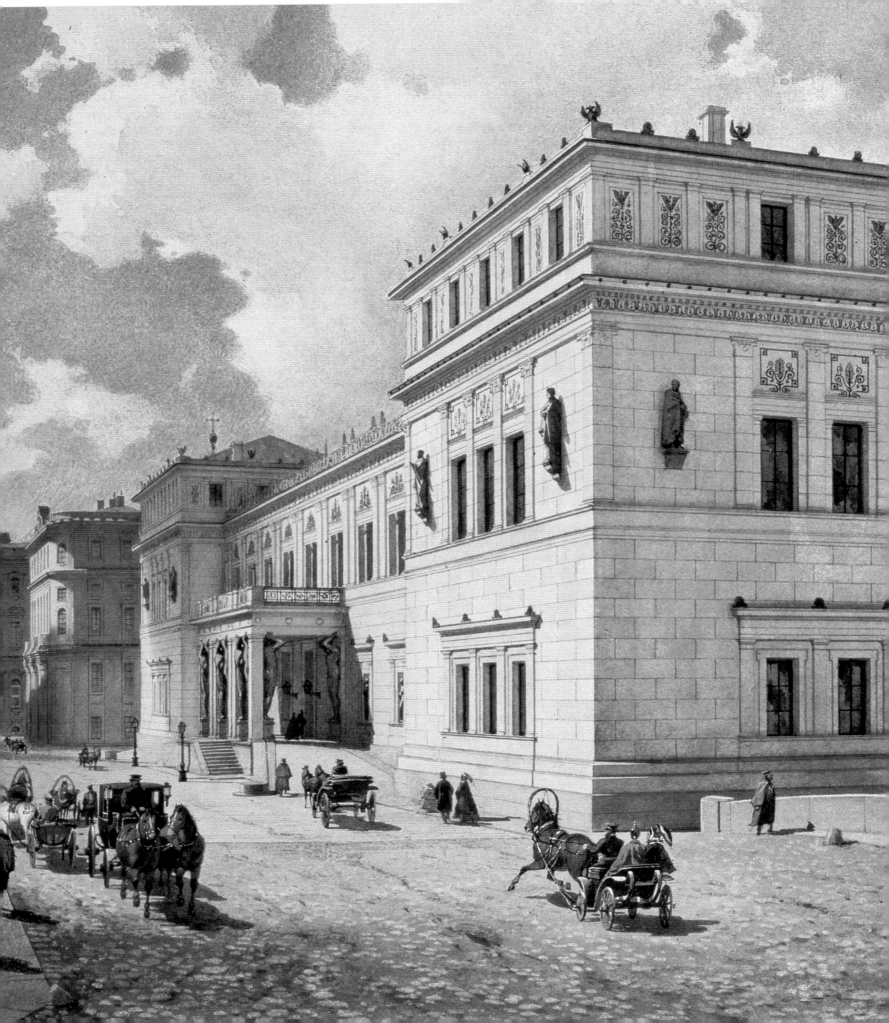

ALEXEY LEPORC

Nicholas I and the New Hermitage: The Ancien Régime Moving Toward the Public Museum

Nicholas I stands out in the parade of Romanov monarchs in that his attitude toward art, and particularly toward collecting, was highly refined. He was, in essence, the only Romanov ruler to apply an almost art-historical, museum-minded approach to the imperial collections. Of the two prevailing ways in which such collections were founded—either as princely collections dominated by fleeting whims of taste, or as museum collections created and advanced with the goal of presenting a history of art—Nicholas I's approach tended toward the latter, and he had no equal among the Romanov dynasty. For Peter I, the fine arts were an important element of Russia's overall cultural reform, but it cannot be said that he nurtured a specific taste, or even that he strove to create a truly balanced collection. (The habits of his daughter Empress Elizabeth, on the other hand, would suggest that art and art collecting were essentially a matter of decorum.)

The first awareness of collecting's ideological significance hit Russia with the accession of Catherine II; not only did she form a vast collection (in a remarkably brief period of time), but also, in full accordance with her chosen role as the enlightened monarch, her purchases included many works by contemporary artists. Catherine's fascination with architecture and her passion for collecting cameos and intaglios were particularly intense and personal. Her son Paul (the father of Nicholas I) unarguably enjoyed a heightened awareness of the arts, and his Grand Tour in 1781–82 provides evidence of his curiosity about the latest European art, but in practical terms this led to no more than the creation and/or decoration of various residences, and he did little to augment Catherine's collection. The activities of Nicholas's elder brother Alexander I were naturally circumscribed by their historical context, overshadowed as they were by the Napoleonic Wars, so that even the acquisition of the outstanding Malmaison collection was more a matter of chance than evidence of a conscious desire to enhance the imperial collection.

The influence of Napoleon and his Louvre on the overall development of museums throughout Europe during the first half of the nineteenth century has been extensively discussed. The creation of museums in Germany and Britain reveals the profound impression Napoleon made on European rulers—for him the Louvre was a matter of state pride and an opportunity for self-aggrandizement, and the ideology behind public access to the museum was part of the glorification of the ruler himself. But Russia occupies a special place in this historical unfolding, for the New Hermitage only indirectly reflects Napoleon's policies at his Parisian museum. There is nothing to suggest that Alexander I entertained any particular wish to open his imperial collection to the public, even though such an idea was expressed by Count Dmitry Buturlin, keeper of the collection, as early as 1804.[1] Nor did Nicholas manifest any such desire during the first decade of his reign.

But while such a desire is in keeping with the popular image of the relatively liberal Alexander, a monarch not without dreams of reform, it is completely unexpected in Nicholas. Despite changes in the way in which history perceives his reign, there is general agreement that he was throughout an autocrat who ruled without restraint on his powers, driven solely by the aim to preserve the status quo in the face of opposition. This was essentially the last vestige of the *ancien régime* in Europe, of which Nicholas sought to preserve any surviving feature. He was resolute in his belief regarding royalty on the Continent, and Louis Philippe in particular, that a king chosen "by the people's will" could never be the equal of any member of a family of sovereigns chosen "by the will of God."[2] It was this consciously cultivated conservatism that was, and remains, both the key criticism aimed at Nicholas's regime and the main cause behind its tragedy.

In everything—and that included every aspect of cultural life—Nicholas was an absolute autocrat. He personally approved all designs for buildings in St. Petersburg and at Peterhof, as well as those intended to house state bodies throughout the Russian Empire.[3] Nicholas famously pronounced: "By my very status within the state I must be the first artist in the land." It is

Luigi Premazzi, *View of the New Hermitage from Millionnaia Street*, 1850s. Watercolor, 32 × 43.6 cm (12⅝ × 17⅛ in.). The State Hermitage Museum, St. Petersburg

NICHOLAS I AND THE NEW HERMITAGE | 29

Christian Daniel Rauch, *Nicolas I*, 1832. Marble, height 51.5 cm (20¼ in.). Skulpturensammlung, Staatliche Kunstsammlungen Dresden

widely known that he had a private passion for the military genre; one source notes that 650 of the 666 pictures in his private apartments showed figures in military uniform, while one of Nicholas's painting tutors was the famous battle painter Alexander Sauerweid.[4] It is also known that Nicholas admired Romantic art, and was a principal collector of works by Caspar David Friedrich in the 1820s and 1830s.[5] In this endeavor he was influenced by the family of his wife, Alexandra Fedorovna. Born Princess Charlotte, Alexandra Fedorovna was sister of the future Friedrich Wilhelm IV of Prussia, who undoubtedly influenced Nicholas's tastes (and Friedrich Wilhelm's influence on the New Hermitage is indeed visible), and was himself inspired by a visit to Napoleon's museum in Paris. In this lies a paradox: the very pillars of the Holy Alliance were inspired by an invention of those very republicans who destroyed the *ancien régime*.

During the early stages of Nicholas's reign we cannot ignore the presiding legacy of Alexander I. During the later part of Alexander's reign, while he continued to erect Neo-classical buildings, Nicholas's private construction projects were influenced by the politics of the Holy Alliance and a burgeoning fashion for all things medieval—a fashion that reflected a clear-cut ideology, and a reminder of the eternal and unshakeable nature of absolutism. These projects included important buildings in the Romantic style (such as the ensemble in Alexander Park at Tsarskoe Selo, by Adam enelaws), which were further influenced by the Romantic complex of Franzensburg in Laxenburg, near Vienna (by Franz Jäger and Michael Rieder, 1798–1801). One German scholar justly quoted Hegel when discussing these buildings, which he saw as documents of "the unhappy self-consciousness of the aristocracy in an age of revolution."[6] Nicholas personally promoted this ideologically loaded Romanticism. For example, the Cottage Palace at Peterhof (by Menelaws, 1825–29) represented the private abode of a knight (in this case the monarch), to which he could retire in the evening upon fulfillment of his duty. This desire to find refuge in privacy was characteristic of Nicholas—fixing a further wedge between public and private.

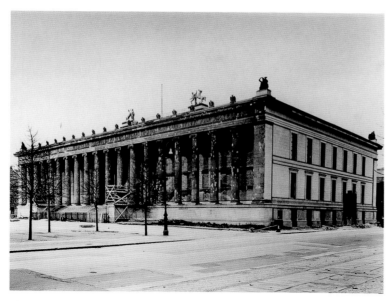

Karl Friedrich Schinkel, Altes Museum, Berlin

Along with an interest in Western Europe's Middle Ages, however, came a new stress on Russian style, realized in a most curious fashion in the form of two important buildings. The first of these was the Church of Christ the Savior in Moscow (designed by Konstantin Ton in 1832; it was demolished in the 1930s and rebuilt between 1996 and 2000), and the second was the Nikolsky House at Peterhof (Andrei Stakenschneider, 1835). The range—from the empire's cathedral, a monument to the victory over Napoleon, to the park pavilion, a plaything for the imperial family—encapsulates the defining characteristic of Nicholas's attitude to art, combining as it does the typical pastimes of the *ancien régime* (compare Marie-Antoinette's Petit Trianon) with the three key tenets behind the ideology of Nicholas's rule: autocracy, Orthodoxy, and the spirit of the Russian nation. Symptomatically, Nicholas saw "Russian style" from the viewpoint of its state importance. He once noted, in connection with the Russo-Byzantine Church of St. Vladimir in Kiev: "I cannot bear this style at all, but—not as an example to be copied—I permit it."[7]

Many of these features would later emerge in the New Hermitage—Russia's first public art museum. Undoubtedly the idea of turning an imperial collection into an accessible museum came from Western Europe. An art museum opened in Berlin in 1830, designed by Karl Friedrich Schinkel, which Nicholas visited just two years later; its initiator was Friedrich Wilhelm, by then heir to the throne. Some paintings from the royal collections were transferred here, but, most importantly, it gained paintings from the Giustiniani collection,

specially acquired for the purpose of being placed on public display. The same scenario is seen in Munich, where the heir to the Bavarian throne, the future Ludwig I, discovered Leo von Klenze (who coincidentally started his career as court architect to Jérôme Bonaparte) and began construction of a series of museums: the Glyptothek opened in 1830, and the Alte Pinakothek in 1836. One of the main motives was to exhibit Napoleon's former "trophies"—the best paintings from the Bavarian royal collection seized by Napoleon for the Louvre—which had now been returned from Paris. The process continued, with an Antique collection (Antikensammlung) opening in 1845, and the Neue Pinakothek in 1846. Between them Schinkel and Klenze essentially created the "museum building" that dominated throughout the nineteenth century and was still hugely influential into the twentieth. (Nicholas was well informed about all these events. Furthermore, during a visit to London in early 1817, when he was still Grand Duke Nicholas, he saw the marbles that Lord Elgin had brought back from Greece and it was probably then that he learned of plans for the creation of a British Museum.)

In 1838 Nicholas I and Alexandra Fedorovna visited Germany again, and during this journey made two important commissions. First they ordered from Schinkel a design for a palace at Oreanda in the Crimea (unbuilt) and, after seeing Munich, offered an invitation to Klenze to work on a design for the New Hermitage. Klenze would seem to have gotten the job largely because Schinkel was already engaged on another major commission.

In 1839 Klenze produced his design, approved by Nicholas in 1840, and a building commission was set up to take responsibility for its implementation. This commission included the leading Russian architects Vasily Stasov, Nikolai Efimov, and Alexander Briullov. Klenze made several more visits to St. Petersburg, between 1840 and 1851, but, curiously, was not invited to the opening of the Museum in 1852.[8] The very idea of uniting within a single building both Antique art and a picture gallery clearly came from Nicholas himself, his inspiration being Schinkel's Berlin museum, since in Munich different epochs were displayed in separate museums. An apparently simple division at the time of its foundation—with the ground floor occupied by Antiquities and sculpture, and the second floor by the ever-growing art of the modern age—was but part of the overall program.

Visitors entering the vestibule could choose between either the Greek sculpture hall or the Russian sculpture hall (Russian sculpture moved to the Russian Museum in the 1890s), thus stressing the notion of Russian art as

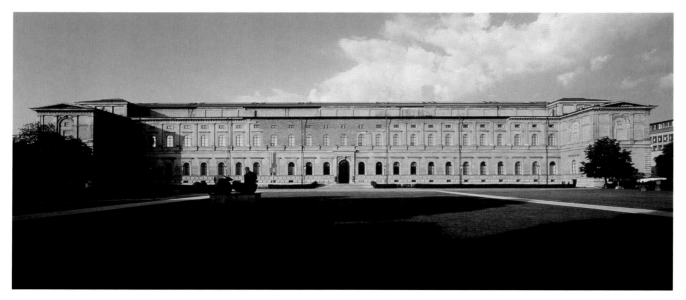

Leo von Klenze, Alte Pinakothek, Munich. North side with entrance

heir to Antiquity. An essential part of the first-floor exhibition was a collection of Greek and Roman art found in southern Russia, which was key to fixing Russia's place in world art history (it is worth noting that a key element in Schinkel's design for the palace at Oreanda was a museum of Crimean antiquities). It was quite logical, then, that when a Classical mosaic was discovered in 1854 in the ruins of Chersonesus (Kherson) in the Crimea, it should be set into the floor of the Hermitage's Athens Hall, and this was done in 1861. The mosaic was discovered alongside the Byzantine chapel in which, according to legend, the Kievan Prince Vladimir (who adopted Orthodox Christianity as state religion for Ancient Russia) was baptized in 988: essentially the very stones that marked the origins of Russian Christianity.

Even greater conceptual significance was attached to the exhibition on the second floor. On reaching the top of a grand staircase visitors found themselves in the Gallery of the History of Ancient Painting, a unique setting comprising eighty-six encaustic paintings placed on the walls and vaults, devoted to the birth of painting and its history in Ancient Greece and Rome. This gallery, with its program compiled by Klenze, is typical of the nineteenth-century desire to set out with maximum clarity a history of the arts. That history was not intended to be limited just to Antiquity. The original plan was to include eight key wall paintings on the birth and development of Russian art in the Antechamber, on the other side of the staircase along the central axis. Here the chronology would stretch from the introduction of the first icons from Constantinople to Kiev, by the

Russian Princess Olga in the tenth century, to the foundation of the Academy of Arts in 1757, thus stressing the overall development of art from Antiquity to Byzantium before moving on to art created on Russian soil. The accentuation of this continuity made the gallery a projection of one of the most important concepts in Russian statehood: Moscow (or St. Petersburg, depending on the period of history) as the third Rome. In his first letter to Nicholas regarding his vision for the museum complex, Klenze wrote: "I feel that for this purpose we would most suitably select subjects from the history of Ancient painting, for that history began in Antiquity, ended its brilliant period in Constantinople, was reborn in Christian form and together with that made its way into Russia."[9] Klenze included a description of both the Gallery and Antechamber in the original program he compiled in French in April 1845.[10] Unfortunately, the complex, as imagined by Klenze, remained but a vision and only the Gallery of Ancient Painting was ever realized. For financial reasons the frescoes were not executed, and the Antechamber (now the Van Dyck Hall) and its neighboring room (now the Snyders Hall) were hung with paintings of the Russian school, despite disagreements on the subject between Nicholas and Klenze, who opposed the inclusion of Russian art. The emperor was, as usual, unbending: for Nicholas there was not, nor could there ever be, any doubt regarding Russian art's integral place within world art. Only toward the end of the nineteenth century, as a result of a growing Slavophilic—at times even nationalistic—mood did the idea evolve of creating a separate museum of national art to match the remarkable cultural

phenomenon seen in Central and Eastern Europe. In St. Petersburg this culminated in the founding of the Russian Museum, which opened to the public in 1898; all paintings and sculptures by Russian artists in the Hermitage were transferred to this new museum.

Almost the whole of the second floor of the New Hermitage was occupied by the Picture Gallery. Here Nicholas demonstrated active interest in every detail, including the selection of paintings to be displayed, by taking charge of the selection committee. A famous anecdote told by the gallery's keeper, the artist Fedor Bruni, brilliantly reveals the level of Nicholas's certainty when deciding museum questions: "The Sovereign had seen in his time many paintings and sometimes identified them quite rightly. But if he had once determined that a painting belonged to a particular school, it was pointless to change his mind.

'A Flemish artist!'

'Your Majesty, it seems to me that …'

'No. Don't argue with me, Bruni. Flemish!' "[11] Nicholas's most controversial decision, in artistic terms,

was made during the process of assembling the permanent display: all the paintings in the imperial collection were divided into four categories: paintings intended for display; paintings to adorn the imperial residences; paintings to be kept in the museum stores; paintings to be sold. The selection was made by a commission composed of the artists Fedor Bruni, Petr Basin, and Timoleon von Neff, and the results were approved by Nicholas personally. We know that 1219 paintings—among them some works considered of great importance today—were indeed sold at auction, in March 1854. (It should be noted that such sales of paintings were not unique, or even rare: a similar sale was held in 1852 in Munich.) A very small number of these works later returned to the Hermitage by various routes, but the rest were lost for ever. In making this decision Nicholas demonstrated not so much petty tyranny as a form of common sense: why store paintings superfluous to requirements? From the point of view of a museum such a decision was criminal, but to a private owner it was simply part of a normal process, and in this

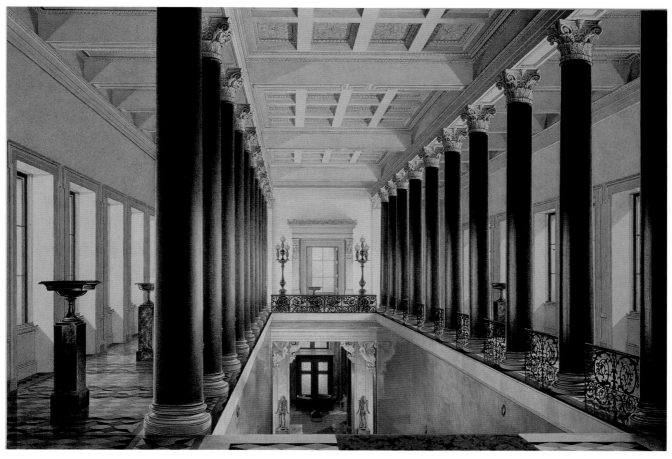

Edward Petrovich Hau, *Interiors of the New Hermitage: The Upper Landing of the Main Staircase*, 1853. Watercolor, 31.5 x 45.4 cm (12³/₈ × 17⁷/₈ in.). The State Hermitage Museum, St. Petersburg

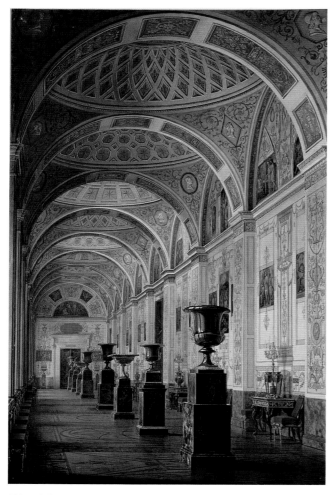

Edward Petrovich Hau, *Gallery of Ancient Painting*, 1859. Watercolor, 44 × 28.9 cm (17⅜ × 11⅜ in.). The State Hermitage Museum, St. Petersburg

lies the specific nature of the Hermitage's birth as a museum—one whose origins rely on the attitudes and tastes of a private individual and not on the objective presentation of art.

On the other hand, Nicholas was aware of lacunae in the collection and he took decisive measures to rectify them. In 1850, for instance, he acquired the celebrated Barbarigo collection in Venice, and while the overall standard of this collection is arguable, its significance for the Hermitage is that it included the museum's most important works by Titian, above all *The Repentant Magdalene*, *St. Sebastian*, and *Venus Before a Mirror*. The last, however, is now in the National Gallery in Washington, D.C., the result of sales during the Stalinist period, which were far more pitiless with regard to the Hermitage than those of Nicholas's time, depriving the museum of many true masterpieces. Even before this, a number of important works had been acquired in Italy between 1840 and 1843 through the secretary at the Russian

embassy in Rome, P.I. Krivtsov. The most notable acquisitions of this period included works by Francesco Francia, Garofalo, and Guercino. In 1836 seven Italian paintings were acquired from the London collection of William Coesvelt, including its chief masterpiece, Raphael's *Madonna Alba* (also now in the National Gallery, Washington, D.C.). In his memoirs Fedor Bruni—who was responsible for the restoration of the painting—recalls that it so appealed to Empress Alexandra Fedorovna that she wished to hang it in her study, but Nicholas, despite his great affection for his wife, refused: "'That's having too much of a good thing. Look, he'll make you a copy,' said Nicholas, pointing at Bruni, 'It'll be no worse than the original, the place for which is here [in the Hermitage].'"[12]

In 1850, at the sale of the collection belonging to King Willem II of The Netherlands, Bruni acquired a number of masterpieces: Francesco Melzi's *Colombina*, Sebastiano del Piombo's *Descent from the Cross*, and Guercino's *Martyrdom of St. Catherine*. At the same time the Hermitage gained important Flemish paintings—Jan van Eyck's *Annunciation* (now in Washington), Rogier van der Weyden's *St. Luke Drawing the Virgin*, Provost's *The Virgin in Glory*, and Gossaert's *The Descent from the Cross*. Together with paintings that came to the Hermitage from the Tatishchev collection in 1845 (notably two wings of a triptych by Jan van Eyck, *Golgotha* and *The Last Judgment*, now in the Metropolitan Museum of Art, New York; a diptych by Robert Campin; and works by Isenbrandt and Provost), they formed the core of the old Netherlandish painting collection. Significant additions were also made to the Spanish collection: in 1831 several paintings were acquired from the collection of Manuel Godoy, and after a number of more minor acquisitions in 1852, at the sale of the collection of Marshal Soult in Paris, the Hermitage acquired Zurbarán's *St. Lawrence* and Murillo's *Liberation of the Apostle Peter from Prison*.

As a result of all these acquisitions, there was a radical shift in the balance and coverage provided by the collection: while the Dutch, Flemish, and French schools had been exceptionally rich even before Nicholas came to the throne, the Italian collection was now excellent, complemented by copies of Raphael's frescoes produced in Rome in the 1820s and 1830s by graduate students of the Academy of Arts, which to this day adorn the Academy building in St. Petersburg.[13] Reconstruction, necessitated by the building of the New Hermitage, incorporated the Raphael Loggias, copies on canvas of originals in the Vatican, produced in Rome in 1778–82, which in 1782–85 had been set into a specially designed building by Giacomo Quarenghi. No further attempts were made, however, to fill gaps in the collection, and

thus works that had not been deemed important during Nicholas's reign never found their way into the Hermitage. Not a single monarch or statesman from Russia's later history ever showed a similar interest in the museum; all felt that the goal had already been achieved.

Nicholas's personal passion for contemporary sculpture reached its height during a trip he made to Italy in December 1845, when he visited the studios of the masters. In Rome he visited the Russian sculptors Petr Stavasser, Konstantin Klimchenko, Nikolai Ramazanov, and Anton Ivanov, as well as Pietro Tenerani (cat. 44), Luigi Bienaimé (cat. 49), Emil Wolff (cat. 40), Rinaldo Rinaldi, Heinrich Imhoff, Carlo Finelli, and Giuseppe de Fabris; in Florence he visited Lorenzo Bartolini, Giovanni Dupré, Felice de Fovo, and Nikolai Pimenov; in Bologna Cincinnato Baruzzi. A list of these names provides convincing evidence of the emperor's commitment to the museum he was then in the process of creating. In all of these studios he acquired or commissioned new works.

Even then the museum was global in nature, with a small Egyptian collection on the first floor, and on the second floor collections of prints and drawings, manuscripts, a library, rooms for coins and medals, and others for engraved gems. Characteristically, Nicholas entered into all the details regarding construction and equipping of the museum, and it was he who proposed bilingual inscriptions in Russian and French. His directions extended to the ordering of frames and the approval of furniture made for the museum.[14]

According to legend, Nicholas, already ill but still some years away from death, visited the New Hermitage in the winter of 1854–55 and pronounced: "Yes, it is indeed marvelous."[15] By an irony of fate, the museum was perhaps the emperor's most important and progressive act, yet the limitations of his interest in art had endless repercussions. Such is the paradox, one partly rooted in the very nature of Nicholas I himself. The best description of Nicholas remains that provided by Baron Nicholas Wrangell, an amateur—but extremely important—art historian of the late nineteenth century:

> A man of narrow ideas but expansive execution; a mind of limited range, always unbending, almost obstinate and never in doubt; the monarch *par excellence*, who saw his whole life as a form of duty; a man who knew what he wanted, although he sometimes wanted too much; a powerful ruler, often with un-Russian thoughts and tastes, but with a purely Russian expansiveness; unbending, commanding, exceeding proud, the Emperor in everything he did: an autocrat in his family, in politics, in military matters and in art.[16]

Notes

1 V.F. Levinson-Lessing, *Istoriia kartinnoi galerei Ermitazha. 1764–1917* (The Story of the Hermitage Picture Gallery 1764–1917), Leningrad 1985, p. 128.

2 Quoted in S.S. Tatishchev, *Imperator Nikolai I i inostrannye dvory* (Emperor Nicholas I and Foreign Courts), St. Petersburg 1889, p. 128.

3 A. Benois (Benua) and N. Lanceray (Lansere), "Dvortsovoe stroitel'stvo pri imperatore Nikolae I" (Palace Construction under Emperor Nicholas I), in *Starye gody* (Days of Old), July–September 1913, p. 180.

4 O. Neverov and M.B. Piotrovsky, *Hermitage Sobranie i Sobirateli*, St. Petersburg 1997, p. 71.

5 For more information, see e.g. *German Art for Russian Imperial Palaces 1800–1850*, ed. B. Asvarishch, exhib. cat., Hermitage Rooms at Somerset House, London 2002.

6 Chr. Dittscheid Kassel, *Löwenburg im Bergpark Wilhelmshöhe*, Bad Homburg v.d. Höhe 1976, p. 57.

7 A.V. Prakhov, "Imperator Aleksandr III kak deiatel' russkogo khudozhestvennogo prosveshcheniia" (Emperor Alexander III as a Proponent of Russian Artistic Education), in *Khudozhestvennye sokrovishcha Rossii* (Art Treasures of Russia), vol. III, St. Petersburg 1903, p. 152.

8 For more detailed information on the construction of and approach to this building, see A. von Buttlar, *Leo von Klenze. Leben-Werk-Vision*, Munich 1999.

9 Russian State Historical Archive, Fund 468, *opis'* 35, *delo* 327, f. 2.

10 Ibid., pp. 62ff. I would like to thank E. Onoprienko, a student of the European University at St. Petersburg, for kindly providing the quotations from archive documents. A detailed description of the history behind the design of the Antechamber can be found in T.L. Pashkov, *Zal van Deika* (The Van Dyck Room), St. Petersburg 2002.

11 A.V. Polovtsov, *F.A. Bruni. Biograficheskiy ocherk* (F.A. Bruni. A Biographical Sketch), St. Petersburg 1907, p. 68.

12 "Rasskazy iz nedavnei istorii. Soobshcheno Ivanom Stepanovichem Listovskim" (Tales from Recent History. Related by Ivan Stepanovich Listovsky), *Russkii Arkhiv* (Russian Archive), book I, 1882, no. 1, p. 176.

13 For further detail on Nicholas I's acquisitions see *Nikolai I i Novyi Ermitazh* (Nicholas I and the New Hermitage), exhib. cat., Hermitage Museum, St. Petersburg 2002.

14 Levinson-Lessing, p. 190.

15 *Musée de l'Ermitage Impérial. Notice sur la formation de ce musée et description des diverses collections qu'il renferme avec une introduction historique sur l'Ermitage de Catherine II*, by F. Gille, St. Petersburg 1860 (Russian ed. *Muzei imperatorskogo Ermitazha. Opisanie razlichnykh sobranii sostavliaiushchikh muzei s istoricheskim vvedeniem ob Ermitazhe imp. Ekateriny II i ob obrazovanii muzeia Novogo Ermitazha*, by F. Zhil (Gille), St. Petersburg 1861), p. XXVI.

16 N. Wrangell (Vrangel'), "Iskusstvo I Gosudar' Nikolai Pavlovich" (Art and Emperor Nikolai Pavlovich), in *Starye gody* (Years of Old), June–September 1913, p. 55.

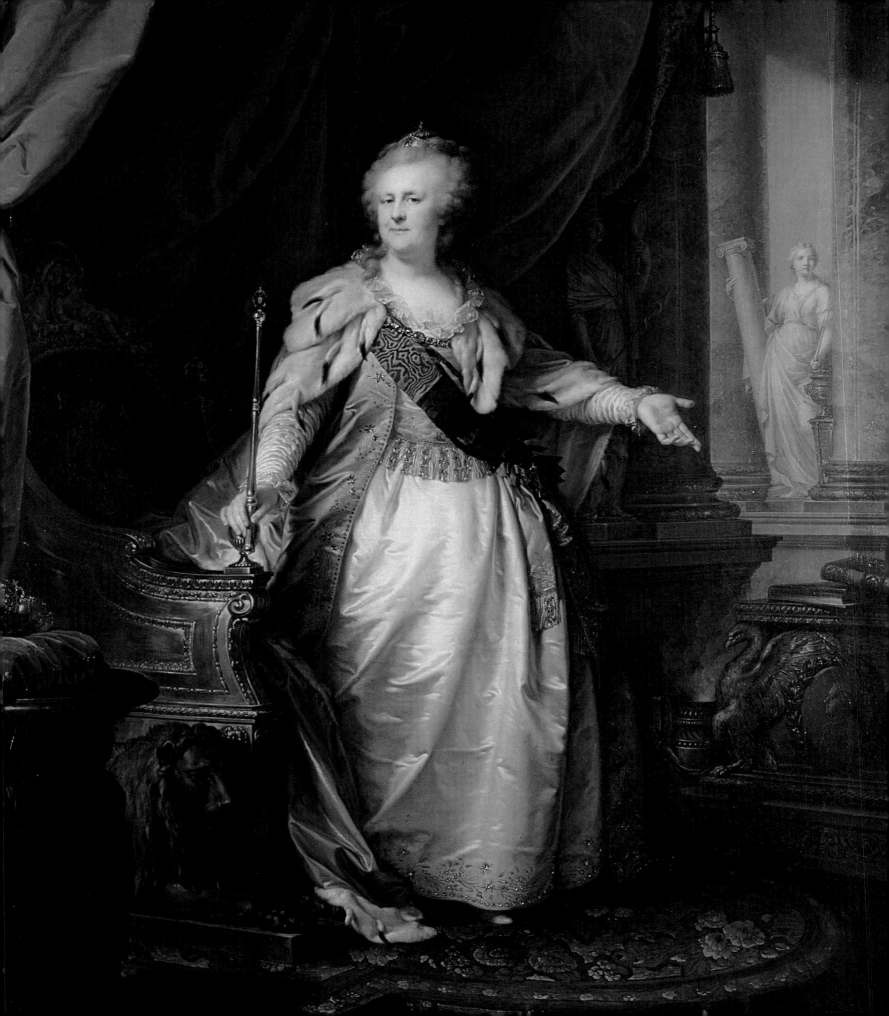

KATIA DIANINA

The Museum and the Nation: The Imperial Hermitage in Russian Society

The age of nationalism advanced the public museum as a compelling showcase of cultural identity and one of the strongest anchors of national consciousness. The museum is a powerful institution that serves to represent the national community and promote allegiance to the state.[1] The Louvre was one of the first museums to demonstrate this remarkable capacity to forge a commonality in art when it opened to the public in 1793. Public display drew together art and citizenship in a scenario in which works of art came to symbolize the very spirit of a nation.[2] Other European countries soon followed suit, and by the middle of the nineteenth century the national museum had become emblematic of the modern state.

The public museum serves as the face (more often the façade) of a nation. It is a site of symbolic representation and a meeting place for different groups within a society. Unlike private collections, the public museum offers a common space open—at least theoretically—to all. Public displays concretize the abstract ideas of a nation into something visible—works of art; the museum-going public—offering open access to national riches and fostering social relations. As a result of the representational shift from private to public display, the museum came both to advance the national community and, at the same time, to *mold* it by rendering the visitor a participating citizen.[3]

In Russia, as elsewhere in Europe, the nineteenth century was an era of public museums and exhibitions. As a direct result of the Great Reforms of the 1860s, which saw the emancipation of serfs and the easing of censorship, a public culture began to evolve in tsarist Russia. This took place against the background of three major changes in urban Russian society: the incipient modernization of the country, a conspicuous proliferation of exhibitions of all kinds, and a considerable expansion of the public sphere. Russia entered the "museum age" relatively late in comparison with many advanced European states.[4] In the second half of the nineteenth century, however, Russian society witnessed a veritable exhibition boom. Museums and exhibitions of all kinds (artistic, agricultural, and industrial) mushroomed in unprecedented numbers. By the end of the century, forty-five new museums of general interest had appeared throughout the Russian empire, while the number of exhibitions organized between 1843 and 1887 is estimated to have been an astronomical 580.[5] Exploring and exalting national identity was at the root of many of these temporary and permanent displays.

The Imperial Hermitage was the last of the major royal galleries in Europe to open its doors to the public, in 1852. (Free entry to the museum was instituted even later, in 1865.) Although in Russia the idea of a public art institution was both appealing and necessary—all the more so in an age that, elsewhere in Europe, actively advanced both museums and nations—the Hermitage tarried before joining the nation-building project. At that time, the world-famous Hermitage was virtually invisible, to judge from the contemporary periodical press. Why such a delay? The discussion below follows the twisted road that the Imperial Hermitage traveled to meet Russian society, and surveys selected milestones that marked the museum's gradual progress toward its public.

For its first hundred years the Hermitage museum, contiguous with the official residence of the Russian tsars in the Winter Palace, was a peculiar institution of mixed character. Conventionally, the museum's "birthday" is considered to be 1764, when the first major acquisition arrived: the collection of Berlin dealer Johann Gotzkowski. In the following two decades, Catherine the Great, the museum's founder, quickly accumulated an impressive collection of Western art that could rival the older and more prestigious museums in Europe. A choice assortment of paintings was but one side of the museum, however. An "enlightenment project" par excellence, the Hermitage grew to become an encyclopedic collection of, among other things, engravings, natural curiosities, and Catherine's impressive group of ten thousand cut gemstones. The museum originated as a small pavilion, curiously named "the hermit's abode," which became the site for the so-called Hermitage assemblies, consisting of games, theater performances, and sumptuous banquets. Ironically, paintings formed only a small part—essentially

Johann-Baptist Lampi the Elder, *Portrait of Catherine II*, 1793.
Oil on canvas, 290 × 208 cm (114⅛ × 81⅞ in.).
The State Hermitage Museum, St. Petersburg

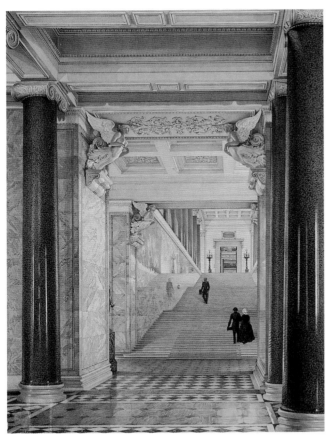

Konstantin Andreevich Ukhtomsky, *Interiors of the New Hermitage: The Main Staircase and the Vestibule*, 1853. Watercolor, 40.1 x 29.2 cm (15¾ × 11½ in.). The State Hermitage Museum, St. Petersburg

few before the 1850s: elite art-lovers, foreigners, and the students of the Academy of Fine Arts. One foreign visitor, the German traveler Johann Georg Kohl, observed, for instance: "The visitors to the Hermitage are not very numerous, because strangers as well as foreigners must obtain special tickets, which, it is true, are granted without difficulty; yet this little obstacle is sufficient to keep a great number of persons away … . There are in Petersburg numbers of highly cultivated families who have never yet visited the Hermitage."[6] In 1826, for example, only 600 tickets were printed. The Hermitage was not even listed as a museum; it belonged to the Ministry of the Imperial Court's domain, and early guidebooks placed it under imperial palaces, not institutions of culture.[7] Only gradually, during the first half of the nineteenth century, did the Hermitage begin its metamorphosis from an exclusive private collection to a freely accessible public museum.

The Gallery of 1812, which opened in December 1826 to display 332 portraits of military leaders who had distinguished themselves in the war with Napoleon, was one pocket of public culture within the Romanovs' official residence that attracted the attention of contemporary patriots.[8] Another was the exhibition of Karl Briullov's famous painting *The Last Day of Pompeii*. Judging by the social resonance elicited by Briullov's painting, its unveiling was a cardinal event in the museum's history before the Hermitage formally went public in 1852. On the wings of European fame the painting arrived at the Hermitage in August 1834 as a gift to Nicholas I, who accepted it graciously and summoned Briullov home from Italy to assume a professorship at the Academy of Fine Arts.[9]

These two isolated episodes of public display within the Winter Palace anticipated the ultimate conversion of the Romanovs' art gallery into a public museum. The credit for this milestone in the museum's history belongs to Nicholas I, who commissioned a German specialist in museum architecture, Leo von Klenze, to build for the collection a separate building: the New Hermitage. On 5 February 1852, after ten years of construction, the Neo-classical edifice, with a Greek-style portico supported by huge granite figures of Atlas, received its first visitors—guests of honor invited to an elaborate fête, a glamorous mix of luxury, art, and theater in the tradition of Catherine the Great, which the emperor hosted to mark the occasion.

Russians, too, now had a public art gallery of their own. However, the change did not occur overnight. For its first decade the New Hermitage was a public museum in name alone: "One visited the emperor, not the museum," as Germain Bazin laconically observed.[10]

a background—for the Hermitage theatrics in the age of Catherine the Great.

In establishing her famous collection, Catherine was motivated less by the accumulation of cultural capital than by its representation. The empress put the politics of museum display to good use: in her day the museum art collection—located next door to the Hermitage Theater—became another stage upon which to display the cultural advancement of Russia. Underlying Catherine's politics of representation, which were based on a tight alliance of museum and power, was an old paradigm: Russia imitated Europe in order to be recognized as part of it. A showcase of national wealth and progress, the Hermitage served to represent Russia advantageously to foreign visitors—not Russia as it was, but as it was envisioned by the enlightened empress. After all, a national identity manufactured by triumphant display, no matter which form it takes, is always a construct, a fiction.

As the Hermitage was essentially an extension of the Winter Palace, access to its riches was limited to a select

According to the 1853 set of "rules" set out for visitors, formal dress—a black frock coat or a uniform—remained a necessary attribute for the museum-going public (with the exception of artists who came to work in the museum), and tickets were required of all visitors. One of the first guidebooks to the public museum described the situation succinctly: "In the previous century, the Hermitage functioned as a retreat for the imperial family and *coincidentally* as a museum. In our times, its character remains the same."[11]

As in the days of Catherine the Great, the judgment of the ruling family continued to define taste in the public museum as well. More specifically, the collection of the New Hermitage was organized around Nicholas's erratic aesthetics, which can be summarized in one sentence: "The initial placement depends on His Majesty the Emperor."[12]

Nicholas likewise distinguished himself by auctioning over a thousand paintings from the collection that he deemed inferior. Despite these acts of "epidemic barbarism," as Baron Wrangell (Vrangel') qualified the refined taste of the sovereign, the opening of the

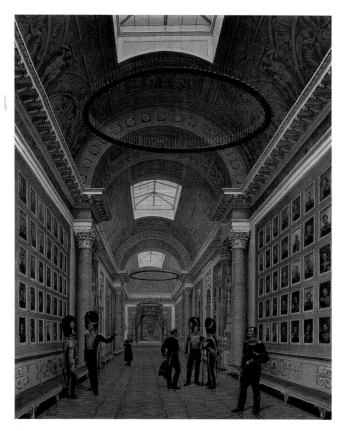

Grigory Grigorievich Chernetsov, *Interiors of the Winter Palace: The Military Gallery of 1812*, 1827. Oil on canvas, 122 × 93.6 cm (48 × 36⅞ in.). The State Hermitage Museum, St. Petersburg

Hermitage as a public museum during his reign was no mean achievement. In recognition of the emperor's concerted efforts to promote the museum, the writer Dmitry Grigorovich, secretary of the Society for the Encouragement of the Arts at that time, opined that the prerogative of founding the Hermitage museum should belong to Nicholas alone.[13]

The whole of the following decade was required for the Hermitage to implement a new organization and structure, completing its transformation from a private gallery to a public institution. In the 1850s the Hermitage still lacked all the necessary attributes of a modern museum: a complete inventory, catalogues, guidebooks, reproductions, art criticism, and unrestricted access. It was not until the early 1860s, when the director of the Berlin Museum Art Gallery, G.F. Waagen, was invited to modernize Russia's main museum, that the Hermitage's collection was systematized and its full catalogue produced. A new set of "rules," adopted in 1863, eased the dress code, allowing social groups lacking the requisite frock coats and uniforms access to the museum.[14]

These institutional changes, necessitated by the cultural and social renaissance of the 1860s, were an important landmark in the history of the Hermitage as a public museum. In early 1864 the popular newspaper *Golos* (*The Voice*) captured the spirit of the reforms in the following summary: "Recently, significant changes have been taking place in the Hermitage, the necessity of which has been felt for a long time. Thus those wishing to visit the gallery and museum now do not encounter the same restrictions, which prevented many, perhaps, from such visits: now it is no longer absolutely necessary to wear a frock coat, for instance, etc. But these are trifles; most importantly the new reforms consist in the strict system, which had been applied to the Hermitage's multifaceted departments, and in the chronological order, in which the precious artworks stored there have been classified."[15]

The newspaper mentioned another innovation as well: the museum had established the position of "director," appointing Stepan Gedeonov to occupy this post in 1863. This seeming formality introduced more than just a new title; as Geraldine Norman has suggested, it marked a whole new stage in the history of the museum. "From the 1850s onwards, the moulding of the museum's character slipped out of the hands of the imperial family and into those of professional administrators." It was Gedeonov who, during the reign of Alexander II, bought for the Hermitage such masterpieces as Leonardo da Vinci's *Litta Madonna* and Raphael's *Madonna Connestabile*, as well as an invaluable

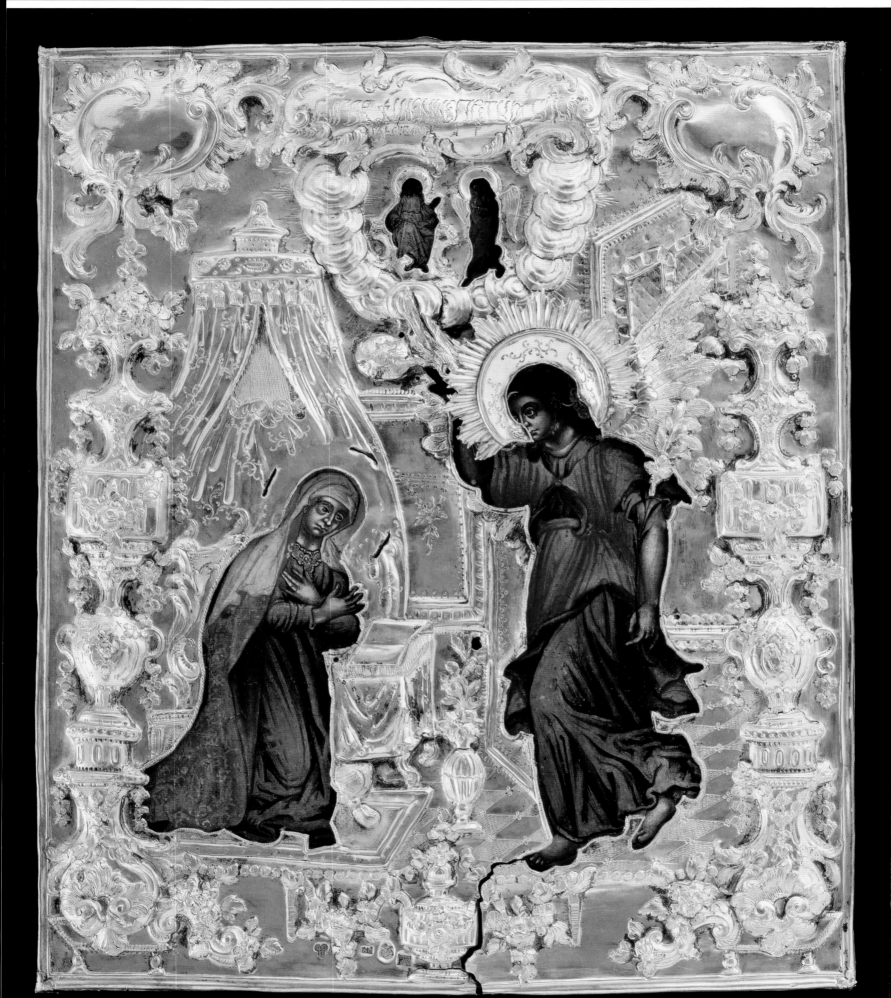

WENDY SALMOND

The Romanovs and Their Public:
A View From the Provinces

Russia's Romanov family took seriously its role as tastemaker and trendsetter for a vast and diverse empire. The foundation of St. Petersburg in 1703 was the grandest example of how, throughout the imperial period, the autocrats of all the Russias provided visual, tangible models of how this vast empire, where Europe meets Asia, might take its place in the ranks of "civilized" nations. The splendid works of art that the Romanovs collected had an important role in expanding the "window on the West" that Peter the Great so famously opened.

For the vast majority of their subjects, however, these glimpses of a new and alien world must have appeared as if through the wrong end of a telescope. The bifurcation of culture that was set in motion during the reign of Peter is one of the most vivid and deeply rooted images of imperial Russia. Western ideas, styles, and artists had long been familiar in Russia and had had their part to play in the formation of a distinctive national culture. It was not until Peter's reign (1682–1725) that the culture of Western Europe was imposed speedily and wholesale upon the upper echelons of Russian society, while the lower classes were left to the "backward" and "Oriental" traditions of their forefathers. No detail of life was overlooked in stressing that a new age had arrived for Russia. By a decree in 1701, "all with the exception only of the clergy and 'plowing peasantry' were to wear 'German' dress, French and Saxon topcoats, and German vests, breaches, boots, shoes and hats, and to ride on German saddles."[1] The population of Russia was visually and symbolically segregated into two camps: an educated urban elite insulated from a benighted and reactionary populace. Even time itself was forcibly redirected when the old Orthodox Church calendar, which began on September 1, was pushed forward to synchronize with a world that began its year on January 1.

The raw materials of art reverberated with symbolic import. Stone was reserved for building the new Russia, making wood a contemptible symbol of the bad old days. Porcelain, the "white gold" of eighteenth-century Europe, outranked the older precious metals of gold and silver at the banqueting tables of the court. And the lustrous medium of oil paint, when applied to the art of holy icons, brought an element of sensuality quite alien to the effects of traditional tempera painting.

These extremes cannot be ignored. But nor should they obliterate the rich spectrum of a new culture that leached out into the hinterland and left its mark on the lives of the population at large. For the vast majority of his subjects, Peter's reforms were not imposed by fiat, as they were for the highest levels of society, but trickled down to them through less direct routes. The rural peasantry who made up the bulk of his subjects were often receptive onlookers, by turns admiring of, outraged at, and amused by the foibles of Russia's newly modernized gentry. Within a generation or two of the introduction of breeches and periwigs, grandees wearing them began to appear in folk embroideries and lace reached remote parts of the empire; Classical pediments and swags cropped up in the most traditional forms of wooden architecture; and incongruous forms of modern life became decorative motifs on spinning distaffs and dowry boxes. Between the most perfect imitation of foreign ideals (as practiced in the Imperial Academy of Arts, the Imperial Porcelain Factory, and the Imperial Lapidary Works) and the most obdurate rejection of them (in the manner of the Old Believers, religious sectarians for whom Western ways were a mark of the Antichrist), an expansive middle ground of adaptation and assimilation opened up.

An obvious conduit for Western culture was the mobility of craftsmen enlisted to help construct the new capital of St. Petersburg. Entire villages of skilled carvers, metal smiths, and painters were drafted for years at a time, but on their return home they brought with them a stock of new images and patterns that quickly found their way into local life. Equally effective were the mass-produced engravings, illustrated books, and printed broadsheets that were printed in Moscow, St. Petersburg, and the southern city of Kiev, and distributed throughout the empire. The slyly satirical broadsheets known as *lubki* often adapted prints from Germany, Holland, and

The Annunciation, icon with chased metal *oklad*. *Oklad*, 1781.
Tempera on wood, silver gilt, 33.2 × 27.8 cm (13 × 11 in.).
Hillwood Museum and Gardens, Washington, D.C.

Pan Tryk and Khersonia Lubok, colored woodblock print, mid-eighteenth century. 27.2 × 33.2 cm (10³/₄ × 13 in.). Slavic and Baltic Division, The New York Public Library

France, and singled out for special notice the outlandish attire and dubious morals of the "new Russians."

Peter's own collecting interests, along with his fondness for all things Dutch, are reflected in the bound volume of allegorical prints by Maarten van Heemskerck included in the exhibition (cat. 68). In a more famous example of imperial collecting for the good of the nation, in 1705 he commissioned from Amsterdam a Russian edition of the Dutch book *Symbols and Emblems*, as part of his campaign to bring Russia into closer contact with Western Europe. This visual dictionary of eight hundred allegorical images with mottoes provided artists at Peter's court with the imagery essential to the celebration of his new imperial culture. Peter found a fitting alter ego in the classical hero Hercules, while cupids, hearts, and thunderbolts laid the foundation for a new symbolic language. The allegorical language of mottoes and emblems beloved of Dutch artists very quickly entered the visual vocabulary of Russian craftsmen, as copies of *Symbols and Emblems* were strategically distributed to important craft centers of the empire. One example can show how effectively this publication could breathe change into the crafts of an entire region: a slant-front jewel box (in the collection of the Hillwood Museum) is decorated with two plaques showing a falcon pursuing a hare. The motif is derived from an image in *Symbols and Emblems* with the accompanying, characteristically obscure motto, "I do it willingly."[2] This box was crafted and adorned with carved walrus ivory in the town of Kholmogory, some thirty miles from the northern port city of Archangel. Despite their distance from cultural centers, Kholmogory's carvers and craftsmen were not provincials.

In the previous century they had been summoned to Moscow to work for Peter's grandfather in the Armory Workshops of the Kremlin. Returning home at century's end, they brought not only new ideas and patterns, but also a habit of adapting their native talents to the interpretation of unfamiliar ideas for an urban, often aristocratic clientele. Their finely carved combs, boxes, and other elegant trifles were enlivened with delicate scrolls and genre scenes in which figures in Western dress engaged in decidedly Western pursuits.

It has long been thought that, in the area of religious art at least, the effects of Peter's reforms were overwhelmingly pernicious. This is especially true in the field of icon painting, which came to symbolize the conflicts between old and modern Russia. Alive to the galling fact that traditional icons, with their rejection of earthbound realism in favor of a higher spiritual truth, frequently "aroused the laughter and contempt of foreigners," Peter and his successors pushed relentlessly for their modernization, having in mind as a model the Italianate religious painting taught in European art academies. By a decree of 1703, the Armory Workshops in Moscow, which had set aesthetic standards during the reigns of Peter's father and grandfather, were abolished,

Frontispiece to *Simvoly i emblemata* (*Symbols and Emblems*), Amsterdam, 1705. Slavic and Baltic Division, The New York Public Library, Astor, Lenox, and Tilden Foundations

Jewel box, Kholmogory, mid-eighteenth century. Walrus ivory, wood, and silk, 38.5 × 27.6 × 12.4 cm (15¹/₈ × 10⁷/₈ × 4⁷/₈ in.). Hillwood Museum and Gardens, Washington, D.C.

and a new Chamber of Iconographers was established in St. Petersburg. Icon painters were now required to sign their names on the front of the icon board, a calculated reversal of the pious anonymity of tradition. For Catherine the Great, too, Orthodoxy's traditional aesthetic came into conflict with her own enlightened tastes, reflected in an appreciation for such European artists as Anton Raphael Mengs (cat. 19, 20).

A curious innovation in the production and veneration of icons during the reigns of Catherine and her successors was the habit of applying sumptuous metal covers (*oklads*) that obscured all but the painted heads, hands, and feet of the sacred personages depicted. A particularly fine example of this taste is the gilded silver Rococo *oklad* that covers an icon of the Annunciation, also now in the Hillwood collection. Taken as a whole, the icon is a tribute to the speed with which tastes changed in eighteenth-century St. Petersburg. Just a generation separates the showy gilded cover (hallmarked 1781) from the icon beneath, painted perhaps at the beginning of the century in the style of German or Dutch engravings. Even so, by 1781 Rococo was already out of date in the upper reaches of St. Petersburg society, where a simpler Neo-classicism now prevailed.

In an empire almost entirely agrarian and feudal, the country estate (*usad'ba*) increasingly became the point of greatest intersection between the tastes of the capital and the provinces, a place where two worlds met. Historian Priscilla Roosevelt has revealed much about the role that country estates played in spreading new artistic skills among the peasantry. "Estate master craftsmen, who produced virtually everything their owners required, including cash revenues, were one of the major reasons large Russian estates were autarchic fiefdoms that were self-sufficient economically as well as culturally," she writes.[3] On great estates owned by noble families the arts were developed to a high degree of technical perfection and sophistication.

It is in the serf artistry of such estates that the fabled Russian capacity for imitation found ideal conditions in which to flourish. Frequently serf artists proved such cunning imitators that their copies could not be told apart from the imported originals. Their precious, finely crafted Valenciennes lace was often sold as the genuine article in the shops of Moscow and St. Petersburg—packaged in boxes from Paris to remove any taint of domestic production that might reduce its market value. The architecture, gardens, and furnishings of the country estate were the very embodiment of Western culture, created by the skilled hands of the master's serfs, who, with the use of foreign pattern books, could "copy any style chosen by the owner."[4]

The Resurrection, silver-gilt *repoussé* plaque. St. Petersburg, 1849. 18.1 × 15.2 × 2.9 cm (7⅛ × 6 × 1⅛ in.). Bob Jones University Museum and Gallery, Inc.

A curious—and touching—example of this adaptability and facility is a piece made in 1849 by a serf silversmith for presentation as a gift to Emperor Nicholas I. It depicts, on a large oval plaque, the Resurrection of Christ, worked in high relief on gilded silver. Made in St. Petersburg, perhaps while the artist was training there at the behest of his master, Count Sheremetev, the pendant icon has the following inscription engraved on the back:

> To the Sovereign Emperor and Autocrat of all the Russias, Nikolai Pavlovich, and the Sovereign Empress Alexandra Fedorovna, on the day of the Resurrection of Christ, 3rd April 1849. This humble offering from the peasant of Count Sheremetev, Fedotov Il'in, made by his own hand.

The plaque shows not the canonical Orthodox "Harrowing of Hell," in which the risen Christ tramples the Gates of Hell and draws forth Adam and Eve, but the "new" Resurrection as it had been depicted by artists of the Italian Quattrocento, such as Piero della Francesca. A smooth-limbed Christ levitates in a jagged sunburst, while two sharp-featured angels are draped about the tomb in rather mannered attitudes. In the closing years of Nicholas I's reign such liberties with the

strict iconography of Orthodoxy would have surprised none but the most conservative. In fact, some of the most Westernized holy images that circulated in the nineteenth century were also the cheapest and most widespread—the delightfully naïve enamels produced in the city of Rostov, for example. Everything about this image illustrates Fedotov Il'in's thorough assimilation of his master's desires, and his understanding that those desires would be shared by the Emperor himself. To be sure, Nicholas promoted a return to Russia's Byzantine heritage throughout his long reign, but his Byzantinism was strongly colored by the aesthetic values of his thoroughly European upbringing. In the inner sanctum of the Cottage Palace, his rustic retreat at Peterhof, Nicholas derived considerable pleasure from the melancholy visions of the German Romantic artist Caspar David Friedrich, whose drawings and paintings he was among the first to collect (see cat. 55).

It is perhaps not surprising that the present exhibition includes no examples of masterworks collected by the last Romanov emperor, Nicholas II. For two centuries his forebears had collected on an international scale, staking their claim to a generous share of the world's cultural treasures and laying the foundations for one of its richest museums. Of course, the rituals of diplomatic gift giving and the imperial patronage of the arts and crafts continued to take place, but by Nicholas II's reign (1896–1918) the great age of royal collecting was coming to an end throughout Europe. A new kind of collector on the grand scale was emerging, in the persons of the merchant prince and the robber baron.

If one were to imagine what masterpiece might best represent the collecting habits of the last Romanov, the celebrated Easter Eggs made by Fabergé and Co. immediately spring to mind. But some of the most significant items collected by Nicholas II and his consort,

Alexandra Fedorovna, were of far humbler origin. After two centuries of growing cultural estrangement between the Russian emperors and their subjects, Nicholas yearned for a return to the unity of tsar and people, which, he believed, the reforms of his ancestor Peter I had brutally disrupted. It was above all in the *narod*, the common peasant folk of the empire, that Nicholas looked for a sign of reconciliation and rebirth. Both he and his wife took an active interest in the revival of traditional icon painting, church building, and folk crafts such as embroidery and lace making.

In 1913 three hundred years of Romanov rule were celebrated with great fanfare throughout the Russian empire. Among the thousands of gifts made to the imperial family in this tercentenary year, none more poignantly signals the conflicts and continuities of Nicholas's reign than a set of dolls presented to the young heir to the throne, the Tsarevich Alexei, by the peasant craftsmen of Oposhnia, a village in Poltava province. Eighteen dolls, dressed with ethnographic exactitude, participate in a "Little Russian Wedding" in a child's *tableau vivant* that echoes the genre paintings of the Wanderers, Russia's school of Realist painters in the late nineteenth century. This self-consciously rustic gift returns us to one of the central themes of imperial collecting: the role it played in establishing themes of rulership and empire. Like a far more splendid gift, the Berlin Dessert Service given to Catherine the Great by Frederick II of Prussia in 1772 (cat. 86), these ethnographic figures symbolized the vastness of an empire that encompassed innumerable ethnic groups. (Little Russia was the rather belittling name given to the Ukraine during the imperial period.) The Berlin service included in its centerpiece ethnic figurines in authentic costume to elaborate on the theme of Catherine's triumphant subjugation of entire peoples in the forging of her empire.5 The Little Russian revelers of 1913 were intended not for the banqueting table but for the nursery, where they would instruct the future emperor in the obligations of his position.6

Notes

1 Lindsey Hughes, *Russia in the Age of Peter the Great*, New Haven (Yale University Press) 1998, pp. 283, 286.
2 Anne Odom, "Decorative Arts of the Russian North: Western Imagery in Provincial Cities," in *The Art of the Russian North*, Washington, D.C. (Hillwood Museum and Gardens) 2001, p. 50.
3 Priscilla Roosevelt, *Life on the Russian Country Estate. A Social and Cultural History*, New Haven (Yale University Press) 1995, p. 246.
4 Roosevelt, p. 252.
5 Anne Odom, *Russian Imperial Porcelain at Hillwood*, Washington, D.C. (Hillwood Museum and Gardens) 1999, pp. 30–33.
6 For comparison with other toys from the nursery of the imperial children, see *Na detskoi polovine. Detstvo v tsarskom dome. OTMA i Aleksei*. St. Petersburg (Pinakoteka) 2000.

"A Little Russian Wedding," a tableau of dolls made by the craftsmen of Oposhnia, Poltava province, and presented to the Tsarevich Alexei Nikolaevich in 1913

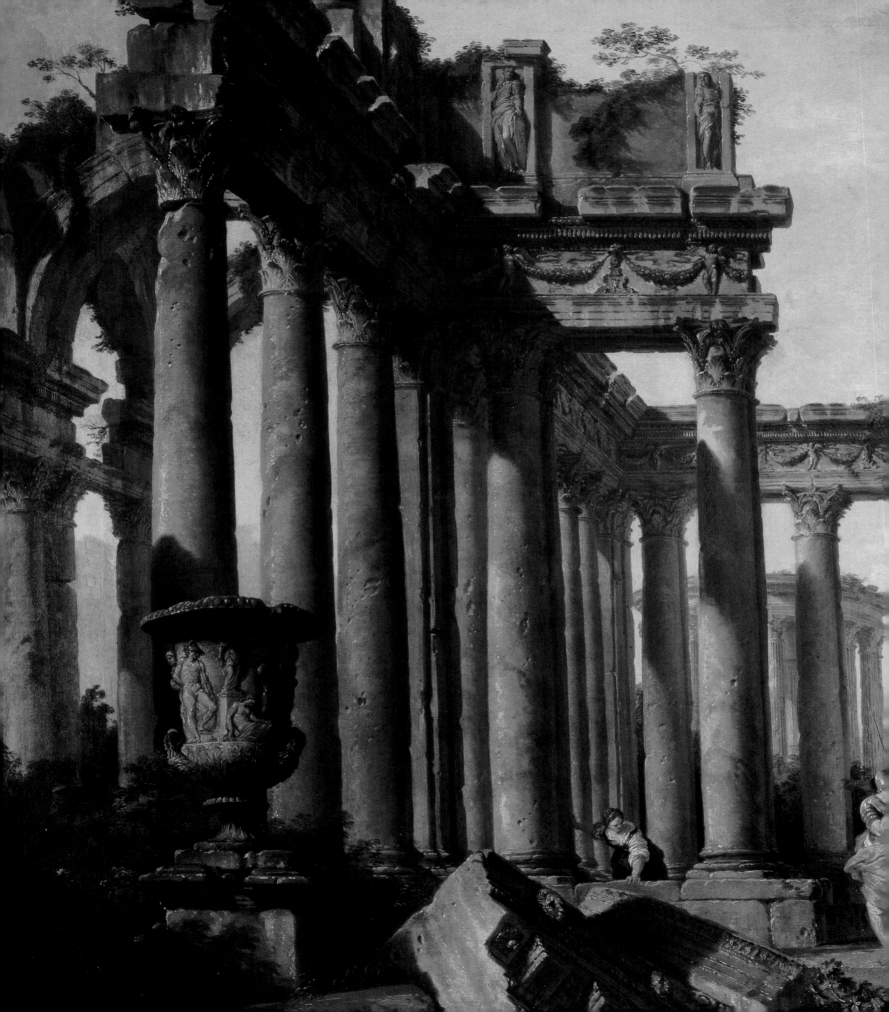

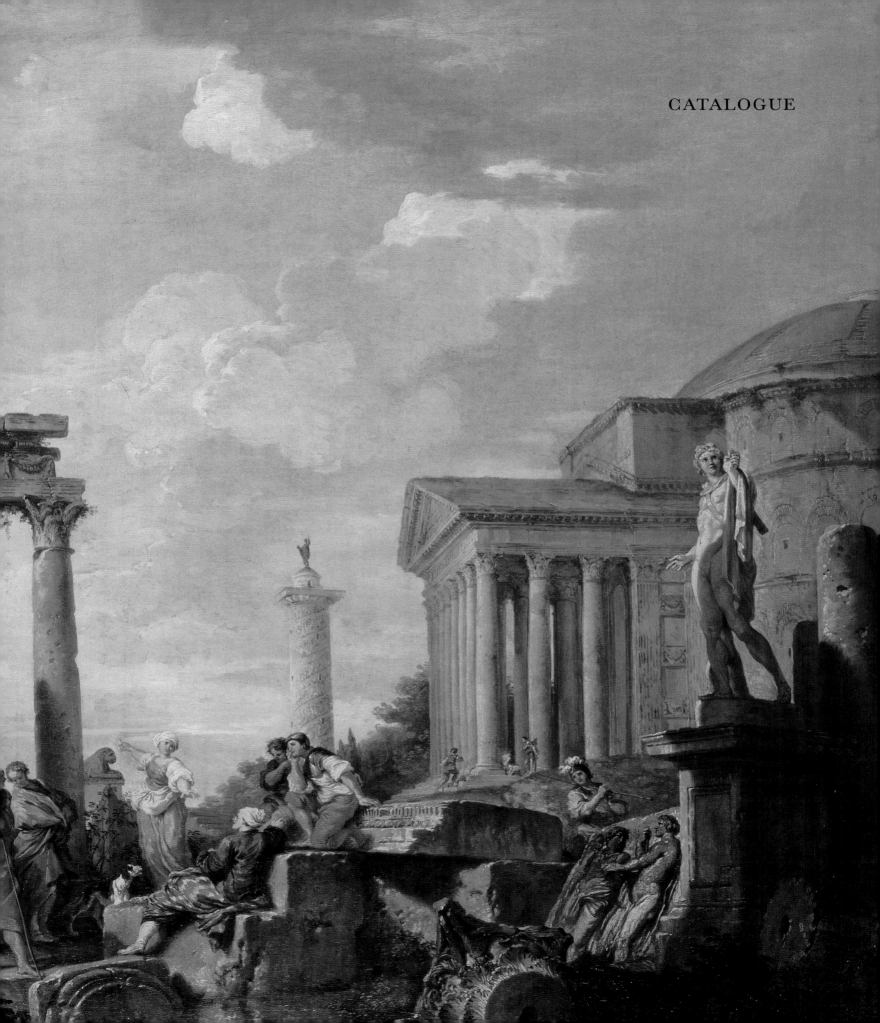

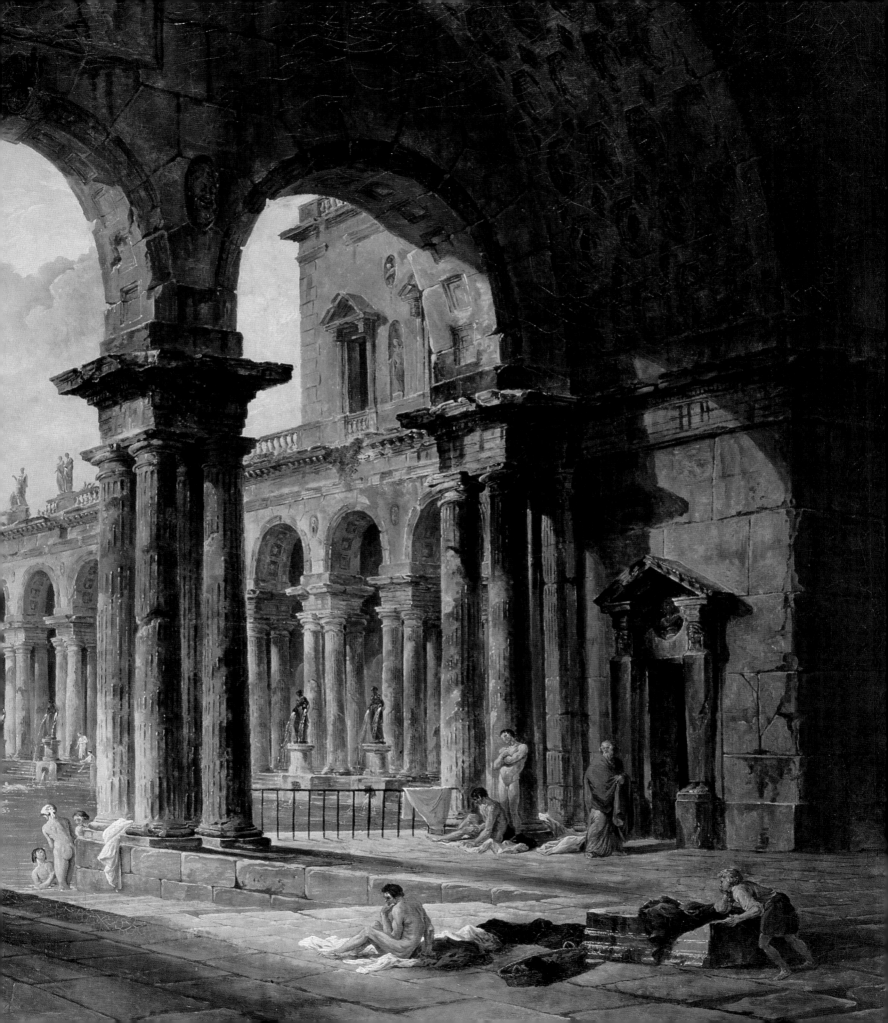

ALEXEY LEPORC

Paintings

It cannot be said that the Romanovs as a family developed a conscious tradition of collecting painting, or even that they demonstrated a consistent interest in painting as an art form. Some works were acquired as an expression of contemporary taste, and others were an expression of the individual taste of one member of the family or another. After the October Revolution of 1917 a third component appeared in the formation of the collection, through the emergence of nationalized art collections, which included some works formerly the private property of the ruling family.

It was only after the opening of the New Hermitage as a public museum in 1852 that the strict division between public museum and private collection came about, continuing right up to the Revolution and beyond, when some paintings were kept in the Winter Palace and, for many years, the imperial paintings moved between different palaces. In addition, there were special collections that had taken shape in the various imperial residences, often more specifically personal than acquisitions made deliberately for the Hermitage. Personal tastes were more strongly manifested here, the most striking examples being the collections of paintings that appeared under Paul I at his palace at Pavlovsk, and under Nicholas I in the Cottage Palace at Peterhof and the palace at Ropsha.

While the Hermitage's foundation is generally dated to 1764, the year Catherine II purchased her first major collection of paintings (formed by Johann Ernst Gotzkowski), the Hermitage also contains works acquired somewhat earlier, during the reign of Peter I. Indeed, it was he who introduced the concept of collecting paintings to Russia. Snippets of information recording the presence of paintings by Western European masters in Russia before Peter only serve to emphasize their very varied nature. Such paintings were acquired purely with the aim of decorating an interior and they came in ones and twos. It was Peter's desire to transform daily Russian life in the Western European manner, and his personal, all-encompassing interest led to the first acquisitions of paintings by European artists. Thus the first picture gallery in Russia was born, at his Monplaisir pavilion

in the grounds of his palace at Peterhof. Clearly, Peter's long stay in Holland influenced his dominant interest in painting of the Dutch and Flemish schools. Peter's interest in the Dutch school was markedly practical, determined by his love of the sea and the Navy, whence comes his personal preference for the works of the marine artist Adam Silo (cat. 29). From Peter comes that tradition of particular respect for Dutch art that can be noted throughout the history of the Hermitage, and that culminated in the creation, by the geographer Petr Semenov-Tian-Shansky, of a special collection intended to complement that in the Hermitage. This was acquired for the museum in 1910. (The present selection includes a painting linked with Semenov-Tian-Shansky, cat. 30.)

Peter invited foreign painters to Russia and sent Russians to train in Europe, a tradition that lay dormant for many years after his death. His daughter, Empress Elizabeth, for instance, essentially invited foreign artists only for the purpose of having her own portrait painted (the most famous example being that by Louis Tocque; a less famous but similarly interesting portrait is that by Georg Caspar Joseph Prenner, cat. 25). The largest acquisitions of paintings made during Elizabeth's reign were intended specifically to adorn the Picture Gallery in her new Catherine Palace at Tsarskoe Selo. It was mainly Italian artists who worked on this palace (see cat. 31), but with the foundation of the Academy of Arts, in 1757, a whole troop of French professors arrived in St. Petersburg.

When Catherine II took the throne, the efforts of her predecessors were completely overshadowed by an approach that made collecting essentially part of state policy. Inspired above all, it would seem, by the example of Frederick the Great (Friedrich II) of Prussia, from 1764 Catherine acquired major collections *in toto*, these laying the foundation for the Hermitage Picture Gallery. The very statistics speak for themselves: during Catherine's reign the collection grew to some four thousand paintings. This is the chronology of the most important acquisitions: 1764: Gotzkowski collection (225 paintings, cat. 22, 26); 1768: the Brussels collection of Count Carl

Cobenzl (46 paintings—none of which appears in this book, although it does include examples of Cobenzl's excellent collection of drawings, which came with the paintings, cat. 53, 56, 61, 62); 1769: the Dresden collection of Count Heinrich von Brühl (cat. 15; again the collection included drawings, cat. 52, 57); 1772: the Crozat collection from Paris (400 paintings, cat. 11, 24); 1778–79: the collection of Sir Robert Walpole from England (204 works, including one drawing and two pastels); 1783: the Baudouin collection from Paris (119 paintings, cat. 31). But in addition to these major collections there were also regular smaller acquisitions, such as the more modest collection of Jean-François de Troy, as early as 1764 (cat. 21). Individual pieces were regularly purchased at auctions in Paris, The Hague, and other places, through the mediation of Catherine's advisors, such as Denis Diderot or the Russian ambassador in Paris and The Hague, Dmitry Golitsyn.

In keeping with contemporary tastes, the better part of these collections was made up of seventeenth-century Dutch and Flemish, seventeenth- and eighteenth-century French, and sixteenth- to eighteenth-century Italian painting; German sixteenth-century painting was considerably less well represented, while early Netherlandish and early Italian works were almost totally absent. But Catherine also had a taste for contemporary painting, above all in the Neo-classical style: she purchased a number of paintings after the death of Anton Raphael Mengs (cat. 19, 20), commissioned works from Jakob Philipp Hackert, Hubert Robert, Joshua Reynolds, and Pompeo Batoni, and—inspired by Diderot—took an interest in the work of Jean-Baptiste Greuze. Working at the Russian court was a whole range of foreign artists of varying significance, from Alexander Roslin, Johann-Baptist Lampi, and Elisabeth Vigée Le Brun to lesser artists such as Richard Brompton (cat. 1, 2) and Jean-Louis Voille (cat. 34). In a number of cases it is for his or her work in St. Petersburg that the artist's name has gone down in posterity.

But through all this it should be noted that neither the purchases of whole collections nor acquisitions of individual works indicate that Catherine had a truly personal interest in painting: they were visibly intended to make a splash, determined by her to accord in every aspect of her behavior with the image of an enlightened monarch. The Comte de Ségur, French envoy to the Russian court, noted sagaciously: "Her ambition knew no bounds, but she knew how to use it for sensible ends."

By contrast, her son Paul revealed a markedly personal interest in painting. Yet in his purchases, both while heir to the throne and after he became ruler, Paul was acting solely with the purpose of decorating the

Nicolas Lancret, *Concert in a Park*, detail (see cat. 16)

palaces he lived in, not with any intention of adding to the Hermitage collection. During his travels through Europe in 1781–82, Paul revealed himself to be an admirer of everything fashionable, visiting the workshops of all the most famous artists, such as Pompeo Batoni, Jakob Philipp Hackert, Angelica Kauffman, Hubert Robert, and Claude-Joseph Vernet, and placing important commissions with them (cat. 13). Paul retained his love for these artists throughout his life. Some of the paintings he acquired were later transferred from his country palaces at Pavlovsk and Gatchina and from the Mikhail Castle in St. Petersburg itself to the Hermitage collection.

Alexander I possessed little interest in painting. Any acquisitions he made during the initial period of his rule seem to be the result of inertia, continuing the tastes of his grandmother and father (such as the love for Hubert Robert, cat. 27, or for Vernet, cat. 32). There was a little flurry of activity after the Peace of Tilsit in 1808, when he made a number of acquisitions through the mediation of Dominique Vivant-Denon, the main figure behind Napoleon's creation of the Louvre. Then, in 1814, came his key purchase, a famous collection that had belonged to the late Empress Josephine, composed of paintings formerly in the possession of the Landgrave of Kassel. This purchase only serves to stress the fact that throughout the rest of his reign, right up to 1825, Alexander made not a single purchase of any significance, and the royal interest in contemporary

painting almost totally died out. The sole serious exception to this was the invitation to Russia, in 1819, of the English painter George Dawe, but even this resulted above all from a political desire to create a gallery of military heroes from the 1812 war against Napoleon. An extremely prolific artist, Dawe also produced a large number of other works in Russia (e.g. cat. 5), an example that also left its mark on Russian culture in the image of the artist-craftsman (as in Nikolai Gogol's short story "The Portrait").

Against this background, Nicholas I strikes us first and foremost as creator of the Hermitage as a public museum (for more detail see the essay "Nicholas I and the New Hermitage: The *Ancien Régime* Moving Toward the Public Museum"), but he was most certainly not without his own private artistic preferences. His favorite artists included Caspar David Friedrich and the German Romantics (e.g. cat. 12, 18, which also provide evidence of his close links with the Prussian court), numerous battle painters, and the artists of the Accademia di Bologna. It was in his reign that paintings came to be distributed according to a certain method among the museum and the imperial palaces; it was then that some of the older acquisitions were moved to palaces in the countryside, often for purely decorative purposes (cat. 3, 6, 16).

Nicholas's son Alexander II demonstrated only a faint interest in painting, despite manifesting a taste for art in his youth (when he was perhaps influenced by his talented tutor, the Russian Romantic poet Vasily Zhukovsky). From this time the museum led an independent existence, merely receiving any allocations of funds necessary to make odd purchases. A characteristic example of how paintings entered the Picture Gallery is Raphael's *Madonna Connestabile*. This painting was originally purchased by Alexander in 1870 as a gift for his wife, Empress Maria Alexandrovna, and only entered the Hermitage as a bequest after her death in 1880—a striking illustration of how very separate were the museum and the private imperial collection.

Under Alexander III this division between public museum and the sovereign's personal collection reached its height. While continuing to support the Hermitage, at times personally funding significant purchases, Alexander created his own museum (closed to the public, of course) at his favorite town residence, the Anichkov Palace. Passionate in his collecting, he acquired works by Russian artists, Russian and French furniture, the paintings of Hubert Robert, seventeenth-century embroidery, and also his favorite artists of the Barbizon School. Extremely varied, his collection was a typical example of a good collection of a well-to-do late nineteenth-century family.

Nicholas II certainly did not inherit his father's passion, and he acquired only the odd, largely insignificant, work. If Alexander III brought imperial taste a little more up to date (although the Barbizon School was fully accepted by the 1870s and his taste was hardly contemporary), the concept of contemporary art ceased to be at all relevant to the imperial collection under Nicholas. When we see how the Moscow merchants Ivan Morozov and Sergei Shchukin were busy collecting Post-Impressionists, Nicholas's tastes seem extremely banal. At best, he manifested an interest in artists of the Paris Salon, particularly those such as Jules Lefebvre and François Flameng (cat. 7–10). Yet, even now, monies continued to be allocated when demanded for major purchases, making possible the most important acquisition of the early twentieth century, Leonardo da Vinci's *Madonna Benois*, in 1914.

By this time, however, personal acquisitions by members of the imperial family had ceased to serve the high aims established with such panache by Catherine the Great. Art, and painting in particular, had become once more nothing but a means of adorning new interiors. In their collecting habits, the Romanovs had come full circle.

Claude-Joseph Vernet, *The Entrance to the Port of Palermo by Moonlight*, detail (see cat. 32)

I

Portrait of Grand Dukes Alexander and Constantine

Richard Brompton
(British, c. 1734–1783)
1781
Oil on canvas
210 × 146.5 cm (82⅝ × 57⅝ in.)
Signed and dated bottom right:
R.Brompton pinx. 1781
Inv. No. GE 4491

PROVENANCE

Transferred to the Hermitage from
the Romanov Gallery of the Winter
Palace, 1918; commissioned by
Catherine II, 1781

Grand Duke Alexander Pavlovich
(1777–1825), from 1801 Emperor
Alexander I, and Grand Duke
Constantine Pavlovich (1779–1831)
were the eldest sons of Grand Duke
Paul Petrovich, the future Emperor
Paul I, and his wife, Maria
Fedorovna.

Richard Brompton's name first
appears in Russian sources, in May
1780, in the correspondence between
Catherine II and Baron Melchior
Grimm in connection with a portrait
of Catherine's eldest grandson,
Alexander. Producing portraits of
Catherine's favorite grandchildren—
for whom she entertained high
hopes—was one of the main tasks
for the artist when he arrived from
Britain. He initially painted separate
portraits of them, but in 1781
completed this rather unusual
composition showing the two royal
children not merely as the next
generation of the Romanov dynasty
but also, through their unusual and
striking attributes, as the
embodiment of the empress's own
political ambitions. Grand Duke
Alexander is shown cutting the
Gordian Knot, while his younger
brother, Constantine, holds a
banner crowned with the *labarum*,
the military insignia adopted by
Constantine the Great after his
vision of the Cross (after which the
Roman Empire adopted
Christianity) (Vilinbakhov 1983,
pp. 26–41). Contemporaries would
undoubtedly have associated these
two little boys with Alexander the
Great and Constantine the Great, in
whose honor they were named. It is

well known that Catherine dreamed
of placing her eldest grandson,
Alexander, upon the Russian
imperial throne, thus bypassing the
legal heir, Grand Duke Paul. For
Constantine she also planned a
glorious future, seriously intending
to resurrect the Byzantine Empire
and eject the Turks from Europe
under his name. "I happened to be
at Tsarskoe Selo when Grand Duke
Constantine Pavlovich was born.
The Empress was overjoyed … .
The name of Constantine had been
chosen for him in advance, and a
Greek wet-nurse prepared for him.
The sovereign planned the future
resurrection of the Eastern Greek
Empire and intended to place upon
the throne gr. Constantine," wrote
a contemporary, Fedor N. Golitsyn
(Golitsyn 1874, p. 1319).

By 1781, when she commissioned
this painting from Brompton,
Catherine was already confident in
the realization of her future project
and wished to demonstrate, through
the language of art, the stability of
Russian policy and Russian loyalty
to the interests of Christianity. She
repeatedly mentioned the portrait in
her correspondence with Grimm
and ensured that a copy was sent
to him in Paris. Upon receipt of the
copy, Grimm wrote to Catherine in
February 1783: "Everyone finds this
painting charming, they come
to visit me in crowds in order to see
it … it amazes everyone."
(Grimm–Catherine Correspondence
1885, p. 322).

Interestingly, Catherine played
an active role in the education and
upbringing of her grandchildren,
writing moralizing fairy-tales and
stories from Russian history, even
designing clothing for them. In
Brompton's painting they wear attire

similar to that which still survives
today in the private collection of
R. Dimsdale in the United
Kingdom, whose great-grandfather,
Dr. Thomas Dimsdale, was given
them by Catherine the Great when
he was invited to Russia to vaccinate
the children against smallpox. Each
child wears upon his breast the star
of the Order of St. Andrew.

Another version of this painting
by the artist's hand is also in the
Hermitage (Inv. No. GE 4435), and
there are two miniature copies of
the portrait: one by Heyde in the
Hermitage, and another by an
unknown artist in the Pavlovsk
Palace Museum Reserve, near
St. Petersburg. Also in the
Hermitage collection is a snuffbox
by the Parisian Louis Cousin
(1781–82), set into the lid of which is
a miniature copy of the figures of
the two grand dukes after
Brompton's portrait.

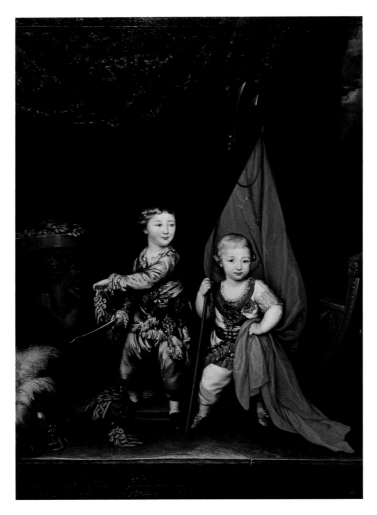

EXHIBITIONS

St. Petersburg 1905, issue 4, No. 777;
Moscow 1997, No. 6; Stockholm
1998–99, No. 108

BIBLIOGRAPHY

Catherine–Grimm Correspondence
1878, pp. 206, 251, 262; Rovinsky
1886–89, vol. 4, pp. 137, 247, 276,
397, 627; List of Portraits 1905,
p. 250, No. 117; Renne 1987,
pp. 56–62; Dukelskaia, Renne 1990,
pp. 35–38; Stählin 1990, pp. 92, 110

E.R.

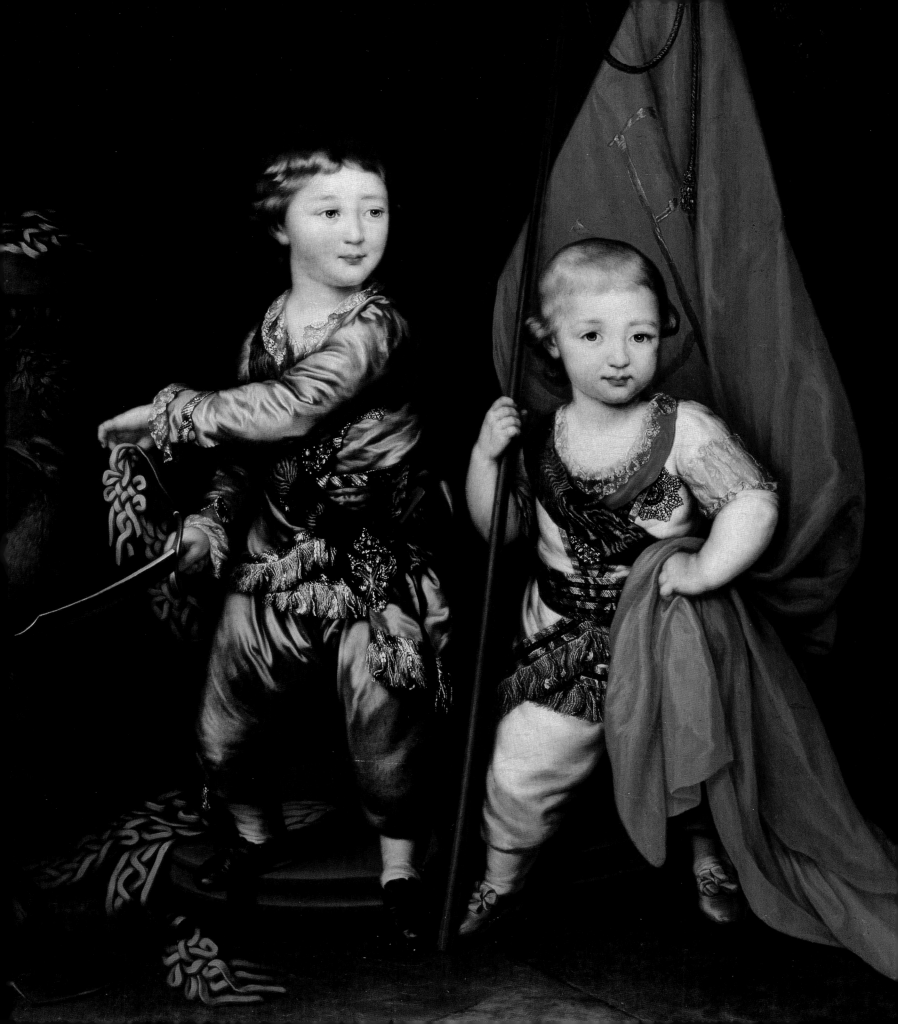

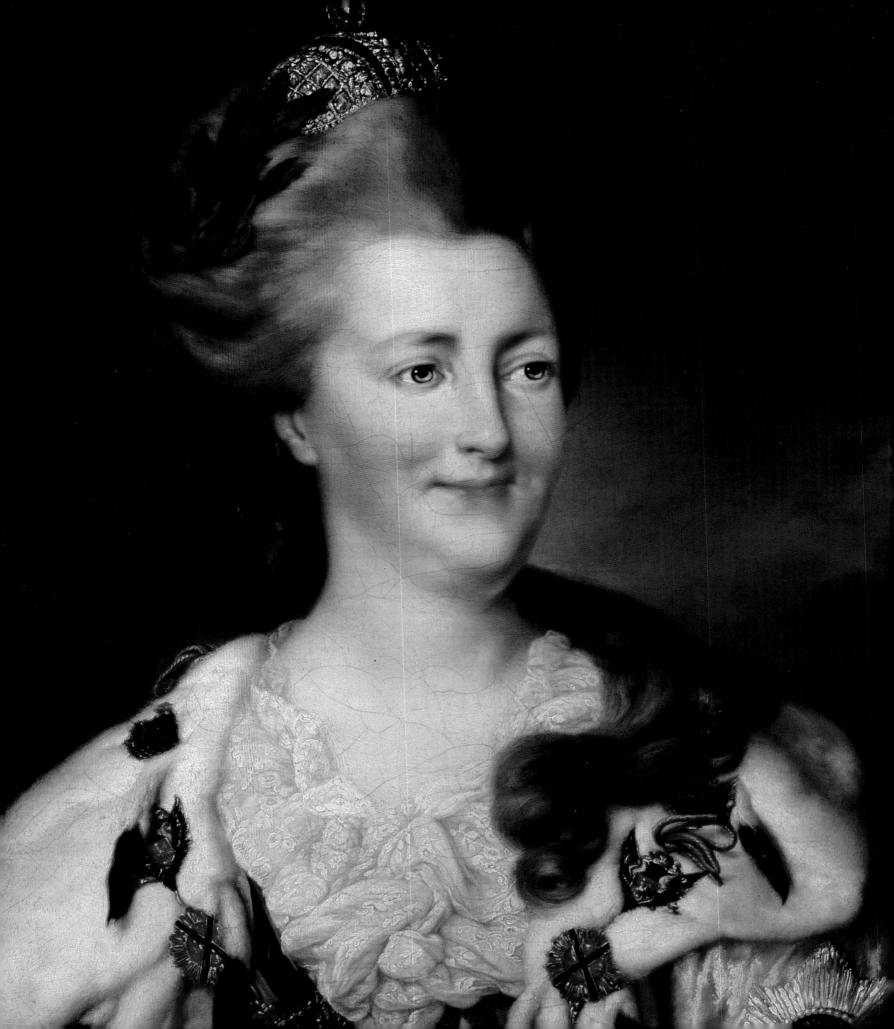

2
Portrait of Catherine II
Richard Brompton
(British, *c.* 1734–1783)
1782
Oil on canvas
83 × 69 cm (32⅝ × 27⅛ in.)
(oval set into a rectangle)
Signed and dated to left by the
shoulder: *R. Brompton pinx 1782*
Inv. No. GE 1318

PROVENANCE
Transferred to the Hermitage from
the Romanov Gallery of the Winter
Palace, 1918; in the Romanov
Gallery from its formation in the
mid-nineteenth century

Catherine II (1729–96), born
Princess Sophia Frederika Augusta
of Anhalt-Zerbst, was from 1762
Empress of Russia. In 1745 Empress
Elizaveta Petrovna chose her as the
bride for her nephew, the heir to
the Russian throne and future Peter
III. On adopting the Orthodox
faith, the girl took the Russian name
Ekaterina Alekseevna, and after the
coup d'état of 1762, which led to
Peter's death, she ascended the
Russian throne as Catherine II.

Here Brompton depicted Catherine
at the age of fifty-three, wearing
an ermine robe and a large chain
with the star of the Order of St.
George, 1st Class, and the Lesser
Imperial Crown.
 In his notes on the fine arts
in Russia, Jacob Stählin mentions
two portraits of the empress by
Brompton: "a very large portrait of
Her Majesty full length with various
allegorical attributes," and "a most
pleasingly successful half-length
portrait" that the artist painted
"for his close friend, the court
apothecary M. Greveau" (Stählin
1990). The half-length that belonged
to Greveau can probably be
identified with this painting. It s
eems to have preceded the large
allegorical picture Brompton
mentions, which remained
unfinished upon his death and may
perhaps be the full-length attributed
to an unknown artist now in the
Catherine Palace at Pushkin
(Tsarskoe Selo, near St. Petersburg).
Poor restoration has seriously altered
the latter painting's appearance, but

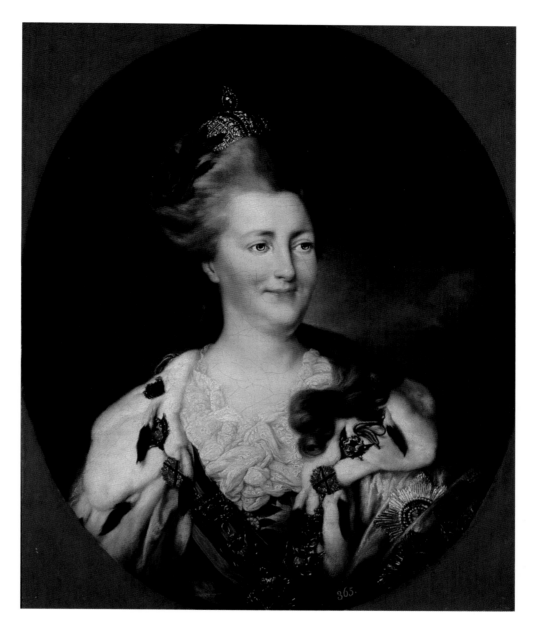

a comparison between an old
photograph taken before restoration
and the Hermitage portrait reveals
significant similarities in the depiction
of Catherine, which allows us to
assert with some reason that the full-
length was based on this portrait.
 Brompton's portrait of Catherine
never gained the sort of fame
enjoyed by much-copied portraits of
the empress by Alexander Roslin,
Vigilius Eriksen, and Grigory
Levitsky. Only one copy after it is
known (Fine Arts Museum, Tomsk),
and it was never engraved. The
Russian travel notes of the Revd
William Coxe (William Coxe: *Travels*

*into Poland, Russia, Sweden, and
Denmark. Interspersed with historical
relations and political inquiries*, 2 vols.,
London 1784 and succeeding
editions) included an engraved
portrait of Catherine II with the
inscription: "Bromton [sic] pinxit A
Toppfer sculpt," but the print differs
significantly from Brompton's
original, and in fact seems to bear
greatest resemblance to the work
of Roslin.

EXHIBITIONS
St. Petersburg 1870, p. 110, No. 392;
St. Petersburg 1905, issue 4, No.
869; New Haven–Toledo–St. Louis

1996–97, No. 15; Moscow 1997,
No. 7

BIBLIOGRAPHY
Rovinsky 1886–89, vol. 2, columns
107–16; Rovinsky 1886–89, vol. 4,
column 627; List of Portraits 1905,
p 248, No. 100; Cat. 1958, p. 375;
Krol' 1969, pp. 18–19; Cat. 1981,
p. 241; Renne 1987, pp. 56–62;
Stählin 1990, vol. 1, pp. 92, 110;
Dukelskaia, Renne 1990, No. 10

E.R.

3

The Molo with the Doges' Palace

Luca Carlevaris
(Venetian, 1663–1730)
After 1710
Oil on canvas
64 × 121 cm (25¼ × 47¾ in.)
Inv. No. GE 215

PROVENANCE
Returned to the Hermitage from the Gatchina Palace, near St. Petersburg, 1920s; transferred to the Gatchina Palace from the Hermitage in the second half of the nineteenth century; acquired by the Hermitage before 1859

Carlevaris selects a somewhat unusual spot from which to depict one of the main sights of Venice: from the foot of the Column of San Todaro—silhouetted against the light, marking the central axis of the composition—opens a view of the Piazzetta, the Riva degli Schiavoni, and the Bacino di San Marco flooded with light. Through the unexpected contrast of dark and lit zones, and the balance between the ordered row of buildings to left and the vertical masts of schooners and

barques to right, the artist creates a stunning visual effect. With the sea covered in sails, and the embankment and Piazzetta crowded with colorful figures, the painting shows Venice turning its best face to the viewer. It clearly enjoyed some success, since Carlevaris produced at least four versions (Galleria Nazionale d'Arte Antica, Rome; priv. coll., UK; Staatliche Gemäldegalerie, Potsdam, Berlin; priv. coll., Milan).

The original is thought to be that in Rome, painted in around 1710, while the others (including that in the Hermitage) seem to have been produced later and differ mainly in the staffage. The St. Petersburg version has a pendant showing the regatta on the Grand Canal on 4 March 1709, held to honor the arrival in Venice of Friedrich IV of Denmark (Succi 1994). Thus the idea of "rendere più facili alla notizia dei paesi stranieri le venete magnificenze" ("making foreign countries more aware of the splendors of Venice")—as was written on the frontispiece of the first publication of Carlevaris's engravings, *Le fabbriche e vedute di Venezia* (1703)—was linked by these

two canvases, one of which showed the historic regatta, the other one of Venice's most attractive and beloved sites, the Doges' Palace.

EXHIBITIONS
Petrograd 1923; Leningrad 1959, p. 14; Göteborg 1968, No. 6; Milan 1977, No. 27; Padua 1994, No. 44; Udine–Bruxelles 1998–99, No. 13

BIBLIOGRAPHY
Rizzi 1967, p. 89, pl. 112; Fomicheva 1974, p. 469; Fomicheva 1992, No. 80; Succi 1994, pp. 66–67; Artemieva 1998, p. 102

I.A.

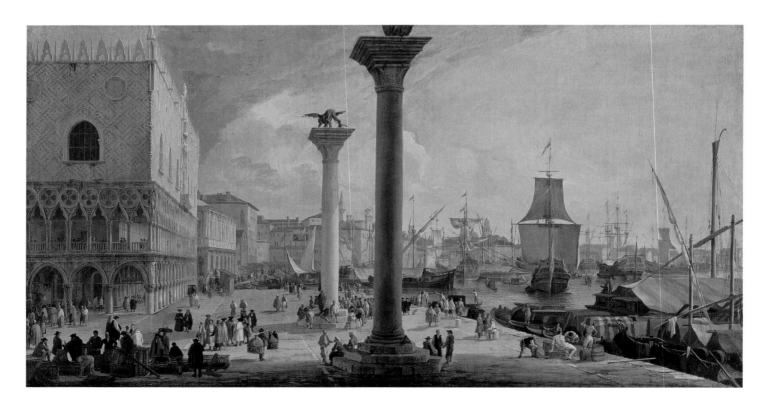

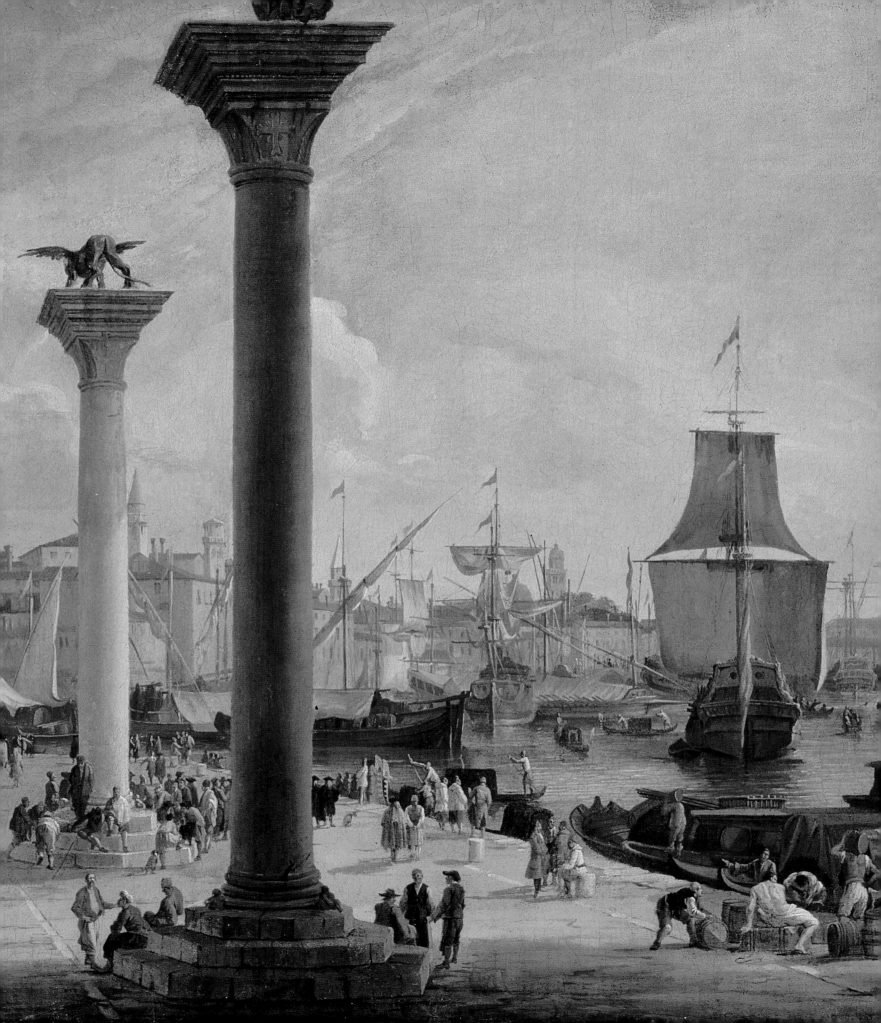

4
Portrait of Grand Duchess Maria Pavlovna

George Dawe
(British, 1781–1829)
1822
Oil on canvas
240 × 147 cm (94½ × 57⅞ in.)
Inv. No. GE 4518

PROVENANCE
Transferred to the Hermitage from the English Palace at Peterhof, near St. Petersburg, 1931; commissioned from the artist, 1822

Grand Duchess Maria Pavlovna (1786–1859) was the third daughter of Emperor Paul I. In 1804 she married Crown Prince Karl-Augustus-Friedrich of Sachsen-Weimar-Eisenach (from 1828 Grand Duke).

Maria Pavlovna had suffered severely from smallpox in childhood, but she grew to be so pretty, and her character was so open and merry, that she was called "la perle de la famille." When she married Karl-Augustus she found herself, thanks to the efforts of her mother-in-law, Grand Duchess Luisa, in Weimar, one of Europe's most intellectual cities, a place of gathering for the best minds in Germany—Goethe, Schiller, Wieland, and Herder. Through her exposure to and conversations with Weimar intellectuals she vastly increased her learning, and she took lessons at Jena University. After the death of Grand Duchess Luisa, Maria Pavlovna continued her patronage of the arts and sciences, setting up a museum in Weimar dedicated to the memory of the great poets and philosophers who had made the city famous.

Dawe may have produced this portrait of Maria Pavlovna immediately upon his arrival in Russia in 1822. An interesting story is associated with the commission, for the artist requested that as payment for the work he be given a painting in the Hermitage by his great compatriot Sir Joshua Reynolds, *The Infant Hercules Strangling the Serpent sent by Hera*. This painting, commissioned by Catherine the Great and finished in 1789, was at the time in storage, and

Dawe perhaps thought that it was not appreciated and valued. He was wrong, however, and he was paid for this portrait of Maria Pavlovna in the usual way, while Reynolds's painting soon returned to its place on show in the Hermitage (Trubnikov 1912).

Another same-sized version by Dawe was, from the nineteenth century, in the collection of Count Dmitry Sheremetev at Ostankino (now Ostankino Museum Estate, Moscow, Inv. No. 299). At Ostankino there is also a portrait of Grand Duchess Anna Pavlovna (1795–1865), youngest daughter of Paul I, probably intended to form a pair to that of Maria.

BIBLIOGRAPHY
Russian Portraits 1905–09, No. 391;
Trubnikov 1912, pp. 158–60;
Dukelskaia, Renne 1990, No. 20

E.R.

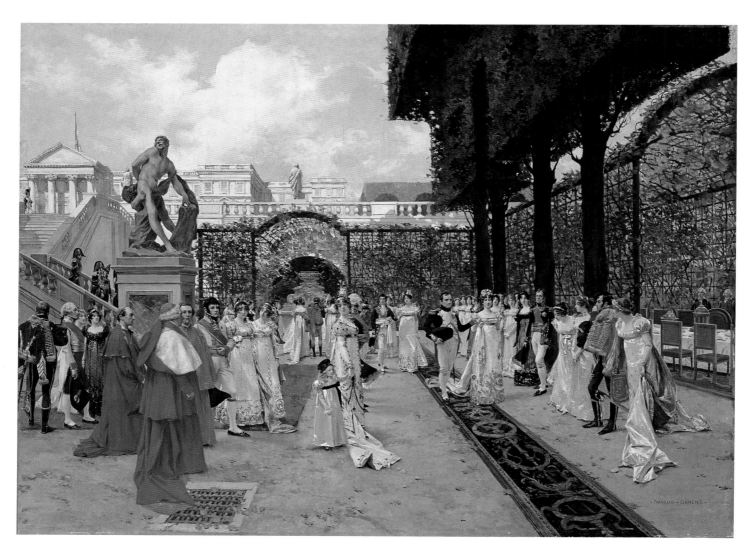

8

**Reception at Compiègne
in 1810**
François Flameng
(French, 1856–1923)
c. 1896
Oil on panel
104 × 138 cm (50 × 54⅜ in.)
Signed and dated bottom right:
François Flameng
Inv. No. GE 6273

PROVENANCE
Transferred to the Hermitage, 1926;
collection of Empress Alexandra
Fedorovna (1872–1918), exhibited in
the White Drawing Room of the
Winter Palace; acquired by Emperor
Nicholas II, mid-1890s. Judging by
the date on a colour reproduction,
this painting was produced in
around 1896

This park scene is set against the
background of the Château of
Compiègne, with Puget's statue of
Milo of Croton (on the pedestal to
left). Flameng probably borrowed
the sculptural element from the
painted ceiling in the Louvre,
produced in 1832 by Eugène
Devéria (1805–65): *Puget présentant le
groupe de Milon de Crotone à Louis XIV,
dans les jardins de Versailles.* Napoleon
presents his new wife, the
Archduchess of Austria, Marie-
Louise, who arrived at Compiègne
on 27 March 1810, to the numerous
guests (generals, cardinals, and
ladies-in-waiting). On 1 April of that
year the civil marriage registration
ceremony was performed at Saint-
Cloud, and the next day the
religious rite was performed in
Paris by Cardinal Fesch.

BIBLIOGRAPHY
Cat. 1958, vol. 1, p. 451 ("Napoleon
at a Ball in a Park"); Cat. 1976,
p. 298; Berezina 1983, No 171

A.B.

9

Napoleon I and the King of Rome at Saint-Cloud in 1811

François Flameng
(French, 1856–1923)
c. 1895
Oil on panel
105 × 138 cm (41⅜ × 54⅜ in.)
Signed bottom right: *François Flameng*
Inv. No. GE 6271

PROVENANCE
Transferred to the Hermitage, 1926; collection of Empress Alexandra Fedorovna (1872–1918), exhibited in the White Drawing Room of the Winter Palace; acquired by Emperor Nicholas II during a visit to an exhibition of French art in St. Petersburg, 12 January 1896 (Old Style)

Left of centre is Napoleon, holding in his arms his newborn son by the Empress Marie-Louise, Napoleon François Charles (1811–32), also known as Napoleon II. On the day of his birth, 20 March 1811, the child was given the title of King of Rome, but after the fall of the First Empire in 1814–15 he became Duke of Reichstadt. The birth of the King of Rome was a subject taken up frequently by artists contemporary to Napoleon Bonaparte, and in his work on this painting Flameng referred to artists such as François Gérard (1770–1837) and Pierre Paul Prud'hon (1758–1823).

The Château of Saint-Cloud, on the banks of the Seine, was associated with some of the era's most important events. On 9 November 1799 (18th Brumaire), the historic Council of Elders and Council of Five Hundred were held here, which led to Napoleon becoming First Consul and then, in 1804, Emperor. Refurbished by Napoleon, the château was one of his favorite residences. Here, in 1815, the capitulation of Paris to the anti-Napoleonic coalition was signed. The château was destroyed in 1870 during the Franco-Prussian War.

EXHIBITIONS
St. Petersburg 1896, No. 108 ("Napoleon and the King of Rome at Saint-Cloud in 1811")

BIBLIOGRAPHY
Cat. 1958, vol. 1, p. 451 ("Scene from the Life of Napoleon"); Cat. 1976, p. 298; Berezina 1983, No. 172

A.B.

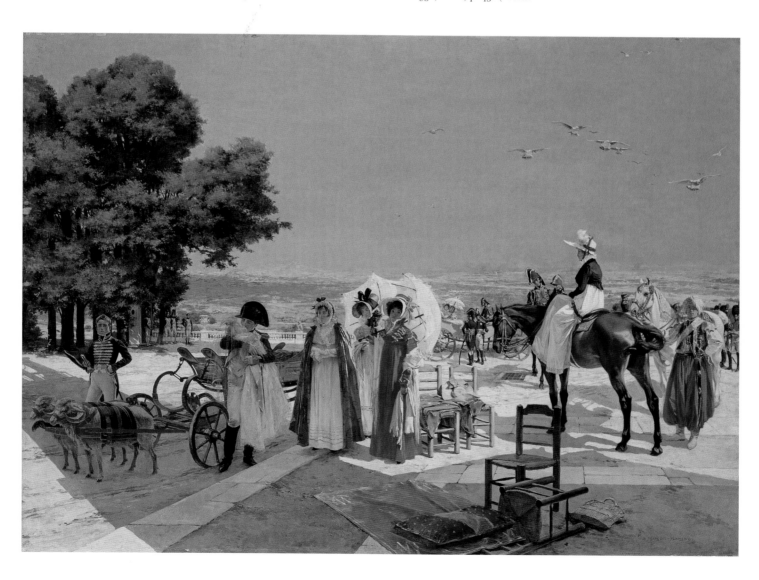

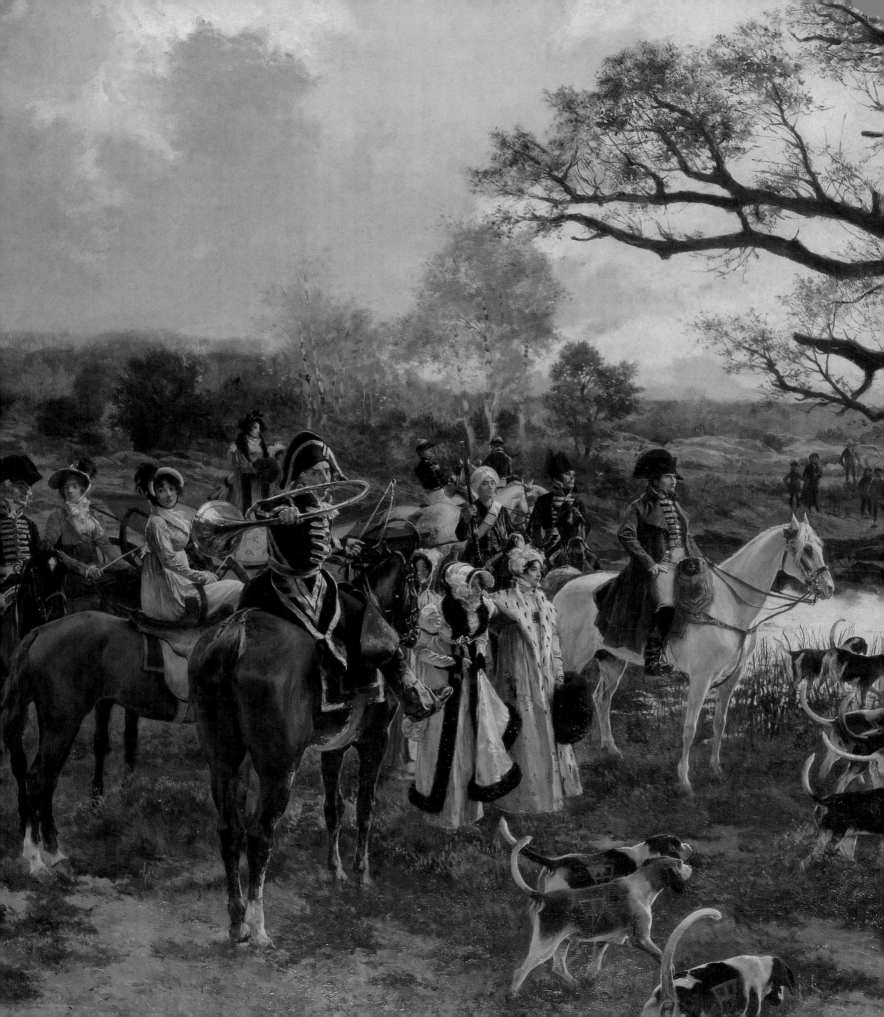

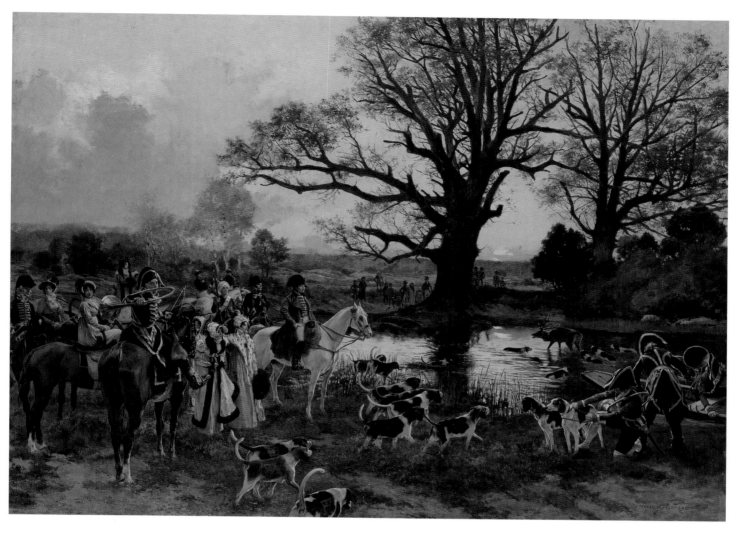

10

Napoleon I in the Forest of Fontainebleau in 1807
François Flameng
(French, 1856–1923)
c. 1898
Signed and dated bottom right:
François Flameng
Oil on panel
104 × 140 cm (50 × 55⅛ in.)
Inv. No. GE 6270

PROVENANCE
Transferred to the Hermitage, 1926; collection of Empress Alexandra Fedorovna (1872–1918), exhibited in the Silver Drawing Room of the Winter Palace; acquired by Emperor Nicholas II, 1905

This painting was probably painted somewhat later than the other three works in the series, but no later than 1898, since the print made after it was executed in the spring of 1899. The source of Flameng's composition was a canvas by Carle Vernet (1758–1836), *Napoleon Hunting in the Forest of Compiègne*, known in several versions (e.g. of 1811; Hermitage, Inv. No. GE 5671). In Vernet's painting, however, the emperor is accompanied by Marie-Louise, while here we see Empress Josephine standing to the left of Napoleon's horse.

While Meissonier chose a scene of Napoleon at Friedland to represent the important events of 1807 (*Friedland, 1807*, Metropolitan Museum of Art, New York), Flameng preferred this scene of Napoleon I deer hunting.

BIBLIOGRAPHY
Cat. 1958, vol. I, p. 451 ("Napoleon's Hunt"); Cat. 1976, p. 298 (with wrong date for painting: gives date of acquisition rather than execution); Berezina 1983, No. 173

A.B.

11
Portrait of a Youth in a Hat
Jean-Baptiste Greuze
(French, 1725–1805)
1750s
Oil on canvas
61 × 50 cm (24 × 19⅝ in.)
Inv. No. GE 1256

PROVENANCE
Acquired for the Hermitage by
Catherine II as part of the collection
of Louis Crozat, Baron de Thiers,
Paris, 1772

When acquired, this painting was
attributed to Greuze, which gave
rise to no doubts for many years,
since the painting was made during
the artist's lifetime. At present,
however, historians disagree
regarding its authorship. In his
monograph on the mid-eighteenth-
century French painter Jean-Siméon
Chardin, G. Wildenstein (1933) cites
a portrait of the poet and sculptor
M.J. Sedain as having similarities
with the Hermitage canvas, but at
the same time throws doubt on
the authorship of both paintings.
M. Stuffmann (1968) considers
Portrait of a Youth in a Hat to be close
to the works of Joseph Ducreux,
while I. Nemilova (1982, p. 180;
1984, p. 122) suggests that the
composition be linked with François-
André Vincent, whose early works
are often attributed to Greuze or
Fragonard. As evidence, Nemilova
cites a *Portrait of a Man* by Vincent
(reproduced in *American Art Gallery
Catalog*, New York, 1927, No. 11) and
another that was in a private
collection in Paris in 1780. But the
original attribution in the catalogue
of the Crozat collection (Stuffmann
1968) finds no contradiction in the
painting itself; many of Greuze's
early works are marked by a similar
free painterly style and use of
brushstrokes in the face as seen
in this portrait.

EXHIBITIONS
Leningrad 1956, p. 18; Stockholm
1998–99, No. 397

BIBLIOGRAPHY
Cat. 1774, No. 1204; Georgi 1794,
p. 479; Livret 1838, pp. XXII, 234,
No. 40; Dussieux 1856, No. 961;
Cat. 1863, 1908–16, No. 1518;

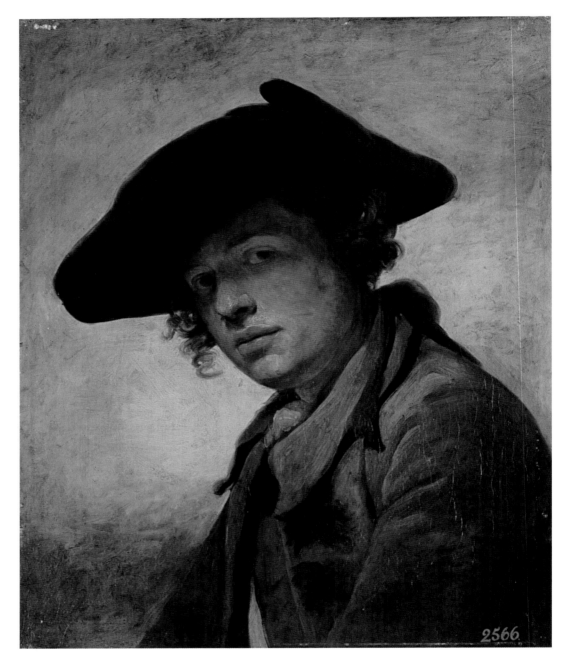

Waagen 1864, p. 307; Mauclair
1920, No. 963; Wildenstein 1933,
No. 462; Sterling 1957, pp. 53–54;
Cat. 1958, p. 281; Stuffmann 1968,
p. 129, No. 135; Cat. 1976, p. 197;
Nemilova 1982, No. 133; Nemilova
1985, No. 69

E.D.

12

View Near Palermo

Heinrich Louis Theodor Gurlitt
(German, 1812–1897)
1847
Oil on canvas
79 × 100 cm (31⅛ × 39⅜ in.)
Signed and dated bottom left:
LGurlitt 47 (L and G intertwined)
Inv. No. GE 6034

PROVENANCE
Transferred from the Marble Palace,
Petrograd (St. Petersburg), 1919;
formerly at the Gatchina Palace,
near St. Petersburg

According to the artist's son, during Gurlitt's stay in Palermo, Sicily, in August–September 1846, he "drew and painted the whole time" the picturesque crest of Monte Pellegrino, "considering it to be the queen of mountains." In this painting the mountain is seen from the church of Santa Maria di Gesù, from which, as was noted in nineteenth-century guides, one had what was probably one of the best views of Palermo (particularly in the morning), with Monte Pellegrino in the background.

In the middle of the nineteenth century such Italian landscapes by Gurlitt were highly prized, arousing in contemporaries the same admiration as Cézanne's views of Mont St. Victoire some hundred years later: "I doubt that any of the artists now practicing would be capable of conveying so faithfully, down to the smallest details, the warm tone of the southern sun and the nature of the landscape forms and lines." (*Männer der Zeit. Biographisches Lexikon der Gegenwart,* Zweite Serie, Leipzig 1862, p. 649.) It was natural that when Nicholas demanded a view of Palermo, it should be commissioned from Gurlitt.

In 1845 Nicholas's daughter Alexandra Nikolaevna died in childbirth; this so affected the health of her mother, Alexandra Fedorovna, that doctors insisted the empress spend a long period of recuperation in the south. In October 1845 she arrived in Sicily, passing four months in Palermo before she was able to return to normal life. Her biographer related how she was charmed by the surrounding countryside, her particular admiration being aroused by Monte Pellegrino: when she first saw it, "she could not restrain an exclamation of pleasure" (S.P. Yakovlev: *Imperatritsa Aleksandra Fyodorovna* (Empress Alexandra Fedorovna), Moscow, 1866, p. 140; see also V.M. Tourov: "Gli Zar a Palermo: cronaca di un soggiorno," *Kalós. Arte in Sicilia,* 2000, No. 1, pp. 4–11).

Nicholas, who had been to Palermo and was well aware of his wife's love of "memorial pictures" (see Lütke, cat. 19), commissioned this *View of Palermo* from Gurlitt in November 1846, through the Russian envoy in Berlin, Baron P.K. Meyendorf. Gurlitt had just produced such a view for a client in Hamburg, but at once recognized the greater importance of the Russian commission and immediately presented the existing work as "a small painting … on trial." This work having received the monarch's approval, the desired "large painting" was then delivered to St. Petersburg in April 1847, and this Nicholas presented to Alexandra on her birthday, 13 July 1847 (Old Style).

In addition to this painting—for which Gurlitt was paid three hundred *friedrichsdors*—another four landscapes were acquired from the artist and hung in various imperial palaces in St. Petersburg.

EXHIBITIONS
Petrograd (St. Petersburg) 1920, p. 21

BIBLIOGRAPHY
Boetticher 1891–1901, vol. I–1, p. 434, No. 13; Gurlitt 1912, p. 209; Asvarishch 1988, No. 76; Gurlitt 1997, p. 130, No. 60

B.A.

13

The Villa of Maecenas and the Waterfalls at Tivoli

Jacob Philipp Hackert
(German, 1737–1807)
1783
Oil on canvas
121.5 × 169 cm (47⅞ × 66½ in.)
Signed and dated bottom left: *La Villa de Mecène à Tivoli Ph. Hackert. f. 1783*
Inv. No. GE 7156, pair to GE 7634

PROVENANCE
Transferred from Pavlovsk Palace Museum, near St. Petersburg, 1933; at the Gatchina Palace, near St. Petersburg, late 1790s; arrived in St. Petersburg and taken to Kamennoostrovsky (Stone Island) Palace, 1785; commissioned in Rome by Grand Duke Paul Petrovich, 1782

Tivoli, not far from Rome, was a favorite place for the building of villas as early as the time of the Roman Empire. Thanks to its picturesque setting, from the end of the seventeenth century it attracted not only those in search of retirement from the bustle of the city but also numerous artists. In the wake of Claude Gellée (Lorrain), who had spent much of his time working in Tivoli and its environs, sketching there became a more or less obligatory tradition among succeeding generations of landscape painters (Weidner 1998).

Jakob Philipp Hackert was a German landscape painter working in Italy, one of the leading masters of Classical landscape in eighteenth-century Europe. In his best works he glorifies the grandeur, power, and eternal beauty of nature, its harmony and its tranquility, seeking to match the works of Claude. Hackert began working in Tivoli in the summer of 1769, spending four months there with his brother Gottlieb.

Weidner studied in detail the numerous painted and graphic works that the German painter produced in the area and he mentions a good dozen of the artist's favorite viewpoints, but he does not include the one seen in the St. Petersburg painting. To the left of the hanging north face of Colle Ripoli the Cascatelle Grandi waterfalls drop down into the river, and the valley formed by the river, cutting diagonally across the painting from left to right, opens up a view of a row of peaks. At left, above the waterfalls, are the ruins of a long Antique building with two tiers of arcades, known from the eighteenth century (when its plan was first taken) as the Villa of Maecenas. In the foreground to the right a vast tree fills the whole height of the canvas, balancing the massive left side of the composition. Spread out comfortably beneath the tree are small figures—two peasant women (one with a spindle), a child, and two peasant men. Nearby a small herd of goats is at pasture. As is often the case in Hackert's works, this vivid little scene introduces an idyllic note that softens the overall sense of nature's grandeur and majesty and helps draw the viewer forward into the very landscape.

A drawing in the Pierpont Morgan Library, New York, comes closest to the composition of this painting. It is also dated to 1783 (pen and brown ink over pencil on paper, 53.5 cm × 73.9 cm/21 × 29 in.).

The work is mentioned under No. 519 in the 1925 manuscript catalogue of paintings at Pavlovsk Palace (*Kriticheskii katalog kartin Pavlovskogo dvortsa-muzeia* [Critical Catalogue of the Paintings in Pavlovsk Palace Museum], compiled by V.P. Zubov, 1925; Archive of Pavlovsk Palace Museum Reserve).

EXHIBITIONS
Leningrad 1979a, p. 22, No. 208; Frankfurt-am-Main 1991, p. 180, No. 44; St. Petersburg 1998a, p. 83, No. 36, note 77

BIBLIOGRAPHY
Krönig 1966, p. 318, No. 1; Cat. 1981, p. 211; Vityazeva 1985, p. 37; Nikulin 1987, p. 262, No. 208; Nordhoff 1994, p. 75, No. 68

M.G.

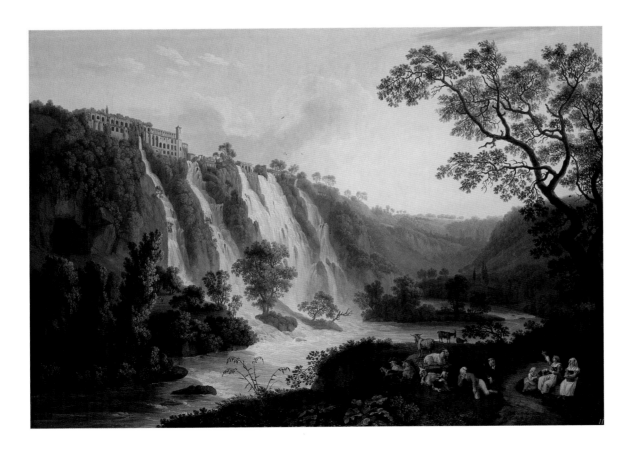

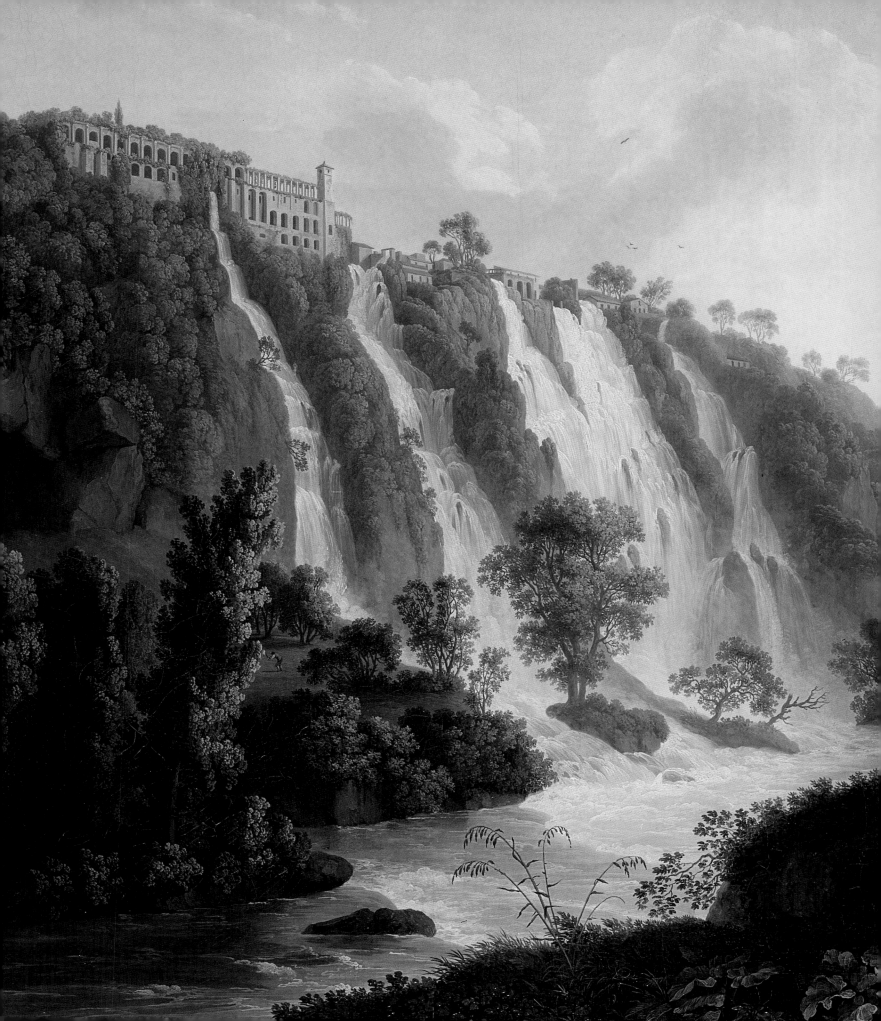

14
Voltaire's Morning
Jean Huber
(Swiss, 1721–1786)
Before 1775
Oil on canvas
52 × 43 cm (20½ × 17 in.)
Inv. No. GE 6724

PROVENANCE
Transferred to the Hermitage, 1934;
at the Vorontsov Palace in Alupka
(Crimea, now Ukraine), 1900–34;
on the estate of the Counts
Vorontsov, Odessa (Ukraine), until
1824; removed from the imperial
collection, probably c. 1778; acquired
for the Hermitage from the artist by
Catherine II, c. 1775

Fragmentary documents record the
execution of a series of paintings by
Jean Huber showing scenes from
Voltaire's life in Ferney, Switzerland.
The works are mentioned in letters
exchanged by Catherine II and her
correspondent of many years, the
French Enlightenment philosopher
Baron Melchior Grimm, from which
it becomes clear that the paintings
were acquired around 1775 on
Grimm's advice.

Four compositions from the series
seem to have drawn Catherine's
attention and are mentioned in the
correspondence: *Voltaire's Morning*,
Voltaire in a Cabriolet, *Voltaire Taming a
Horse*, and *Voltaire's Breakfast* (all now
in the Hermitage). It is impossible to
establish exactly how many paintings
were acquired from Huber since
they are not mentioned in
eighteenth-century catalogues of the
imperial Picture Gallery. Today the
Hermitage has nine compositions.
Various documents record six
compositions, four of them in the
Hermitage and two more—*Voltaire
Receiving Gifts Sent by Catherine II* and
Voltaire and his Friends—that have
since been lost.

Catherine II mentions Huber's
paintings—at times at some
length—in at least seven of her
letters to Grimm between 10
February 1775 (here and below Old
Style)—from the text it is clear that
the subject has already been the
topic of discussion over a relatively
long period of time—and 28 August
1776. The majority of them contain
an insistent request from Catherine

for detailed descriptions of all the
compositions, which Grimm put off
for more than six months. The
letters from the empress, who was
then moving around Moscow and
its environs, provide evidence that
she was impatient to receive
the paintings.

At last, in December 1775,
Catherine returned to St. Petersburg,
visited Tsarskoe Selo, and reported
to Grimm on 20 January 1776, as
she had promised, her impressions of
the paintings. She seems to have
been disappointed but, out of respect
for Grimm, avoided giving a specific
opinion: "A mon arrivée à Tsarsko-
Selo j'ai trouvé ces tableaux dans un
endroit assez sombre et exessivement
froid, de façon que je n'ai été
frappée et que je n'ai éclaté de rire
qu'au lever du patriarche; celui-la est
original selon moi: la vivacité de son
caractère et l'impatience de son
imagination ne lui donnent pas le
temps de faire une chose à la fois.
Le chevale qui rue et Voltaire qui le
corrige est très bon encore; la
distraction du cabriolet m'a plu,
mais que faut-il que je fasse pour le
grand Huber pour m'avoir cédé ses
tableaux?" ("Upon my arrival at
Tsarskoe Selo, I found these
paintings in a rather dim and
extremely cold place, to the extent
that I was not impressed, but merely
burst out laughing at the patriarch's
awakening [*Voltaire's Morning*]; in my
view this one is original: the vivacity
of his character, and the impatience
of this imagination, prevent him
from doing just one thing at a time.
The horse that kicks and Voltaire
correcting him [*Voltaire Taming a
Horse*] is also very good; the cabriolet
amused me [*Voltaire in a Cabriolet*],
but what must I do to get the great
Huber to give up his paintings?")

The empress resolved the
question of payment only seven
years later: "J'ai ordonné au
factotum de vous envoyer deux
médailles d'or … l'autre pour
Huber" ("I have arranged for a
secretary to send you two gold
medals … the other one for
Huber"). (Catherine–Grimm
Correspondence 1878, letter of
9 March 1783, p. 269).

Some mystery surrounds the
further fate of this series: it seems
to have been removed from the

imperial collection around 1778, for
on 11 August Catherine told Grimm
that she could no longer look upon
Voltaire's image in the wake of his
death (Catherine–Grimm
Correspondence 1878, p. 95).
Evidence suggests that by the 1870s
even the keeper of the Hermitage,
Baron von Koehne, knew nothing
about the paintings, which were
discovered in the early twentieth
century at the Vorontsov Palace at
Alupka in the Crimea, where they
were moved in 1900 with the rest
of the family collection from the
Odessa house of Count Mikhail
Vorontsov. Indirect evidence
suggests that Huber's paintings may
have come into the Vorontsovs'
possession in the first quarter of the
nineteenth century.

Jean Huber was one of only a
few people closely acquainted with
Voltaire's life in Switzerland. The
Swiss amateur artist and engraver
embarked on painting scenes of the
French philosopher's life in 1754,
when Voltaire invited him to
illustrate *Les Actes Familiers*. Although
Huber was no outstanding master,
Voltaire was attracted to him by the
very breadth of his interests, for in
addition to painting Huber also
studied aerostatics and was writing
a study on the flight of birds. For
many years Voltaire tolerated the
sarcastic Huber (who was very like
him in this respect), even though the
artist often went beyond the borders
of the permissible.

In picking out *Voltaire's Morning*,
Catherine unerringly identified the
most expressive of the compositions
she had acquired, although Voltaire
was offended by the work, seeing it
as a caricature (letter from Voltaire
to Catherine of 11 November 1772;
Catherine–Voltaire Correspondence
1803). Without doubt the artist
himself saw *Voltaire's Morning* as the
most successful of the compositions,
since he repeated it—with some
variations—more frequently than
the other subjects.

In this scene, Voltaire, dictating
to his secretary (probably Vanière),
wears a nightshirt and cap, and
indeed in all of Huber's paintings he
is shown either in a wig or in some
unusual headwear. The Venetian
adventurer Giacomo Casanova, who
visited the philosopher in

Switzerland, explained this strange
habit thus: "J'accompagnai M. de
Voltaire dans sa chambre à coucher
où il changea de perruque et mit un
autre bonnet, car il en portait
toujours un pour se garantir des
rumes auxquels il était très-sujet."
("I accompanied M. de Voltaire
to his bedroom, where he changed
his wig and put on another cap, for
he always wore one on account of
the rheumatism to which he was
very prone.") (*Mémoires de Jaques
Casanova de Seingalt, écrits par lui-même.
Édition complète*, Brussels, 1872,
vol. IV, p. 215).

Catherine corresponded with
Huber for many years, perhaps until
his death, and maintained a very
high opinion of him. In one of her
letters to Grimm she hastened to
recall his own warm praise of the
artist, intended as an apology for
not always respectful manners.

EXHIBITIONS
Paris–Moscow 1974–75, No. 454;
Leningrad 1978, No. 41; Potsdam
1991, No. 27; 1998–99 Venice,
No. 154

BIBLIOGRAPHY
Catherine–Voltaire Correspondence
1803, part 1, p. 127; Rigaud 1876;
Catherine–Grimm Correspondence
1878, pp. 16, 21, 24, 25, 27, 39, 42;
Desnoiresterres 1879, pp. 53–56;
Band-Bovy 1902, p. 108; Band-Bovy
1923; Bulletin 1924, p. 244; Shiriaev
1927, p. 109; Levinson-Lessing 1936,
pp. 19–78; Jean-Aubry, 1 June 1936,
pp. 593–626, 15 June 1936,
pp. 807–21; Deonna 1938, p. 171;
Levinson-Lessing 1939, p. 935;
Gielly 1948, p. 115, pls 13–22;
Cat. 1958, p. 461; Bulletin du Musée
Carnavalet 1960, pp. 5–6; Nemilova
1975, p. 434; Cat. 1976, pp. 307–08
(series); Nemilova 1982, No. 140
(series, Nos. 138–46); Apgar 1986,
pp. 46–53; Cat. 1994–95, pp. 186–89

E.D.

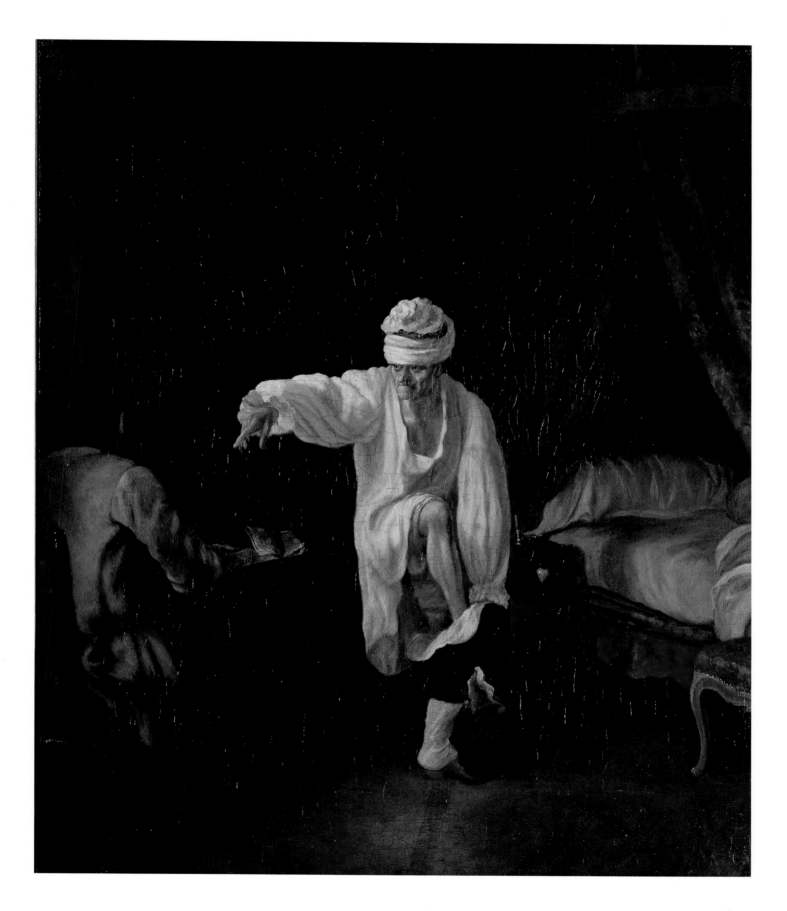

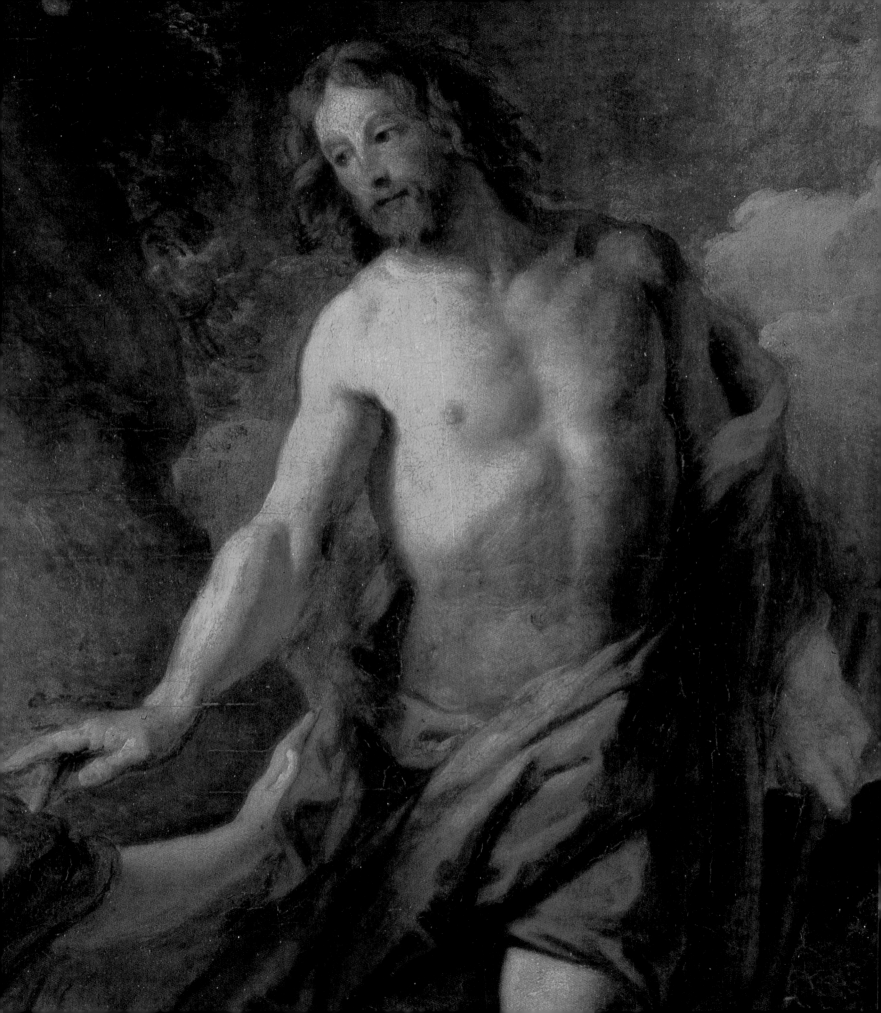

15

**Christ's Appearance to Mary
Magdalene**

Charles de Lafosse
(French, 1636–1716)
1680–85
Oil on canvas
81 × 65 cm (31⁷⁄₈ × 25⁵⁄₈ in.)
Inv. No. GE 1215

PROVENANCE
Acquired as part of the collection of
Count Heinrich von Brühl, Dresden,
1769

This work was painted with its pair,
*Christ's Appearance to the Women at the
Tomb*, with which it remained united
in the Brühl collection and in the
Hermitage until the latter was
transferred to the Pushkin Museum
of Fine Arts in Moscow in 1924.
The two works bring together
episodes from different books of the
Gospels: the Hermitage painting is
taken from John (20: 11–18) and the
Moscow painting from Matthew
(28: 9–10).

Both paintings were originally
oval in shape but late additions
made them rectangular. The oval
top must have been the author's
original conception, since it is
reflected in eighteenth-century
copies of both the Hermitage and
Moscow paintings in the Musée
d'Angers, and in a version attributed
to Lafosse, *Christ's Appearance to the
Women at the Tomb*, in the Musée des
Beaux-Arts, Valenciennes.

Frederick the Great (Friedrich II)
of Prussia owned another autograph
version of the Hermitage painting
(present location unknown), while a
third version by the artist, of almost
the same size (oil glued on to panel,
77.4 cm × 64.3 cm/30½ × 37⅜ in.),
was sold at auction at Christie's in
London (15 December 1989, No. 15);
the catalogue for the Christie's sale
states that the Hermitage has the
main version, and confirms the
original oval form. Another oval
painting on the same subject, with
dimensions identical to that at
Christie's, was sold at auction in
Paris, although the references may
be to one and the same work.

Lafosse studied under Charles Le
Brun and, like other French masters
of history painting, was originally
strongly influenced by both his tutor

and Nicolas Poussin. After five years
in Rome and Venice (1658–63),
however, he turned to the work
of Correggio, Venetian artists, and
Rubens, and it was Lafosse who
introduced into French painting
those developments of the last
quarter of the seventeenth century
that were to shape succeeding
generations of French masters.

Stuffmann (1964) dates the
paired compositions to 1680–85,

when Lafosse's work was strongly
influenced by Rubens. His
compositions of this time are
marked by a tendency toward
luxuriance and bright color contrasts
subdued by the overall golden-
brown tonality.

EXHIBITIONS
Leningrad 1972, No. 35;
Ibaraki–Mie–Tokyo 1994, No. 20

BIBLIOGRAPHY
Cat. 1774, No. 40; Cat. 1908–16,
No. 1464; Réau 1929, No. 145;
Cat. 1958, p. 298; Stuffmann 1964,
No. 26; Nemilova 1975, p. 434;
Cat. 1976, p. 207; Nemilova 1982,
No. 196; Nemilova 1985, No. 87

E.D.

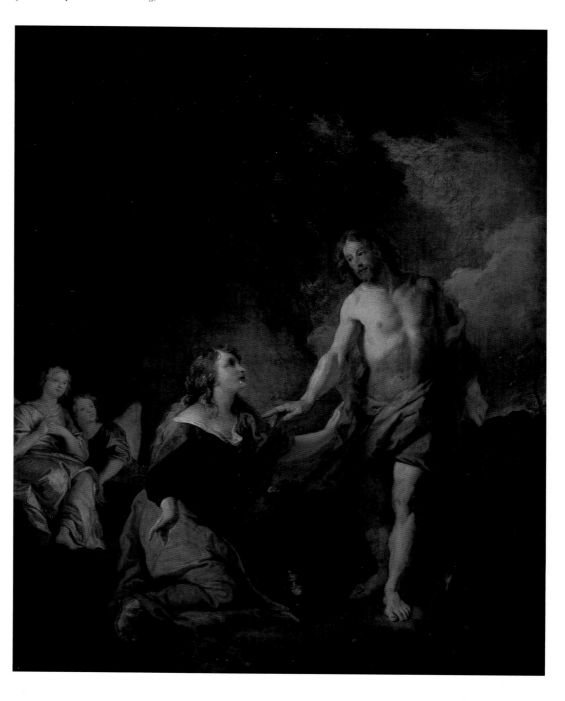

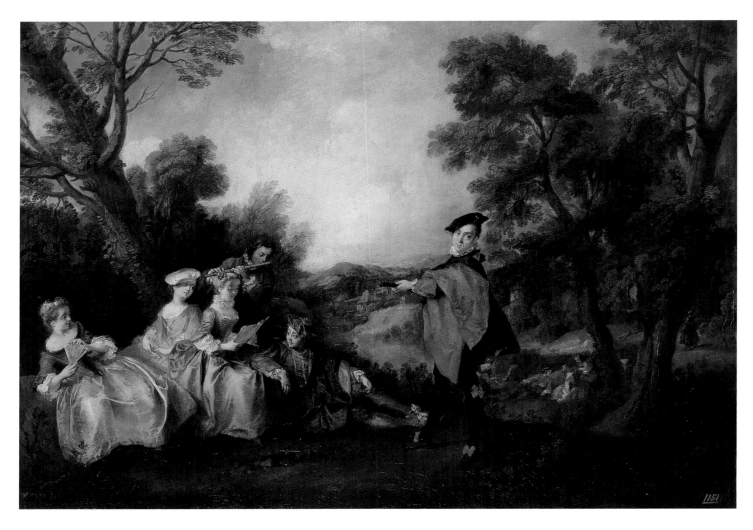

16
Concert in a Park
Nicolas Lancret
(French, 1690–1743)
1730s
Oil on canvas
76 × 107 cm (29⁷/₈ × 42¹/₈ in.)
Inv. No. GE 5624

PROVENANCE
Transferred to the Hermitage, 1928;
at the State (now Pushkin) Museum
of Fine Arts, Moscow, 1923–28; at
the Imperial Private Dacha, Peterhof,
1840–1923; acquired for the
Hermitage between 1763 and 1774

Like his great contemporary and
inspiration Antoine Watteau, Lancret
reflected the spirit and morals of
his age in his art, with all its light-
heartedness, its love of music, dance,
poetry, and elegant conversation. He
took from Watteau an interest in the
depiction of *fêtes galantes*—scenes set
in the lap of nature that recalled
theatrical performances, and this
painting is an excellent example of
the genre. It contains no profound,
emotionally charged images, but is
extremely attractive with its variety
of physiognomic types, its virtuoso
depiction of folds of cloth, its fine
use of nuances of color, and the
lightness of the brushstrokes.

Some scholars see in this
composition an ingenuous variation
on two of Watteau's works (Wallace
Collection, London; Sanssouci,
Potsdam). There is a preparatory
drawing in red chalk for the woman
with a fan to the left (Musée
Carnavalet, Paris).

Lancret remained extremely
popular among collectors in the
second half of the eighteenth
century, and his works adorned the
collections of many European ruling
houses. The most avid taste for *fêtes
galantes* was demonstrated by
Catherine II's great rival in
collecting, Frederick the Great
(Friedrich II) of Prussia, while the
empress's own collection contained
some ten of Lancret's works.

EXHIBITIONS
Belgrade 1968–69, No. 45; Leningrad
1972, No. 32; Irkutsk-Novosibirsk
1986, No. 13; Nara–Osaka 1990,
No. 34; Copenhagen 1995, No. 88,
pl. 23, p. 71

BIBLIOGRAPHY
Cat. 1774, No. 2050; Miller 1923,
pp. 62–63; Wildenstein 1924, No.
297; Ernst 1928, p. 173; Réau 1929,
No. 568; Cat. 1958, p. 296; Cat.
1976, p. 206; Nemilova 1982, No.
190; Nemilova 1985, No. 109

E.D.

17

Portrait of Count Semen Vorontsov

Thomas Lawrence
(British, 1769–1830)
1805–07
Oil on canvas
76.5 × 64 cm (30¹⁄₈ × 25¹⁄₄ in.)
Inv. No. GE 1363

PROVENANCE
Acquired by Nicholas II from the heirs of Count Mikhail Vorontsov, M. Vorontsova and Nikolai Stolypin, and given to the Hermitage, 1900; family of the Counts Vorontsov; probably commissioned from Lawrence by Count Semen Vorontsov for his son Mikhail

Count Semen Romanovich Vorontsov (1744–1832), outstanding statesman and diplomat, began his career in the military and demonstrated his outstanding skills during the Russo-Turkish War. Intrigue forced him to retire from the army in 1776 with the rank of Major-General. In 1782 he was appointed envoy to Venice, but after the death of his wife, Ekaterina Seniavina, he was transferred in 1784 to London. There he was to remain, with only short intervals away, for more than forty years. He served as Russian ambassador to the Court of St. James between 1785 and 1796, and again between 1801 and 1806. He did not return to Russia on his retirement but spent the last years of his life in Richmond and Southampton. Uniting a profound love of his native land with a great admiration for the English lifestyle and state system, he did everything in his power to promote relations between the two countries and to establish contacts on all levels in many different spheres. His efforts were crowned with great success, despite the complex political situation in Europe in the wake of the French Revolution and the battle for colonies in the East and in North America. It was thanks to Vorontsov that a trading agreement was renewed between Russia and Britain in 1793. By the time of his retirement he was a knight of all the Russian Orders, but in Lawrence's portrait he wears only the star and ribbon of the most important of these, the Order of St. Andrew.

Two more images similar to this superb Hermitage portrait exist, one in the Pembroke Collection at Wilton House, the other formerly in the collection of the late Sir Michael Duff, Baronet. The portrait at Wilton House, which Garlick (1989, p. 288) considers to be the original, was bequeathed by Count Vorontsov to his daughter Catherine, who had married George, 11th Earl of Pembroke, in 1808. The Hermitage portrait belonged to Vorontsov's son Mikhail, from whose heirs it was acquired by Nicholas II.

In his 1954 monograph on Lawrence, Garlick published the Coutts list records that show that on 14 February 1805 Lawrence received from Vorontsov the sum of £220 and 10 shillings (Garlick 1954, p. 71). Exactly what the payment was for is not mentioned, but Garlick presumed that the sum was too large for a mere half-length, suggesting therefore that "the portrait was originally commissioned as a full-length." In the light of a total lack of evidence of the existence of such a full-length, it seems more probable that the sum related to several works produced for Vorontsov, e.g. for both the half-length and the identical version that the Count intended to give his son. It may even be that he was paying for two copies, i.e. also for the version that once belonged to Sir Michael Duff.

By the end of the nineteenth century, the owners of this painting thought it to be the work of George Romney, and with this mistaken attribution it entered the Hermitage and was listed in a number of Hermitage catalogues (Cat. 1900–07; Cat. 1958). The information is repeated in a number of later publications (Cross 1977; Cross 1992). Benois (1910), Weiner (1923), and Garlick (1954), however, were never in any doubt that Lawrence was the true author.

A miniature copy of this portrait by an unknown British artist is in the collection of G. Milius in Italy (G. Cagnola: "La mostra di miniature e ventagli a Milano," *Rassegna d'Arte*, No. 5, May 1908, p. 87). There is an anonymous lithograph, undated and in reverse (Krol' 1969).

EXHIBITIONS
Moscow 1956, p. 34 (as Romney); London 1967, No. 59; New Haven–Toledo–St. Louis 1996–97, No. 20; Moscow 1997, No. 143

BIBLIOGRAPHY
Cat. 1900–07, No. 1872 (as Romney); Williamson 1904, No. 33; Russian Portraits 1905–09, vol. 2, No. 42; Cat. 1908–16, No. 1872; Schmidt 1908, p. 355; Benois [1910], p. 187; Weiner 1923, p. 316; Krol' 1939, pp. 33, 46; Garlick 1954, pp. 64, 71; Cat. 1958, p. 308 (as ?Romney); Garlick 1964, pp. 204, 271; Pembroke 1968, p. 24, No. 40; Krol' 1969, pp. 68–70 (as Lawrence); Cross 1977, p. 11, No. 25; English Art 1979, No. 296; Cat. 1981, p. 262; Garlick 1989, p. 266, No. 846; Dukelskaia, Renne 1990, No. 53; Cross 1992, p. 24, No. 38

E.R.

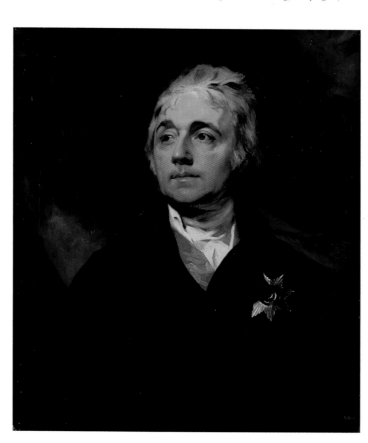

18

Peacock Island
Peter Ludwig Lütke
(German, 1759–1831)
1821
Oil on canvas
50 × 68 cm (19⅝ × 26¾ in.)
Signed and dated bottom right:
Lütke p. 1821
Inv. No. GE 6283

PROVENANCE
Transferred from the Winter Palace,
1925; acquired by Empress
Alexandra Fedorovna, possibly 1821

Pfaueninsel, or Peacock Island,
appears on maps showing the River
Havel around Potsdam as early as
1683. Toward the end of the
eighteenth century Friedrich
Wilhelm II and Friedrich Wilhelm
III of Prussia transformed it into one
of the most picturesque locations in

the environs of Berlin, with a
beautiful English park (planned by
Peter Lenné) in which peacocks
strutted freely. Dotted with a variety
of pavilions, hothouses, and cages
containing exotic beasts (which in
1842 formed the basis of Berlin
Zoo), the island became the Prussian
royal family's favored summer
residence.

Princess Charlotte, daughter of
Friedrich Wilhelm III, married the
heir to the Russian throne, Grand
Duke Nikolai Pavlovich (later
Nicholas I) in 1817, and took the
Russian name Alexandra
Fedorovna. In the autumn of 1821
she made her first visit to Germany
since her wedding. In need of rest
and recuperation, having given birth
to three children in three years, the
last of whom died, she spent much
time on the island in the spring and
summer of 1822. Peacock Island was

closely associated in her mind with
memories of her happy childhood as
the much-loved daughter in a united
family. One perpetual reminder of
this was an extremely rare flower,
the Charlotte, planted there at her
father's command.

Before the development of mass
means of reproduction, "memorial
pictures" enjoyed great popularity,
the most striking example being the
vedute of Antonio Canaletto. Such
works were particularly prized for
their precision and the easily
recognizable depiction of a specific
landscape. These were the qualities
that contemporaries admired in
Lütke's landscapes—his nature
studies were so very precise that
they were used as teaching models.

Among the several surviving
views of the Pfaueninsel that Lütke
produced in and around 1821, this
painting differs in the presence of

peacocks in the foreground. This
feature suggests that it was painted
specifically for Alexandra Fedorovna
and brought back to St. Petersburg,
not merely as a sentimental
reminder of happy days on the
Pfaueninsel, but also as an
allegorical depiction of her happy
marriage. In Classical art the
peacock symbolizes faithfulness,
being the bird of Juno, patroness
of marriage, and the marriage of
Alexandra and Nicholas was thus
depicted as representing the ideal.

EXHIBITIONS
Worpswede 1994, p. 46; London
2002, No. 13

BIBLIOGRAPHY
Asvarishch 1988, No. 160

B.A.

20

The Annunciation

Anton Raphael Mengs
(German, 1728–1779)
1767
Oil on paper, lined with canvas
69×41 cm (27⅛×16⅛ in.)
Inv. No. GE 1331

PROVENANCE
Purchased by Catherine II from the artist's heirs in Rome, 1781; in the artist's studio in Rome on his death, 1779

Even in his childhood Anton Raphael Mengs worked extensively in the Vatican, copying works under the guidance of his father, the artist Ismael Mengs. He worked in Rome almost his whole life and it was there that he became friends with Johann Joachim Winckelmann, a leading eighteenth-century scholar of antiquities and theoretician of Neo-classicism. Mengs's own brand of Neo-classicism, of which he was both a theoretician and a practitioner, sought to return painting to the Classical ideal, and he particularly admired the artists of the High Renaissance, taking Raphael as his model.

In *The Annunciation*, Mary's idealized features—her head bowed and eyes lowered before the Archangel Gabriel, indeed her whole appearance, including the smooth, plaited hair—derive from Raphael's Madonnas. God the Father in the heavens, surrounded by an assembly of angels, is inspired by Michelangelo's image of God the Creator on the ceiling of the Sistine Chapel. Perhaps, as was suggested by N. Nikulin (1987), Mengs was basing Him rather on the softer, calmer interpretation by Raphael in his *Vision of the Prophet Ezekiel* in Florence's Palazzo Pitti. Certainly one can see the marked influence of seventeenth-century Bolognese masters, particularly Guido Reni; this opinion is shared by Christoph Frank (Frankfurt-am-Main 1999–2000) and S. Roettgen (1999).

The composition is so conceived that the busy upper section contrasts with the calm of the lower part, in which Mary and the angel seem to be posed upon a stage. The widespread arms of the future

Mother of God indicate her total submission to God's will as explained by His messenger.

Taking up Nagler's suggestion (Nagler 1835–52), Nikulin (1987) wrote that the Hermitage sketch served as *bozzetto* for a large altarpiece in the chapel of the Castle of Aranjuez (commissioned by Charles III of Spain), Mengs's last work, produced in Rome in 1779: Azara recorded that the artist died while working on the Archangel Gabriel's hand.

Roettgen, however, author of a major monograph on Mengs (first volume published 1999) and curator of an international exhibition of the artist's work in Padua and Dresden (2001), suggests with some reason that the Hermitage painting is in fact the *bozzetto* for an altarpiece in the Church of Castrogeriz in Burgos. Her analysis was based on marks surrounding the Hermitage painting that accord with the frame around the altarpiece in Burgos. Luckily the Hermitage painting has preserved the form of the frame in which it was originally exhibited, one intricately shaped above with a characteristic projection below (compare Roettgen 1999, No. 5). The client for the altarpiece was a friend of Mengs, Don Diego Sarmiento Conde de Castro y Ribadavia (or Rivadaria). Unlike the Hermitage model, the large altarpiece at Castrogeriz lacks the sleeping cat in the bottom-left corner, although it still retains the basket covered with cloth nearby.

In addition to the Hermitage sketch, there are relating to the altarpiece for the Church of Castrogeriz a large unfinished canvas (originally *c.* 4 m/13 ft long) in the Kunsthistorisches Museum, Vienna, and a *bozzetto* at Weston Park Foundation, England, which is the closest to the St. Petersburg work and differs only in a certain hastiness and superficiality of manner (Roettgen 1999, No. 9). Roettgen dates the Hermitage *bozzetto* to *c.* 1767. In Padua 2001 she recorded five surviving paintings by Mengs showing the Annunciation, suggesting that the artist attached particular significance to the subject. The Hermitage also has a large, unfinished painting unconnected with the *bozzetto* but also acquired by

Catherine II from the artist's heirs (oil on canvas, 388×222 cm/152¾× 87⅜ in., Inv. No. GE 7684).

EXHIBITIONS
Leningrad 1981, p. 27, No. 18; Frankfurt-am-Main 1991, p. 126, No 28; Padua 2001, p. 157, No. 31; Frankfurt-am-Main 1999–2000, p. 264, No. 154

BIBLIOGRAPHY
Azara 1786, p. 33; Ponz 1788, p. 49; Cat. 1863–1916, No. 1297; Nagler 1835–52, vol. 10, p. 173; Cat. 1958, p. 324; Honisch 1965, p. 94,

No. 102; Cat. 1981, p. 205; Nikulin 1987, p. 315, No. 256; Roettgen 1999, p. 36, No. 7

M.G.

1712 was returned to his family. Nattier cut his throat while in prison.

There was a version of this composition known until 1769 at Sanssouci, Potsdam, possibly the same work as that sold at auction at the Hôtel Drouot in Paris in 1864. Both references may perhaps have been to the sketch mentioned in the Academy records.

EXHIBITIONS
Leningrad 1972, No. 37; Karlsruhe 1996, No. 2; Schloss Rheinsberg 2002

BIBLIOGRAPHY
Cat. 1774, No. 2025; Georgi 1794, p. 480; Cat. 1863, No. 1478; Waagen 1864, p. 304; Clément de Ris 1879–80, part V, p. 269; Garshin 1888, p. 434 (Jean-Mark Nattier); Mantz 1894, p. 100; Cat. 1908–16, No. 1478; Nolhac 1910, p. 19; Réau 1929, No. 254; Thieme-Becker 1907–50, vol. 25, 1931, p. 356; Cat. 1958, p. 312; Cat. 1976, p. 214; Nemilova 1982, No. 227; Nemilova 1985, No. 156; Cat. 1999–2000, p. 300

E.D.

21

Joseph with Potiphar's Wife
Jean-Baptiste Nattier
(French, 1678–1726)
1711
Oil on canvas
73.5 × 92 cm (28⅞ × 36¼ in.)
Signed and dated bottom left:
J.B.Natier fecit 1711
Inv. No. GE 1268

PROVENANCE
Acquired at the auction of the collection of Jean-François de Troy, Paris, 1764; Damery collection, Paris; in possession of the artist's family, Paris, from 1726

Joseph, son of Jacob, was sold by his brothers into Egypt, where he rose to become overseer in the house of Pharaoh's captain of the guard, Potiphar. For his hard work and good behavior, Potiphar entrusted him with important affairs and set him to take care of the house, but Potiphar's wife fell in love with the handsome young man and pursued him. One day she sought to tempt Joseph into her bed, but he broke away and escaped, leaving his garment in her hands. Angered by her failure, Potiphar's wife accused Joseph of attempting to rape her and the youth was thrown in jail. (Genesis 39). "And it came to pass about this time, that Joseph went into the house to do his business; and there was none of the men of the house there within. And she caught him by his garment, saying, Lie with me: and he left his garment in her hand, and fled, and got him out." (Genesis 39: 11–12) The subject was very popular with artists, who usually selected the bedroom scene as offering greatest opportunity for artistic expression.

Nattier places in the foreground the luminous, seductive naked body of Potiphar's wife. The bright, direct light plays in highlights and half-shadows over the young woman's flesh. Joseph, by contrast, is sunk in gloom, only part of his face and his gesture of repulsion caught in the light.

This composition was a program work, painted to gain the artist's acceptance into the Académie Royale. The protocols of the Academy's assembly (P.V. 1881) record in detail work on the painting. On 31 December 1710, Jean-Baptiste Nattier, the son of an Academician, requested that he be allowed to take steps to be accepted as a member. The Academy, led by the painter de Troy, agreed to the request and set the theme for his acceptance work. On 25 April 1711 Nattier presented his sketch to the Academy, and this was accepted by a majority of votes, with the artist being set a term of six months to produce the final version. Nattier, it would seem, found work on the painting difficult, since he later received permission to extend the period for another six months. At last, on 29 October 1712, he was accepted into membership of the Academy.

In 1725 Nattier was compromised in the scandalous Deschauffoir court case and sentenced to imprisonment in the Bastille. As a result he was deprived of his Academy membership, and the painting he had presented to the Academy in

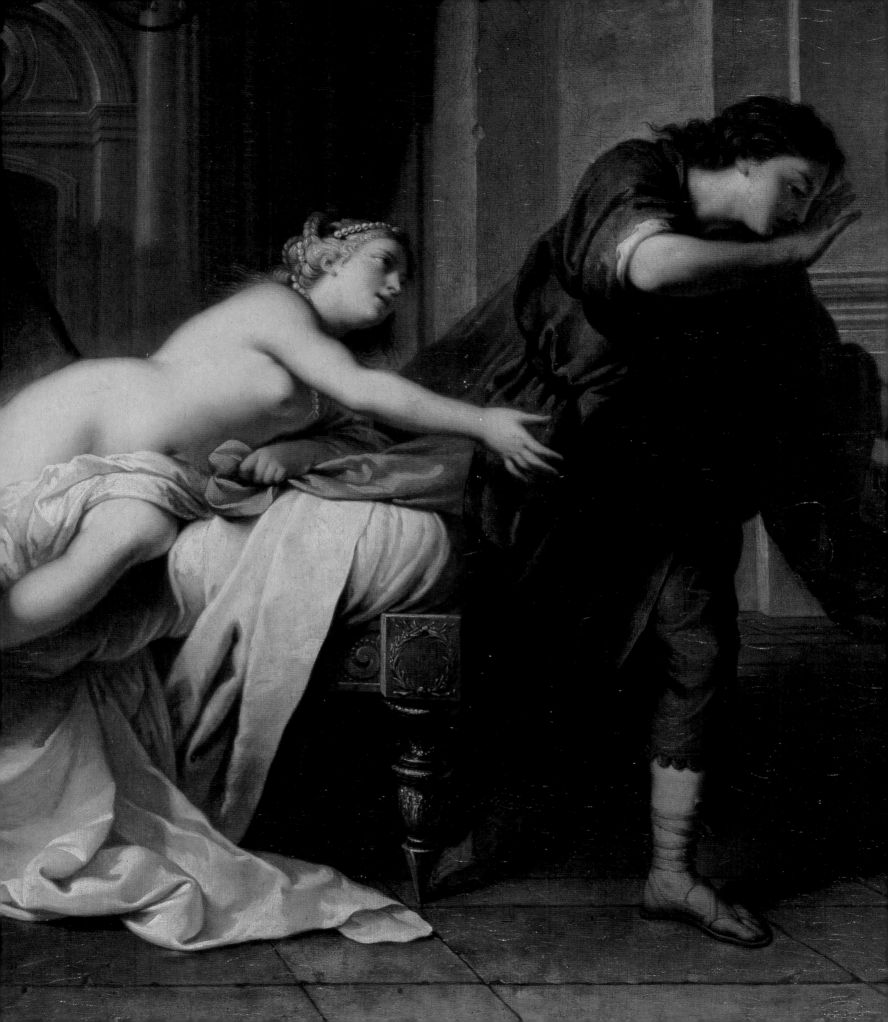

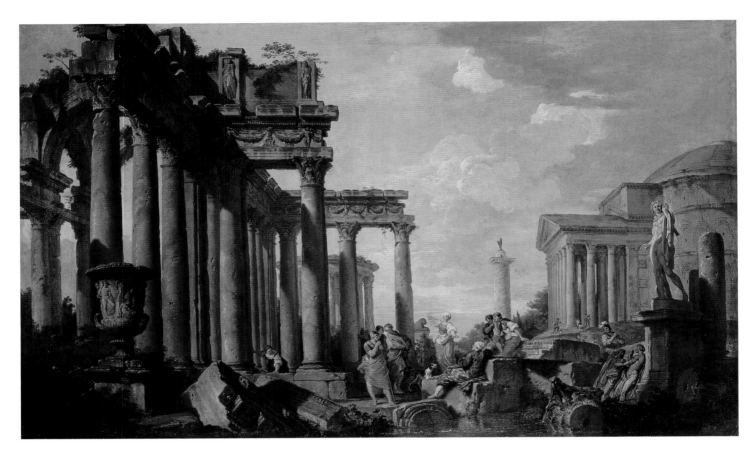

23

The Sibyl's Sermon Amidst Roman Ruins with the Apollo Belvedere
Giovanni Paolo Panini
(Roman, 1691–1765)
Mid-1740s
Oil on canvas
85 × 124 cm (33½ × 48⅞ in.)
Signed to left on the vase base:
I.P.PANINI ROMA…
Inv. No. GE 174

PROVENANCE
Acquired by Catherine the Great
for her Hermitage between 1763
and 1774

Panini was the unrivalled master
of the *veduta ideata* or "ideal
landscape." His images of the
celebrated monuments of ancient
Rome, of overgrown ruins and
landscapes strewn with fragments
of capitals and sarcophagi, freely
united the artist's fantasy and lively
painterly groups of figures to form
harmonious, spacious compositions.
Panini's landscapes became

extremely popular among travelers,
seized by a new interest in Classical
history, and they were to hang in
some of Europe's most famous
houses. From the mid-eighteenth
century they were much sought after
by Russian collectors of the imperial
house and members of the nobility
in St. Petersburg.

In a description of the
Hermitage Gallery included in his
Russian-language publication on
the sights of St. Petersburg, Johann
Georgi (1794) noted "seven most
handsome images of architectural
objects and ruins" by Panini.

The Sybil's Sermon forms a pair
with another landscape, *The Apostle's
Sermon Amidst Roman Ruins with the
Farnese Hercules* (Hermitage, Inv. No.
GE 181), and is an excellent example
of Panini's "ideal landscapes" of
the mid-1740s. We see the Pantheon
and the Apollo Belvedere to the
right, the Temple of Vesta and
Trajan's Column in the distance,
while a stone vase at the left
reproduces the Medici Vase. Men
and women scattered freely amid

the Classical ruins listen with
interest to the Sibyl's sermon, which
prophesies the birth of a new world.
A close version of the composition
showing *A Sermon by the Apostle Paul* is
in the Musées Royaux des Beaux-
Arts de Belgique in Brussels, but the
Hermitage composition is less
confused, less overloaded with
architectural details, and the temple
columns are smooth rather than
fluted. The whole scene is suffused
with pink light and soft shadow, the
openings between the columns and
the low horizon seem to extend the
space and fill it with air, while the
balance in proportion between the
human figures and surrounding
architecture gives the composition
a sense of harmony and peace.

In the literature both landscapes
in the Hermitage are sometimes
mistakenly identified with a pair
of works by Panini that entered the
Hermitage Gallery in 1764 as part
of the collection of Johann
Gotzkowski.

BIBLIOGRAPHY
Ozzola 1921, p. 18; Voss 1924,
p. 634; Labo 1932, p. 201; Arisi 1961,
p. 187, No. 195; Arisi 1993, No. 383;
Bushmina 2001, p. 16

T.B.

24
Old Man in a Kitchen
Jean-Baptiste-Marie Pierre
(French, 1713–1789)
c. 1745
Oil on canvas
130 × 97 cm (51⅛ × 38¼ in.)
Inv. No. GE 7240

PROVENANCE
Transferred to the Hermitage, 1931;
kept at the Catherine Palace,
Tsarskoe Selo, near St. Petersburg;
acquired for the Hermitage by
Catherine II as part of the collection
of Louis Crozat, Baron de Thiers,
Paris, 1772

Pierre is best known as a history
painter, the author of works on
religious and mythological subjects
as well as *scènes galantes* and
allegorical compositions. He did
not often turn to folk subjects, but
when he did, he revealed the clear
influence of Louis Le Nain, an artist
of the previous century. The two
masters are linked by their static
compositions deprived of strong
emotion, their everyday subjects
and their characters sunk in their
own thoughts rather than engaged
with the outside world.

It is thought that this work was
painted around 1745, the year in
which it figured at the Salon in
Paris, but one scholar of Pierre's
work (Sainte-Marie 1974) has
suggested that it had been engraved
as early as 1743 by A.C. Ph. de
Caylus and E. Fessard under the
title *Ménage savoyard*. The same
author cites the description of a
composition in the *Mercure de France*,
which notes: "… leurs habits, leurs
meubles, quelques poteries et
utensiles répandus sur les planches
expriment une grande indigence"
("their clothes, their furnishings, a
few ceramics and utensils spread on
boards, indicate great poverty").

Sainte-Marie suggests that a
painting in the Musée des Beaux-
Arts in Auxerre, *The Schoolteacher*,
should be seen as a pair to the
Hermitage work. There is also a
preparatory drawing for the
Hermitage painting in the
Nationalmuseet, Stockholm.

At the time this painting was
produced, Pierre had recently
returned from his studies in Rome
(1735–40) and begun to enjoy great
success in his native land. He was
an active participant in exhibitions
at the Académie, becoming an
Academician in 1742, a Professor in
1748 and Director of the Académie
in 1770. As protégé of Madame de
Pompadour he became first painter
to the king, replacing the deceased
François Boucher.

EXHIBITIONS
Paris 1745, Salon, No. 70; Paris
1986–87, No. 314; Leningrad 1987,
No. 414; Ibaraki–Mie–Tokyo 1994,
No. 41; Karlsruhe 1996, No. 11

BIBLIOGRAPHY
Georgi 1794, p. 480; Dussieux
1856, No. 961; Cat. 1958, p. 332;
Stuffmann 1968, p. 132, No. 161;
Sainte-Marie 1974, pp. 3–6;
Cat. 1976, p. 224; Nemilova 1982,
No. 261; Nemilova 1985, No. 181;
Conisbee 1986, p. 43, ill. 32

E.D.

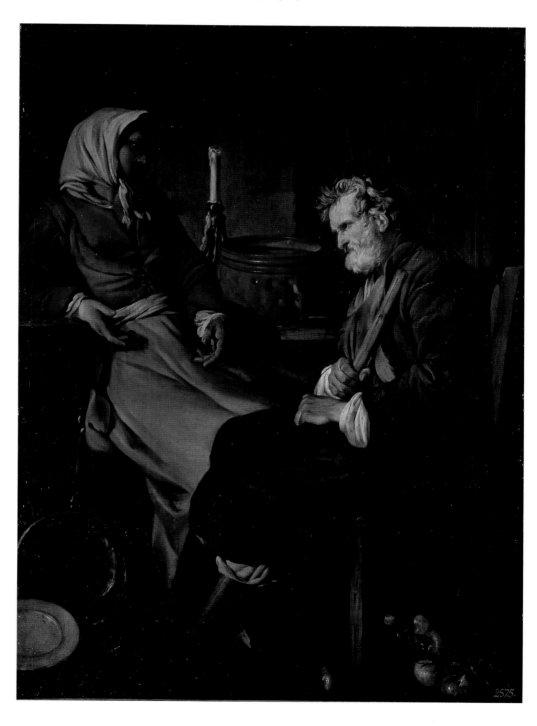

25
Portrait of Empress Elizabeth

Georg Caspar Joseph Prenner
(Austrian, 1720–1766)
Between 1750 and 1754
Oil on canvas
160 × 128 cm (63 × 50⅜ in.)
Inv. No. GE 4341

PROVENANCE
Transferred from the estate of
Krasnaia Slavianka, near
St. Petersburg, 1920

Elizaveta Petrovna (1709–61),
daughter of Peter the Great and his
second wife Ekaterina Alexeevna
(later Catherine I), ruled as Russian
Empress Elizabeth 1741–61. She is
here shown wearing the Order of
St. Andrew on a blue silk sash with
the star of the Order on her left
breast.

Elizabeth stands before us as a
black-browed, pink-and-white-faced
buxom beauty dressed in the very
latest French style, left arm proudly
planted upon her hip. She holds a
scepter in her right hand, with an
orb resting beneath it upon a satin
cushion. Looking down at us
majestically, she has a hidden smile
flickering over her lips, this last
being not merely a Rococo feature
but also a symbol of royal grace and
mercy. The artist has successfully
presented the very ideal of
absolutism, the image of a monarch
who is strict but just, concerned with
the welfare of the state of which she
is absolute ruler.

In 1750 Count Mikhail
Vorontsov, Vice-Chancellor and
confidant of the Empress Elizabeth,
requested that his Italian friend, the
Senator Count N. Bielche, send
from Rome a "strong painter of
portraits" for the imperial court.
The man who arrived was the little-
known Austrian Georg Prenner,
who had been working in Rome
since 1742 (Makarov 1929; Androsov
2001, p. 253).

During his time in Russia
(1750–55) Prenner repeatedly painted
the Empress Elizabeth. Sergei
Androsov (2001) cites a letter from
Vorontsov to Bielche dated
27 October 1750 (Old Style), in
which he records that Prenner "has
begun a portrait of the Empress,

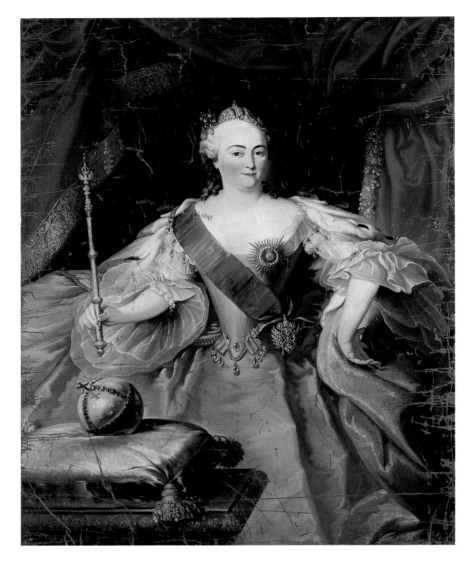

and although he has worked only
for one sitting this first sweep of the
brush already convinces us of its
happy conclusion" (Androsov 2001,
p. 256, note 53). It is unfortunately
not clear which portrait of the
Empress is being referred to.

In the Tret'iakov Gallery,
Moscow, is an image of Elizabeth
almost identical to that in the
Hermitage (except that she wears a
garland of flowers upon her head),
signed and dated 1754 (oil on
canvas, 202.8 × 157.2 cm/79⅞ ×
61⅝ in., Inv. No. 6249). This
painting was formerly at the
Andreevskoe Estate in Vladimir
Province, the property of Countess
E.A. Vorontsova-Dashkova and then
in the Vladimir Museum, from
where it was transferred to the

Tret'iakov in 1923. The Hermitage
portrait, meanwhile, would seem in
the nineteenth century to have been
on the estate of Grafskaya Slavianka
(later renamed Tsarskaia Slavianka
and in the Soviet period Krasnaia
Slavianka), not far from Pavlovsk,
just outside St. Petersburg. This
estate belonged to Countess Julia
Samoilova (1803–1875) and was
acquired in the 1840s by a relative
on her mother's side, I.I. Vorontsov-
Dashkov, before being purchased in
1846 by Nicholas I. It is possible
that both portraits once belonged to
the Vorontsov-Dashkovs, but it may
be that the Hermitage painting
arrived at the estate after the latter
passed into royal hands. No precise
information is available (*Russian
Portraits* 2000, p. 279, No. 69).

Stored on a roll in the
Hermitage is another portrait
of Elizabeth by Prenner (Inv. No.
GE 4335). Although this is full-
length, the upper part of the body
is exactly as seen in both the
Moscow and St. Petersburg works.

A free copy (with a frame of
flowers) by E. Petrov is in Yaroslavl
Art Museum (oil on canvas,
128 × 108 cm/50⅜ × 42½ in., Inv.
No. 976).

BIBLIOGRAPHY
Nikulin 1987, p. 498, No. 425;
Tretiakov Catalogue 1998, p. 187;
Androsov 2001, p. 252

M.G.

26
Vestal Virgin
Jean Raoux
(French, 1677–1734)
c. 1700–25
Oil on canvas
89 × 74.5 cm (35 × 29⅜ in.)
Inv. No. GE 1212

PROVENANCE
Acquired by Catherine II as part of the collection of Johann Gotzkowski, Berlin, 1764

This painting was listed when in Gotzkowski's possession as the work of Jacques-François Courtin (1672–1752), under whose name it continued in the Hermitage until 1974, when Nemilova (1974) proved it to be the work of Courtin's contemporary, Jean Raoux. Raoux was of modest talent, but he had his circle of admirers and clients. He painted mainly *fêtes galantes*, the times of the day, the seasons, and the ages of human life. An important place in his work was occupied by allegorical figures and portraits of court ladies, depicted above all as Pomona, as Ceres, and particularly as vestal virgins. The latter subject almost dominated his work, for Raoux frequently included it in his paintings, in genre compositions with a multitude of figures, as single figures of virgin priestesses of the Temple of Vesta, and in allegorical portraits of specific individuals, such as *Mademoiselle de Pressoy en vestale* (sold at auction, Monte Carlo, 22 February 1986; Lyons, 2 December 1996). Indeed, Raoux became known as "the vestal artist."

Nemilova has noted clear painterly and stylistic similarities between this painting, *Vestal Virgin* (Musée de Bayeux), and *Portrait of the Wife of the King's Secretary Boucher* (Versailles), identifying all of them as costume portraits.

In the customs description of the Gotzkowski collection compiled in 1764, this painting is number 44: "Priestess of Venus, painted upon canvas, two feet eleven inches, width two feet four inches, five hundred reichsthalers, by the seal on the frame, painted by Korteing [Courtin]" (Uspensky 1913).

BIBLIOGRAPHY
Cat. 1774, No. 2043; Georgi 1794, p. 477; Cat. 1908–16, No. 1495; Uspensky 1913, No. 44; Réau 1929, No. 42; Cat. 1958, p. 290; Faré 1966, p. 293; Nemilova 1974, pp. 11–13; Nemilova 1975, p. 431; Cat. 1976, p. 224; Nemilova 1982, No. 263; Nemilova 1985, No. 186

E.D.

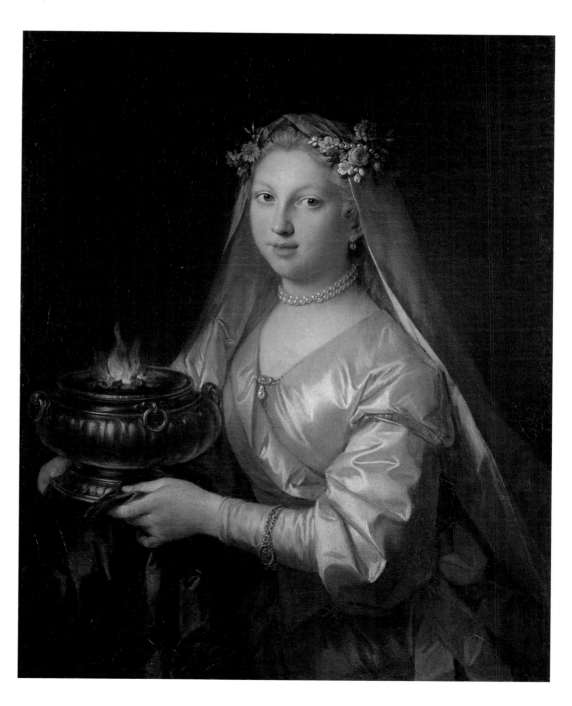

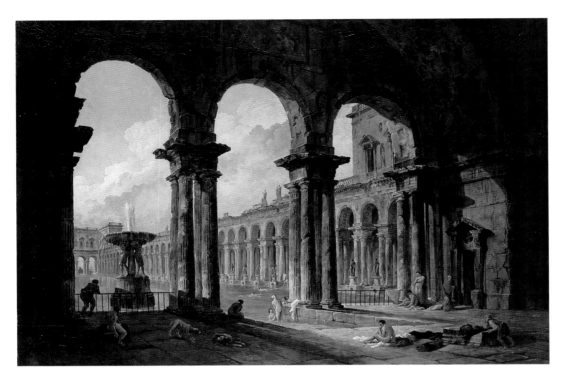

preserve all the stylistic features characteristic of Robert's best works. As was typical of his earlier commissions from high-ranking individuals, the artist paid equal attention to observing all rules of linear and aerial perspective, conveying the play of light and dark, and to the execution of the staffage.

Both compositions are known in several versions, which have, however, never been linked. The best of the other versions of *Ancient Ruins Used as a Public Baths* (just a quarter of the size at 66×80 cm/ 26×31½ in.) was in the collection of Grand Duchess Maria Nikolaevna (now priv. coll., St. Petersburg; reproduced in *Nasledie velikoi kniagini Marii Nikolaevny* [The Bequest of Grand Duchess Maria Nikolaevna], compiled by Baron N.N. Wrangell (Vrangel'), St. Petersburg, 1913, No. 23). It cannot be overlooked that this was a study for our composition, as is indicated by the free, sketchy manner. The fountain in the pool was inspired by the Fountain of Atlantes in the park of the Villa Albani, Rome, and recurs repeatedly in the artist's works: e.g. *Fountain and Colonnade in a Park* (1775; Musées Royaux des Beaux-Arts de Belgique, Brussels); sketch, *Washerwomen in a Park* (Petit Palais, Paris), etc. An auction at the Hôtel Drouot held on 9–10 June 1929 included a red chalk drawing (No. 49) showing this sculptural group with a pedestal adorned with playing cupids. This was possibly made from life, and may have served Robert as the model when creating this canvas.

27
Ancient Ruins Used as a Public Bath
Hubert Robert
(French, 1733–1808)
1796
Oil on canvas
133×194 cm (52³⁄₈×76³⁄₈ in.)
Signed and dated bottom left:
H.Robert 1798
Pair to *Arch on a Bridge over a Stream*, Hermitage, Inv. No. GE 7682
Inv. No. GE 1262

PROVENANCE
Acquired from the artist, 1802; commissioned for the Winter Palace by Count Alexander Stroganov, 1798

The literature frequently notes that Robert participated in the Salon for the very last time in 1798, with just two paintings, *Ancient Ruins Used as a Public Bath* and *Entrance into an Ancient Palace*, but always omits to mention that both are now in the Hermitage.

A slight misreading of the provenance of these works is contained in two Hermitage catalogues of the early 1980s (Nemilova 1982; Nemilova 1985), which state that they were produced on commission from Count Stroganov for the Winter Palace, and acquired by him "directly from Robert in 1802." The catalogue of paintings acquired under Alexander I in fact contains more precise information: "Ces tableaux ont été fait pour S.E. Mr le Comte A. Stroganoff en 1798 et acquit en 1802 par S.M. l'Imp[ereur]. Alex[andre]. 1er." ("These paintings were done for His Excellency the Count Stroganoff in 1798 and acquired in 1802 by His Majesty Emperor Alexander I.") This is confirmed by a letter from Stroganov dated 15 August 1802 (Old Style), addressed to Count Guryev, Minister of the Court: "For the two pictures from the painter Robert ordered by me from Paris His Imperial Majesty has deigned to order the issue from the cabinet of six thousand *livres*" (cited in Trubnikov 1913, p.19 note 39). These would seem to be the two works mentioned in a document in which restorer Ivan Gauf requests payment from Stroganov: "Since I have still not been paid for my expenses and for my work, I hereby dare to address you with my humble request, both for the painting by Salvator Rosa, corrected by me, in new frames, and those two works by Robert brought me from your Highness, entrusted to me last summer; which were also transformed by me from the extremely damaged state to which they were reduced by the seawater into their former condition …" (cited in [Petrov] 1864, p. 592). Indeed just two works had arrived in St. Petersburg by sea—the above-mentioned *Entrance into an Ancient Palace* (now *Arch of a Bridge over a Stream*, in the early twentieth century transformed into a *dessus-de-porte* and set into the wall of the foyer of the Hermitage Theatre) and *Ancient Ruins Used as a Public Bath*. These were shown to Alexander I by Count Stroganov in 1802, i.e. not immediately upon their arrival in Russia, since they had had to spend some time in restoration. The paintings acquired by the emperor were immediately hung in his dining room along with two Robert ovals presented to Catherine II by Stroganov.

Gauf's delicate restoration would seem mainly to have involved reinforcing areas of lift in the paint surface resulting from damp, and it did nothing to reduce the artistic merits of the paintings, which

EXHIBITIONS
Paris 1789, Salon, No. 346; Leningrad 1985, No. 36; Valence 1999, No. 20

BIBLIOGRAPHY
[Petrov] 1864, p. 592; Trubnikov 1913, pp. 12, 19 note 39; Réau 1913, p. 299; Réau 1914, p. 178; Ernst 1928, p. 242; Réau 1929, No. 300; Kamenskaia 1939, p. 48; Cat. 1958, p. 337; Cat. 1976, p. 226; Nemilova 1982, No. 294; Nemilova 1985, No. 218; Deriabina 1992, p. 84

E.D.

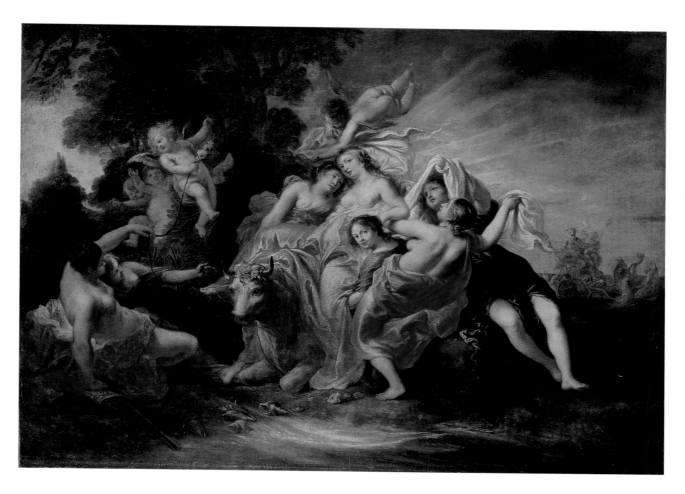

28
The Rape of Europa
Cornelis Schut
(Flemish, 1597–1655)
Early 1640s
Oil on canvas, transferred from
panel
61 × 83.5 cm (24 × 32⅞ in.)
Inv. No. GE 664

PROVENANCE
Presented to Emperor Nicholas I by
Prince Khristofor Lieven (1774–1838)
and given to the Hermitage, 1838

The subject derives from Ovid
(*Metamorphoses*, II, 870–75; VI, 103–7;
Fasti, V, 605–14), who relates how
Zeus, disguised as a tame white bull,
abducted Europa, daughter of
Agenor, King of Sidon (Tyre). This
painting shows the moment before
the abduction, when the princess's
friends innocently help her to climb
upon the bull's back, while the
ominous events to follow are
indicated only by the appearance

(in the far background to right) of
a cavalcade of sea gods headed by
Poseidon and Amphitrite riding a
chariot accompanied by tritons
blowing upon conch shells. This
motif derives from other literary
sources (Moschos' *Europa*, 115–24;
Lucianus' *Sea Conversations*, XV) and
was popular in the Antwerp school,
where it usually referred to the city
of Antwerp itself and its naval trade.
It appears consistently in designs for
the decoration of Antwerp to mark
the triumphal entry into the city of
new rulers of the Spanish Netherlands.

This attractive little "cabinet"
picture, brightly colored and finely
painted, is a mythological work by
Cornelis Schut, a major history
painter of the Antwerp school
working in the first half of the
seventeenth century. Although Schut
mainly produced commissions for
Catholic churches and monasteries,
his paintings on mythological
subjects were also highly prized by
contemporaries.

Of Schut's several known images
of the rape of Europa, all the others
depict the moment more commonly
chosen by artists, that of the
abduction itself, when Zeus (the bull)
carries Europa away across the
waves. It was the more unusual
Hermitage picture, however, that
Schut chose as the basis for his
etching on the subject (F.F.W.
Hollstein: *Dutch and Flemish Etchings,
Engravings and Woodcuts ca. 1450–1700*,
Amsterdam, 1949–[unfinished],
vol. XXVI, 1982, p. 141, No. 110).

The only preparatory work for
this painting currently known is a
drawing by Schut showing the heads
of Europa and six of her friends
(Kunstsammlungen zu Weimar,
Inv. No. KK 5339; first reproduced
in G. Wilmers: *Cornelis Schut
(1597–1655): A Flemish Painter of the
High Baroque*, Brepols, 1996, fig. 12).
In style, the Hermitage painting can
be dated to the early 1640s.

Documents in the Hermitage
Archive establish that the painting

was among objects presented to
Emperor Nicholas I by Adjutant
General Prince Khristofor
Andreevich Lieven (1774–1838), who
served during the last years of his
life as a trustee of the heir to the
throne, Alexander Nikolaevich (the
future Alexander II). Together with
other works from his collection it
was delivered to Peterhof from Italy
on 11 June 1838 (Old Style) aboard
the ship *Provorny* (Expeditious), and
on 24 October (Old Style) was
added to the collection of the
Imperial Hermitage.

The painting was first listed in
Hermitage documents as the work
of Rubens, but in inventories
compiled after 1859 it was given as
"school of Rubens." It was identified
as the work of Cornelis Schut by the
present author (Gritsay 2000).

BIBLIOGRAPHY
Gritsay 2000, pp. 24–26

N.G.

29

Fleet Maneuvers in the Gulf of Eij in Honor of Peter I's Arrival in Amsterdam

Adam Silo
(Dutch, 1674–1757)
1697/98
Oil on canvas
69.5 × 87 cm (27⅜ × 34¼ in.)
Inv. No. GE 8682

PROVENANCE
Transferred from the Catherine Palace in Tsarskoe Selo, near St. Petersburg, 1922

Little study has been made of Adam Silo's life and work. We know that before he took up painting he made pipes for fountains and gold wire, and even worked as a draftsman on the design of ships, in which capacity he was presented to Peter I by the burghermeister of Amsterdam. Peter was visiting Holland with the specific purpose of studying shipbuilding and naval affairs, and he wished to take lessons from an established master of ship design. Silo possibly turned to painting after he made the acquaintance of Peter, in whom the artist saw a potential client.

If that hypothesis is true, then he judged well, for a number of contemporary witnesses record that Peter particularly admired Silo's works for their faithful depiction of a ship's equipment and rigging, and that he commissioned several paintings from the artist during his first stay in Amsterdam.

It is unclear when the painting first arrived in Russia, although we do know that it was at the Catherine Palace, the imperial summer residence at Tsarskoe Selo, south of St. Petersburg, from the second half of the nineteenth century, and that it came to the Hermitage in 1922. It is among Silo's early paintings and was probably executed in 1697 or 1698: it differs from later works in the bright local colors and extreme interest in even the tiniest of details (which is what led to the identification of the subject). Silo scrupulously recorded the specific features of different kinds of ships, their rigging, and the color of their flags (to left on the yacht is the flag of the Dutch West Indies Company, to right the flag of the Amsterdam branch of the East Indies Company). Moreover, he even conveyed the strong wind mentioned in descriptions of the event depicted: the fleet maneuvers in Amsterdam on 1 September 1697 in honor of the first Russian Embassy. All the vessels are shown with their side keel-haulers lowered, to reduce their drift in the strong wind. It is possible that the man standing in the rowboat is Peter I, a suggestion supported by the placing of the figure in the center foreground and by eyewitness reports that "... the spectacle, which was accompanied by the roar of an unbroken cannonade, so appealed to Peter that he could not remain a mere viewer and crossed from his yacht to a military ship and kept redirecting it to move to the areas where the firing was greatest" (cited in Jacobus Scheltema: *Rusland en de Nederlanden*, Amsterdam, 1818).

Silo was probably the first to show these events. Certainly the painting reveals no hint of any knowledge of Carl Allard's print on the subject, made in 1699, or the painting made after it in 1707 by Abraham van Storck, which differs in being more painterly but less precise in the details. This helps confirm the suggested early dating of the painting.

EXHIBITIONS
Lipetsk 2001–02, No. 3.14

BIBLIOGRAPHY
Stroganov 1997, pp. 35–39

S.S.

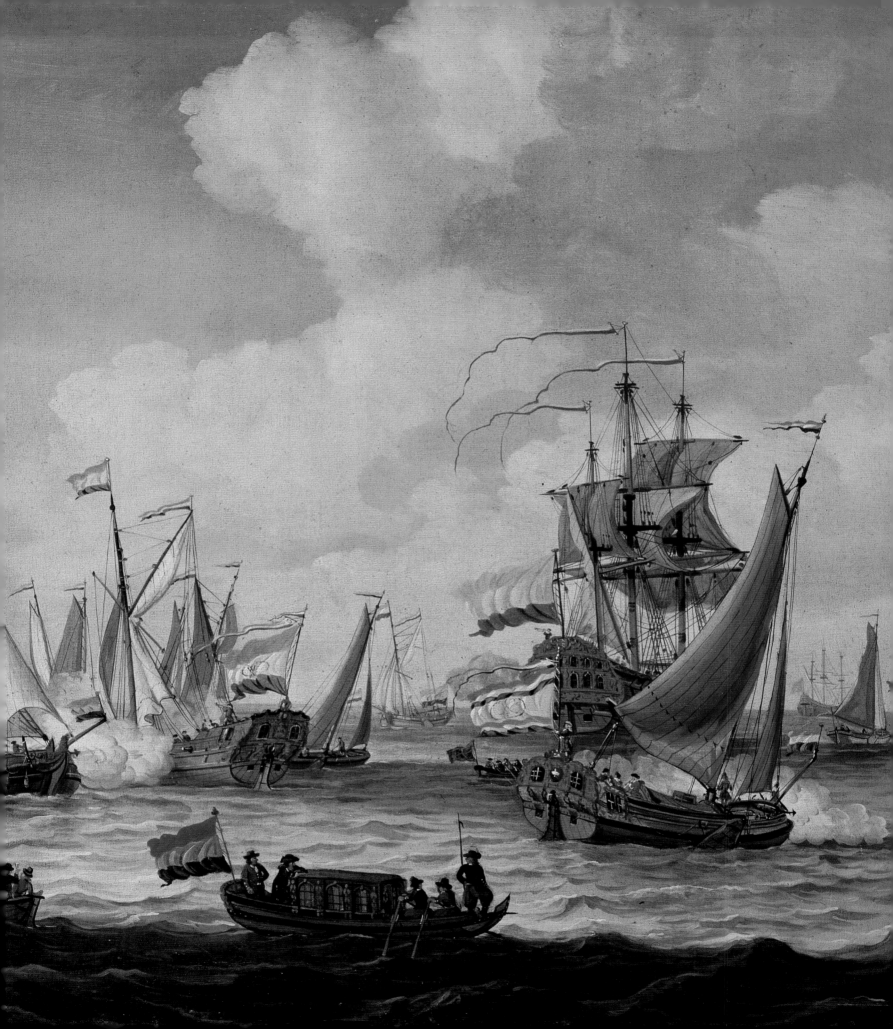

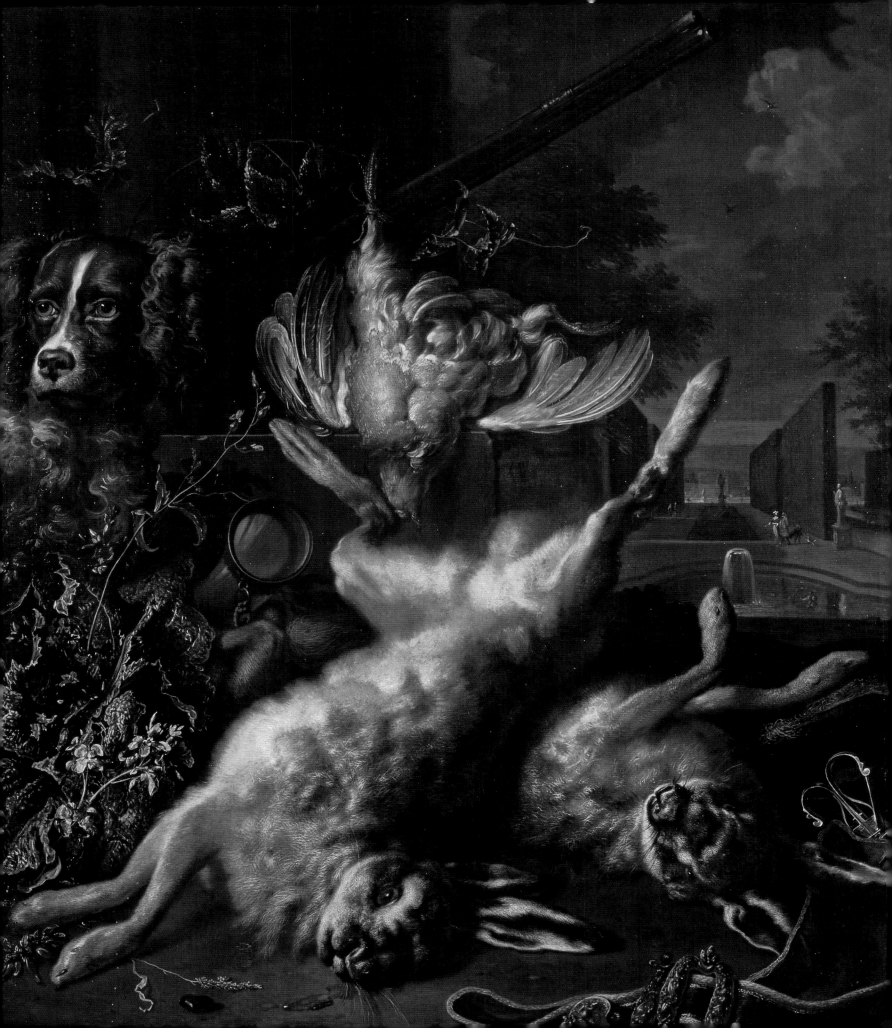

30
Hunting Trophies
Dirk Valkenburg
(Dutch, 1675–1721)
c. 1700
Oil on canvas
100 × 82 cm (39⅜ × 32¼ in.)
Inv. No. GE 2785

PROVENANCE
Acquired as part of the collection
of P.P. Semenov-Tian-Shansky, St.
Petersburg, 1914; belonged to Grand
Duchess Ekaterina Mikhailovna
(1827–94), St. Petersburg, in the
mid-nineteenth century

For many years thought to be the
work of Jan Weenix, the celebrated
Dutch master of hunting still lifes,
this elegant painting in the mid-
nineteenth century was in the
collection of Grand Duchess
Ekaterina Mikhailovna. It was later
given by her, in memory of her
mother Grand Duchess Elena
Pavlovna (1806–73), to the Russian
public figure and collector Petr
Semenov (1827–1914).
　Elena Pavlovna was renowned
for her vehement opposition to the
practice of serfdom (the ownership
of peasants) in Russia. Through a
variety of historical circumstances,
Semenov was actively involved in
drawing up the Manifesto of 1861,
which abolished serfdom, forbidding
the sale and physical punishment of
peasants in the Russian empire.
Imperial and private collecting and
social activism were thus linked by
the gift of this painting. In 1910
Senator Semenov (who in 1906
officially took the name Semenov-
Tian-Shansky) offered to sell his
extensive collection of Dutch
painting to the Imperial Hermitage.
The owner compiled a manuscript
inventory of all his paintings
(Hermitage Archive), setting the
price he would like against each
entry: by *Hunting Trophies* by Jan
Weenix he wrote "not for sale but
to be given to the Hermitage." The
painting was added to paintings
attributed to Jan Weenix (1642–1719).
　The choice of elements and the
color of the Hermitage painting
clearly derive from a specific kind of
composition developed by Weenix,
characterized by a combination of
dead game, hunting equipment, live

animals, and plants. In the
Hermitage painting two dead hares,
a partridge, a hunting belt for a
game-bag, a horn, a gun, and a
spaniel guarding the spoils form a
colorful and dynamic composition,
set against the background of a
formal park with a fountain,
sculptures, and trimmed hedges,
flooded with the pinkish-gold light
of early evening. Such elegant
compositions, markedly influenced
by French taste, enjoyed great
popularity among the Dutch elite
in the late seventeenth and early
eighteenth centuries. Nonetheless,
in the hardness of the treatment of
form (e.g. the hare's fur and the
vegetable motifs), and in the over-
bright light that plays over the
objects, we find evidence to suggest
that this is the work of a master
closely imitating the famous artist

rather than that of Weenix himself.
Fred Meijer of the Netherlands
Institute of Art History at The
Hague (in verbal communication)
was the first to draw attention to a
nineteenth-century lithograph
reproducing the Hermitage
composition and giving the author
as Dirk Valkenburg, Weenix's only
known pupil. Valkenburg mastered
his teacher's style down to the very
smallest detail, with the result that
many of his works have been
attributed to the more famous artist
even in the most recent literature.
The presence of Valkenburg's name
on the nineteenth-century lithograph,
however, provides significant support
for an attribution to the lesser artist,
and we must note that the Hermitage
composition uses the barrel of a
hunting rifle cutting diagonally
across the picture to emphasize the

flatness of the painting, a striking
feature that was a favorite device in
many of Valkenburg's works.
　The lithograph after the
Hermitage painting was produced in
the workshop of Soetens & Fils,
which is known to have existed in
The Hague in the period 1836–40.
The painting was probably in The
Netherlands at this time, and it
would thus have arrived in Russia
at a later date.

BIBLIOGRAPHY
Art Treasures 1901, No. 8, p. 139;
Cat. Semenov 1906, No. 586; Études
1906, p. CLII; Shchavinsky 1909,
p. 32; Shchavinsky 1914, p. 14;
Cat. 1958, vol. 2, p. 153; Cat. 1981,
p. 116; Fekhner 1981, pp. 39, 174,
No. 101

I.S.

31

Diana Resting after the Hunt

Charles-André (Carle) Vanloo

(French, 1705–1765)

1732–33

Oil on canvas

65 × 80.5 cm (25⅝ × 31¾ in.)

Inv. No. GE 1140

PROVENANCE

Transferred from the Gatchina Palace, 1925; at Gatchina Palace, near St. Petersburg, from the nineteenth century; acquired by Catherine the Great, 1783; coll. Comte Baudouin, Paris, until 1783; coll. Louis-Michel Vanloo, nephew of Carle Vanloo, until 1771

Diana, Roman goddess of hunting and mistress of the beasts, daughter of Jupiter and sister of Apollo, the sun god and patron of the arts, is shown just returned from the hunt, surrounded by her nymphs. One of the figures is untying her sandals, another brings a tray of fruits, while a third calms the dogs excited by the hunt. Scattered around is the equipment discarded by the huntress: her cloak and hunting horn, the quiver on its belt.

Suffused with calm, this composition was perfectly suited to the interior for which it was intended, as it was a sketch for the ceiling painting in the bedroom of the Queen of Sardinia in the Stupinigi Castle in Piedmont, built for Vittore Amadeo II of Sardinia. Giuseppe Valeriani was in charge of the decoration of the palace, and he invited Carle Vanloo, then living in Italy, to assist him. Valeriani himself took charge of the state rooms, designing a ceiling painting, *Diana Preparing for the Hunt*, but the bedroom ceiling was the responsibility of Vanloo. In order to maintain a sense of continuity throughout the decorative program, he was forced to adjust his work to accord with that of the Italian master—in *Diana Resting* he gave the goddess a blue cloak and made white deer pull her chariot, fitting his own painting style to that of his colleague—and it is probably this that explains the great difference between this painting and his usual work. Decorative works at Stupinigi continued during 1732–33, to which time this sketch should be dated. An X-ray of the Hermitage sketch shows slight changes in the composition and corrections, probably in the hand of Valeriani.

There is an interesting difference between the sketch and the final version: the light-brown-haired, pretty Diana of the original concept becomes a buxom beauty with an unexpressive face and a fashionable hairstyle. One dominant fact in Vanloo's biography explains the transformation: according to contemporaries, it was in Piedmont that he fell in love with the singer Cristine Somis, who was to become his wife. It was Somis whom he depicted in the ceiling composition for the royal bedroom.

When sold at the auction of Louis-Michel Vanloo, the painting was mistakenly described as the work of Jean-Baptiste Vanloo, although it is possible that the latter helped his brother and pupil by taking part in working up the ceiling composition.

EXHIBITIONS

Ekaterinburg 1995, No. 137, pp. 70–71; Stockholm 1998–99, No. 411

BIBLIOGRAPHY

Cat. 1774, No. 259; Ernst 1935, p. 142; Cat. 1958, p. 266; Nemilova 1973, pp. 72–81; Cat. 1976, p. 189; Rosenberg, Sahut 1977, No. 15; Nemilova 1982, No. 27; Nemilova 1985, No. 265

E.D.

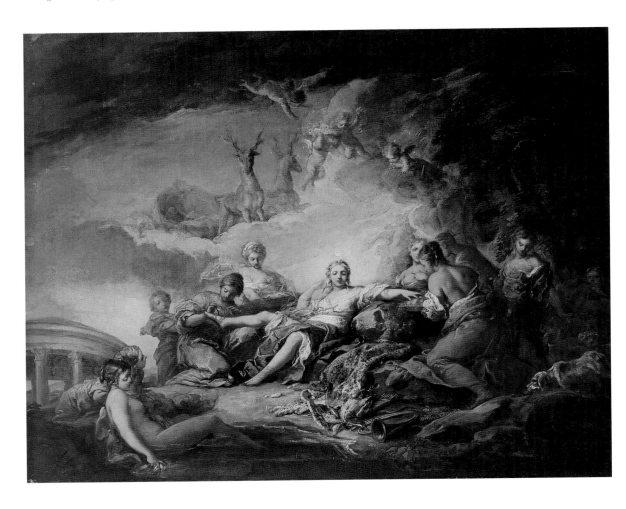

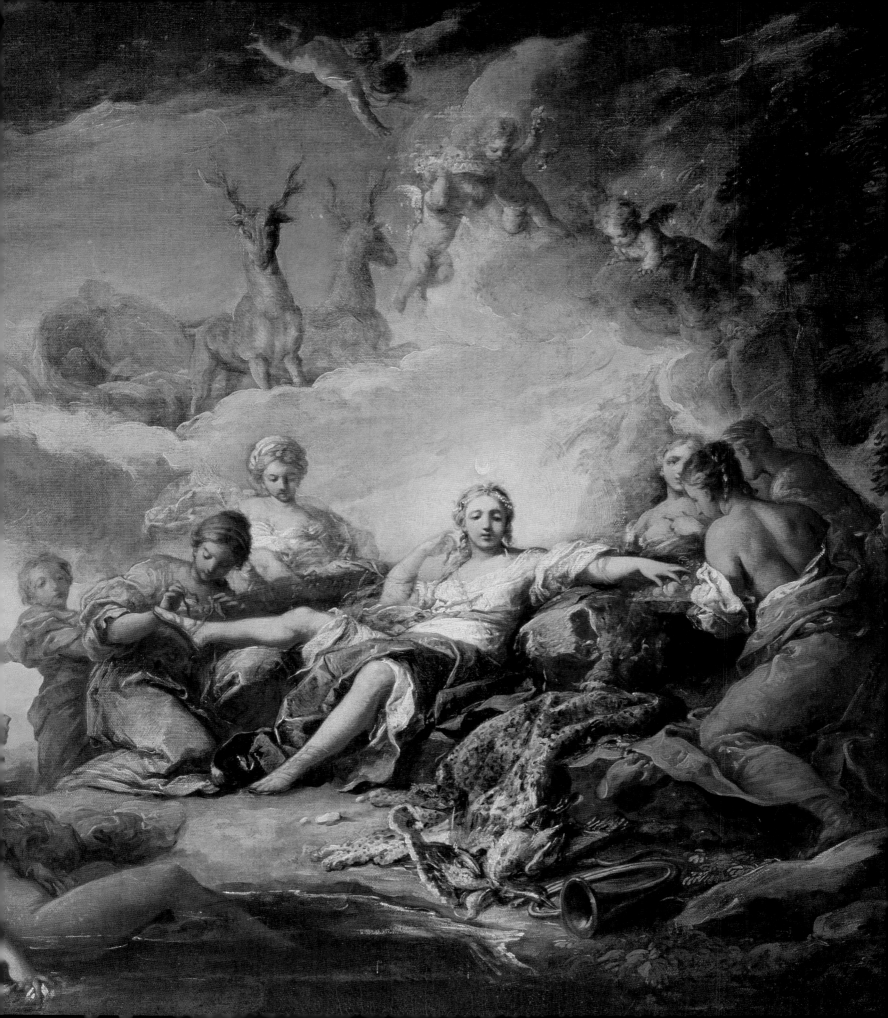

32

The Entrance to the Port of Palermo by Moonlight
Claude-Joseph Vernet
(French, 1714–1789)
1769
Oil on canvas
99.5 × 138 cm (39⅛ × 54⅜ in.)
Signed and dated bottom left:
J. Vernet f. 1769
Inv. No. GE 1764

PROVENANCE
Probably acquired from the dealer
Pirling, St. Petersburg, 1803; until
1791 coll. Boyer de Fonscolomb,
Aix-en-Provence; from 1769 (?) coll.
Longvilliers, Montreuil-sur-Mer.
Painted with its pair, *In the Environs
of Reggio di Calabria*, both of them
being engraved by N. Dufour with a
note that they were in the
Longvilliers collection.

From the start of his rise to fame in
the 1760s, and throughout the reign
of Catherine II, Vernet rapidly
gained popularity among Russian
collectors. Today the museums of
Russia contain around fifty of his
painted works, most of which
arrived during the second half of
the eighteenth century and the
early nineteenth. For the imperial
collections alone some thirty of
Vernet's paintings were acquired
from the 1760s onward, and others
were presented by members of the
imperial family to the St. Petersburg
Academy of Arts. The circumstances
of each acquisition varied: for
instance, we know that Catherine
was offered two works by Vernet by
the celebrated sculptor Étienne-
Maurice Falconet; Alexander I
made purchases from famous
St. Petersburg antiquarians and
from his courtiers; the artist himself
received commissions from the heir
to the throne, the future Paul I, and
from such celebrated Russian
collectors as Prince Nikolai Yusupov

(at the end of the nineteenth century
the Yusupov collection had ten of
Vernet's canvases).

This view of the port of Palermo
and its pair were probably brought
to St. Petersburg in the early
nineteenth century by a Nuremberg
dealer, Pirling, and they were
acquired in 1803 for the Imperial
Hermitage. This information is cited
by Ingersoll-Smouse (1926), although
there is no reference to the
provenance in the Hermitage's own
manuscript inventory begun in 1797.

Vernet's success in Russia can be
explained not only by the artist's
own talent but also by a growing
interest in the sights of Rome and
the countryside around, as well as a
new interest in the "lesser genres."
In his paintings contemporaries were
acquiring "portraits" of Italian towns
and landscapes, genre scenes with
numerous details from everyday life,
and skillful works filled with a
marvelous play of light and shade.

*The Entrance to the Port of Palermo by
Moonlight,* for instance, reveals
Vernet's talent for the effects of
night-time illumination.

EXHIBITIONS
Göteborg 1968, No. 36;
Shizuoka–Tochigi–Okayama–
Kumamoto 1995, No. 24; Niigata
(Nagaoka)–Osaka 1996, No. 7

BIBLIOGRAPHY
Livret 1838, XIX, p. 175, No. 29;
Waagen 1864, p. 310; Lagrange
1864, p. 474; Clément de Ris
1879–80, part V, p. 270; Benois
1912, p. 386; Cat. 1908–16, No.
1550; Ingersoll-Smouse 1926, vol. 2,
No. 904; Réau 1929, No. 383;
Cat. 1958, p. 273; Cat. 1976, p. 191;
Nemilova 1982, No. 74; Nemilova
1985, No. 304; Deriabina 1987, p. 53

E.D.

33
The Death of Virginie
Claude-Joseph Vernet
(French, 1714–1789)
1789
Oil on canvas
87 × 130 cm (34¼ × 51⅛ in.)
Signed and dated bottom left:
Vernet 1789
Inv. No. GE 1759

PROVENANCE
Acquired by Paul I from Girardot
de Marigny, Paris, 1801;
commissioned by de Marigny from
the artist

Many artists were inspired by the
sentimental story *Paul et Virginie* by
the French writer Bernardin de
Saint-Pierre (1737–1814), which
describes the love affair of a noble-
man's daughter and a peasant youth,
their sufferings at Nature's hands,
and Virginie's death on the journey
to her native island. But Vernet's
painting was the first work on the
subject, executed, moreover, under
the direct literary guidance of the

author himself. It also did much to
contribute to the novel's popularity.
 According to contemporaries,
Bernardin de Saint-Pierre first read
his work aloud in the salon of Mme.
Necker, where, despite its success
among the ladies, it was mocked by
his patron, M. Necker. Angered by
the malicious comments, the writer
determined to burn the manuscript,
but Vernet happened to visit him
and stopped him, expressing his
admiration of the story. Most
scholars agree that such a story is
more likely to be mere legend, with
no facts to support it, but it is true
that Vernet was a great admirer of
Paul et Virginie. In a letter to the
author dated 27 January 1789 the
artist notes that he has received
twelve copies of the book and is
sending a sketch for his painting,
although he himself considered it to
have been executed in too much
haste. This was probably a
preparatory work showing a
different episode from that in the
Hermitage painting, since in his
letter of 12 May Vernet writes that

he nonetheless wishes to pick out
the most poignant and interesting
moment in the story, writing further
on 20 May that he has sketched out
the composition on canvas and
begging the author to check if he
has indeed faithfully conveyed the
sense of the subject. Bernardin de
Saint-Pierre saw Virginie's death
during a shipwreck—the event
intended to embody the central idea
in this idyllic story of the loss of an
earthly paradise and humanity's
golden age—as his chief literary
and artistic success.
 This somewhat unexpected
painting by Vernet, famed for
his landscapes and marine views,
marked a new step in the
development of history painting:
Ingersoll-Smouse (1926), leading
scholar of the artist's work,
compared the significance of
this painting with the moralizing
works of Greuze.
 Ingersoll-Smouse notes that
The Death of Virginie was the fifteenth
painting that Vernet produced for
the Marquis de Marigny.

EXHIBITIONS
Paris 1789, Salon, No. 26; Paris
1976–77, No. 61; Paris 1986–87,
No. 328; New York–Chicago 1990,
No. 15; Ibaraki–Mie–Tokyo 1994,
No. 44; Karlsruhe 1996, No. 22

BIBLIOGRAPHY
Dussieux 1856, No. 961; Lagrange
1864, pp. 292–94, 458–59; Clément
de Ris 1879–80, part V, p. 270; Cat.
1908–16, No. 1554; Ingersoll-Smouse
1926, vol. 1, p. 32, vol. 2, No. 1186,
p. 44, fig. 279; Réau 1929, No. 387;
Khay 1939, pp. 981–82; Cat. 1958,
p. 274; Cat. 1976, p. 191; Nemilova
1975, p. 440; Cailleux 1980–81,
No. 41; Nemilova 1982, No. 78;
Nemilova 1985, No. 308; Deriabina
1987, p. 53

E.D.

34
**Portrait of Grand Duchess
Elena Pavlovna as a Child**
Jean-Louis Voille
(French, 1744–after 1804)
1792
Oil on canvas
71 × 56 cm (28 × 22 in.)
Signed and dated right on the
background: *Voille 1792*
Inv. No. GE 1282

PROVENANCE
Transferred from the Romanov
Gallery of the Winter Palace, 1918;
acquired from the artist's studio,
1792

Grand Duchess Elena Pavlovna
(1784–1803) was the second daughter
of Emperor Paul I and Empress
Maria Fedorovna, and favorite
granddaughter of Catherine II.
Catherine wrote of her: "This little
one is of great beauty, and thus I
called her Helen, in honor of the
beauty of Troy, Helen the
Beautiful." We know that Catherine
marked her out from her sisters for
her grace, elegance, and talent; the
Grand Duchess had a particular
talent for the arts and for dancing.
In 1799 the young princess married
Friedrich, heir to the Duke of
Mecklenburg-Strelitz, whose
extremely unsound upbringing was
noted by all, even the girl's mother,
Maria Fedorovna. Elena Pavlovna
died very young, contemporaries
attributing her death to a longing
for her homeland.

Voille spent many years working
in St. Petersburg, and between 1762
and 1795 he depicted members of
the family of Grand Duke Paul, the
heir to the throne, and of the
Stroganov family. Many scholars
have suggested that his painting
manner and style acquired some
"Russian" features over those thirty
years, and indeed we might see
similarities with Russian portrait
painters in the warm intimacy and
softness in conveying facial features.
In 1795 the artist left for Paris,
returning to Russia a little later
to work under Paul I and then
Alexander I, but finally returning
to France in 1803. Although he left
behind numerous works in Russia,
Voille remained almost totally
unknown in his native land.

There is another version of this
portrait by the artist's hand in the
Musée Jacquemart-André in Paris.

EXHIBITIONS
St. Petersburg 1905, No. 462;
Karlsruhe 1996, No. 28

BIBLIOGRAPHY
Réau 1924, p. 151; Réau 1929,
No. 402; Cat. 1958, p. 277; Taneev
1959, p.108; Nemilova 1975, p. 440;
Cat. 1976, p. 195; Nemilova 1982,
No. 104; Nemilova 1985, No. 336

E.D.

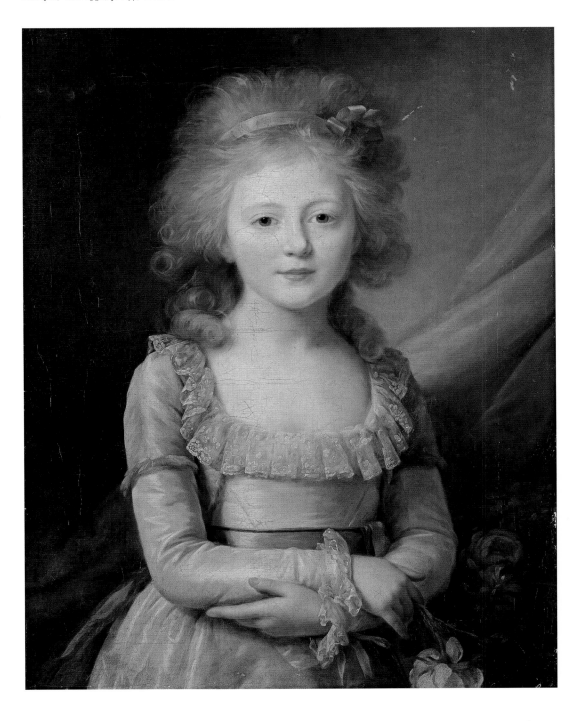

SERGEY ANDROSOV

Sculpture

Although the first member of the Romanov dynasty, Mikhail, was elected to the throne in 1613, the first examples of sculpture in the round did not arrive in Russia until the reign of his grandson Peter I. Reformer of public and political life, Peter the Great made irreversible changes to Russian cultural life. Previously the Orthodox Church had forbidden sculpture owing to its direct connection to popular pagan beliefs among those living in the Russian territory, but Peter the Great was becoming influenced by Western European culture and experience, and began to buy and commission sculptures for his palaces, his gardens, and even for the Orthodox Church. The tsar's enthusiasm for sculpture was unusual for his time, and it is due solely to his interests that St. Petersburg acquired so large and varied a selection of sculptures in such a brief period.

Most of the sculptures Peter I brought to St. Petersburg were placed in the Summer Garden—the tsar's private "back garden" at the Summer Palace. By 1710 the Summer Garden contained nearly thirty marble statues and busts. Contemporaries mention portrait busts of the Polish King Jan Sobieski and his wife, Maria Kazimira, both of which stand in the Summer Garden to this day, and this early collection may also have included three works by the Flemish sculptor Thomas Quellinus, *Minerva*, *Ceres*, and *Flora* (?).

Peter's collecting activities were particularly intense around 1715–16, notably during his travels abroad. It was around this time that he was giving specific orders to Russian diplomatic and trading representatives around Europe to purchase sculpture for his new capital—St. Petersburg.

The tsar's greatest activity was in Italy, where the conditions for purchasing works of art were most favorable. Between 1716 and 1722 the Serbian Count Savva Vladislavich Ragusinski worked in Venice, and regularly purchased works of art on the tsar's behalf. Over the course of six-and-a-half years he sent from Venice to St. Petersburg no fewer than six ships carrying the work of contemporary Venetian masters, including fifty statues and ninety busts. Most of these had been specially commissioned, but Ragusinski seems to have acquired some of them on the Venetian art market. The result of his activities was a unique collection of work by the leading Venetian sculptors of the time.

In 1718 a Russian nobleman named Yury Kologrivov was sent to Rome. He had served as Peter's *denshik*, or batman, and then essentially became his artistic agent. Over two years he acquired some fifty pieces of sculpture in the Eternal City: Antique pieces, works by seventeenth-century masters, and the creations of contemporaries. Among the latter were the striking busts of a *Moor* and a *Mooress* (cat. 36, 37) included in this book.

The most important contemporary sculptural work to arrive in Russia during this time was undoubtedly the *Tauride Venus* (Hermitage Museum), a marble version of the *Medici Venus* that was unearthed in 1719 near Rome and immediately purchased by Kologrivov for a song. The statue was later confiscated by the Roman authorities for being acquired illegally, but after negotiations the *Venus* was returned to its Russian owner—only now as a gift from Pope Clement XI to the Russian tsar.[1] When the statue was transported—with considerable care—to St. Petersburg, Peter the Great placed it in a special gallery by the entrance to the Summer Garden and ordered that an armed guard be placed near it.

Even though not all of Peter's plans for the acquisition of sculpture could be put into effect, he still managed to assemble a rich collection unique for its time. His collection satisfied all his successors' decorating requirements for many years: whenever they needed new statues they simply "borrowed" them from the Summer Garden, moving them to the imperial residences at Tsarskoe Selo or Peterhof.

Although Catherine II did not possess a specific interest in sculpture, she did acquire works of both Antique and contemporary sculpture in accordance with the tastes of the age, and the collection provided an important role to educated Russians living abroad. Ivan Shuvalov, for instance, first President of the Academy of Arts, exiled from Russia by the empress, spent many years in Rome, where he purchased Antique works and

Emil Wolff, *Diana Resting after the Hunt*, detail (see cat. 49)

pieces by contemporary Neo-classical masters that later entered the imperial collection. He also ordered plaster casts of many famous Antique statues for the Academy of Arts. A correspondent of Denis Diderot and other French Enlightenment thinkers, Catherine acquired a series of busts by Jean-Antoine Houdon, among them his celebrated portrait *Voltaire Seated*. Another major French sculptor, Étienne-Maurice Falconet, recommended to the empress by Diderot, even traveled to Russia, where he spent some eleven years working on the equestrian monument to Peter the Great (unveiled 1782) that still stands on the banks of the River Neva and is famous in both art and literature as *The Bronze Horseman*. He was accompanied by his pupil, Marie-Anne Collot, who made a number of busts in St. Petersburg, among them portraits of Catherine II and Falconet. Of vital importance for the Antique collection was the acquisition in 1785 of the collection of John Lyde Browne, a director of the Bank of England, which also brought more modern works, among them Michelangelo's so-called *Crouching Boy*.

It is important to note that Catherine II had no intention of keeping the sculpture she acquired in her "Hermitage": instead she placed it at her favorite country residence south of St. Petersburg, Tsarskoe Selo, in the Grotto or the Morning Hall not far from the Catherine Palace. Most of these works of art, however, found their way back to the city during the reign of Catherine's son Paul I, who placed them in his new residence, the Mikhail Castle. Central to the Hermitage collection was the acquisition of the Farsetti collection in Venice at Paul's specific request.[2] In the middle of the eighteenth century Abbot Filippo Farsetti conceived of an Academy of Arts in Venice for the training of young artists. He commissioned many casts from famous Antique works, which he placed in his palace on the bank of the Grand Canal, and in Rome he acquired a considerable number of clay sketches and models by leading masters of the Roman Baroque, from Alessandro Algardi and Gianlorenzo Bernini to Camillo Rusconi and Pietro Bracci. This unique collection was presented to the Russian emperor as a gift by the last of the Farsettis after negotiations with the tsar's representatives. The collection remained at the Academy of Arts until 1919 when the terracotta sketches and models were transferred to the Hermitage. This book includes works by Bernini (cat. 39) and Algardi (cat. 38), as well as by the notable early-eighteenth-century masters Pierre-Étienne Monnot (cat. 42) and Pierre Le Gros II (cat. 41).

Among those who trained by studying casts in the Farsetti collection was the young Antonio Canova, who later gained worldwide fame himself. One group and three statues by Canova were the sole acquisitions of sculpture by Paul's son Alexander I: purchased in 1815 from the heirs of Josephine de Beauharnais, first wife of Napoleon, they laid the foundation for today's unique collection of works by Canova.

Unlike his elder brother Alexander I, Nicholas I made contributions to all departments of the imperial collection, but most important of his activities was the construction of the New Hermitage, the public museum attached to the imperial residence. The opening of the building in 1852 marked the culmination of years of work sorting and classifying the collections, in which Nicholas himself was closely involved. As a result the New Hermitage was filled with the very best examples of sculpture, both earlier acquisitions (notably the Antique pieces) and contemporary works brought from the Tauride Palace (it was at this time that the *Tauride Venus* arrived in the Hermitage).

Not satisfied with what the imperial collection already contained, Nicholas conceived the idea of creating on the first (i.e. ground) floor special rooms

devoted to contemporary European and Russian sculpture. During a visit to Italy in 1845 the tsar spent much time visiting the studios of sculptors, mainly in Rome and Florence, where he commissioned a number of works, and thus it was that the Hall of Modern Sculpture contained not only statues by Canova, but also pieces by Pietro Tenerani, Luigi Bienaimé, Lorenzo Bartolini, Giovanni Dupré, and by foreigners working in Rome—Emil Wolff and Heinrich Imhoff. Works by Russian graduates of the Academy of Arts, purchased or commissioned in Rome, also permitted the creation of a Russian Sculpture Room in the New Hermitage, although in the late nineteenth century these works were nearly all transferred to the newly created Russian Museum. Nicholas also purchased or ordered statues and portrait busts by leading sculptors in Germany (Christian Daniel Rauch, Carl Friedrich Wichmann, and Ludwig Wichmann).

Nicholas's active interest in sculpture affected other members of his family. A number of works were acquired

in Italy by his sons, Grand Dukes Mikhail and Nikolai (some of these came to the Hermitage after the Revolution in 1917), while his daughter, Grand Duchess Maria Nikolaevna, who spent many years in Italy, began to collect Italian Renaissance sculpture; her collection, too, partly entered the Hermitage over time.

The family interest in sculpture was shared by Alexander II, Nicholas's son. Even while he was still heir to the throne, a visit to Italy in 1839, on which he was accompanied by his tutor, the poet Vasily Zhukovsky, resulted in the acquisition of sculpture in the studios of Bertel Thorvaldsen, Pietro Tenerani, Luigi Bienaimé, and Emil Wolff. Of vital importance to the Antique collection of the Hermitage was the purchase of a large collection of sculptures from the Marchese Campana in 1861. Paradoxically, it was this that led to the closure of Nicholas's Hall of Modern Sculpture on the first floor: to make room for the Antique works, the statues and groups had to be moved up to the second floor, where they are located today.

Alexander II was the last emperor to make extensive acquisitions of sculpture, and after his death only the odd purchase was made for the imperial residences. The fact that a number of important works were added to the Hermitage owes more to the generosity of private collectors than to any initiative on the part of the Romanovs.

To sum up nearly two hundred years of collecting of sculpture by the Romanovs, it must be noted that the family most often acquired works by contemporary masters, and these pieces were generally produced on commission. From the time of Peter the Great, however, members of the imperial family also demonstrated an interest in Antique sculpture. While Peter the Great's interest can be explained as the admiring enthusiasm of a man who had discovered the joy of sculpture for himself, the activities of Paul I, Nicholas I, and Alexander II were such that a sincere and profound interest in sculpture was for them essentially a matter of family tradition.

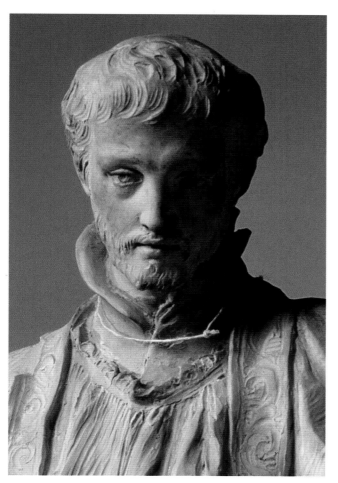

Pierre Le Gros, *St. Francis Xavier*, detail (see cat. 41)

Notes

1 Detailed information on this fascinating story is published in S. Androsov, "Istoriia Venery Tauricheskoi" (The Story of the Tauride Venus), in *Ital'anskaia skul'ptura v sobranii Petra Velikogo* (Italian Sculpture in the Collection of Peter the Great), St. Petersburg 1999, pp. 92–106.
2 S. Androsov, "The Farsetti Collection in Italy and Russia," in *From the Sculptor's Hand. Italian Baroque Terracottas from the State Hermitage Museum*, exhib. cat., Art Institute of Chicago; Philadelphia Museum of Art; National Gallery, Washington; Chicago 1998, pp. 2–13.

35
St. Theresa (?)
Anonymous Roman master
Late seventeenth or early
eighteenth century
Marble
Height 29 cm (11⅜ in.),
length 71 cm (28 in.)
Inv. No. N. sk. 879

PROVENANCE
Transferred to the Hermitage from
the Tauride Palace, St. Petersburg,
after 1859; moved to the Tauride
Palace from the Summer Garden in
the late eighteenth century; acquired
for Peter I in Venice, 1717.

Archive documents allow us to trace
the history of this marble statuette of
a reclining nun in some detail.
The list of sculptures acquired by
Savva Ragusinski in Venice and
sent to Russia in April 1717 includes
"1 statue of St. Theresa," valued at
twenty gold ducats. According to
inventories compiled in 1728, 1736,
and 1771 it stood in the Grotto of
the Summer Garden, on the bank
of the River Fontanka. In 1738
documents record an act of
vandalism in which a scribe, Nikita
Sedelnikov, entered the Grotto and
threw the statue to the ground. As
a result it sustained damage to the
head, nose, and left knee.
Restoration was carried out by the
apprentice Ivan Safonov (traces of
his work can still be seen today), and
the cost of the work was charged to
Sedelnikov. In the late eighteenth
century St. Theresa was moved to the
Tauride Palace, where it remained
until 1859; at some time after this it
was transferred to the Hermitage.

In eighteenth-century documents
the statue is variously described as
showing St. Theresa and St. Clare,
although it was entered in the
Hermitage inventory as St. Rosa of
Lima. It seems more correct to the
present author, however, to return
to the earlier identification as
St. Theresa.

We know that Ragusinski
acquired the sculpture in Venice,
but this piece relates rather to the
Roman school, deriving from such
monumental statues as St. Rosa of
Lima by Melchiore Caffa (Lima
Cathedral) or The Blessed Ludovica
Albertoni by Gianlorenzo Bernini
(San Francesco a Ripa, Rome). It
seems possible, therefore, that the
author was a Roman sculptor
working at the turn of the
seventeenth and eighteenth
centuries.

EXHIBITIONS
St. Petersburg 1996a, p. 113,
No. 128; Amsterdam 1996, p. 248,
No. 222

BIBLIOGRAPHY
Androsov 1984, p. 69; Androsov
1999a, p. 34; Androsov 2000, p. 11

S.A.

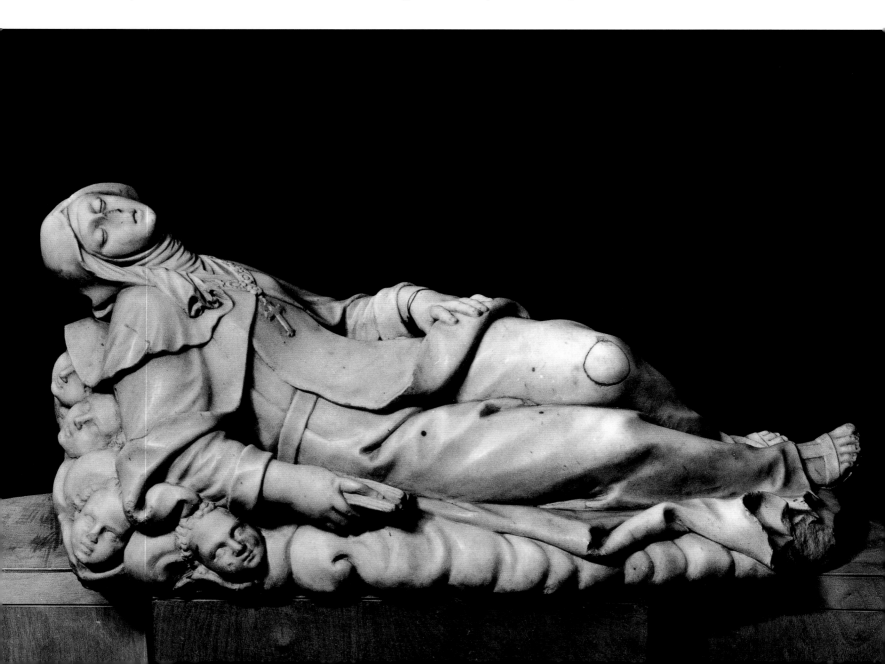

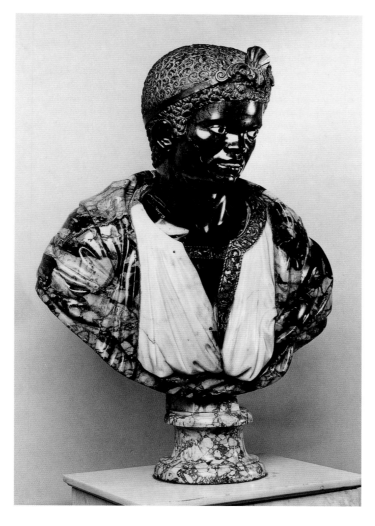

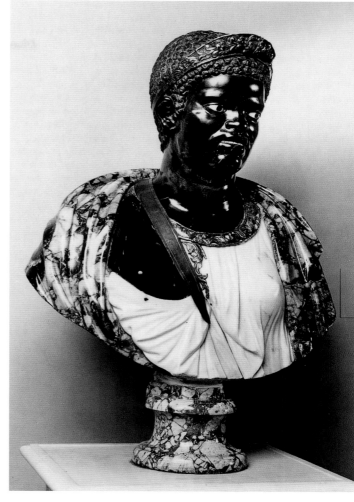

36
Moor
Anonymous Roman master
Late seventeenth century
Colored marble, gilded bronze
Height 82 cm (32¼ in.)
Inv. No. N. sk. 756

37
Mooress
Anonymous Roman master
Late seventeenth century
Colored marble, gilded bronze
Height 80 cm (31½ in.)
Inv. No. N. sk. 757

PROVENANCE
Transferred to the Hermitage from
the Tauride Palace, St. Petersburg,
after 1859; Summer Garden,
St. Petersburg; acquired for Peter I,
1718

Both busts were among a series of
four images of Moors acquired in
Rome in 1718 by Yury Kologrivov.
The list of works he sent from there
mentions "four busts of Arabs,"
although "two heads of Arabs in
paragone" might also refer to them.
In the eighteenth century they
stood in the Grotto in the Summer
Garden and were then transferred
to the Tauride Palace, where they
remained until 1859, after which
they were transferred to the
Hermitage.

When the origin of these busts
in Peter's collection was established,
the present author sought to
attribute them to a master of the
Venetian school, since the majority
of the statues and busts sent to
St. Petersburg were acquired in
Venice. Later, however, A.G.
Kaminskaia published documents

recording their acquisition by
Kologrivov in Rome, indicating that
they were more likely produced
there. Indeed, the tradition of
creating busts and statues in
different colored marble and using
bronze details derives from the
work of sculptor Nicolas Cordier
(1567–1612), who used a similar
technique (e.g. the so-called *Borghese
Moor*, Louvre, Paris; statue of a
Moorish woman known as *La
Zingarella*, Galleria Borghese, Rome).
If this is the case, the busts were
probably produced in the late
seventeenth rather than the early
eighteenth century. Peter's collection
included a number of similarly
colorful works, indicating that he
had a marked taste for such items.

BIBLIOGRAPHY
Androsov 1981, p. 50; Kaminskaia
1984, pp. 143, 148; Androsov 1999a,
p. 89

S.A.

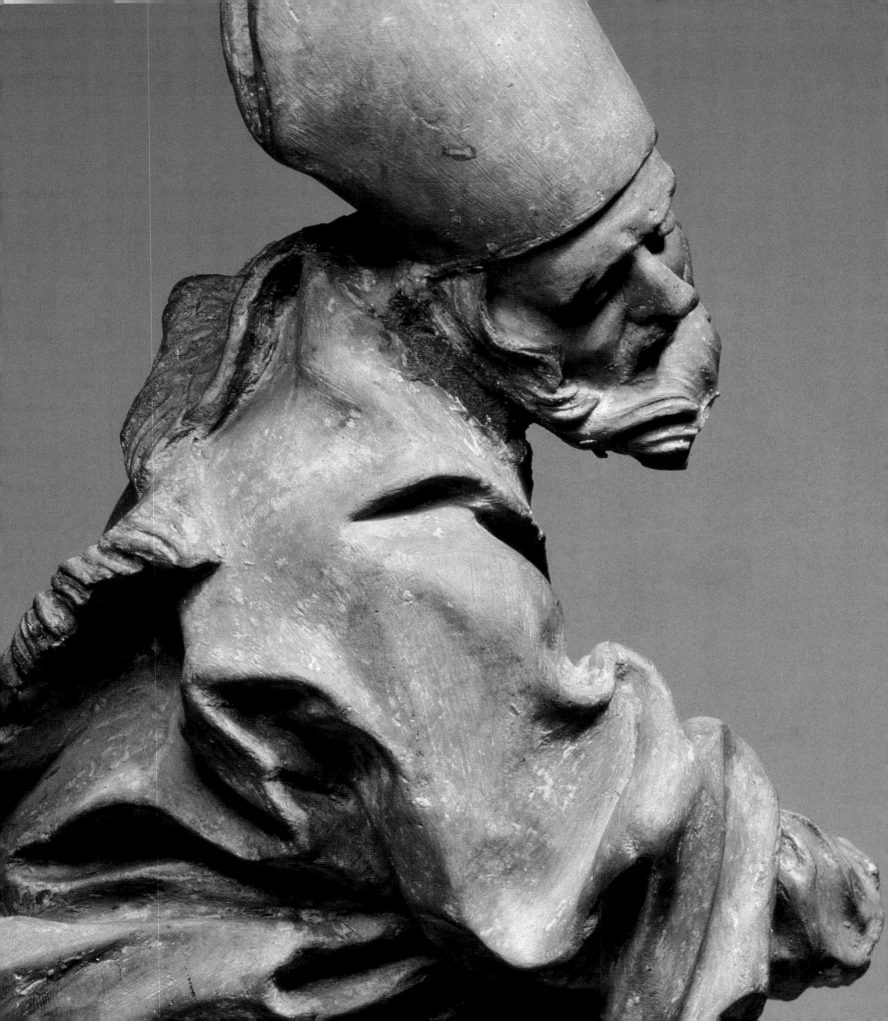

39
St. Ambrose
Gianlorenzo Bernini
(Roman, 1598–1680)
Before 1663
Terracotta
Height 46 cm (18⅛ in.)
Inv. No. N. sk. 624

PROVENANCE
Transferred to the Hermitage from
the Museum of the Academy of
Arts, Petrograd (St. Petersburg),
1991; acquired by Paul I as part
of the collection of Filippo Farsetti
and given to the Museum of the
Academy of Arts, 1799; Farsetti
collection, Venice

This statuette is mentioned in the
catalogue of the Farsetti collection
(Museo della Casa [1788]) as one of
"i tre Dottori vestiti da Vescovo, con
libro in mano, in S. Pietro in
Roma" ("three doctors in episcopal
attire, with books in their hands, in
the Cathedral of St. Peter in
Rome"). Georg Trey saw all three
terracottas as copies after Bernini,
but the statuette was entered in the
Hermitage inventory as by Bernini
himself, and reproduced with this
attribution in an album of 1970.

The work is indeed very
similar to the monumental bronze
statue of St. Ambrose that adorns
the Cathedra Petri, or Throne of

St. Peter, in Rome, on which
Bernini worked for ten years, from
1657 to 1666. Assistants were actively
involved in the making of the
Cathedra. Among those who worked
on the figures of Fathers of the
Church were Ercole Ferrata,
Antonio Raggi, and Lazzaro
Morelli, who, in March 1657,
received money for models of four
saints. The statue of St. Ambrose,
which stands to left, was cast before
early 1663.

On the basis of the high quality
of its execution, the Hermitage
terracotta can perhaps be attributed
to Bernini himself: as the master
with overall responsibility for the
work, he may well have assumed the
responsibility of producing models
for the main figures. J. O'Grody
recently undertook an in-depth study
of another model for the statue of
St. Ambrose acquired by the
Harvard University Art Museums.
He insists on Bernini's authorship
for the very damaged Harvard
statue, throwing doubt on the
attribution of the Hermitage piece,
in which he sees features of a studio
copy made after production of the
monumental statue (O'Grody 1999).
Such an opinion does not seem
convincing, however, and the deep,
sharp drapery folds point, in this
author's opinion, to the individual
manner of Bernini himself.

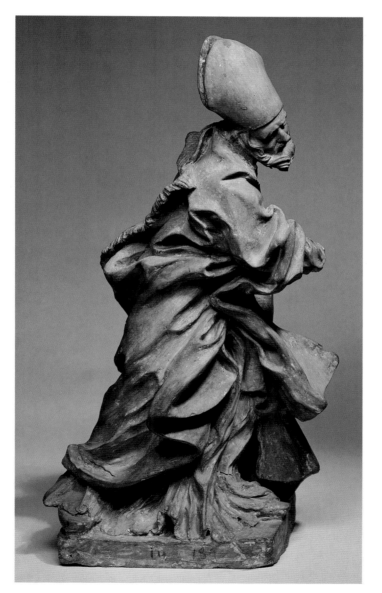

EXHIBITIONS
Leningrad 1989, p. 18, No. 19;
Rome–Venice 1991–92, p. 62,
No. 18; Chicago–Philadelphia–
Washington 1998–99, p. 72, No. 15;
St. Petersburg 1999a, p. 12, No. 3;
Bonn 2002–03, p. 316, No. 232

BIBLIOGRAPHY
Petrov 1864, p. 600; Trey 1871,
p. 50, No. 708, 710 or 711;
Zaretskaia, Kosareva 1970, No. 40;
O'Grody 1999, p. 135

S.A.

40

Portrait of Nicholas I
Luigi Bienaimé
(Italian, 1795–1879)
1846
Marble
Height 92 cm (36¼ in.)
Signed and dated on the back of the
bust: *L.Bienaime f. Roma 1846*
Inv. No. sk. 1363

PROVENANCE
Transferred to the Hermitage from
the State Russian Museum,
Leningrad, 1925; in the collection of
Grand Duke Nikolai Nikolaevich the
Elder, 1831–91

This portrait of Nicholas resulted
directly from the Russian emperor's
visit to Rome in December 1845,
during which he commissioned from
Bienaimé four statues for the New
Hermitage (it should be noted that
other masters were considered
worthy of no more than one or two
pieces). As a mark of his gratitude
for such attention, Bienaimé
conceived the idea of producing a
bust of Nicholas, and he completed
a plaster portrait just two months
after the sovereign's departure. The
sculptor had hoped to present it to
Nicholas's wife, Empress Alexandra
Fedorovna, who was due to arrive in
Rome from Palermo in February
1846, but the empress cancelled her
visit and Bienaimé therefore decided
to produce the marble bust at his
own expense, hoping to be granted
in time the opportunity to present it
personally. In the autumn of 1846
the sculptor addressed a request to
the Russian Mission in Rome to be
permitted to present the work to
Alexandra Fedorovna. Through the
efforts of the Russian diplomat A.P.
Butenev, the empress agreed to
accept the bust, ordering that the
sculptor be sent a diamond ring
valued at 800 silver rubles.

Bienaimé based his work initially
on his own personal impressions,
gained during his meeting with
Nicholas in December 1845, but these
were clearly insufficient for a portrait,
and the master was forced to make
use of an existing lithographed
portrait and a bust by the German
sculptor Christian Rauch. While he
repeated Rauch's sharp turn of the
head toward the left shoulder,

Bienaimé produced a considerably
more imposing portrait, presenting
the tsar wearing Roman armor and
a cloak, with a wreath of laurels upon
his head. It was this laurel wreath,
however, that aroused the empress's
distaste: she knew well her husband's
dislike of such pompous features.
She therefore gave orders that the
Russian sculptor Ivan Vitali remove
the laurel wreath, after which the
bust was sent in her name as a gift to
the St. Petersburg Academy of Arts,
where it remains today.

From the very start Bienaimé's
portrait of Nicholas drew much
attention, and it was repeated in
marble on several occasions by
Bienaimé himself. We know that a
similar bust belonged to Butenev
himself, who in 1864 sold it to the
state, after which it was presented
by order of Alexander II to the
Moscow Public Museum (present
location unknown). Another
example, formerly in the Shuvalov
collection in St. Petersburg, is today
in the State Russian Museum in
St. Petersburg. The example
included here was formerly in the
possession of Nicholas I's son Grand
Duke Nikolai Nikolaevich the Elder.

EXHIBITIONS
Massa-Carrara 1996, p.169, No. 26;
St. Petersburg 2002, pp. 126–27

BIBLIOGRAPHY
Karcheva 1996, pp. 77–79

E.K.

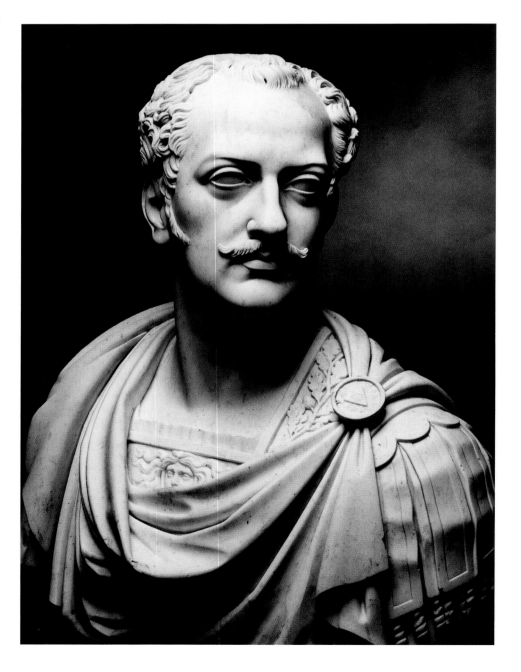

41

St. Francis Xavier
Pierre Le Gros II
(French, 1666–1719)
1701–02
Terracotta
Height 58 cm (22⅞ in.)
Inv. No. N. sk. 632

PROVENANCE
Transferred to the Hermitage from the Museum of the Academy of Arts, Petrograd (St. Petersburg), 1919; acquired by Paul I as part of the collection of Filippo Farsetti and given to the Museum of the Academy of Arts, 1799; Farsetti collection, Venice.

Arriving in Rome around 1690, Pierre Le Gros remained there for the rest of his life, occupying an honored placed among sculptors and producing important works such as the tomb of Pope Gregory XV for the church of Sant'Ignazio, statues of the apostles Thomas and Bartholomew for the church of San Giovanni in Laterano, and his celebrated group *The Triumph of Religion over Heresy* in the Gesù. It could be said that the Baroque style in sculpture reached its height in the works of Le Gros.

In the 1788 catalogue of the Farsetti collection this statuette can be identified only with *St. Caetano* by Carlo Monaldi, although in fact it shows no resemblance whatsoever to the sculptures by Monaldi in St. Peter's. On the contrary, the terracotta reveals undoubted similarities with a marble statue of St. Francis Xavier by Le Gros (Sant'Apollinare, Rome), the poses of the two figures being almost identical (albeit reversed), with similar treatment of the robes, including the folds and the lace on the sleeves. The expressive faces in both works are also very close. This author's suggested attribution has been accepted by F. Souchal, G. Bissel, and O. Ferrari and S. Papaldo.

Le Gros represented the saint holding a crucifix in his hands and with a large crab by his feet, attributes that reflect a key episode in the life of St. Francis Xavier. The ship on which the saint was sailing to the West Indies was wrecked in a terrible storm, during which, by a miracle, the saint was saved and tossed up on to the shore, but the crucifix that he had been carrying, a gift to him from St. Ignatius, seemed to be lost for ever. Great was Francis's surprise when a gigantic crab crawled out of the sea, holding in its claws his priceless crucifix.

Le Gros concluded the contract for a figure of St. Francis Xavier after October 1701, receiving the first payment on 7 June 1702, and he seems to have completed the monumental statue that same year. The Hermitage statuette should thus probably be dated to late 1701 or early 1702. Another terracotta of smaller dimensions, also thought to be a sketch by Le Gros for the same statue, is in the Museo di Roma.

EXHIBITIONS
Leningrad 1989, p. 29, No. 40; Rome–Venice 1991–92, p. 98, No. 43; Chicago–Philadelphia–Washington 1998–99, p. 110, No. 34; St. Petersburg 1999a, p. 20, No. 7; Massa 2000, p. 98, No. 2

BIBLIOGRAPHY
Museo della Casa [1788], p. 23; Petrov 1864, p. 600; Trey 1871, p. 51, No. 716; Souchal 1993, p. 145; Bissel 1997, p. 64; Ferrari, Papaldo 1999, p. 48

S.A.

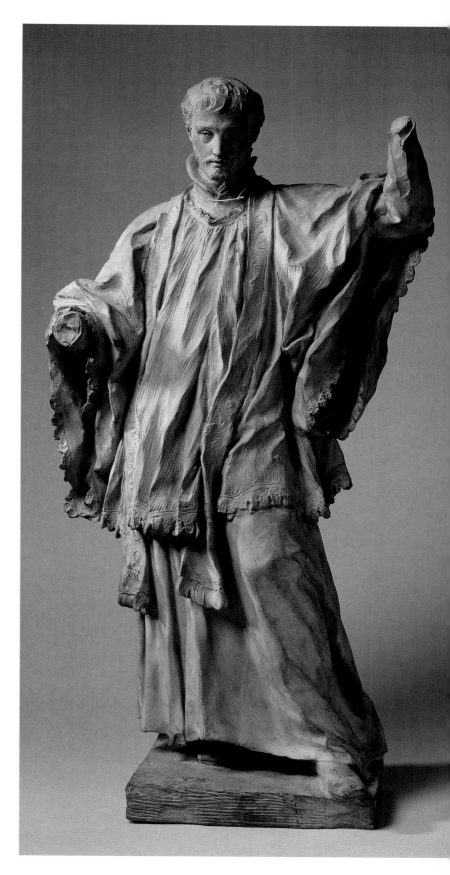

42
Cybele
Pierre-Étienne Monnot
(French, 1657–1733)
Second half of the 1690s
Terracotta
Height 58 cm (22⁷⁄₈ in.)
Inv. No. N. sk. 645

PROVENANCE
Transferred to the Hermitage from
the Museum of the Academy of
Arts, Petrograd (St. Petersburg),
1919; acquired by Paul I as part
of the collection of Filippo Farsetti
and given to the Museum of the
Academy of Arts, 1799; Farsetti
collection, Venice

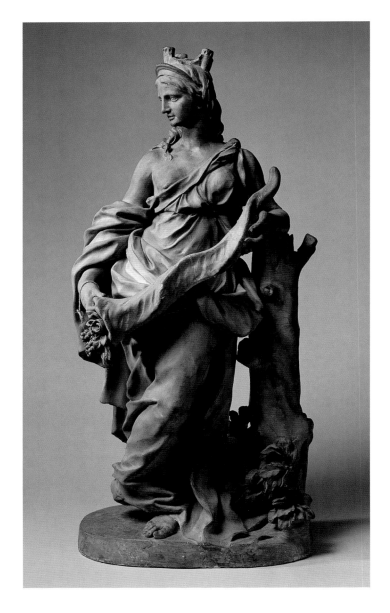

A cornucopia and a crown of city
walls are the attributes of allegories
of Earth, and this sculpture was
identified in the seventeenth and
eighteenth centuries as representing
the goddess Cybele. The very
subject of this work suggested its
attribution, for in the catalogue of
the Farsetti collection (Museo della
Casa [1788]), under the section
"Modelli originali di Figurine di
Creta Cotta di tutto rilieva," we find
the entry *Cibele di Mr. Manot*. There
can be no doubt that "Manot"
should be read as indicating the
celebrated sculptor of French origin
Pierre-Étienne Monnot, who spent
nearly the whole of his creative life
in Rome and whose work fits neatly
into the context of early-eighteenth-
century Italian sculpture. It was in
Rome that he produced important
commissions such as the tomb of
Pope Innocent XI in St. Peter's and
a statue of St. Paul in San Giovanni
in Laterano.

This statuette reveals similarities
to female images on reliefs that
Monnot made for the Church of
Santa Maria della Vittoria in Rome,
The Adoration of the Magi and *The
Flight into Egypt*, dated *c.* 1695–98.
In subject, *Cybele* is close to statues
from the Marmorbad complex in
Kassel, one of Monnot's key works.
Commissioned by Karl, Elector of
Kassel, this was begun in the 1690s,
the first statues (of *Bacchus with a
Faun* and *Leda and the Swan*) dating
from 1692, although the last statues
at Marmorbad date from the 1720s.
While none of the Kassel statues
shows Cybele, the subject of the
Hermitage terracotta and its manner
of execution are fully in keeping
with the complex. The present
author therefore suggests Monnot
as the author of this work, giving
it a date in the second half of the
1690s. S. Walker, while accepting
the suggested authorship, places it
in the first decade of the eighteenth
century.

EXHIBITIONS
Leningrad 1989, p. 35, No. 51;
Rome–Venice 1991–92, p. 112,
No. 54; Chicago–Philadelphia–
Washington 1998–99, p. 104, No. 31;
St. Petersburg 1999a, p. 19, No. 6;
Massa 2000, p. 96, No. 1

BIBLIOGRAPHY
Museo della Casa [1788], p. 23;
Petrov 1864, p. 600; Trey 1871,
p. 52, No. 729; Walker 1995, p. 104

S.A.

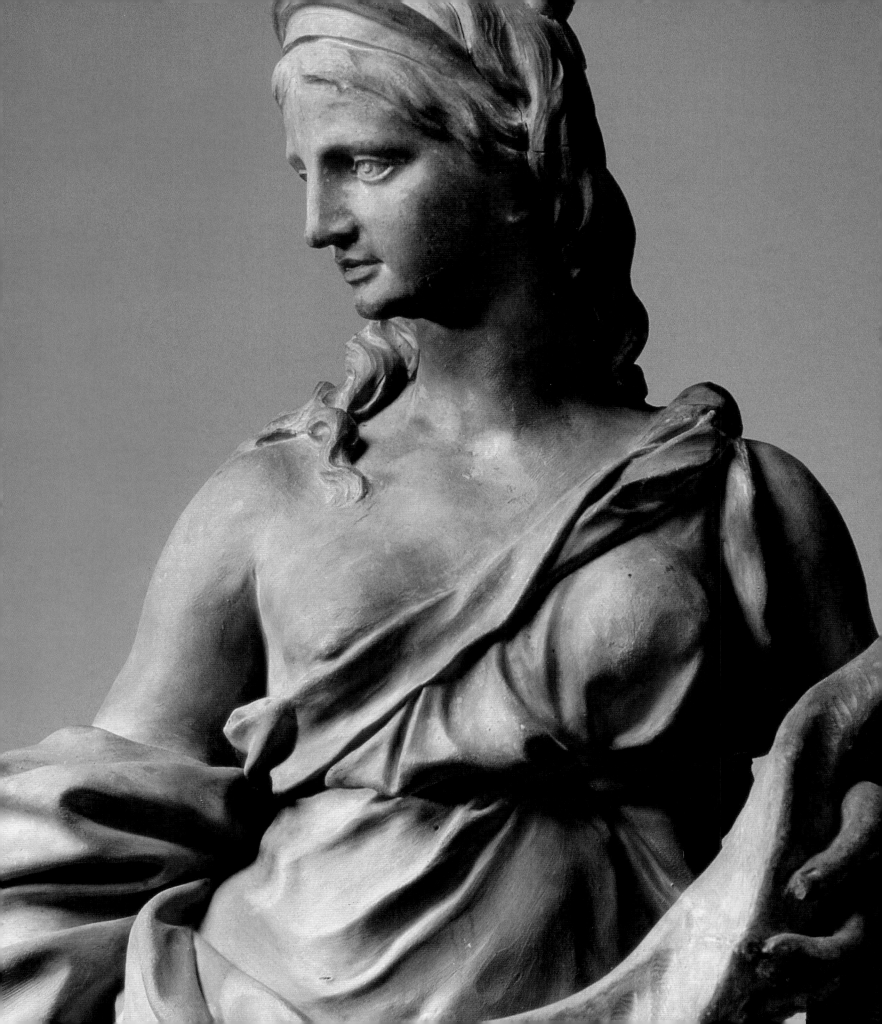

43
Portrait of Charles James Fox
Joseph Nollekens
(British, 1737–1823)
1791
Marble
Height 56 cm (22 in.)
Signed and dated on the back of
the bust: *Nollekens F.t London 1791*
Inv. No. sk. 13

PROVENANCE
Transferred to the Hermitage from
the Tauride Palace in the late 1840s;
moved to the Tauride Palace no
later than 1803; moved to the
Mikhail Castle 1797; placed in the
Grotto at Catherine's favorite
summer residence at Tsarskoe Selo,
near St. Petersburg; acquired by
Catherine II for her Hermitage 1791

Charles James Fox (1749–1806) was
a British statesman and celebrated
orator, a Whig Member of
Parliament, and later the leader
of the Whig Party.

 Catherine the Great's interest in
Fox began in the early 1790s as a
result of the Russo-Turkish war:
Russia had seized lands between the
rivers Dnestr and Danube as well as
the Ochakov Fortress, an important
strategic site. Britain and Prussia,
disturbed by Russia's successes,
demanded that all these lands be
returned to Turkey, threatening
to attack in the event of non-
compliance. The British fleet was
already waiting in the Baltic Sea,
but a speech in Parliament by Fox
convinced the government to reject
so risky a step, which would have
had many consequences for Britain.
 Seeking a discreet way of
marking her gratitude to Fox for
his "accidental" favor to Russia,
Catherine ordered that a portrait
of the orator be acquired in London
for her private Hermitage. By the
summer of 1791 Nollekens had
finished a marble bust of Fox
intended for Earl Fitzwilliam.
Learning of the empress's desire
to own such a portrait, the Earl
deferred his claims to this first
version, which was instead delivered
to St. Petersburg in September 1791.
It was initially placed in the
Hermitage and then moved to
Tsarskoe Selo, where it stood in
the Grotto. Soon after the marble's

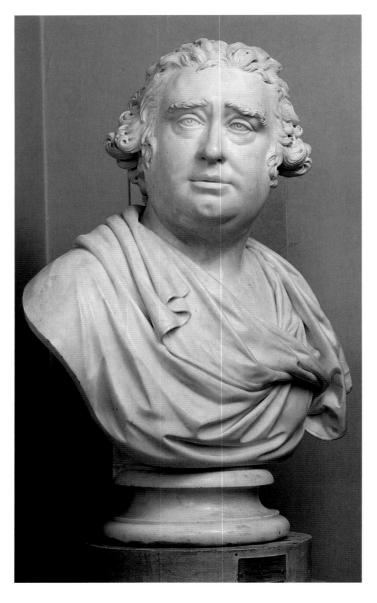

arrival, Catherine ordered that
a bronze copy of the portrait be
made to set among her busts of
outstanding philosophers and figures
from Antiquity in the colonnade of
the Cameron Gallery at Tsarskoe
Selo, from where it was removed
when the empress's enthusiasm for
the British politician waned in the
wake of his support for the French
Revolution.
 In 1797 the marble bust of Fox
was moved to the Mikhail Fortress
in St. Petersburg, but by 1803 it was
on show in the Antique Hall of the
Tauride Palace. At the turn of the
1840s and 1850s, when the New
Hermitage was nearing completion,

the portrait of Fox and other works
of art were moved from the Tauride
Palace to the new Imperial Museum
by order of Nicholas I. A watercolor
of 1855 by the Russian artist
Konstantin Ukhtomsky shows it
standing in a room in the library
of the New Hermitage (see p. 25).
 The history of Catherine II's
acquisition of the portrait of Fox
was reflected in numerous English
caricatures in the early 1790s. The
bust itself was very popular, and
Nollekens repeated it in marble on
a number of occasions; there is, for
instance, a similar portrait in the
Yale University Art Gallery.

EXHIBITIONS
New Haven–Toledo–St. Louis
1996–97, p. 226, No. 54;
St. Petersburg 1998b, p. 226, No. 54;
London 2000–01, p. 132, No. 213

BIBLIOGRAPHY
Gille 1860, pp. 111–12 (Russian edn.
1861, p. 126); Khrapovitsky 1901,
p. 218; Troinitsky 1923, pp. 92–94;
Ettinger 1924, p. 88; Smith 1929,
p. 313; Zaretskaia, Kosareva 1960,
No. 74; Zaretskaia, Kosareva 1970,
No. 91; English Art 1979, No. 135;
Treasure Houses 1985, p. 539,
No. 476; Christie's, London,
6 December 1988, No. 135;
Androsov 1999b, p. 60; Karcheva
2002, p. 5

E.K.

44

Psyche Swooning
Pietro Tenerani
(Italian, 1789–1869)
1830s
Marble
Height 112 cm (44 in.)
Signed on the rock to right:
P ro TENERANI
Inv. No. N. sk. 91

PROVENANCE
Presented to Emperor Nicholas I by
Prince Khristofor Lieven and given
to the Hermitage, 1838

Pietro Tenerani is justly considered
to be the most important Italian
sculptor of the generation after
Canova and Thorvaldsen. Born in
Torano, near Carrara, as a youth
Tenerani mastered the virtuoso
working of marble before moving
to Rome, where he worked with
Thorvaldsen for some time. In 1817
the statue *Psyche Abandoned* brought
him European fame.

No less famous was *Psyche
Swooning*, the first version of which
Tenerani produced in 1822 for
Count Gian Battista Sommariva.
Here the sculptor found a pose
that—without breaking any of the
rules of sculpture—captured the
transition from movement to
lifelessness as the girl drops senseless
to the ground. At the same time
the somewhat sentimental aspect
of this image of Psyche reveals the
influence of Canova. As we see from
the four *bozzetti* which remained in
the sculptor's studio, Tenerani did
not immediately find the pose he
sought, working intensely on
different variations before he arrived
at the final resolution.

Tenerani's biographers mention
between seven (Campori) and twelve
(Raggi) marble replicas of Psyche,
although the present location of
most of these is currently unknown.
In the Galleria Nazionale d'Arte
Moderna in Rome is just one such
version in marble, while the master's
original plaster, from which the
marble copies would have been
made, is in the Tenerani Gipsoteca
in the Galleria Communale d'Arte
Moderna, Rome.

Both Campori and Raggi
mention the version of the statue
that Tenerani made for Prince
Khristofor Lieven (1774–1838), at
various times Russian ambassador to
Berlin and London. During the last
years of his life he served Grand
Duke Alexander Nikolaevich, the
heir to the throne and future
Alexander II, dying during
Alexander's visit to Rome in
December 1838. Shortly before his
death Lieven had presented his
collection of works of art, put
together during his many years
abroad, to Nicholas I, and that same
year the works were shipped to
St. Petersburg (see also Schut,
cat. 29). Nicholas personally looked
them over and ordered that two
statues, Tenerani's *Psyche* and Luigi
Bienaimé's *Sleeping Bacchante*, be
given to the Hermitage. When
construction of the New Hermitage
was completed some thirteen years
later, both works were moved to the
Hall of Modern Sculpture conceived
by Nicholas himself.

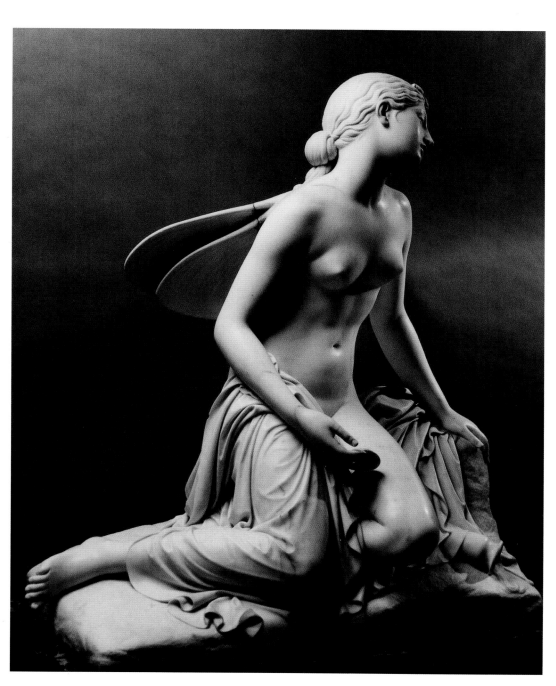

EXHIBITIONS
Massa-Carrara 1996, No. 17

BIBLIOGRAPHY
Campori 1873, p. 244; Raggi 1880,
pp. 103, 573; Scultura a Carrara
1993, p. 105

S.A.

45–48
Series of Bas-reliefs:
**Cupid's Power over
the Elements**
Bertel Thorvaldsen
(Danish, 1770–1844)
Before 1838

45
Cupid on a Dolphin
Marble
Height 50 cm (19⅝ in.),
length 67 cm (26⅜ in.)
Inv. No. N. sk. 1497

46
Cupid with Cerberus
Marble
Height 50.5 cm (19⅞ in.),
length 66.7 cm (26¼ in.)
Inv. No. N. sk. 1496

47
Cupid on an Eagle
Marble
Height 50 cm (19⅝ in.),
length 67 cm (26⅜ in.)
Inv. No. N. sk. 1498

48
Cupid with a Lion
Marble
Height 50 cm (19⅝ in.),
length 66.7 cm (26¼ in.)
Inv. No. N. sk. 1499

PROVENANCE
Transferred to the Hermitage, 1928;
acquired in Rome from the artist's
studio for the collection of Grand
Duke Alexander Nikolaevich (future
Alexander II) and kept in his private
apartments in the Winter Palace,
1839

Thorvaldsen produced the models
for this series of four bas-reliefs in
Rome in 1828. Cupids riding upon
swans, lions, eagles, and dolphins
are frequently seen in Antique
sculpture of the kind with which
the Danish master was very familiar,
and which was indeed to be found
in his own collection. Such pieces in
Thorvaldsen's possession may have
served as prototypes for the bas-reliefs
(Hartmann 1979, pp. 178–79).
A drawing in the Thorvaldsen
Museum in Copenhagen, *Cupid on
a Dolphin*, also produced in 1828,
may justly be considered a sketch
for the relief.

As conceived by the sculptor,
the image of Cupid with a powerful
lion standing patiently by was
intended to symbolize the taming
of the Earth by Venus' son, the
god of Love. Cupid on an eagle
(in ancient mythology the holy bird
of Jupiter, ruler of the heavens)
indicated the God of Love's rule
over the Air. Cupid with Neptune's
trident in his hand riding a dolphin
shows his power over Water, while
Thorvaldsen depicted the taming of
Fire by Cupid restraining the three-
headed Cerberus, guard-dog of the
Underworld.

In the middle of the nineteenth
century Thiele noted that the first
marble version of the bas-reliefs was
created for Grand Duke Alexander
Nikolaevich, a fact confirmed by
contemporary research. In 1838–39
the heir to the Russian throne
undertook a study tour through
Western Europe, spending much
time looking at the sights and
visiting the studios of the most
celebrated painters and sculptors.
The paintings, statues, and busts
he commissioned during this trip
formed important additions to
his personal collection. On
14 December 1838 (Old Style)
Alexander Nikolaevich visited the
Rome studio of Thorvaldsen, noting
in his diary the bas-reliefs with
little figures of Cupids that he saw
there. It is possible that this was a
reference to the series *Cupid's Power
over the Elements*, since as early as
6 February 1839 (Old Style) the
Russian Mission in Rome paid
Thorvaldsen 870 *scudi* for four
bas-reliefs, the titles of which are
not mentioned, but which should
be identified with those in
St. Petersburg. These were set in the
nineteenth century into the wall of a
closed balcony abutting the private
apartments of Alexander
Nikolaevich in the Winter Palace.

Marble reliefs similar to those
in the Hermitage are also in the
Thorvaldsen Museum in
Copenhagen.

BIBLIOGRAPHY
Thiele 1857, p. 5; Plon 1867, p. 261;
Mikhalkova 1993, p. 40; Mikhalkova
1999, p. 82; Karcheva 2000, pp. 86,
88

E.K.

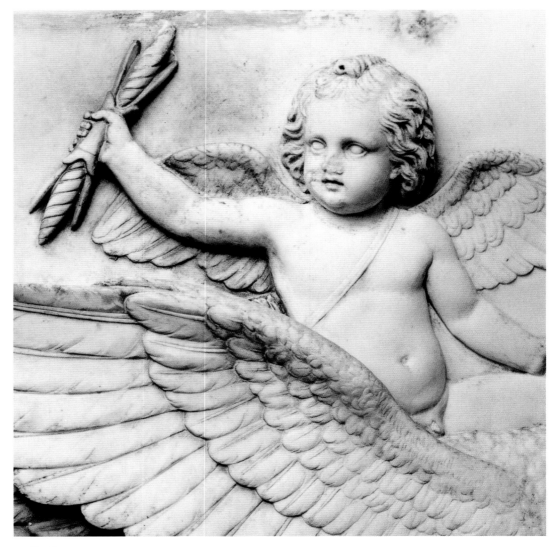

47 (detail)

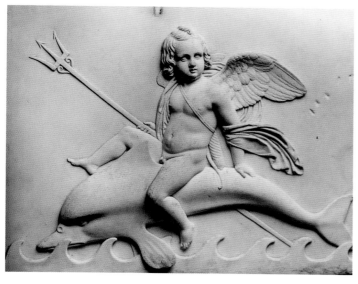

45

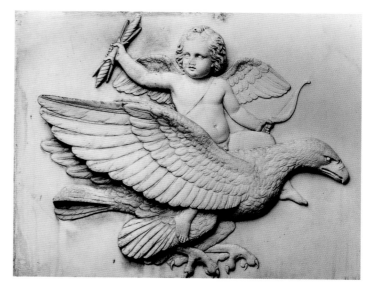

47

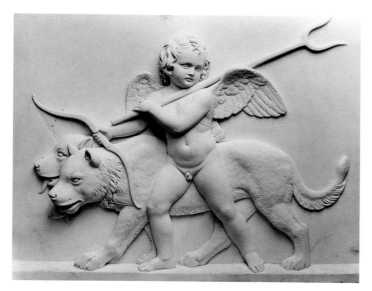

46

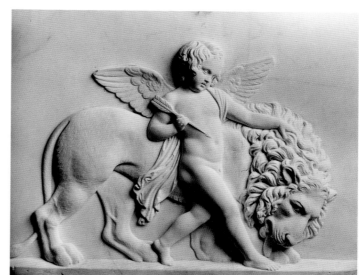

48

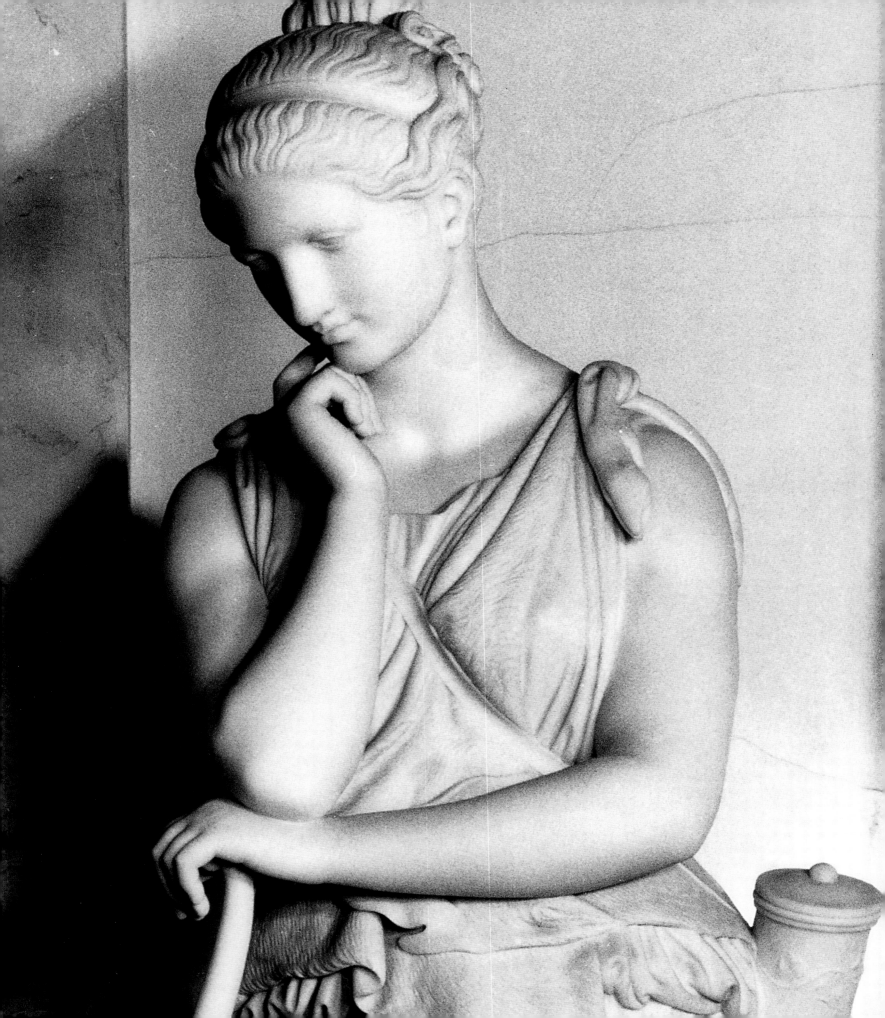

49
Diana Resting after the Hunt
Emil Wolff
(German, 1802–1879)
1847
Marble
Height 150 cm (59 in.)
Signed and dated on the edge of the
foot: *E.WOLFF FC. ROMAE. 1847*
Inv. No. N. sk. 250

PROVENANCE
Transferred to the Hermitage
Museum from the Winter Palace
after the October Revolution,
1917; moved to the White Hall,
one of the private apartments in
the Winter Palace, 1857; delivered to
St. Petersburg and set up in the first
Hall of Modern Sculpture of the
New Hermitage, 1847; commissioned
from the sculptor in Rome by
Nicholas I, 1845

At the end of 1845 Nicholas I
completed an extended journey
through Italy, during which he had
visited many towns on the Apennine
Peninsula. On 1 December (Old
Style) the Russian Emperor arrived
in Rome, where he spent five days
looking at the sights and visiting the
studios of leading sculptors. On
4 February 1845 (Old Style) Nicholas
visited Emil Wolff, commissioning
from him a marble statue of a
"resting Diana" (for 1100 *scudi*) and
a group of "Amazonians" (for 4400
scudi). Later that month the sculptor
signed a contract to produce these
two works "in accordance with the
models shown to the Russian
Emperor." Wolff undertook to
complete *Diana Resting* within the
year, and in October 1847 the statue
was successfully delivered to Russia
aboard a Neapolitan ship. On
looking the work over, Nicholas
gave orders that it be placed in the
New Hermitage when his new
public museum was completed (the
doors opened in 1852). *Diana Resting*
is shown in a watercolor produced
by Luigi Premazzi in 1856, *The First
Hall of Modern Sculpture in the New
Hermitage* (Hermitage Museum), but in
early 1857, by orders of Alexander II,
the statue was moved to the White
Hall of the Winter Palace, where it
remained for many years.
 Wolff produced a model for
Diana Resting in the middle of the

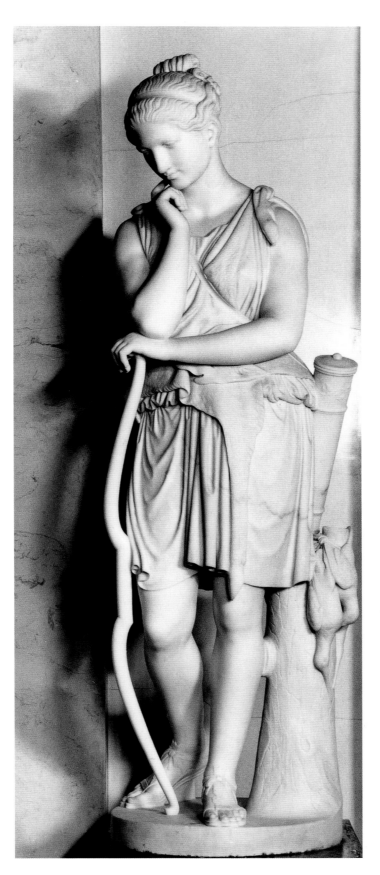

1830s, and in the autumn of 1838
he showed *Diana Resting after the Hunt,
Resting on her Bow* at the exhibition
of the Berlin Academy of Arts. This
was seen in Wolff's studio, along
with other works, in December 1838
by the Russian poet (and tutor to
the heir to the throne) Vasily
Zhukovsky (Zhukovsky 1901, p. 451).
It is possible that this model was
later used to produce the statue for
the New Hermitage.
 We know that in the early 1840s
there was a *Diana Resting on her Bow*
in the collection of one "Vladimir
Davydov" in St. Petersburg
(Raczynski 1841, p. 343), while a
statue of *Diana the Huntress* by Wolff
is listed in the mid-nineteenth
century among sculptural works
adorning the Mariinsky Palace of
the Dukes of Leuchtenberg in
St. Petersburg (Denisov 1995, p. 64).
Nonetheless, these works may have
differed in composition from the
Hermitage statue, and sadly nothing
is known of the fate of either of
them today.

EXHIBITIONS
Massa 1998, p. 231, No. II.12;
St. Petersburg 2002, pp. 130–31

BIBLIOGRAPHY
Vogel 1995, p. 99, No. 62.4;
Karcheva, Androsov 1998, p. 32

E.K.

50
Sleeping Boy
Johann Xavery
(Flemish, d. 1777)
1765
Marble
Height 41 cm (16⅛ in.),
length 94 cm (37 in.)
Signed in the right corner by the
boy's head: *I. H. XAVERY F t/ 1765*
Inv. No. N. sk. 887

51
Sleeping Boy
Johann Xavery
(Flemish, d. 1777)
1766
Marble
Height 47 cm (18½ in.),
length 94 cm (37 in.)
Signed in the right corner by the
boy's head: *I. H. XAVERY F t/*
1766 / St. Petersburg
Inv. No. N. sk. 886

PROVENANCE
Transferred to the Hermitage from
the Tauride Palace, St. Petersburg,
after 1859; formerly in the Hanging
Garden of the Small Hermitage

These two statuettes are rare works
by the little-known sculptor Johann
Xavery. According to Jacob von
Stählin (1990), he came to Russia in
1766 and applied to work for the
Chancellery for Construction (the
organization in charge of all
building works in St. Petersburg)
but was refused. Later he is
mentioned as occupying the post
of modeler at the St. Petersburg
Imperial Porcelain Factory. There
he produced not only models for
porcelain statuettes but also small
portrait busts, including images of
Catherine II and the heir to the

throne, Grand Duke Pavel
Petrovich.

Despite the absence of
documents regarding acquisition of
these statuettes, the date of the first
suggests that it was produced before
the sculptor's arrival in Russia, and
he must have brought it with him,
possibly as a demonstration of his
skill. The second, as is clear from
the inscription, was created in
St. Petersburg, probably as a pair to
the first. In 1771 "reclining boys of
white marble," that should be
identified with these pieces, were
located in the Hanging Garden of
the Small Hermitage. It can be
suggested that the two pieces were
specifically acquired from the
sculptor to stand in the Hanging
Garden, which contained almost
exclusively statues of small

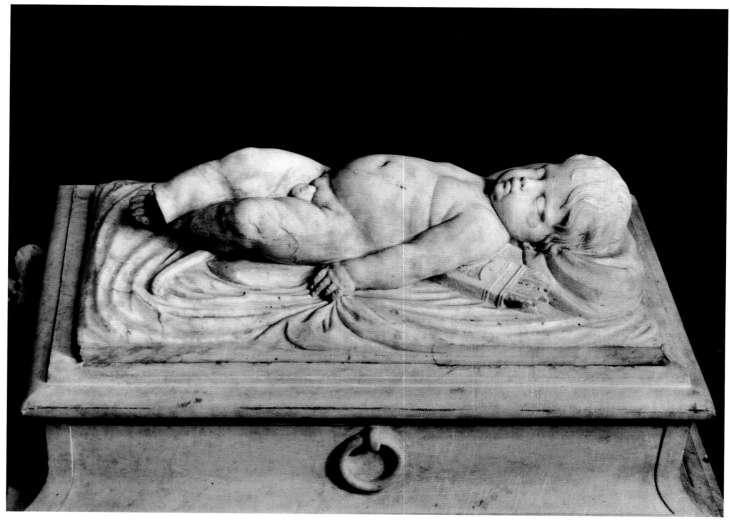

50

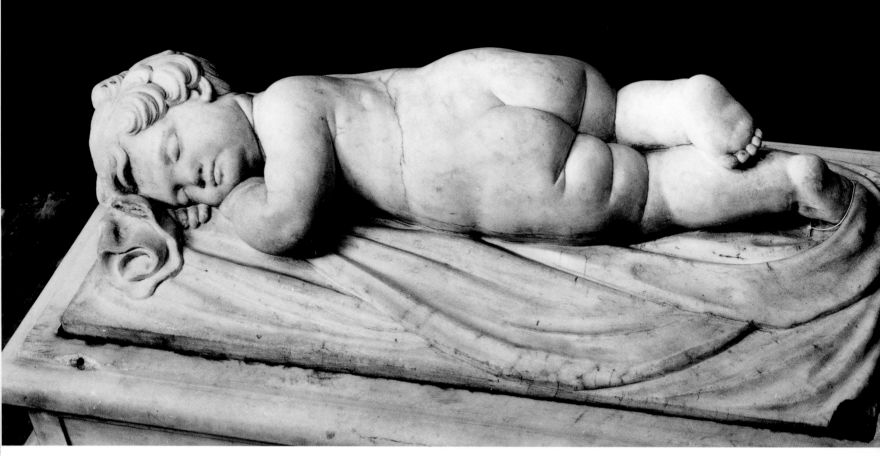

51

dimensions. In 1836 the *Sleeping Boys* were again to be set up in the Hanging Garden, and marble pedestals were made for them, but in 1859 we find them standing in the garden of the Tauride Palace, from where they returned to the Hermitage in the second half of the nineteenth century.

Johann Xavery is not known in the West, although he undoubtedly came from the celebrated Flemish Xavery family of sculptors active in the seventeenth and eighteenth centuries. It is not surprising, therefore, that in creating his figures of sleeping boys Xavery referred to Flemish traditions. The first such compositions are found in the work of François Duquesnoy (1597–1643), who spent many years working in Rome, and from this time images of sleeping or reclining boys, whether cupids or angels, were frequently created by Flemish sculptors in

different materials—bronze, marble, and ivory. In mid-eighteenth-century Russia such subjects must have seemed innovative, particularly when it is considered that the figures seem to have been acquired to decorate a garden used exclusively by Catherine II and her narrow circle of friends.

BIBLIOGRAPHY
Shelkovnikov 1961, p. 48;
Shelkovnikov 1967, p. 33; Androsov
1989, p. 33

S.A.

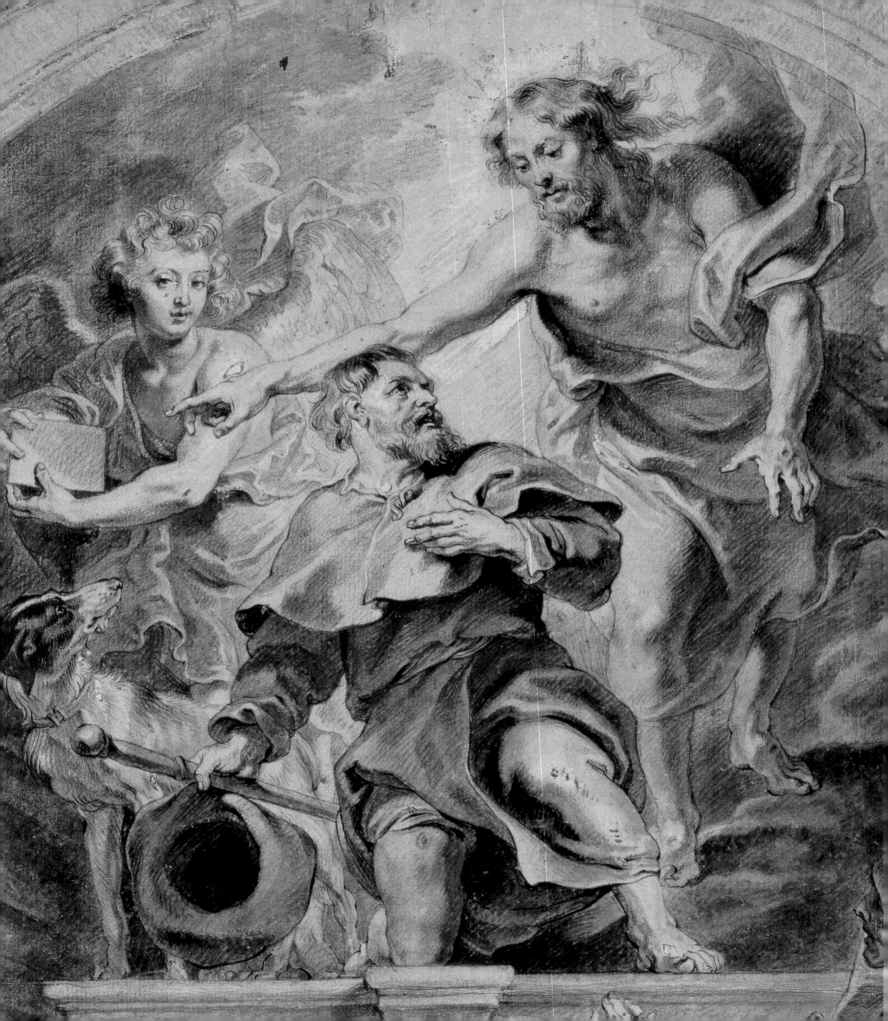

ALEXEI LARIONOV

Drawings and Prints

At its most fundamental level, the evolution of the imperial drawings collection in St. Petersburg parallels that of the rest of the Imperial Hermitage. The first—extremely modest—acquisitions were made even before the museum was founded, during the reign of Peter I. During his visit to Amsterdam in 1716 Peter purchased drawings by contemporary Dutch artists for his private library, clearly valuing them mainly for their documentary qualities; among them were calligraphically precise images of sailing ships by Adrian van der Salm and botanical studies by Maria Sybilla Merian. Such rarities, important evidence of an awakening interest in European graphics in Russia, were but seeds from which the imperial collection was to grow, their acquisition an isolated incident that found no germination for half a century. Only when Catherine II came to the throne were artistic drawings acquired on any scale, and it is to her all-embracing passion for collecting that the Hermitage today owes the greater part of its most outstanding drawings.

In acquiring drawings, Catherine employed her preferred method, tried and tested in the creation of her Picture Gallery—the purchase of celebrated European collections in their entirety. In 1768, for instance, Prince Dmitry Golitsyn, the Russian ambassador in Paris, informed her of the availability of the Brussels art collections of Count Cobenzl, and her purchase of them that same year is considered to mark the official foundation of the Hermitage's Cabinet of Drawings.

Count Carl Cobenzl (1712–1770), Austrian diplomat and statesman, was from 1753 head of the administration of the Austrian Netherlands (based in Brussels). His collection consisted of more than four thousand drawings from all the main schools. It formed a ready-made museum of Western European drawing, sorted and arranged in model order: each drawing glued on to a mount of dark-violet card in one of five standard formats, classified according to author and school, and arranged in alphabetical order in specially made folders and wooden boxes. Written in an engraved cartouche on each mount was the name of the suggested author,[1] and the whole group was accompanied by a bound manuscript catalogue.

Although uneven in composition—containing many copies (often with over-ambitious attributions) alongside excellent works—the Cobenzl Collection laid a solid foundation for the imperial drawings collection. It was particularly rich in Italian, French, and Flemish sections, bringing the Hermitage the largest collection of French crayon portraits outside France, a broad range of drawings by Rubens and his school (cat. 62), superb pieces by Piero di Cosimo, Francesco Francia, Annibale Carracci, Poussin, Claude Lorrain, and François Boucher. It also included sheets by Dürer, Rembrandt, Hendrick Goltzius, Roelant Savery (cat. 63), Wolf Huber (cat. 56), Hans Bol (cat. 53), and Rudolf Meyer (cat. 61).

In 1769 Catherine purchased another major collection, that of Count Heinrich von Brühl, first minister to Augustus III, Elector of Saxony and King of Poland (who for many years was also responsible for purchasing art for the Dresden Gallery). In addition to six hundred paintings, St. Petersburg received fourteen *in folio* albums containing 1020 drawings, mainly by French, Italian, and Dutch masters, filling gaps where the Hermitage had very few or no works by a particular old master. Notably the collection brought nine drawings by Jacob Jordaens (cat. 57), twelve by Abraham Bloemaert (cat. 52), twenty-five by Nicolas Poussin, and eight by Paolo Veronese.

Acquisitions continued to be made throughout the reign of Catherine II. Not all of these can be precisely dated, but they include 120 excellent Dutch landscape drawings from the seventeenth and early eighteenth centuries, formerly the property of the Amsterdam collector Denis Muilman (e.g. cat. 54), and a large album once belonging to the Paris collector Jean de Jullienne, containing some eight hundred original drawings by the seventeenth-century French draftsman and printmaker Jacques Callot.

Catherine also laid the foundation for an extensive body of architectural, theatrical, and topographical drawings, acquiring between 1779 and 1781 more than 1100 designs, architectural fantasies, and archaeological

53
Allegory of Spring
Hans Bol
(Netherlandish, 1534–1593)
1579
Pen and brown wash on paper
20.5 × 30.4 cm (8 × 12 in.)
Signed and dated bottom right:
Hans Bol 1579
Inv. No. OR 354

PROVENANCE
Acquired for the Hermitage (Lugt
mark 2061) as part of the collection
of Count Carl Cobenzl, Brussels
(Lugt mark 2858b), 1768

Hans Bol, a younger contemporary
and follower of Pieter Bruegel the
Elder, was one of the most notable
artists working in Antwerp during
the second half of the sixteenth
century. He made his name as
a miniaturist, author of small
compositions in gouache and
watercolor on parchment, and
as a draftsman whose many
drawings—mainly landscapes—
served as designs for prints. This
sheet is an example of the latter,
and with three other drawings (also
in the Hermitage) it forms a series
reflecting "The Four Seasons,"
which formed the basis for
engravings by Jacob Sadeler
published in 1580.

Images of the four seasons were
very common in sixteenth- and
seventeenth-century European art.
Such series gave symbolic form to
ancient—and essentially pagan—
perceptions of the eternal cycle of
death and rebirth. Christian art
assimilated these ideas during the
medieval period, developing an
iconography for calendar scenes in
which nature's cycle was identified
with the cycle of seasonal peasant
occupations and—more broadly—
with the round of man's life on
earth as he passes along his
preordained path from birth to
the grave.

The Hermitage series of
drawings was not the first such
in Bol's work. In 1569 the famous
Antwerp publisher Hieronymus
Cock commissioned from him
drawings for two prints showing
Autumn and Winter, to complete
a cycle left unfinished on the death
of Pieter Bruegel the Elder, who had
completed designs for Spring and
Summer (all four were engraved in
1570 by Pieter van der Heyden). In
1573 Bol produced a series of four
drawings in a free-sketch manner
that were probably not intended
to be engraved (Kupferstichkabinet,
Dresden), and dated to that same
year are three images of Spring,
different in composition (Herzog
Anton Ulrich-Museum,
Braunschweig; British Museum,
London; Kupferstichkabinet, Berlin),
also never engraved. All the works
listed reflect the direct influence
of the series of celebrated paintings
on the subject of the months by
Bruegel the Elder (1565; various
locations).

But the series of 1579, while in
some details close to the art of
Bruegel, is resolved in a different
key, the foregrounds dominated by
allegorical features characteristic of
sixteenth-century Netherlandish
Mannerism. This is clearly seen in
Spring, where Spring herself is
personified by a richly dressed
female figure at the center holding
a bouquet of flowers and with
more flowers in her hair. She is
surrounded by the tools of rural
labor and probably represents Flora,
the ancient goddess of flowers and
plants, who was often associated
with nature's awakening in
springtime. Behind her unfolds a
broad panorama of life in a small
Flemish town, packed with narrative
details. Bol fits into the limited space
of this sheet gardens, roads,
pastures, canals, fields, vegetable
patches, nearly twenty buildings,
and more than fifty figures, creating
an epitome or collective image of
the Netherlandish landscape.

This abundance of motifs is
strictly ordered in accordance with
the allegorical program. To right,
beneath the zodiac symbol of Aries
(the image would have been
reversed in the print, and the
drawing should therefore be read
from right to left), are the peasant
occupations of planting and pruning
of trees, i.e. tasks traditionally
associated with the first month of
spring, March. To left, beneath the
symbol for Gemini, are knights and
ladies indulging in elegant pastimes
in a garden around a rich castle,
scenes that accord with the wedding
month of May. The trees in the
right part of the drawing are bare
but to left are shown in full leaf;
clouds that pour forth a stream of
rain are replaced by a cloudless
clear sky, and so on. One important
detail is the church, which cuts off
the perspective in the distance: its
bell-tower, crowned with a cross,
was intended as a reminder of the
wisdom of God's scheme of things.
Stretching out beyond the church
to the very horizon is endless space,
offering a panorama of a river,
its waters tumbling between fields
and spinneys. The contrast between
this majestic, uninhabited landscape
and the world of men, blindly
immersed in their everyday affairs
(a device with a long tradition in
Netherlandish art), gives Bol's
composition a didactic tone,
introducing the theme of the
vanity of human life on earth.

EXHIBITIONS
Leningrad–Moscow 1969, No. 11;
Vienna–Graz 1972, No. 5;
St. Petersburg 1999d, No. 7

BIBLIOGRAPHY
Franz 1965, p. 47, No. 101 a;
Western European Drawing 1981,
No. 123

A.L.

54

**Bridge Across the Loire
at Amboise**

Lambert Doomer
(Dutch, 1624–1700)
After 1646
Pen and brown ink and brown
and gray wash
23.1 × 41.1 cm (9 × 16⅛ in.)
On the reverse inscribed in pen and
brown ink: *Amboosie Aen de Loore* and
signed in pencil: *Doomer fecit*
Inv. No. OR 2827

PROVENANCE
Acquired for the Hermitage (Lugt
mark 2061) before 1797; sale of D.
Muilman, Amsterdam, 29 March
1773, portf. D., No. 1106 (to
Fouquet); Sale of H. Wacker van
Zon, Amsterdam, 26 October 1761,
portf. A, No. 81 (to H. de Leth)

Toward the end of 1645 or in early
1646 Lambert Doomer, who had
recently quit the studio of
Rembrandt (whose pupil he is
thought to have been in the period
1640–45), set off for France to visit
his brothers, who were traders at
Nantes. On 17 May 1646 a friend,
the Amsterdam painter Willem

Schellinks, joined him in Nantes,
and in early July the two young
artists undertook a trip of several
weeks up the Loire to Orléans
before traveling on to Le Havre by
way of Paris. Schellinks's travel diary
has survived (published in Van den
Berg 1942), containing full
information about their route and
their stays in various towns.

During this journey Doomer
produced numerous topographical
drawings capturing the excellent
views encountered upon the way.
On his return to Holland these life
studies served the artist as the basis
for large finished drawings intended
specifically for sale, which he
produced both immediately in the
wake of the journey and many
years, even decades, later, making
dating difficult. We know of more
than a hundred drawings capturing
Doomer's impressions of France.

According to Schellinks's diary
they arrived in Amboise, on the
Loire, on 29 July 1646, and
remained there for three days; the
town was to provide the subject for
eight surviving drawings. The sheet
in the Hermitage, which had
already passed through the hands of

several celebrated eighteenth-century
Dutch collectors before reaching
Catherine II, shows the old bridge
across the Loire and the medieval
bridge fortifications near the city
gates. Absolutely correct in its
topography, like all the drawings in
this series, it convincingly summons
up a vivid impression of that
summer day when the artist visited
Amboise, but it was undoubtedly
produced later, in the studio. Schulz
placed it among the earlier works
that appeared directly in the wake
of the journey, in the second half
of the 1640s (Schulz 1974, p. 68).
A different view was supported by
Sumowski, who dated the drawing,
on the basis of style, to the 1660s,
relating it to works from this period
such as *View of Saumur, Seen from the
South* (Netherlandish Institute, Paris;
Sumowski 1983, vol. 2, p. 1028).

Whether he based himself on
the Hermitage drawing or on the
original study from nature, Doomer
later produced a painting known
today only from an engraving by
Baillie (1764). According to Nagler
(1835–52, vol. 1, p. 22), in the
nineteenth century this was in the
collection of the Earl of Bute in

London. Sumowski indicated that
the same landscape motif was also
used by the artist in working on
another painting, *Town on a River in
the Mountains* (Musées Royaux des
Beaux-Arts de Belgique, Brussels).

The Hermitage used to possess
another view of Amboise by
Doomer, which came from the same
source and was analogous to this
sheet in style and technique, but its
current location is unknown (passed
at auction, Boerner, Leipzig,
29 April 1931, No. 55, Abb. IV).

EXHIBITIONS
Brussels–Rotterdam–Paris 1972–73,
No. 25; Leningrad 1974, No. 21;
Florence 1982, No. 57; New York
1998–99, 56

BIBLIOGRAPHY
Van den Berg 1942, blz 25, No. 2;
Schulz 1972, vol. 2, No. 185; Schulz
1974, No. 125, ill. 63; De Wilde
1976, p. 37, sub No. 68; Schatborn
1977, p. 53; Schulz 1978, p. 93, No.
58; Western European Drawing
1981, No. 177; Sumowski 1983–(94),
vol. 2, p. 1028, No. 481a

A.L.

55
**Two Men on the Seashore
(Moonrise Over the Sea)**
Caspar David Friedrich
(German, 1774–1840)
1835–37
Sepia over pencil preparatory sketch
on Whatman paper, edges bordered
with black ink 24.5 × 34.5 cm
(9⅝ × 13⅝ in.)
Inv. No. OR 43907

PROVENANCE
Transferred to the Hermitage after
1917; collection in the Winter Palace,
St. Petersburg (mark in the form of
a crown in the lower right corner—
Lugt no. 2469d)

Of Nature's numerous faces
Friedrich chose only those in
keeping with his own mood,
repeating over many years the same
motif, with some variations. Behind
the Hermitage sepia (and several
other compositions showing two
men on the seashore at sunset or
moonrise) lies a contour pen
drawing of two standing figures seen
from behind, wearing long, wide
cloaks and berets recalling medieval
attire (1815–18, Staatliche Museen
zu Berlin, Sammlung der

Zeichnungen). This motif was first
transformed in *Moonlight Landscape*
(1817 or 1821, Staatliche Museen zu
Berlin) and again in two Hermitage
compositions from the last years of
the artist's life, *Sunset (Brothers)* and
this sepia drawing, where both
figures appear without any noticeable
alterations. Variations on the theme
of two figures, wearing contemporary
attire and in relaxed, if somewhat
mannered, poses found their way
into a number of paintings,
including the Hermitage *Moonrise
Over the Sea* of 1821 and a late sepia
Two Men on the Seashore (Pushkin
Museum of Fine Arts, Moscow).

In the majority of works
featuring this pair the artist
remained faithful to his cult of
romantic friendship—the union
of twin souls in the face of Nature,
which the figures (or the artist) saw
as divine—but the Hermitage
drawing resonates with a more
tragic note. A full, pale moon rises
above the horizon and the boulders
on the shore; everything acquires a
mystical hue and finds analogy in
numerous sepia and pencil drawings
(Börsch-Supan, Jähnig 1973, Nos.
482–87 etc). The landscape is
suffused with quiet, elegiac sorrow,

the colors washed out by the
moonlight to create a sense of
mirage. Although the men stand
close to each other, they do not
touch, accentuating their division,
the solitude of each in the
moonlit world.

The emotional resonance
and manner of execution are
characteristic of works of the last
years of the artist's career, particular
parallels being visible in the
Hermitage sepias *Boat on the Beach at
Arkona by Moonlight* and *Owl in Flight
Before a Full Moon*, both of 1835–37.
All are on identical paper and
framed in black ink, with the same
treatment of rocks on the shore, the
reflections of moonlight on the
water, and the pencil lines visible
through the thin layer of sepia
wash. The late dating of this sepia
(1835–37) can be reasoned by a
slight tiredness in the artist's
manner, forced by weakness and
ill health and by his reminiscences
and impressions from the past.

As with several of the other
Hermitage sepias, the drawing was
in the imperial collection until 1917,
but when and under what
circumstances it was acquired
remains unknown. It is possible that

this sheet was acquired at the same
time as *Sunset (Brothers)* through the
mediation of the Russian poet Vasily
Zhukovsky (personal tutor to the
heir to the throne, Grand Duke
Alexander Nikolaevich), who took a
close interest in the artist with whom
he had much in common and was
personally acquainted, and whose
paintings he himself owned.

EXHIBITIONS
Leningrad–Moscow 1968, No. 73;
Budapest 1970, No. 43; Prague 1972,
No. 42; Hamburg 1974 (exhib. cat.);
Leningrad 1974a, No. 20; Dresden
1974–75, No. 227; New Delhi 1987,
No. 109; Chicago–New York
1990–91, pp. 90–91; Trento 1993,
No. 54; Munich–Edinburgh–
London–Berlin 1995, No. 192;
Rouen 2001, No. S. 8; London 2002,
No. 25

BIBLIOGRAPHY
Izergina 1964, pp. 28, 30, 32; Hinz
1966, p. 60; Sumowski 1970, pp. 79,
130, 155, 206, 227, 233, 236; Börsch-
Supan, Jähnig 1973, No. 479;
Western European Drawing 1981,
No. 211; Bernhard, Hofstätter 1974,
p. 782; Rewald 1990, p. 90;
Hermitage Masterpieces 1994,
No. 342

A.K-G.

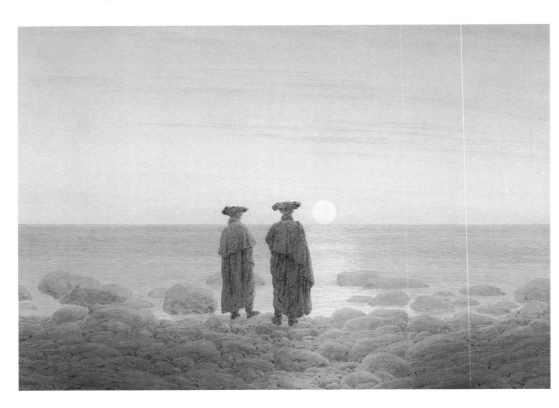

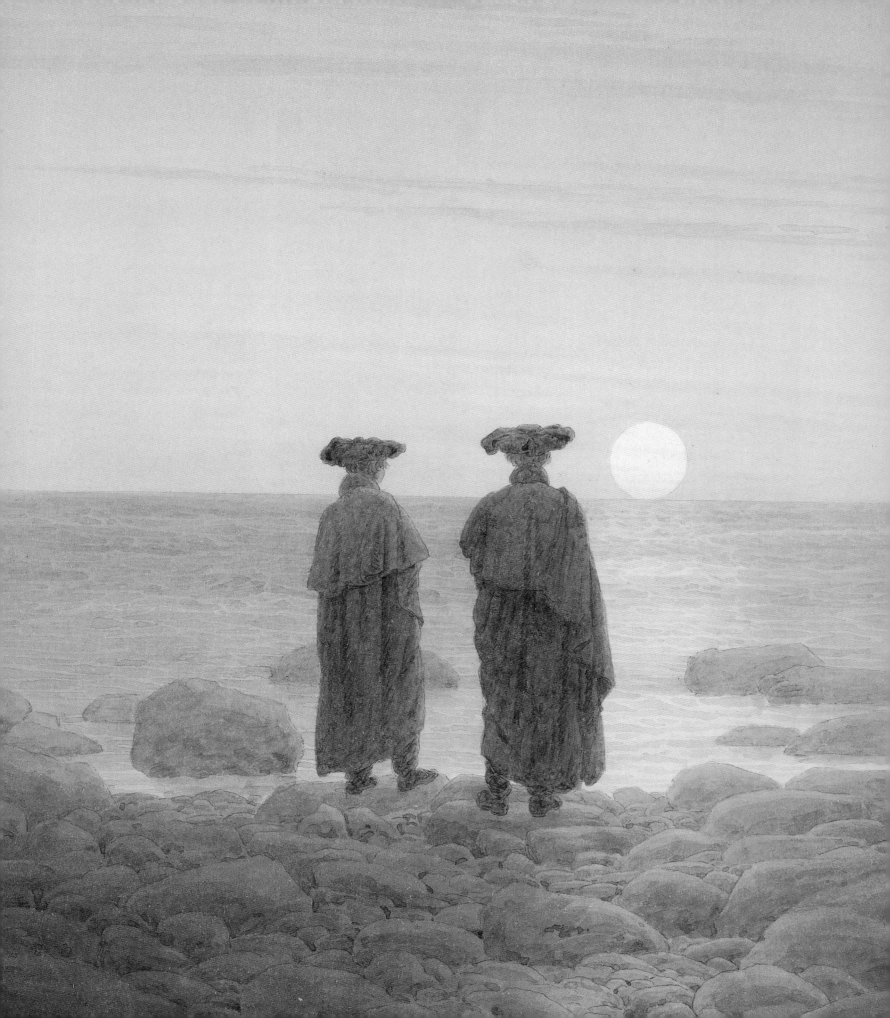

Indeed the sheet is typical of works by this master, who, with Altdorfer, was one of the leading representatives of the "Danube School." An artist of varied talents in charge of a large workshop, Huber was a painter, an architect, and the author of designs for prints, but the greater part of his surviving work consists of drawings, some one hundred and fifty of which survive, allowing us to describe him as one of Germany's most original draftsmen during the first half of the sixteenth century. Of particular significance is his contribution to the development of landscape drawing: executed in a strange, fantastical style, his landscape compositions are often based on nature studies of genuine views in the upper reaches of the Danube and the central Alps, but presented in reworked and stylized form.

Stylistically, the Hermitage drawing is close to Huber's works of the early 1520s, such as *View of Feldkirch*, dated 1523 (British Museum, London). Such compositions enjoyed great popularity among contemporaries and exerted great influence on the next generation of German landscape artists, including Augustin Hirschfogel and Hans Lautensack. They were often copied, even by Huber himself, for the purpose of sale, which frequently complicates the question of attribution to the master's hand. Despite this drawing's considerable artistic qualities, a certain monotony in the drawing of lines and an insufficient sense of breadth suggest it is a replica produced by one of Huber's assistants.

BIBLIOGRAPHY
Western European Drawing 1981, No. 195.

A.L.

56
Landscape with a Bridge
Wolf (Wolfgang) Huber (workshop)
(German, c. 1480/85–1553)
Early 1520s
Pen and black ink
21.5 × 15.4 cm (8½ × 6 in.)
Inv. No. OR 6951

PROVENANCE
Acquired in 1768 for the Hermitage (Lugt mark 2061) as part of the collection of Count Carl Cobenzl, Brussels (Lugt mark 2858b)

Listed as the work of Albrecht Altdorfer in Cobenzl's manuscript catalogue of his collection, compiled by his nephew (now Hermitage, Drawings Department), and in old Hermitage inventories, the drawing was attributed to Wolf Huber, according to a note on the mount, by Mikhail Dobroklonsky in the 1920s.

57
The Rape of Europa
Jacob Jordaens
(Flemish, 1593–1678)
First half of the 1650s
Pen and brown ink and watercolor
over black and red chalk
23 × 38.5 cm (9 × 15⅛ in.)
A later inscription bottom left in pen
and brown ink: *Jordaens*
Inv. No. OR 4210

PROVENANCE
Acquired for the Hermitage as part
of the collection of Count Heinrich
von Brühl, Dresden, 1769

The basis for the Hermitage's rich
assortment of drawings by Jordaens
was provided by sheets acquired
during the reign of Catherine II.
Around twenty works by the
celebrated Flemish master appeared
in the first inventory of the Cabinet
of Drawings, compiled in 1797, and
most of these retain their traditional
attributions to this day. A particu-
larly impressive group of drawings
by Jordaens—including this sheet—
arrived in 1769 as part of the
collection compiled by Heinrich von
Brühl, prime minister to August III,
Elector of Saxony and King of
Poland.

The Rape of Europa is a subject
taken from Ovid's *Metamorphoses* (II,
833–75): Ovid relates how Europa,
daughter of the Phoenician King
Agenor, was abducted by Jupiter,
who appeared to her in the form of
a white bull. From the mid-sixteenth
century the subject acquired great
popularity in European art, greatly
facilitated by a symbolic
interpretation of this ancient
mythological subject in the spirit of
Christian morality: Europa, carried
away across the waves, was
perceived as an allegory for the soul
that had turned away from God,
thrown upon an ocean of sufferings
and the burdens of earthly life. Her
gaze, turned sorrowfully back to the
land she is leaving behind,
symbolizes the soul's yearning to be
reunited with the Creator, a state to
be achieved only upon completion
of one's path through life, with all
its burdens and alarms. It was
precisely this understanding of the
subject that Karel van Mander set
out in his commentaries to the
Metamorphoses (*Wtlegghingh op den
Metamorphosis*, Haarlem, 1604, f. 21).

Over a long career, Jordaens
turned to the subject of the Rape of
Europa on a number of occasions.
The earliest painting, executed
around 1615, is now in a private
collection in Stockholm; another
variation of the composition is
known from an old copy in the
Herzog Anton Ulrich-Museum,
Brunswick; a painting dated 1643 is
in the Musée des Beaux-Arts, Lille.

In this Hermitage drawing the
naked Europa is seated upon the
back of the bull making its way
across the sea, while her friends
remain on the shore, and Boreas,
God of the North Winds, flies
overhead. In composition it differs
from the painted versions and would
seem to have been produced later;
the majority of scholars have dated
it, on the basis of style, to the first
half of the 1650s. Indeed, the sheet
clearly demonstrates features of
Jordaens's late style: a tendency
towards simplification of form, a
decorative approach to the overall
composition and an unusual
caricature-like tone to the images
that is not without a hint of humor.
The sheet would seem to be a
compositional sketch for some
painting or tapestry that either was
never realized or has been lost.

EXHIBITIONS
Ottawa 1968–69, No. 270;
Leningrad 1971, No. 32; Dresden
1972, No. 42; Leningrad 1979b,
No. 24

BIBLIOGRAPHY
Rooses 1890, p. 285; Kamenskaia
1934–36, p. 207; Dobroklonsky 1955,
No. 200; Puyvelde 1953, No. 59,
pp. 175, 197; d'Hulst 1957, No. 337;
Western European Drawing 1981,
No. 139; d'Hulst 1974, No. A316

A.L.

58
**Two Canons of the Order of
the Garter**
Sir Peter Lely (Pieter van der Faes)
(Dutch, 1618–1680)
Mid-1660s
Black and white chalk on
bluish-gray paper
49 × 36 cm (19¼ × 14⅛ in.)
By the lower right edge a later
inscription in pencil: *Arme Ridders*

PROVENANCE
Transferred from the Library of
the Academy of Arts, St. Petersburg
(mark in the lower left corner, Lugt
no. 2699a), 1924; at the Academy
from the second half of the
eighteenth century

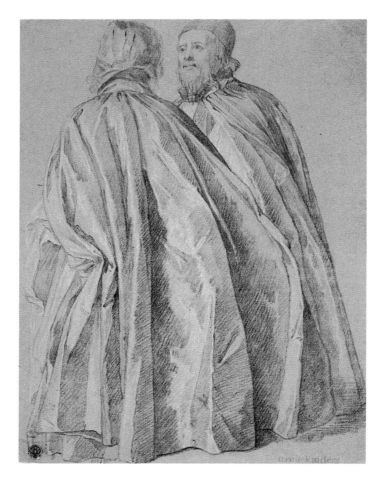

This sheet belongs to a series of
studies for figures in a procession of
Knights of the Order of the Garter.
Some thirty such drawings are
currently known (sixteen in the
British Museum and the rest
scattered around European and US
collections), and together they form
a complex unique in significance
not only within Lely's graphic œuvre
but also in the whole history of
British Baroque drawing. The twelve
canons who served St. George's
Chapel always took part in the
procession of the Garter, and Lely
depicts them in six of the known
drawings (Hermitage; four in the
British Museum, London; one in the
Crocker Art Gallery, Sacramento,
California).

It is not clear under what
circumstances the series was
produced. The ceremonial
procession of Knights of the Order
of the Garter was held annually in
the main courtyard of the Palace of
Whitehall or at Windsor Castle on
St. George's Day, 23 April. This
tradition, broken off during the
Civil War and Charles II's exile,
was revived with great pomp after
the Restoration of the monarchy in
1660. It is not clear which year the
procession Lely depicted took place,
but the identification of several
participants allows us to date the
series to between 1663 and 1671
(Croft-Murray, Hulton 1960, p. 410).

All drawings in the series
are similar in both format and
technique, showing the participants
singly or in pairs, always moving
from right to left. Such is the
vividness and variety of these figures
that they suggest Lely must have
based them on sketches made on
the spot, although the drawings
themselves undoubtedly took on
their final appearance as a result
of careful work in the studio.

Much discussion has been
devoted to the purpose of these
large-format studies, but the
dominant view is that Lely produced
them as part of a project (apparently
never realized) for a large,
decorative composition in one of the
royal palaces. We know that in the
1630s Charles I had intended to
adorn Whitehall with a series of
four tapestries on the history and
ceremonial of the Order of the
Garter, entrusting the development
of this project to Van Dyck, who
produced an oil sketch of six
Knights (Duke of Rutland, Belvoir
Castle). Charles II attached great
political significance to the Order
and its official ceremonies and may
well have revisited his father's idea,
although nothing seems to have
come to fruition. It is worth noting
that Van Dyck's oil sketch appeared
in the posthumous sale of Lely's own
collection; he may have been given
it by Charles II as a model (see
Millar 1978, p. 81).

We do not know where Lely's
studies were originally kept, but by
the middle of the eighteenth century
they were already scattered among
different collections, some of the
sheets appearing in auction
catalogues of the 1740s to 1760s.
A group of eight sheets was sold at
the posthumous sale of the collection
of Charles Jervas in London on
24 March 1740, while an album
including sixteen sheets appeared at
an anonymous sale in Amsterdam
on 23 March 1763. The Hermitage
sheet probably derives from the
latter, where it can be identified
with No. 16 or No. 25.

There is no documentation to
record how the drawing reached the
Academy of Arts, where it is
recorded in the second half of the
eighteenth century. We do know
that a study fund was accumulated
at the Academy over the course of
the 1760s and 1780s, for which
Catherine II acquired, among other
things, numerous life studies by
European artists, including studies
of figures, drapery, and heads. The
drawing was probably acquired in
this way.

Museum inventories listed the
Hermitage drawing as anonymous
when it was acquired, but the
authorship of Peter Lely and the
link with the drawings for the
Garter procession were established
by Mikhail Dobroklonsky in the
mid-1920s.

EXHIBITIONS
Leningrad 1926, No. 107;
Montevideo-Buenos Aires 1968,
No. 91; Botoa 1986, No. 13;
Belgrade–Ljubljana–Zagreb
1987–88, No. 112; New Haven–
Toledo–St. Louis 1996–97, No. 28,
pp. 193–94

BIBLIOGRAPHY
Dobroklonsky 1955, p. 73, No. 274,
ill. 42; Millar 1978, p. 83, No. 98;
English Art 1979, No. 40.

A.L.

59

**Night-time Carousel in the
Reign of Frederick the Great
in 1750**

Adolph Menzel
(German, 1815–1905)
1853
Sheet 4 from the series *The Magic
of the White Rose (Der Zauber der
weissen Rose)*
Watercolor, gouache, over pencil
sketch on Bristol board
44.5 × 56.9 cm (17½ × 22⅜ in.)
Bottom right: *Menzel 1853*
Inv. No. OR 13673

PROVENANCE
Transferred to the Drawings
Department, 1899; formerly
Medieval and Renaissance
Department; presented to Empress
Alexandra Fedorovna, 1854

Menzel's gouaches form part of
a series commissioned in 1853 by
King Friedrich Wilhelm IV of
Prussia as a gift for his sister, the
Russian Empress Alexandra
Fedorovna, wife of Nicholas I.
The series marked the twenty-fifth
anniversary of the Festival of the
White Rose, a huge celebration
held at the Prussian royal summer
residence of Potsdam on 13 July
1829, the birthday of Alexandra
Fedorovna, who was then in Berlin
to attend the wedding of her
younger brother Prince Wilhelm.

The series consists of ten large-
format sheets: a title page, four
compositions devoted to famous
Prussian tournaments of past ages,
and five works showing the 1829
festival at Potsdam. As was usual
when Friedrich Wilhelm IV made
commissions of such significance,
he discussed the ideology and its
embodiment in detail with the artist.

Friedrich Wilhelm exercised a
decisive influence on the artistic
tastes and aesthetic preferences of
the Prussian royal family over the
first half of the nineteenth century,
tastes and preferences that were
brought to Russia after 1818, when
the young Princess Charlotte (she
took the Russian name Alexandra
Fedorovna) married Grand Duke
Nicholas of Russia. Nicholas was to
enjoy a deep and sincere friendship
with his brother-in-law. Thanks to
this link, the imperial Russian family

manifested a number of German
tastes, among them an early interest
in the work of Caspar David
Friedrich, adherence to the
Romantic cult of the Middle Ages
in the collections and festivals held
at the imperial summer residences,
and the building of a Pompeiian
villa in the picturesque gardens at
the Palace of Peterhof.

Friedrich Wilhelm's choice of
Adolph Menzel to carry out this
commission was deliberate, for the
retrospective mood of the project
was very much in keeping with the
artist's work. Menzel had devoted
many years to the scrupulous
study and detailed, convincing
reconstruction of events from
Prussian eighteenth-century history.
In hundreds of drawings and
paintings he had embodied with
such variety and brilliance the myth
of Frederick the Great (Friedrich II)
that it seemed impossible to see
"Old Fritz" any way except through
the eyes of Menzel. Thus the first
works he produced for *The Magic of
the White Rose* were those showing
the tournament and carousel of

1750, a festival organized by
Frederick the Great at Lustgarten
in Berlin. Working on a subject
with which he was already familiar,
Menzel made use of preparatory
materials produced for his images
of Frederick.

Menzel always sought a pedantic
precision in even the tiniest details
of *The Magic of the White Rose*, the
very nature of the gift demanding
virtuosity of concept and perfection
in execution. Artistic talent is
brilliantly combined here with
narrative skill and a profound
knowledge of history. Menzel's
images form a text filled with
carefully assembled and brilliantly
conceived details that draw the
viewer in, encouraging one to linger
over them, but they are aimed,
above all, at the educated viewer.

M.D.

60

Ball in the New Palace in 1829
Adolph Menzel
(German, 1815–1905)
1854
Sheet 9 from the series *The Magic of the White Rose (Der Zauber der weissen Rose)*
Signed bottom right: *Menzel 1854*
Watercolor, gouache, over pencil sketch on Bristol board
44.5 × 56.9 cm (17 1/2 × 22 3/8 in.)
Inv. No. OR 13678

PROVENANCE
Transferred to the Drawings Department, 1899; formerly Medieval and Renaissance Department; presented to Empress Alexandra Fedorovna, 1854

Preparations for the huge celebrations of 13 July 1829, which were to be the most grandiose in Potsdam's history, required rapid improvisation and took just a month. Artists, decorators, and musicians were involved, and both the *tableaux vivants* that would give allegorical form to events from the life of Princess Charlotte—the Blancheflor, or White Rose, at the heart of the festival—and the frame of the "magical mirror" in which these paintings were demonstrated on the theatre stage were designed by the leading nineteenth-century Berlin architect Karl Friedrich Schinkel. Crown Prince Friedrich Wilhelm (later Friedrich Wilhelm IV) himself compiled the program of events.

The celebration went off magnificently. Perhaps somewhat archaic in style, its form deeply rooted in the traditions of previous centuries, it was to be the last impressive manifestation of Romanticism in Berlin. It was universally admitted to have been brilliant and elegant, and, what was most important, deeply sincere. This last quality must have been the reason why the festival remained fixed in Hohenzollern family chronicles as one of the most outstanding and idyllic recollections of the era.

Menzel set all the compositions in rich frames that do more than merely serve as decorative settings. On the one hand they formally link the gouache with the *tableaux vivants*, a key element in the structure of the festival, which were shown in a huge curtain-frame on the stage. On the other hand they derive from the presentation format—accepted and even quite popular in the nineteenth century—of the kind that Menzel was repeatedly called upon to produce. The fanciful interweaving of real and invented figures, and of fantastical ornament and grotesques in the margins, was a fashionable element in Romantic-era decoration, but it also formed a parallel visual series that made it possible to complement and comment on the main text.

This allowed Menzel to introduce in a natural manner the humorous putti whose games accompany the story of White Rose. It is likely that they were conceived together with the client, and that these free, uninhibited little beings emphasize the light-heartedness of events, even introducing a note of self-irony. For the tournament portion of the festival, rather than a potentially fatal duel among knights, there was instead an elegant game and merrymaking.

EXHIBITIONS
St. Petersburg 1897, Nos. 188–97, p. 14; Berlin 1905, No. 116, p. 11; Leningrad 1937, Nos. 156–57; Berlin 1980, Nos. 28–37, pp. 315–318; Berlin–Köpenick 1987; Leningrad 1990, Nos. 60–61; Berlin 1997 (ex-cat.); St. Petersburg 2000, Nos. 13.1–10; London 2002, Nos. 44–53

BIBLIOGRAPHY
F.E. 1854; Jordan, Dohme 1890, p. 33; Diaghilev 1897; World of Art 1903, p. 259; Jordan 1905, pp. 56–58; Tschudi 1906, Nos. 319–28, pp. 224–35; Knackfuss 1906 [1922], pp. 48–50; Hütt 1981, p. 89; Lammel 1988, p. 31; Grummt 1998, pp. 15–16; Ilatovskaia, Pakhomova-Göres 2000; German Art for Russian Imperial Palaces 2002, pp. 109–23

M.D.

61

The Annunciation
Rudolf Meyer
(Swiss, 1605–1638)
1627
Pen and ink and brown wash on
gray-blue paper, heightened with
white
Diameter 16 cm (6¼ in.)
Signed with the monogram *RM* and
dated *1627*
Inv. No. OR 4685

The name of the Swiss painter,
engraver, and draftsman Rudolf
Meyer is known today only to
specialists, yet in the seventeenth
and eighteenth centuries this master
enjoyed some popularity. Meyer's
name often appears in auction
catalogues of the time, and it was
with some reason that Count
Cobenzl, whose collection formed
the basis of the Hermitage Cabinet
of Drawings, as the department was
then known, owned nearly twenty
works by the master, among them
this *Annunciation*.

This signed and dated sheet is
among the best of Meyer's works.
Like many of his other drawings,
it was produced as an independent
finished work intended for sale or
as a gift and is marked by
compositional elegance and
precision in depiction. In its
technique—employing pen and the
point of the brush on a colored
ground, and careful modeling of
masses with fine lines of white—this
drawing recalls German and Swiss
Renaissance masters, whose graphic
devices the artist frequently imitated.

BIBLIOGRAPHY
Western European Drawing 1981,
No. 202

A.L.

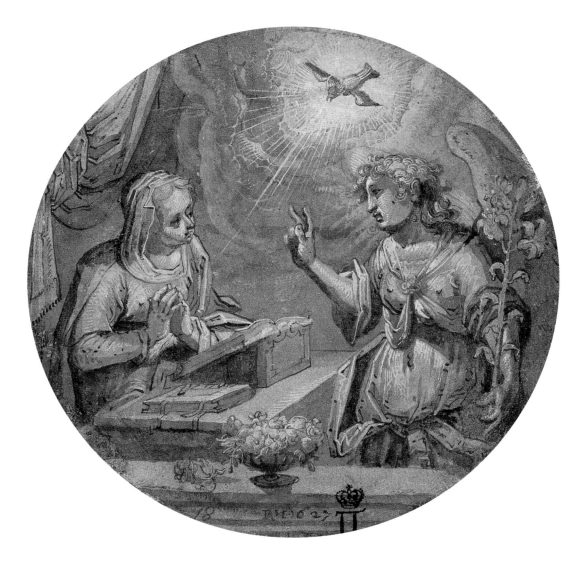

62

St. Roch, Patron of the Plague-stricken

Peter Paul Rubens (workshop)
(Flemish, 1577–1640)
c. 1626
Black chalk, pen and brown and
black wash, heightened with white;
laid down
52.6 × 35.8 cm (20¾ × 14 in.)
Inv. No. 5522

PROVENANCE
Acquired in 1768 (Lugt mark 2061)
from the collection of Count Carl
Cobenzl, Brussels (Lugt mark
2858b); formerly collection of Pierre
Crozat, Paris

Reproducing Rubens's *St. Roch,
Patron of the Plague-stricken*, painted
c. 1623 for the church of St. Martin
in Alst, this drawing was the *modello*
for a print by Paulus Pontius
(1603–1658). It demonstrates
excellently the close attention paid
by Rubens to the making of repro-
ductions after his paintings, and how
carefully he controlled the process of
print production in his workshop.

Before each print was made,
special drawings were usually
produced by Rubens's pupils
and assistants, their task being to
reproduce the original composition
with maximum precision and in as
much detail as possible. Rubens
then corrected these drawings in
his own hand, adding the required
plastic energy and expression.

Here the drawing—the same size
as the intended print—is in black
chalk and gray wash. It is quite
competent and careful, but a little
weak. It is possible (although not
certain) that the artist was the
engraver himself, Paulus Pontius,
but it was Rubens who was
responsible for the pen and white-
highlight corrections that enliven the
rather monotonous surface of the
original pencil shading. With
energetic strokes of the pen he went
over the contours of most of the
figures in brown ink, above all
touching the heads and hands,
reinforcing the plasticity of form and
increasing their expressive natures.
Several rapid touches of white
highlighting endow the work with
a more painterly tonality and give
it greater contrast. All these

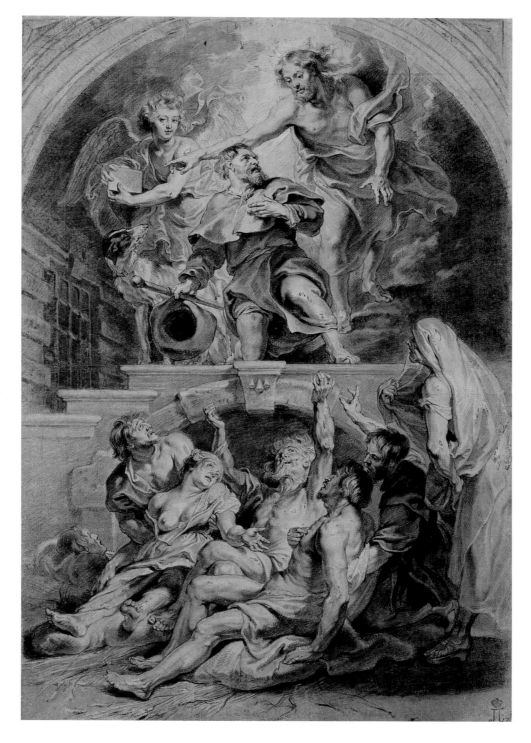

emendations and alterations were
taken into account by Pontius
when transferring the drawing
to his print, the latter rightly
considered to be one of his best
works. The print is dated 1626, and
the drawing was probably produced
in that same year.

EXHIBITIONS
Leningrad 1940, No. 178;
Leningrad–Moscow 1965, No. 43;
Brussels–Rotterdam–Paris 1972–73,
No. 70; Leningrad 1974, No. 61;
Leningrad 1977, No. 111

BIBLIOGRAPHY
Dobroklonsky 1940, No. 31;
Dobroklonsky 1955, No. 624;
Haverkamp Begemann 1973, No. 2;
Western European Drawings 1981,
No. 143.

A.L.

63
Mountainous Landscape
Roelant Savery
(Netherlandish, 1576/78–1639)
c. 1606–07
Pen and brown ink, watercolor
on paper
29.5 × 34.5 cm (11⅝ × 13⅝ in.)
Inv. No. OR 15103

PROVENANCE
Transferred to the Hermitage from
the Academy of Arts, Leningrad,
1924; presented to the Academy of
Arts, St. Petersburg, 1767; collection
of Ivan Betskoy, St. Petersburg
(Lugt mark 2878a)

The most fruitful decade in the life
of the Netherlandish painter and
draftsman Roelant Savery was the
period 1603 to 1612, which he spent
in Prague in the service of the
Emperor Rudolph II. It was in
Prague that his talent found full
development, and he created those
works that determined his reputation
as the leading landscape painter of
Northern Europe. During these
years Savery produced for the
imperial Kunstkammer numerous
small paintings on copper and panel,
depicting with miniature precision
semi-fantastical mountainous views
in which he developed the traditions
of Netherlandish Mannerist
landscape of the second half of
the sixteenth century.

Joachim von Sandrart, author of
the first biography of Savery, tells us
that in 1606–07 the artist undertook
(at Rudolph's command) a journey
through the mountainous regions of
Bohemia and the Tirol in order to
sketch "rare miracles of nature."
The cliffs that form a gigantic arch
in the Hermitage drawing can be
seen as one of these "miracles."
Although the drawing can hardly
have been taken directly from
nature and is to be seen as a free
fantasy on Alpine landscapes rather
than as a depiction of a specific
location, it is undoubtedly connected
to this journey and the artist's
impressions. A similar motif of cliff
gates is present, for instance, in a
pen sketch drawn from life in the
Institut Néerlandais in Paris and in
another in colored chalks in the
Kunsthalle, Hamburg.

A dating of the sheet to the mid-
1600s is confirmed by the manner of
the pen drawing, which, as noted by
J. Spicer-Durham, reveals the
influence of the graphic style of Jan
Breughel the Elder, who visited
Prague in 1604. The closest parallel
to the Hermitage sheet in terms of
technique and hand is seen in a
View of Prague in the Statens
Museum vor Kunst, Copenhagen,
dated between 1604 and 1608. Both
drawings are united by an unusually
broad application of watercolor. In
the majority of Savery's drawings
and in those of his contemporaries
light tinting with watercolor was
used merely to enliven the drawing,
playing a supplementary role. The
Hermitage sheet, on the other hand,
has a purely painterly texture, the
flowing watercolor blending shades
of pale blue and green tones,
introducing to the landscape a sense
of vivid, vibrant air and light. Here
Savery is one of the first artists to
demonstrate the potential of the
watercolor technique, a forerunner
to the achievements of Dutch and
Flemish masters of the next
generation such as Allaert van
Everdingen and Lucas van Uden.

EXHIBITIONS
Leningrad 1937, No. 58;
Vienna–Graz 1972, No. 63;
Brussels–Rotterdam–Paris 1972–73,
No. 95; Leningrad 1974b, No. 66;
St. Petersburg 1999d, No. 29

BIBLIOGRAPHY
Dobrokolonsky 1955, No. 713
(as Lucas van Uden); Kuznetsov
1970, pp. 18, 83, pl. XIV; Western
European Drawing 1981, No. 128;
Eisler 1975, pl. 9; Spicer-Durham
1979, p. 401, No. C7 F8

A.L.

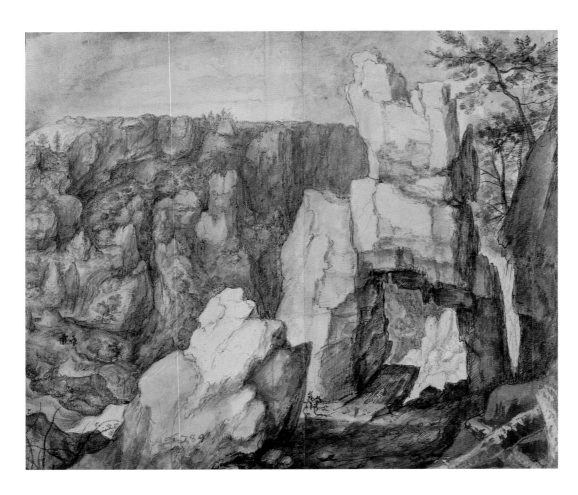

64–66

Album of Italian Prints by or after Annibale Carracci
Album with forty prints, nineteenth-century binding of brown leather with gold stamping
On the cover the imperial arms; on the spine: *Oeuvres des Carraches: Vol. VIII*
63 × 52 cm (24¾ × 20½ in.)
Inv. Nos. OG 1995–2009, 2011–2035

PROVENANCE
1790

One of eleven albums in the Hermitage devoted to the work of the Carracci brothers, this album contains original prints by the masters themselves and numerous copies and prints after their works. Since the latest prints in the album date from the 1780s, we should probably date the compilation of the album to this date. The binding with the imperial arms was made after the album arrived in St. Petersburg. On the first page is a pen inscription describing the number of prints in the album and a date, 1808; this was probably made by the Keeper of the Department of Prints of the Imperial Hermitage.

This album is devoted to Annibale Carracci, the best-known and most talented of a whole family of Bolognese artists whose name is linked with the revival of the Bolognese art schools in the seventeenth century. Annibale was the founder of the Accademia degli Incamminati, one of Italy's first free art institutes, which broke with the traditions of the medieval workshop and introduced the systematic teaching of drawing. This emphasis on drawing later became the ideal for many of the academic bodies modeled on that in Bologna.

Nearly two dozen of Annibale's prints came to be considered classical "standards," extremely popular among collectors from the seventeenth to the nineteenth centuries. His prints were often copied, and it is sometimes difficult to differentiate between original and copy. The Hermitage album opens with prints after portraits by Annibale Carracci, and then continues with works by the master himself, numerous copies, and variations.

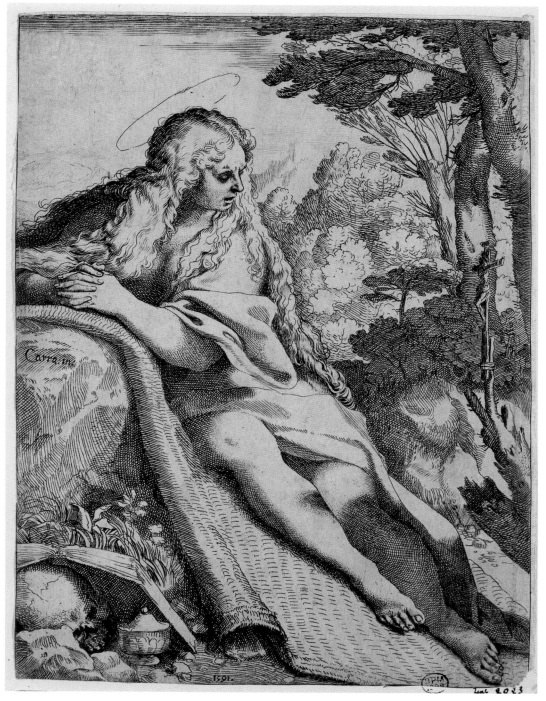

64

Such albums were used by members of the imperial family as "handbooks" in their studies of the fine arts, in order to acquaint themselves with paintings and graphic works celebrated throughout Europe. So pronounced an interest in Annibale Carracci was not a matter of mere chance: during the reigns of Alexander I and Nicholas I a love of his art was considered a manifestation of good taste.

The album is opened at a page showing three prints: two states of a single print and a copy. This deliberate arrangement makes this spread a unique illustration of the workings of late-eighteenth-century connoisseurship.

64

The Repentant Magdalene
2nd state
Etching, engraving
22 × 16.5 cm (8⅝ × 6½ in.)
Inscribed left, on the stone: *Carracci*;
at bottom center: *1591*
Inv. No. 2023

The soft light and dark modeling of the figure of Mary Magdalene and the surrounding landscape, differing from the harsh line engravings characteristic of most late-sixteenth-century Italian printmakers, recall Titian and Venetian art. Annibale created a new style under the impression of Venetian painterliness, a forerunner of the Baroque style that contrasted with the refined smoothness of Late Mannerism.

Beside the print a former keeper has inscribed the note "rare," and indeed this impression is of superb quality. Bartsch considered it to represent the print's first state, but a single earlier print from the unfinished plate was discovered more recently (see *The Illustrated Bartsch*, 3906.014 S1). There is a preparatory drawing in the Louvre, Paris.

BIBLIOGRAPHY
Bartsch XVIII, p. 191, No. 16;
Illustrated Bartsch, 3096.01452

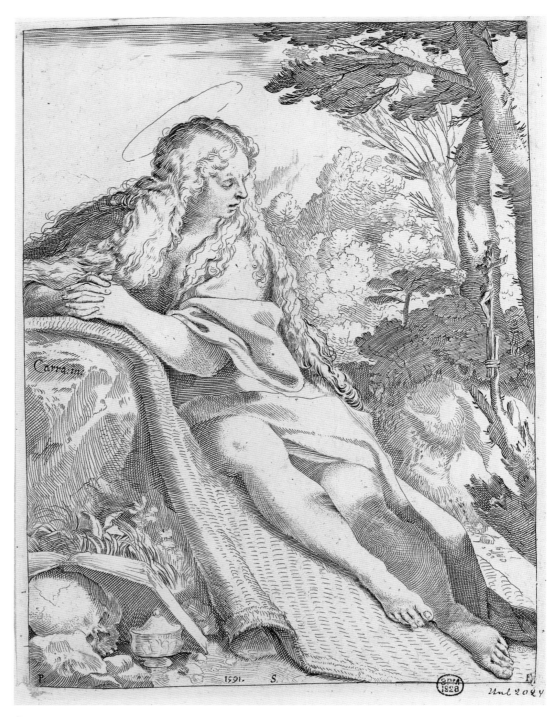

65

65

The Repentant Magdalene
3rd state. Etching, engraving
22.5 × 17 cm (8⅞ × 6¾ in.)
Inscribed left, on the stone: *Carracci*;
bottom center: *1591*; above the frame bottom center: *PSF*

Inv. No. 2024

The 3rd state (previously described as the 2nd state) differs from the previous not only in the addition of the publisher's initials, but also in the greater visible wear of the plate, producing a paler and weaker impression. This print was probably made in the early seventeenth century.

BIBLIOGRAPHY
Bartsch XVIII, p. 191, No. 16;
Illustrated Bartsch, 3096.014 S3

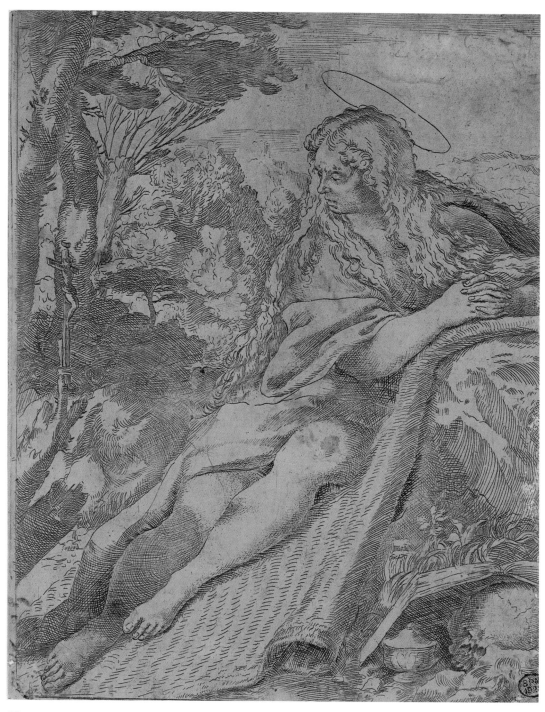

66

66
The Repentant Magdalene
Anonymous seventeenth-century
engraver
Etching
21.3 × 16.2 cm (8³⁄₈ × 6³⁄₈ in.)
Inv. No. 2025

This reversed copy of Annibale
Carracci's print was made at
the beginning of the seventeenth
century. Of relatively good quality,
it provides evidence of the original's
popularity.

BIBLIOGRAPHY
Illustrated Bartsch, 3906.014 C2 S1

A.L.

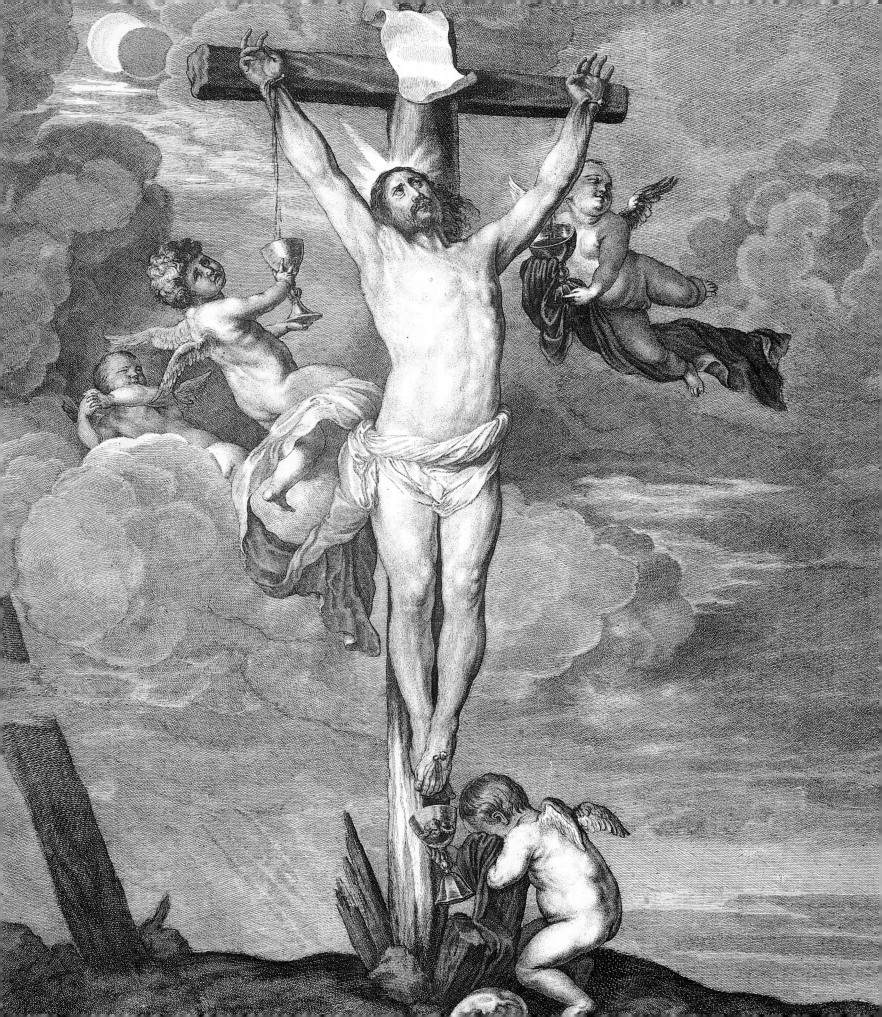

67
Page displayed:

The Crucifixion with Angels
Wenceslaus Hollar, after an
original by Anthony Van Dyck
1652
Etching
55 × 40.7 cm (21⅝ × 16 in.)
Beneath the image: *INTVEMINI ET
VIDETE AN SIT DOLOR SICVT
DOLOR MEVS QUI FACTVS EST
MIHI*
Below: *Antoni van Dyck Eques Pinxit –
W: Hollar fecit 1652.*
Inv. No. OG 30710

From:
Album of Engravings after
Originals by Anthony Van Dyck
Date of album 1815
Album bound in brown leather
with gold ornamental stamping
On the front binding: the imperial
cover ex-libris with the arms of the
Russian Empire
On the spine: *OEUVRE / DE /
VAN DYCK / Tom. VI.*
Inv. Nos. OG 30696–39718

This is one of nine albums
containing prints after originals by
Van Dyck that derive from the III
Department (prints and drawings)
of the Imperial Hermitage. A series
of such albums was compiled by
the Department's keeper at the start
of Alexander I's reign. At the start
of the nineteenth century such
albums of prints formed the core
of the imperial collection; they were
divided according to the national
schools (Italian, French,
Netherlandish, Dutch, Flemish, etc.)
and within the schools by each artist
after whose original each print was
made. First, in accordance with the
norms of contemporary European
art history, came prints of the Italian
school (e.g. cat. 64–66), then of the
French and Netherlandish. Today
the Hermitage's Department of
Prints still has twenty-three such
albums devoted to artists of the
Netherlandish school, including
Hendrick Goltzius (four), Peter Paul
Rubens (nine), Anthony Van Dyck
(nine) and Nicholas Berchem (two).

Each artist's œuvre was arranged
within the albums systematically,
according to a scheme developed in
the eighteenth century and
canonized by Adam von Bartsch,

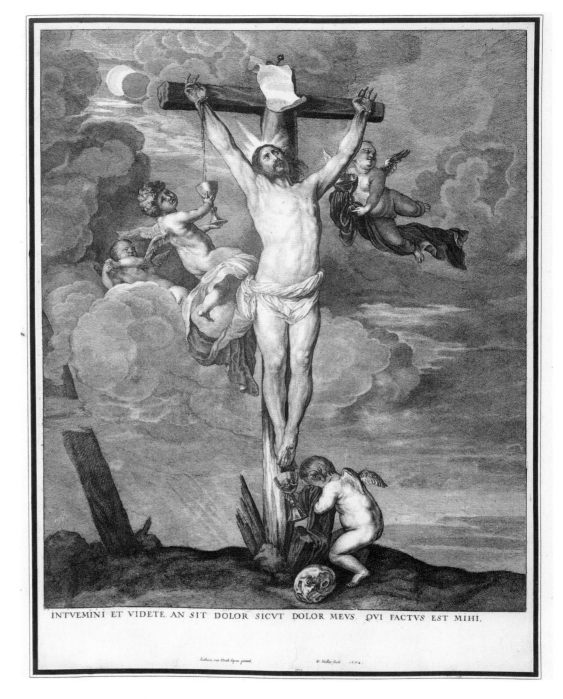

INTVEMINI ET VIDETE AN SIT DOLOR SICVT DOLOR MEVS QVI FACTVS EST MIHI.

keeper of the Albertina, Vienna, in
his celebrated series of reference
works *Le Peintre graveur* (21 vols.,
Vienna). Under this system subjects
from the Old and New Testaments
came first, then the lives and images
of the saints, followed by Church
history and then mythological
subjects, history subjects, portraits,
landscapes, miscellaneous subjects,

etc. Various individual sheets in
the III Department seem to have
been bound in such albums, the
compilation of which continued
throughout the nineteenth century
as new prints were acquired.

Van Dyck created several dozen
prints himself (Hollstein Nos. 1–21),
but his works also served as a point
of departure for the creation of

numerous prints both during his
life—under his own control—and
later, after his many works became
scattered about European
collections. Van Dyck's most famous
connection with printmaking lies in
his series of engraved portraits of
contemporaries known as the
Iconographia (c. 1632–44). This
gathered portraits of historical

figures, monarchs and other powerful figures, politicians, military, and Church leaders in an engraved gallery of a kind not particularly new in the seventeenth century. Van Dyck's innovation lay in that he included—alongside rulers and military commanders—contemporary artists, painters, architects, engravers, and sculptors (for further detail on the engravings see Carl Depauw and Ger Lijten: *Anthony van Dyck as a Printmaker*, exhib. cat., Museum Plantin-Moretus/ Stedelijk Prentenkabinet, Antwerp, 1999; Antwerpen Open/ Rijksmuseum, 1999–2000; Amsterdam, 1999).

The subject Hollar chose to reproduce differs considerably from the majority of surviving images of the Crucifixion by Van Dyck. No painted work by the Flemish artist showing the Crucifixion with angels gathering the blood of Christ from his wounds in the Eucharist bowl— an iconographical type with strongly mystical Catholic overtones—is listed either in Gluck's catalogue of 1931 or in the two-volume *catalogue raisonné* by Larsen (see *Van Dyck: Des Meisters Gemälde*, ed. G. Gluck, No. XIII in the series Klassiker der Kunst, 2nd edn., Stuttgart-Berlin [1931]; Erik Larsen: *The Paintings of Antony van Dyck*, 2 vols., Freren: Lucca, 1988).*

Van Dyck repeatedly turned to the subject of the Crucifixion throughout his career, but in both his First Antwerp Period (before 1621; Gluck [1931] Nos. 19, 27) and in his Italian period of 1622–27 (Gluck [1931], Nos. 133, 143), when he painted five altarpieces of the Crucifixion on commission for Southern Netherlandish churches, he most frequently preferred a different iconographic variant, more closely tied to the Gospel texts, which includes Mary and saints (St. Mary Magdalene, St. John, St. Francis, St. Bernard).

This subject as engraved by Hollar in 1652 is iconographically closer to a version from the Italian period (Gluck [1931] No. 133), which lacks the attendant figures and shows the crucified Christ still alive, set against a darkened landscape with the silhouettes of Gothic buildings, and with the skull of

Adam at the foot of the cross. The differences lie in the images of cherubim, three of which are gathering the blood from Christ's wounds in a chalice while the fourth laments him, and these transform the image from a mere illustration of the Gospel text into an embodiment of its mystic meaning.

The three chalices reveal the semantics of the two main Christian mysteries, the Eucharist and Baptism. The blood of the crucified Christ gathered in the chalice (the Eucharist vessel) recalls the concept of redemption, symbolized by the Christian ritual of Communion. Thus this image recalls one of

Christianity's main tenets, treatment of which was central to the theological polemics between the Catholic and Reformed Churches: Christ's expiation of the sins of mankind.

* An indication that the painted original for this print by Hollar survived is to be found in F.W.H. Hollstein: *Dutch and Flemish Etchings, Engravings and Woodcuts c. 1450–1700*, 21 vols., 1949–81, vol. VI, *Douffet–Floris*, Amsterdam [1952], p. 115, No. 292: "W. Hollar. Christ on the Cross with two [sic] Angels. 1652. 56×40 cm. P. 107. Painting in Toulouse." Compare the

catalogue Denis Milhau: *Musée des Augustins. Guide sommaire (Peintures), Ville de Toulouse, Toulouse* [s.l.], p. 34: "Anton VAN DICK, Anvers, 1599–1641: Le Christ aux anges." Due to the brevity of this catalogue it contains no dimensions or technique.

BIBLIOGRAPHY
Van Dyck as Religious Artist 1979, p. 148 et passim; Parthey 1853, p. 16, No. 107; Pennington 1982, No. 107

R.G.

68
The Triumph of Riches
From the cycle of *The Vicissitudes of Human Affairs*
1564
Cornelis Cort
(Dutch, 1536–1578)
After Maarten van Heemskerck
Hieronimus Cock edn
1st state (of three)
Line engraving
25.5 × 35.5 cm (10 × 14 in.)
Bottom center: *Martinus uan heemskerck inuentor*; bottom left: *H.Cock*
Bottom right: number of this sheet within the series: *2*
In the field: Latin inscriptions by the allegorical figures: *Rapina, Usura* etc.
Beneath the image in an ornamental frame: two three-line Latin poems: *OPULENTIAM SUPERBIAE matrem, uides… Et omne VANARUM VOLUPTATUM genus*
Inv. Nos. OG 386550–386557 (page displayed OG 386550)

PROVENANCE
Transferred to the Hermitage from the Library of the USSR Academy of Sciences, 1941; Library of the Academy of Sciences, St. Petersburg, from 1728; library of Peter the Great until 1728

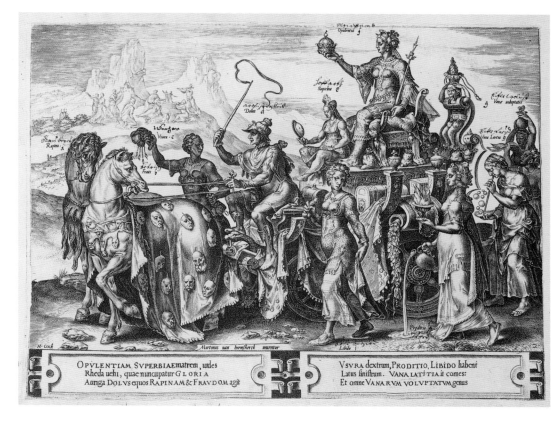

The allegorical series *The Vicissitudes of Human Affairs* represents the fruits of collaboration between two famous sixteenth-century Antwerp artists, the printmaker Cornelius Cort and the painter Maarten van Heemskerck. It was published by Antwerp's leading publisher at the time, Hieronymus Cock. This series was bound into an album, as far as we can judge from the decoration and marbled endpapers, in the late seventeenth century. These particular prints are interesting not just as marvelous examples of Netherlandish Mannerist printmaking, but also as a record of how the allegorical language of Western European art was absorbed by Russian culture during the period of Peter the Great's reforms. The prints contain two layers of handwritten additions: the first (clearly the earlier) is a translation into German of the Latin engraved titles to the allegorical figures (these German inscriptions written directly on to the original sheet), and the

second is a Russian translation of the Latin inscriptions and poems (beside each print on a separate and smaller sheet of paper). The calligraphy of the Russian inscriptions—the so-called *poluustav*—provides us with a date for the work, with evidence that the translation from Latin into Russian was carried out before Peter's reform of orthography in 1700.

This album contains the whole series of prints except the last sheet (*The Last Judgment*), and it came from Peter the Great's own library, figuring as No. 7 in a register of his books (compiled in 1728) that were to move, by order of his widow, Catherine I, from the Drawing Office of His Imperial Highness to the Library of the Academy of Sciences. It is identified with the help of a paper label bearing the inscription (also mentioned in the register), "DESCRIPTION OF FOUR ELEMENTS kopfersht [illegible] and similar affairs" ("kopfersht" is probably from the German, although the inscription is in Russian). This description of Peter's library contains several

indications that both foreign printed books and publications containing Western European prints were given Russian manuscript translations: compare the syllabic verses of Simeon of Polotsk, set into an illustrated Bible of German publication (Bobrova 1978, p. 46); the Russian translation of Latin inscriptions in two albums devoted to Roman Antiquities published in the early 1690s by D.D. Rubens (Bobrova 1978, p. 41); the publication of Giacomo Barozzi da Vignola's architectural treatise (Historical Outline 1956, p. 352); and Russian indexes to atlases published in Amsterdam in the 1690s.

The very nature of this piece, an unusual handbook used by Russian artists to study Western allegorical language, allows us to set it not only within the context of late-seventeenth-century Russian collecting of Western European art but also in a wider context. This refers to a paradoxical feature of the contemporary Russian artistic situation, where a style and visual structure already archaic in Western Europe—Netherlandish

Mannerism—provided the essential source for the development of Russian religious iconography. The clearest manifestation of this is the way that Russian artists adapted the iconography of engravings by Antwerp Mannerists that appeared in the Piscator Bible (the illustrated Old and New Testaments published by a famous Dutch seventeenth-century publisher, Nicolaus [Claasz] Fischer). This is particularly true of the artists who painted frescoes for churches along the River Volga and in Moscow during the last third of the seventeenth century. (In retrospect it seems no matter of chance that one of these artists was the father of two leading figures in the school of etching in the Petrine period, Ivan and Alexei Zubov.)

BIBLIOGRAPHY
Historical Outline 1956, p. 307; New Hollstein, pp. 166–67; Veldman 1977, pp. 133–41; Veldman 1986, pp. 47–57

R.G.

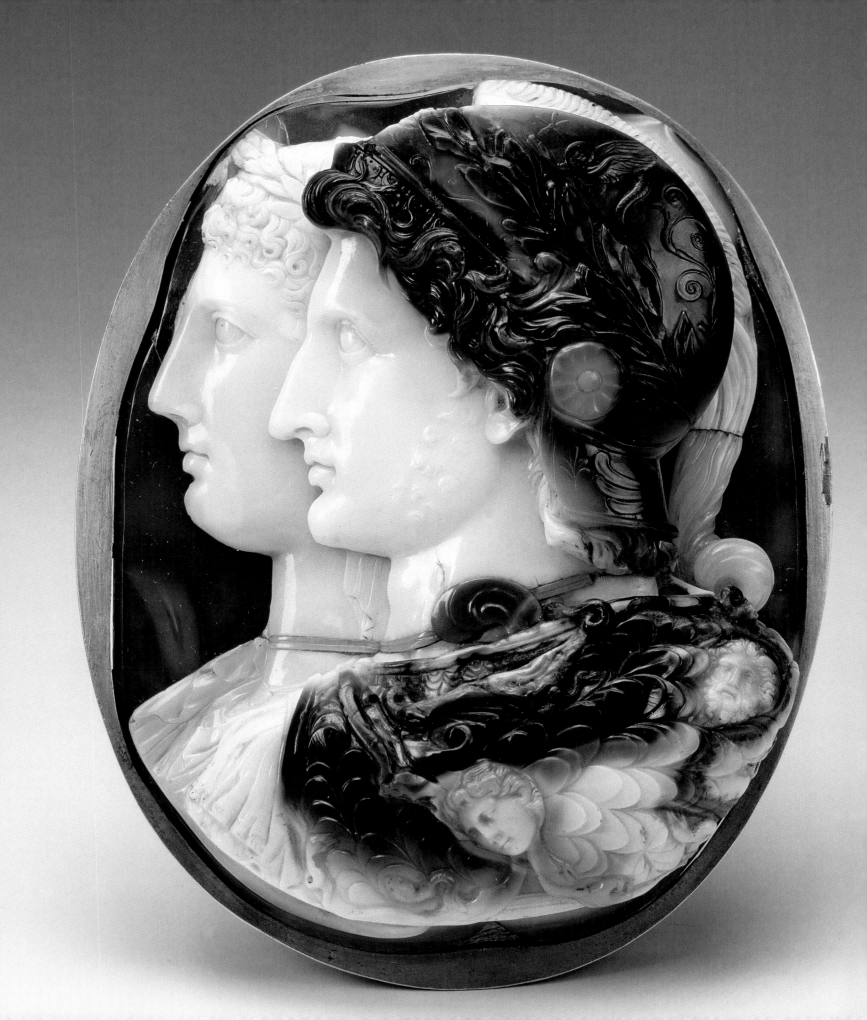

JULIA KAGAN

Cameos

From ancient times to the very end of the nineteenth century, the engraving of portrait gems occupied a special place in the history of engraved gems. Although the genre often included images of private individuals (although not early on), it found its fullest expression in portraits of rulers. Both types of glyptics—intaglio (in which the image is hollowed out from the stone) and cameo (in which the background is cut away to leave the image in relief)—were used to record the appearance of masters of men's fate, sometimes capturing idealized versions of their individual features and sometimes presenting more realistic images.

The evolution of this form of cameo portraiture can be traced to the Hellenistic period. According to legend, Alexander the Great not only had his own painter, Apelles, but also his own gem engraver, Pyrgoteles, who depicted him with the attributes of Zeus or the horns of Amun the Sun God. One of the most famous cameos of all is a piece produced in the court workshop at Alexandria between 278 and 270 B.C., likening the ruler of Hellenistic Egypt, Ptolemy II, and his sister and wife Arsinoë, to gods of the Greek pantheon, and giving Ptolemy himself the features of Alexander the Great. Celebrated as the *Gonzaga Cameo* (opposite, Hermitage Museum), after the Dukes of Mantua to whom it belonged in the sixteenth and early seventeenth centuries, or sometimes as the *Malmaison Cameo*, after the palace inhabited in the early nineteenth century by a later owner, Josephine de Beauharnais, it established for all time a specific type of double portrait with profile heads overlaid one upon the other facing in the same direction, called *capita jugata*. Other rulers of the Hellenistic world also appear on gems as "new" Alexanders, while their spouses were shown as the goddess Isis.

During the first century B.C. many Greek masters moved to Italy, and the Roman emperor Augustus's personal portraitist was the Greek Dioskurides. During the Augustan era large, multi-figure cameos appeared, glorifying the emperor and his victories, but also serving to proclaim important political messages. These "dynastic manifestos" have come to be known in the literature as

"state cameos," and the most significant examples are the *Gemma Augustea* (Kunsthistorisches Museum, Vienna) and the *Gemma Tiberiana* (Cabinet de Médailles, Bibliothèque Nationale, Paris).

Even during the decline of glyptics in the medieval age, the portrait genre never completely disappeared. Portraits of Otto IV, Friedrich II Hohenstaufen, and Charles V of Spain have all survived. As in Antiquity, their creation depended directly on the patronage of rulers. The portraits of the Renaissance era represent an outstanding phenomenon, and among those who gave many highly paid commissions to Italian engravers were the French kings Louis XII, Henri II, and Henri III. All the Renaissance schools of glyptics are represented in the Hermitage collection, offering a gallery of images of

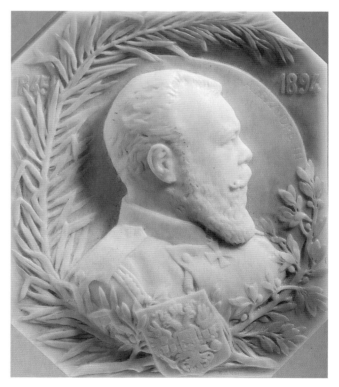

George Tonnellier, *Portrait of Alexander III* (see cat. 77)

secular and spiritual leaders. Among these are an enormous number of cameo portraits of Philip II of Spain and Elizabeth I of England.

Glyptics continued to decline in the seventeenth century. By its very nature the art form could not live up to the demands of the Baroque style for striking decorative effect. During the eighteenth century and the first half of the nineteenth, a period marked by the last flowering of glyptics, the courts of European monarchs remained the key centers of production. As other art forms increasingly moved away from classicizing styles during the second half of the nineteenth century, the divide between mainstream art and glyptics grew wider, and with the collapse of absolute feudal systems, glyptics—above all portrait glyptics—was deprived of its traditional patrons and clients.

This brief history of portrait glyptics introduces the selected Hermitage portraits of the Romanov dynasty in order to demonstrate just how logical, and even inevitable, it was that such items should appear within the Russian imperial circle. Many functions of official portrait glyptics (as seal, votive gift, political message bearer) had already been lost over the ages, yet these items still reflect a reverence for traditions deeply rooted in Antiquity, and their appearance should be seen as a manifestation of the vain desire to be commemorated for all time in a material not vulnerable to wear over the ages. Nor should it be forgotten that the Romanovs had a deeply felt desire to conform to accepted European practice, where carved portraits served as memorial and diplomatic gifts.

Many parallels are to be found between the phenomenon as it developed in Russia and in the West. Orders might be sent to engravers residing in European capitals, and foreign masters were invited to come to Russia, tempted by generous patronage and pay, while attempts were made to encourage the development of home-grown masters to perform those same tasks at far less cost. It should be noted, however, that the majority of the portraits of ruling individuals or their royal predecessors were created in Russia and remained the private property of the imperial family, not entering the Hermitage until much later and eventually forming the world's most extensive museum collection of imperial portraits on engraved gems.

The very earliest examples of this kind date from the reign of Peter I in the first quarter of the eighteenth century. Field Marshal Jacob Brius—James Bruce, of Scottish descent—commissioned a series of portraits of Russian princes and tsars from Rurick through to Ivan V from the Nuremberg master Johann Christoph Dorsch. He provided the engraver with pieces of dark-green

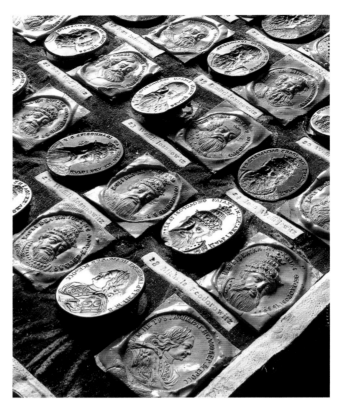

Johann Christoph Dorsch, intaglio seals, first quarter of the eighteenth century. The State Hermitage Museum, St. Petersburg

jasper found by the River Argun in Siberia and tracings of portraits from the *Sovereigns' Book* (also known as the *Titular Book* or *Root of the Great Sovereigns*). This little jasper "portrait gallery" consists of thirty-two oval intaglio seals on which the image of each sovereign is accompanied by an inscription containing his title and name. The portraits are generalized, archaic, and apart from the very latest, have no basis in fact, effectively representing a kind of halfway state between icon and secular portrait.

After the death of Peter, Bruce added his portrait to the series, and, as his successors died, their images were carved as well. These new intaglios were commissioned not from Dorsch but from Russian masters who had studied engraving on stone in the recently founded St. Petersburg Academy of Sciences. Bruce himself died in 1735, bequeathing his library and all his collections, including this series, to the Kunstkammer. In the stoneworking shop attached to the Academy of Sciences and run by the Swiss Isaac Bruckner, the series was continued and copied in the same material by his Russian pupils Fedor Kraiukhin, Andrei Spiridonov, and others. Despite having absolutely no value as a reference to the rulers' real appearance, the engravings play a leading role in the establishment of a Russian iconography, particularly with regard to the early history

of Russia. A copy of the series entered the Hermitage during the reign of Catherine II, around 1785, and Dorsch's own intaglios were transferred to the museum in 1894. The Hermitage today has engraved portraits of all members of the House of Romanov, with the exception of the last ruler, Nicholas II, since, by the time of his reign, cameo portraiture had been superseded by miniatures and daguerreotypes.

Just a small portion of this wealth of material is included here, showing Russian emperors and empresses and their heirs portrayed by Russian and European masters. Archive documents record that the first Russian engravers who worked at the Academy of Sciences, and then in its subsidiary, the Peterhof Grinding Mill, not only made copies after Dorsch, but also on several occasions produced carved portraits in jasper and agate of Peter I, Catherine I, Elizabeth, Peter II, and Anna Ioannovna. The greater part of these perished in a fire at the Academy of Sciences in 1747, but one surviving piece is the state portrait of Peter I's daughter Elizabeth (after a medal by the celebrated medaler Johann Carl Hedlinger)—the work of Fedor Krayukhin, in pale-green jasper of Siberian origin (cat. 70). Catherine II was a passionate collector of engraved gems, and it is to her that the creation at the Hermitage of the largest collection of engraved gems in the world is owed. Some ten thousand original pieces were collected during her lifetime alone, and as many more entered the museum after her death. It was Catherine who commissioned from the celebrated engraver Johann Weder the portrait of Peter the Great in a laurel wreath (cat. 78), but in general she expected contemporary engravers to produce portraits of herself: during the empress's lifetime she was depicted by some fifteen European masters abroad, as well as by foreign engravers (usually German) working at the court and by the few existing Russian masters, so that a total of more than fifty cameos and intaglios survive today. Some thirty of these, including anonymous works, are in the Hermitage.

Catherine's love of engraved gems was so infectious that it drew in those around her: "Scholars and the ill-educated—all have turned into antiquarians," she wrote to Prince Nikolai Yusupov in 1788. One favorite pastime at the court was the making of casts from engraved gems in papier mâché, and, although Catherine herself never went further than this, she encouraged her close family to carve gems. The court medaler and engraver Karl von Leberecht taught this difficult craft to her favorite, Count A.M. Dmitriev-Mamonov, and to Grand Duke Paul's wife, Grand Duchess Maria Fedorovna, and her daughters. Chosen specially for this exhibition is a superb portrait of Catherine II as Minerva, goddess of Wisdom,

carved in jasper by Maria Fedorovna herself (cat. 76; see also cat. 87). The Grand Duchess presented this cameo to her mother-in-law on the latter's name-day in 1789, and on the same occasion in succeeding years she presented the empress with her own carved portraits of Paul and their children. She produced a double portrait of Grand Dukes Alexander and Constantine in the double-headed *capita jugata* format (as seen on the *Gonzaga Cameo*). In painted, sculpted, and miniature portraits we repeatedly see Maria Fedorovna in the years after her husband's murder wearing upon her mourning dress a cameo with her husband's portrait; after the death of her son Alexander I she was also to wear a cameo showing him as a youth. The exhibition is also graced with portraits of Paul and Maria Fedorovna (cat. 72, 73) carved by the famed Giovanni Pichler during the young couple's travels abroad in the early 1780s. Giuseppe Girometti's cameo with double-profile busts of Emperor Alexander I and his wife, Elizaveta Alexeevna (cat. 69), again recalls the famous *Gonzaga Cameo*, which the engraver undoubtedly had in mind; perhaps the parallel was a condition of the imperial commission. It is interesting to note that in February 1831 the Russian stone engraver Peter Dobrokhotov was ordered by the Council of St. Petersburg's Academy of Arts to engrave in four-layer sardonyx portraits of the next Russian emperor, Nicholas I, and Empress Alexandra Fedorovna, "according to the type of the famous stone showing Ptolemy and his wife." If he had managed to fulfill the commission, this might have established a tradition, but Dobrokhotov died while he was still working on the cameo.

From among the Hermitage's many engraved portraits of Nicholas I, the one included here is a cameo by Giovanni Longhi (cat. 71), a little-known but undoubtedly talented Italian engraver of the first half of the nineteenth century. The cameo showing Alexander III by the Paris medaler and engraver George Tonnellier (cat. 77) is a work inspired by French plaques, a large variation on medals that appeared at the end of the century, loaded with inscriptions and emblematic symbols. So late a commemorative cameo (produced in 1896, two years after Alexander's death) is far rarer than the engraved portraits of the more distant past.

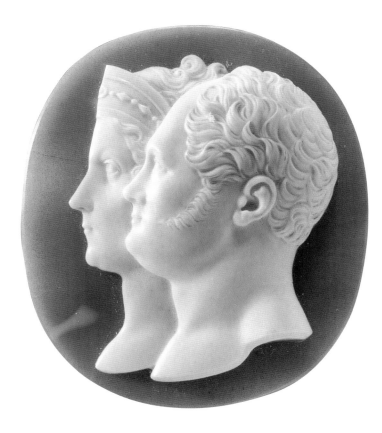

69

Cameo: Portrait of Alexander I and Elizaveta Alexeevna

Giuseppe Girometti
(Italian, 1780–1851)
c. 1816
Sardonyx
4.9 × 4.3 cm (1⅞ × 1¾ in.)
Signed: *GIROMETTI*
Inv. No. K 1100

PROVENANCE
Bequeathed to the Hermitage by
Empress Alexandra Fedorovna,
24 March 1861

Alexander I (1777–1825), eldest son
of Paul I and Maria Fedorovna,
from 1801 Emperor of Russia,
married Elizaveta Alexeevna, née
Luisa Maria Augusta, Electress of
Baden Baden (1779–1826), in 1793.

Giuseppe Girometti was a leading
Italian engraver and medaler in the
first half of the nineteenth century.
A pupil of the sculptor Vincenzo
Pacetti, he began his career with
monumental sculpture but gave this
up in favor of engraved gems and
medals. His first preference
nonetheless made itself felt in the
cameos (which he always preferred
to intaglios) showing figures and
compositions by Canova and
Thorvaldsen, but as both medaler
and engraver Girometti also
produced numerous portraits,
including some of crowned heads.
In addition to this paired portrait
cameo, he was also commissioned
by the Russian court to produce a
portrait cameo of Alexander I *en face*
(after a bust by Thorvaldsen) and
one of Nicholas I in profile. All are
now in the Hermitage, and they are
united by their common material, a
multi-layer sardonyx tinted pinkish-
white, as if they were carved from a
single large piece of the stone.

The prototype for this paired
portrait was the celebrated *Gonzaga
Cameo* or *Malmaison Cameo* (see
p. 152), presented in 1814 by
Napoleon's first wife, Josephine de
Beauharnais, to Alexander I in
gratitude for his generosity to her
after Napoleon's defeat. This double
portrait, born of a particular
historical situation in Egypt,
influenced engravers of the post-
Hellenistic period and of imperial
Rome, and was repeatedly recalled
in works of the Renaissance and
Baroque periods. It was not only
glyptics that was affected, for echoes
of the same composition scheme are
to be found in the works of painters,
printmakers, and medalers such as
Peter Paul Rubens, Jean-August-
Dominique Ingres, A. Denoyelle,
and Bertrand Andrieu.

Well known from casts and
prints, the *Gonzaga Cameo* also drew
the attention of Giuseppe Girometti,
who made a close, if not literal,
copy in stone, the results being
described as "the most significant
cameo of the nineteenth century"
(Umani 1943–44, p. 70); the wax
model for this is in the Museo di
Roma (Righetti 1955, p. 92,
pl. XIX). This experience was of use
to the artist when he created the
double portrait of the Russian
imperial couple. In the Kremlin
Museums in Moscow is a gold
snuffbox with enameling in black
and blue (Inv. No. MR 642) by the
St. Petersburg jeweler Johann
Wilhelm Keibel (1788–1862), set into
the lid of which is a similar but
smaller cameo carved in the same
stone, also with the signature of
Giuseppe Girometti. Around the
cameo is a "frame" in the form of a
snake biting its own tail—symbol of
eternity; above and below are the
dates the subjects died. This
commemorative snuffbox is dated
to 1826.

EXHIBITIONS
St. Petersburg 1999

BIBLIOGRAPHY
Maksimova 1926, p. 33; Neverov
1977, p. 28; Neverov 1988, p. 36

J.K.

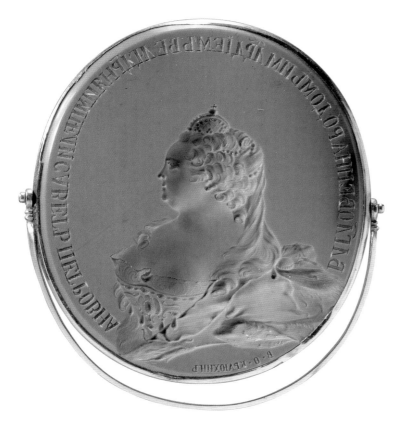

70
Intaglio: **Portrait of Empress Elizabeth I**
Fedor Kraiukhin
(Russian, 1722–1778)
Late 1740s
Green Siberian jasper, gold
5.1 × 4.6 cm (2 × 1¾ in.)
Inscription around the edge:
BL[a]GO[slo]VENNA RODOM I M[i]L[ose]RDIEM' VEL. G[osu]D[a]R[i]NYA IMP. ELISAVET' PETROVNA (Blessed with birth and mercy, Great Sovereign Empress Elizaveta Petrovna)
Inscription below: *V[yrezal'] θ KRAYUKHIN'*
(Carved by F. Kraiukhin)
Inv. No. I 3640

PROVENANCE
Purchased in 1917

Elizabeth (1709–61/62), daughter of Peter the Great and Catherine I, was Empress of Russia from 1741.

Kraiukhin's intaglio is his sole surviving work in stone and it repeats a single-sided portrait medal of Elizabeth by Johann Carl Hedlinger (1691–1771), one of the best works by this famous Swiss medaler. The basis of the medal (the stamp for which Hedlinger sent to Russia in 1745) was a drawing by Louis Caravaque (1684–1754).

Following Hedlinger, Kraiukhin created a superb version of an official engraved portrait: although in transferring such images from metal to stone engravers usually abbreviated and generalized the details, Kraiukhin did not omit here any of the accessories of power. The complex hairstyle, with its long lock of hair interwoven with threads of pearls, the robe and ermine mantle embroidered with precious stones and pearls, the empress's buxom form, and the feminine air she particularly cultivated, are combined with a majestic pose and general air of state symbolism. A lead copy of Hedlinger's original signed by Kraiukhin is in the Department of Numismatics of the Hermitage (Shchukina 1962, p. 63).

Soon after production of this intaglio Fedor Kraiukhin, "pupil of arts engraved in stone and steel" at the Academy of Sciences, was given the title of apprentice and helped train young stone engravers. The copying of Hedlinger's medals remained an obligatory element in the training of Russian carvers and makers of medals over succeeding generations.

BIBLIOGRAPHY
Maksimova 1926, p. 34; Hermitage Masterpieces 1994, vol. II, No. 690

J.K.

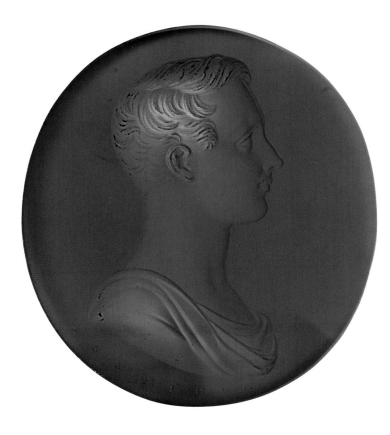

74
Intaglio: **Portrait of Grand Duke Alexander Nikolaevich**
Luigi Pichler
(Italian, 1773–1854)
c. 1836
Signed: Λ. ΠΙΧΛΕΡ [L. PICHLER]
Sardonyx
4 × 3.5 cm (1⅝ × 1⅜ in.)
Inv. No. I 12763

PROVENANCE
2000 acquired by the Hermitage through the Department of New Acquisitions.

Alexander Nikolaevich (1818–81), eldest son of Nicholas I and Alexandra Fedorovna, was Emperor Alexander II of Russia from 1855.

Luigi Pichler was the last major representative of the Pichler dynasty of engravers, son of the dynasty's founder, Antonio Pichler, and half-brother and pupil of Giovanni Pichler. He began his career in Rome, from where he twice traveled to Vienna, in 1796 and 1808; on the second occasion, invited by Prince Metternich, he was elected an Honorary Member of the Austrian Academy of Arts. In 1818 Luigi moved to Vienna, where for thirty-two years he held the post of Professor of Engraving in Hardstones at the Academy. He was also awarded membership of the Accademia di San Luca in Rome and of the Accademias in Florence, Milan, and Venice.

This recently acquired intaglio is among the most significant additions made in recent years to the Hermitage collection of post-Classical gems, particularly with regard to works by the Pichler dynasty of engravers held in the collection.

The portrait is close to a medal by Niccolò Cerbara (1793–1869) produced in 1839 to mark the heir to the Russian throne's visit to Rome, but in the intaglio Alexander looks younger and the portrait is shoulder length, with drapery covering the shoulders in the manner characteristic of Luigi Pichler. As in cats. 72 and 73, the engraver here used dark-brown sardonyx. Perhaps this portrait was commissioned at the same time as Pichler's portrait of Alexandra Fedorovna, around 1836, in which case Cerbara may have worked from a cast.

Numerous sets of casts from engraved gems by all three Pichlers were produced for sale (although the sets varied in composition and in how fully they reflected the masters' œuvre), and these did much to extend the artists' fame. One such set in the Hermitage includes a cast of this portrait of Alexander Nikolaevich, fully confirming its authenticity.

Unlike other portraits commissioned from Luigi Pichler and then transferred to the Hermitage, this childish portrait seems to have remained the property of the imperial family until it was perhaps lost. According to a family legend related by the former owner, the intaglio was found by one his ancestors on a walkway in the park near the imperial palace at Livadia, a favorite summer residence of the last Romanovs in the Crimea (now Ukraine).

BIBLIOGRAPHY
Rollett 1874, p. 61; Forrer 1904–30, vol. IV, p. 524.

J.K.

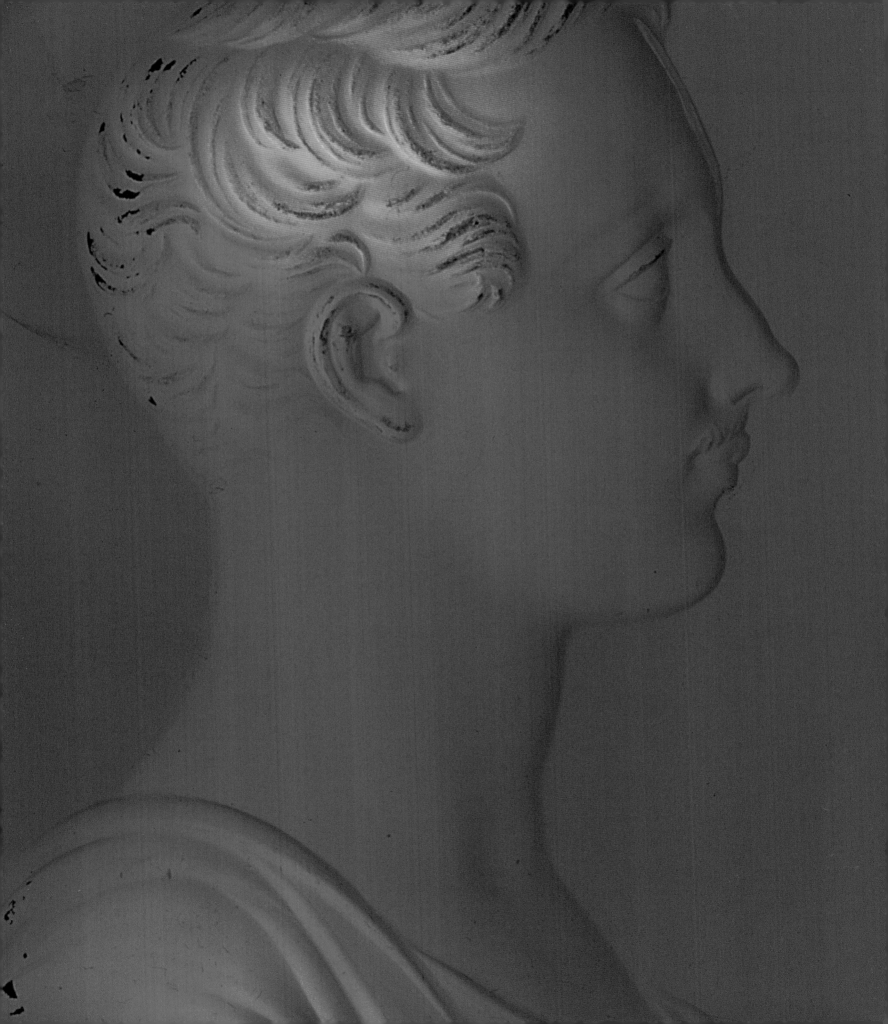

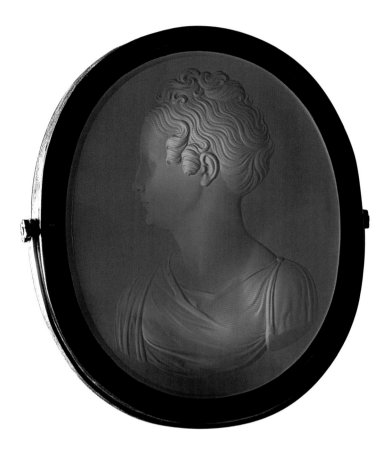

75
Intaglio: **Portrait of Empress Alexandra Fedorovna**
Luigi Pichler
(Italian, 1773–1854)
1836
Sardonyx, gold
7.6 × 6.3 cm (3 × 2½ in.)
Signed: Λ. ΠΙΧΛΕΡ [L. PICHLER]
Inv. No. I 3665

PROVENANCE
Acquired from the artist, 1836

Alexandra Fedorovna (1798–1860), née Frederika Luisa Charlotta Wilhelmina, daughter of Friedrich Wilhelm III and Queen Luisa of Prussia, in 1817 married Grand Duke Nicholas, from 1825 Emperor Nicholas I of Russia.

The Hermitage has a very significant collection of Pichler's gems, which—apart from commissions received directly from the imperial court—were created for the Russian envoy in Vienna, D.P. Tatishchev, who bequeathed his artistic collections to Nicholas I in 1845. Pichler also produced a triple portrait of Tsar Alexei Mikhailovich Romanov with his empress and his son, Peter I, as well as portraits of Alexander I and Nicholas I.

In its iconography—including the hairstyle, the tunic, the nature of the folds, and the cut-off almost at the waist—this intaglio is very like the bust of Alexandra Fedorovna produced by Christian Daniel Rauch around 1818, one version of which (a galvanocopy) is in the Russian Museum in St. Petersburg, while there is a plaster version in the Hermitage (Simson 1996, pp. 108–09, No. 61). Similarities in profile and hairstyle are also noticeable when compared with an engraving by Thomas Wright, but there the bust is cut off much higher and there is no tunic. It is possible that a single visual source was used to create all three portraits.

While the intaglio was still in the engraver's workshop, an impression of it was sent from Vienna to the Hermitage for dispatch to the Imperial Grinding Factory at Ekaterinburg, where a small chalcedony cameo (2.8 × 2.1 cm/ 1⅛ × ⅞ in.) was immediately carved from it for a series of seven similar portraits of representatives of the Russian ruling house from Peter I onward. This series was specially carved to mark the visit to Ekaterinburg in 1837 of the heir to the throne, the future Alexander II, and was presented to him when he came to the factory. Judging by archive records, the series was carved by a master at the factory, Dmitry Petrovsky, and on the heir's return to St. Petersburg it entered the collection of his mother, Alexandra Fedorovna. Between 1842 and 1844, the same model was used at the factory by Vasily Kalugin and Iakov Khmelinin to produce a almost same-size cameo in the Urals stone known as Iamskaia jasper, as a pair to a portrait of Nicholas I.

BIBLIOGRAPHY
Forrer 1904–30, vol. IV, p. 524; Maksimova 1926, p. 31; Kagan 1994, p. 93

J.K.

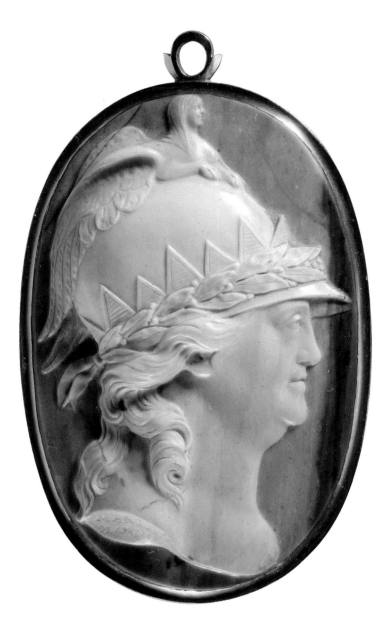

76
Cameo: **Portrait of Catherine II as Minerva**
Grand Duchess Maria Fedorovna
(Russian, 1759–1828)
St. Petersburg, Russia
1789
Jasper, gold
6.7 × 4 cm (2⅝ × 1⅝ in.)
Signed and dated below: *MARIA F. 21 APR. 1789*
Inv. No. K 1077

PROVENANCE
Presented to Catherine II by Maria Fedorovna on 21 April 1789

Catherine II (1729–96) was Empress of Russia from 1762.

Engraving in stone was one of the numerous artistic pastimes of Grand Duchess Maria Fedorovna (Catherine II's daughter-in-law, and herself a future empress) and one in which she was particularly successful. She mastered this most difficult of arts with the aid of the court medaler and gem engraver Karl von Leberecht (1755–1827), although she never allowed him to interfere with her creations. According to the librarian and secretary to Grand Duke Paul, Herman Lafermier, who often observed her at work, "… she makes a model in wax from nature or, as in the case with the Empress, from a good portrait, and from this she then carves the cameo in hard stone, using attractive stones from Siberia with different layers … . When modeling the portrait she receives advice from her teacher or from someone present, and if she finds it just she takes it into account, but once she is working the stone itself at the lathe her teacher has no right to offer his aid and his duties are limited to passing her tools." (Vorontsov Archive 1883, p. 292)

This portrait of Catherine II in Minerva's helmet adorned with a laurel wreath and a winged sphinx, was carved in 1789 in grayish-pink Siberian jasper in honor of her name-day. The Grand Duchess placed the precise date (Old Style) beside the signature on this, the best of her works of this kind. Immediately the cameo gained fame through reliefs cast in biscuit and smalt at the Imperial Porcelain and Glass Factories and molded in glass paste in a special laboratory for the reproduction of gems set up in the Hermitage. Archive materials and surviving objects reveal that Maria Fedorovna herself made such copies in paste, plaster, and mastic with the aid of a special lathe and other equipment, using them not only as gifts but also for the decoration of furniture, clocks, and other objects in the interior of Pavlovsk Palace. Just such a paste (set with diamonds) is visible, together with a pearl necklace on Maria Fedorovna's breast, in state portraits of her by Johann-Baptist Lampi and Jean-Louis Voille and a miniature attributed to L.G. Zharkov (all Pavlovsk Palace, near St. Petersburg).

This cameo portrait was also reproduced in prints. Apart from the rare stipple engravings by William Arendt and Herman Roosing, there was a more common print in the same technique by James Walker, who printed it both on paper and on satin in brown, red, and black ink with the blue background around the oval. The mythological image of Catherine II created by Maria Fedorovna was copied in 1796 by F. Lialin for the series of medals *Russian Princes and Tsars*, in a medal commemorating Catherine's death.

Outside Russia, the cameo was mass-produced in England at the Wedgwood factory in the form of jasper ware cameo-like medallions (see cat. 91); at the manufactory of James Tassie in glass paste; and at the manufactory of Apsley Pellatt in crystallo-ceramics or sulphides.

EXHIBITIONS
Pavlovsk 1989; St. Petersburg 1999b, No. 52; Pavlovsk 1999; London 2000–01, No. 196

BIBLIOGRAPHY
Vorontsov Archive 1883, p. 291; Kobeko 1884, p. 403; Maksimova 1926, p. 35; Reilly, Savage 1973, p. 85; Smith 1995, p. 35; Kagan 1996, p. 231, fig. 1b; Vasil'eva 1997, p. 336; Unforgettable Russia 1997, pp. 66, 78–80; Kagan 1999b, p. 185; Kagan 2000, p. 206, No. 39

J.K.

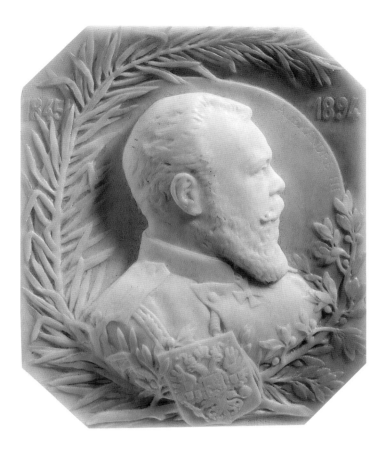

77
Cameo: **Portrait of
Alexander III**
George Tonnellier
(French, 1845–1937)
c. 1895/96
Agate
8.7×7.5 cm (3⅜ × 3 in.)
Inscribed: top left: *1845*; right: *1894*;
to right along the edge of the central
oval: *ALEXANDRE III*
Signed: TONNELLIER
Inv. No. K 1480

PROVENANCE
Transferred to the Hermitage from
the Library of the Winter Palace,
1922; perhaps commissioned 1896

Alexander III (1845–94), second
son of Alexander II and Maria
Fedorovna, was from 1881 Emperor
of Russia.

In all probability this cameo was
commissioned in memory of
Alexander III from the celebrated
French engraver and medaler
George Tonnellier by Alexander's
son Nicholas II, during Nicholas's
visit to France in 1896. Of unusually
large size for a cameo, it recalls a
plaque in both its dimensions and its
octagonal form. Such plaques were
produced in France by medalers at
the turn of the nineteenth century,
and the form passed into glyptics;
the art of carving hardstones was in
deep decline but France was one of
the few European countries where it
continued to be cultivated, enjoying
some success at various Paris
exhibitions. As part of the fight for
existence, gem engravers moved
away from traditional Classical
forms, manifesting a readiness to
subordinate the art form to new
artistic trends. This cameo is a rare
example of Art Nouveau glyptics.

Set in the center of the plaque
is an oval medallion, slightly raised
above the ground but concave (like
the whole of the plaque), bearing a
realistic portrait of the emperor
modeled in high relief. Shown in
profile, wearing a uniform with
epaulettes, he has a sash across his
shoulder and a cross under the
collar. On the background toward
the top, to either side of the
medallion, are the dates of the late
Emperor's birth and death in relief.

The main decorative and stylistic
content lie in the symbolic palm
rising up along the left edge and
the laurel that curves along the
right. These branches form a kind
of cartouche or frame around the
central medallion, overlapping the
outline of the oval itself. Below,
covering the crossing of their stems,
is a shield with the Russian arms.

Here the artist used only the
two upper layers of this multi-layer
Brazilian agate, in white and
yellowish-white, very similar in hue.
Where the yellow shows through
the surface they create a very slight
effect of color and light and shade.
Although the sides and reverse of
the stone are polished, its upper
textured side, worked up in some
detail, is totally matt, which creates
the effect of marble rather than a
hardstone.

Tonnellier was a pupil of the
French sculptors Charles Gauthier
and Aimé Millet; from 1885 he was
a regular exhibitor at the Paris
Salons and, from 1892, Secretary of
the Society of French Artists, author
of medals, engraved gems, and
sculptures *en ronde bosse* in semi-
precious stones (heliotrope,
sardonyx, chalcedony-sapphirine,
amethyst). He produced many
commissions for Europeans of the
highest rank and would seem to
have been specially recommended
to Nicholas II for the making of this
memorial portrait. The same age as
his subject, he lived into old age,
dying in anonymity in 1937. Most
of the more accessible dictionaries
of artists have a question mark in
place of his date of death.

EXHIBITIONS
Paris 1895, Salon

BIBLIOGRAPHY
Forrer 1904–30, vol. VI, p. 112;
Forrer 1904–30, vol. VIII, p. 237

J.K.

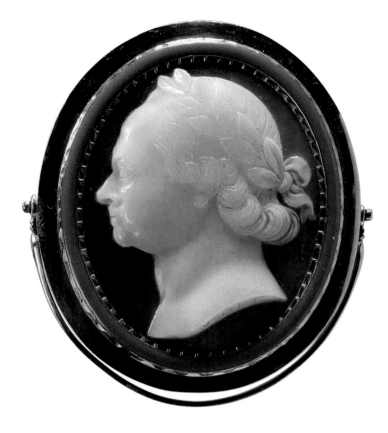

78

Cameo: **Portrait of Peter the Great**

Johann Baptist Weder
(German, 1742–1808)
1780s
Sardonyx, gold, blue enamel
4.9 × 4.2 cm (1⁷⁄₈ × 1⁵⁄₈ in.)
Signed on the shoulder: *WEDER F*
Inv. No. K 1088

PROVENANCE
Acquired by Catherine for her
Hermitage before 1794

Peter I (1672–1725), younger son of
Russian Tsar Alexei Mikhailovich,
by his second marriage to Natalia
Naryshkina, was from 1682 joint
Russian ruler, from 1689 sole ruler,
and from 1721 first Russian emperor.

Johann Weder was one of a large
number of German artists who spent
many years living and working in
the Eternal City but he was known
throughout Europe as an engraver
of cameos (we know of almost no
intaglios by him). The large number
of Weder's works in Catherine II's
gem collection—there are some
fifteen of his signed works alone,
among them portraits of the Russian
empress—can be explained by his
extensive connections. His friend
Johann Friedrich Reiffenstein,
Catherine's agent in Rome for the
purchase of artistic treasures in
Italy, mentions Weder in his letters
to the Russian ambassador in
London, Count Semen Vorontsov
(see portrait, cat. 17) (Vorontsov
Archive 1883, pp. 313, 327), while
Catherine herself writes of him in
1781 to Baron Melchior Grimm
(Catherine–Grimm Correspondence
1881, pp. 120, 160, 170) and to
Prince Nikolai Yusupov (Yusupov
1867, vol. 1, pp. 243, 248). In her
letter to Yusupov, the empress
instructed the prince: "Give the
carved gems to be engraved to
Pichler, Weder and Marchand.
The subjects? I shall note them on
a separate sheet … ." Unfortunately
that list has not survived, and we
can only presume that it included
this portrait of the predecessor she
so much admired. A year later she
wrote to Yusupov in Rome: "I
received your two letters and three
cameos … ."

This portrait of Peter I *à l'antique*,
cut off a little below the neck and
with a laurel wreath upon his head
tied behind with a ribbon, is a
superb illustration of Weder's skill.
Inspired by such a commission, the
carver amended his conscientious,
if somewhat unexpressive and
dispassionate, manner: the precise
contour, the relatively high relief,
and the sitter's intense gaze out into
space all contribute to heighten
the sense of emotion, and the face
itself reveals the influence of prints
capturing Peter's features in the
celebrated *Bronze Horseman*,
the equestrian statue by Étienne-
Maurice Falconet that stands in the
heart of St. Petersburg, for which
the head was modelled by Falconet's
young pupil Marie-Anne Collot.
 Although of later date, the
mount, with its pale-blue enamel
outline setting off the cold hue of
the stone, serves to reinforce the
portrait's heroic nature.

EXHIBITIONS
Amsterdam 1996–97, No. 162;
Florence 1998, No. 125;
St. Petersburg 1999b, No. 45;
London 2000–01, No. 171

BIBLIOGRAPHY
Maksimova 1926, p. 25

J.K.

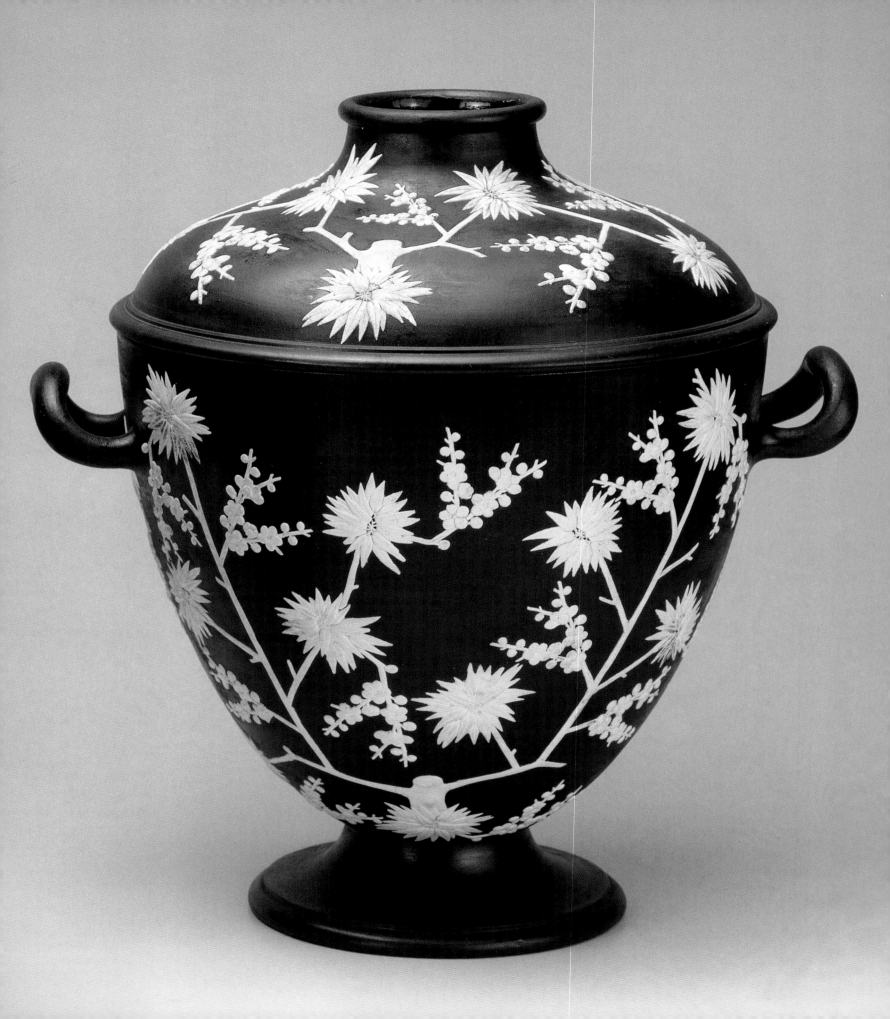

OLGA KOSTIUK, LYDIA LIACKHOVA, MARINA LOPATO, TAMARA RAPPE

Applied Art

Jewelry

Objets de vertu (precious objects) began to accumulate at the Russian court in St. Petersburg in the wake of Peter I's founding of the new capital. Part of the royal collection was transferred to the new capital in 1714 from the Kremlin Armory in Moscow, which had previously housed all royal treasures. Peter's collection, which formed the basis of the celebrated Kunstkammer, included all kinds of curiosities and minerals, as well as the famous "Siberian collection" of Scythian gold objects (also now in the Hermitage).

Initially an increase in state expenditure on military campaigns and on construction of the new capital, as well as a lack of native Russian sources for precious metals, accounted for limited activity in the production of gold and silver items. Both metals had to be imported from abroad, but by a decree of 24 August 1700 (Old Style) Peter set up a governmental body, the purpose of which was to seek domestic sources of precious metals. The first silver works were set up in 1704 near Nerchinsk and jewelers began to use Russian silver for the first time, although gold still needed to be imported in the form of bars or coins from Holland, Germany, Italy, and Turkey. The first Russian gold began to arrive in St. Petersburg after the discovery in 1745 of a source in the Urals, which brought regular income to the treasury. Such was the economic benefit brought by these Russian mines during the last years of the reign of Elizabeth that jewelry production in the capital flourished.

A new era in the history of collecting jewelry and other precious objects began with the accession to the throne of Catherine II in 1762. The new Winter Palace had just been completed and the empress immediately set about making alterations and improvements. In 1764 she transformed her state bedroom into the Diamond Room, or "Room of Brilliants," of which the German Johann Georgi said that "… it could be seen as a cabinet of precious objects of the richest kind. The state regalia … stands on a table beneath a large crystal cover through which one can see everything clearly … . Around the walls of this room are set several glazed cupboards in which lie numerous adornments of diamond and other precious stones, in others a great number of insignia of various Orders, portraits of Her Imperial Majesty, snuffboxes, watches and chains, necéssaires, signet rings, bows, gold sword handles, and other precious objects, from which the Monarch chooses what *she* wishes for the presents which *she* gives."[1]

According to the Revd William Coxe, who visited St. Petersburg in 1778, "The richness and splendor of the Russian court surpasses all the ideas which the most elaborate descriptions can suggest … . Many of the nobility were almost covered with diamonds; their buttons, buckles, hilts of swords, and epaulets, were composed of this valuable material; their hats were frequently embroidered, if I may use the expression, with several rows of them … "[2]

In 1792, when Giacomo Quarenghi completed construction of the Loggias attached to the Large Hermitage (which had been specially designed to house a series of paintings copied from the Raphael Loggia in the Vatican), the Diamond Room was moved to occupy space in the southern part, with the imperial collection of minerals displayed nearby. The new Diamond Room was much larger than its predecessor, its interior decorated in the Russian Neo-classical style and the walls hung with paintings by Anthony Van Dyck, while the exhibits were housed in cases by the celebrated cabinetmakers Hermann Meyer and Heinrich Gambs. In the center stood James Cox's magnificent Peacock Clock. The room served as a storage and display area for precious objects for more than half a century. When building started on the New Hermitage, which would provide public access to the Hermitage Museum, three rooms of the Loggias had to be demolished and more changes resulted for the Diamond Room. The contents were moved to one of the galleries running alongside the Hanging Garden in the Small Hermitage, and to the items of precious stone and metal were added works in glass, ivory, wood, enamel, and ceramics. Pieces that had belonged to Peter I and Catherine II—revered by successive generations for their achievements and striking personalities—were exhibited in separate cases.

From this time the Gallery of Objets de Vertu—as it became known—was the largest collection of jewelry in Russia. Since the gallery was essentially its own museum attached to the Imperial Hermitage, attention was paid for the first time to questions of arrangement, visitor access, conservation, and the creation of an inventory. Works continued to be added to the collection, thanks to bequests from members of the imperial family, gifts, and other acquisitions, but no specific attempt was made to collect contemporary jewelry. In the late nineteenth and early twentieth centuries, there was an influx of entire collections bequeathed or donated to the Hermitage by private collectors, which ensured the collection's evolution.

O.K.

Silverware

When Baron von Foelkersam, Keeper of the Hermitage's Gallery of Objets de Vertu, embarked at the start of the twentieth century on an inventory of all the silver in various imperial stores and on exhibition in palace rooms and in the Hermitage, he discovered that its overall weight was some 22,000 kg (48,500 lb) and its value 1.3 million gold rubles. Most of this was in the form of services that had been commissioned in vast quantities from Europe or produced locally, in St. Petersburg. Moreover, these were largely antique items, the majority of pieces dating from the seventeenth century.

As the new capital grew up on the banks of the River Neva and imperial palaces began to make their appearance, what would become known as an unequaled "collection" of silver was formed. But it is important to note that these items were used from day to day and were not considered part of the imperial "collection" until the nineteenth century.

The earliest known acquisition was the English Service commissioned by Catherine and made in London by the best jewelers of the day; it arrived in the capital in 1727. Among the service's surviving pieces are a punch bowl by Gabriel Sleath, a terrine by Simon Pantin I, and a two-handled cup by Jacob Margas—all held in the Hermitage. Extremely large acquisitions were made during the reign of Peter's niece, Empress Anna Ioannovna, the most striking example being a gold toilet set made 1736–40 by the Augsburg masters Johann Ludwig Biller and Johann Jacob Wald, from which forty-six objects chased with elegant ornament and medallions showing birds, animals, and hunting scenes survive. Many expensive pieces were ordered for the empress's favorite, Count Johann Ernst Biron, and these were placed in the Winter Palace after Ioannovna's death and Biron's subsequent arrest. A *plat-de-ménage* by Biller and a

R. & S. Garrard, Silver centerpiece of a knight on horseback, detail (see cat. 83)

luxurious wine cooler by celebrated British silversmith Paul de Lamerie both formed part of the so-called Riga Service, while London too was the source of the imperial throne, made in the workshop of the silversmith Nicholas Clausen in 1731—a throne that was to serve the Romanov dynasty until its fall in 1917.

Catherine II acquired precious items with the same passion as she purchased paintings, cameos, and other works of art. But while engraved gems, snuffboxes, and hardstones represented her personal taste, the commissions for silver services were of more official significance and were determined by the empress's policies as head of state. Such services fulfilled several functions: like snuffboxes, insignia, and medals, they were symbols of the owner's status and might be a reward for outstanding service or a mark of the ruler's particular favor. Catherine's largest silver project was the commissioning of "Governors' Services" when she revived the reform of regional administration undertaken by Peter I. In 1775 a law divided Russia into eleven provinces (which by 1796 had increased to forty), and the empress decreed that each governor be provided with a silver service according to his status in order to ensure that, if and when she should travel through her domains, she would no longer need to carry with her from St. Petersburg sufficient silver for her own reception. Records in the Office of Her Imperial Majesty tell us that at least twenty of these services were commissioned: five in London, six in Paris, five or six at Augsburg, and four made by St. Petersburg masters.

While St. Petersburg jewelers were somewhat behind

Europeans in the middle of the century, by the 1780s a number of outstanding masters working in the Russian capital were producing very up-to-date pieces. Among them were Johann Heinrich Blom, who started his career in Russia assisting Kopping when the latter could not cope with his numerous commissions. In 1783 Just Nikolai Lund made a large table service for the Governor of Mitava in which the forms and decoration of terrines, covers, monteiths, and bottle-coolers—all the work of St. Petersburg silversmiths—were based on Western European models. Local masters were well acquainted with such models since services from abroad, often the work of leading silversmiths, were regularly imported by the nobility, while European designs for utensils and ornaments were also arriving in the city. The characteristic calm, classicizing forms and ornaments of the second half of the eighteenth century were skillfully adapted by Russian and foreign craftsmen in Russia to the Russian fashion. At the end of the 1780s the leading master silversmith was a Norwegian from Denmark, Ivar Wenfeld Buch, in whose work this classicizing style found full expression. He continued to work into the reign of Paul I, and his most important products were the silver *torchères*, wall-lamps, and consoles for the reception room of Empress Maria Fedorovna in the new Mikhail Castle, which today adorn the Small Throne Room of the Winter Palace.

Paul ordered that all the Governors' Services be returned to St. Petersburg and many items were melted down for Buch's workshop. Paul's wife, Maria Fedorovna, continued the tradition of ordering services abroad even after his death. The Winter Palace gained a gilded service commissioned by her for her son, Grand Duke Mikhail Pavlovich, whose monogram adorns all the objects. Napoleon's court jewelers—Martin Guillaume Biennais, Jean-Baptiste-Claude Odiot, and Jean-Charles Cahier—worked on the service.

The largest commission for silver in the mid-nineteenth century was the London Service, the result of very active contacts between the Russian court and leading British firms. Nicholas I visited London in June 1844, and soon after a commission for a large table service for the Russian court was received by the firm of Mortimer & Hunt and the royal jewelers, Garrard; this service included several silver sculptural groups in the "historicist" style, and many items were added to it in St. Petersburg.

The change in attitude to the "functional" silver in the imperial collection was marked in 1885 when Alexander III ordered that silver items of great artistic and historic value be put on display in his "Muzeum."

M.L.

Porcelain

Porcelain is said to have first arrived in Europe in the late thirteenth century, brought by the Venetian merchant Marco Polo, who had spent seventeen years in China. This previously unknown, man-made material was used to make marvelous objects that seemed to embody Oriental wisdom and secret knowledge. Porcelain was respected and the object of some interest. Nonetheless, in the fifteenth and sixteenth centuries Chinese porcelain was considerably rarer in Russia than in Western Europe. Deeply involved in building an identity for itself, Russian culture was unprepared to pay much attention to the artistic realities of either the Orient or the West

Only during the reign of Peter I, thanks to his own initiatives, did a particular interest in porcelain appear in Russia. In 1697 the "Great Embassy," headed by Peter himself, embarked for Europe, and by February 1698 it was in Amsterdam, where the tsar ordered that a large quantity of porcelain be acquired from the East Indies Company; this would later be exhibited in the Kunstkammer. The opening in 1710 of Europe's first porcelain manufactory, in Meissen, Germany, provoked the fiercely proud Russian monarch and in 1718, at Peter's personal command, the master ceramicist Christopher Conrad Hunger (who knew porcelain production) was invited to St. Petersburg. Hunger's knowledge proved inadequate, and it was not until 1744, during the reign of Peter's daughter, Empress Elizabeth, that the Imperial Porcelain Manufactory was opened in St. Petersburg; nonetheless, it was still only the third porcelain manufactory in Europe—after Meissen and Vienna.

A fashion for porcelain took root during Elizabeth's reign as a direct result of the increasing Europeanization of Russian culture. Meissen porcelain arrived in the form of gifts to the Russian court, and in the summer of 1745 August III of Saxony made Empress Elizabeth a magnificent gift to mark the marriage of her nephew, Grand Duke Peter (the future Peter III), to a minor German princess (later Empress Catherine the Great). This was a large table service, the first such service in Russia, known as the Table Service of the Order of St. Andrew (cat. 85).

Catherine II also received gifts of porcelain from European rulers, of which the most famous example is the Berlin Dessert Service sent to her in 1772 by Frederick the Great (Friedrich II) of Prussia (cat. 86). She herself ordered large porcelain services and series of figures abroad, and it was thus, for instance, that in 1774 the Green Frog Service made its appearance in Russia, made by the English firm of Josiah Wedgwood, and

Meissen Manufactory, Candlestick from the Table Service of the Order of St. Andrew, detail (see cat. 85)

Alexander III was the first Romanov to be a true scholar and admirer of porcelain; in 1879, while still heir to the throne, he revealed himself to be a man of excellent taste when he selected for the Cottage Palace at Peterhof (where he spent his summers) a representative selection of Wedgwood creamware and early Russian porcelain. Married to the Danish Princess Maria Sophia Frederika Dagmar, he often visited his wife's homeland and began to collect Danish porcelain. It was he who, in 1885, gave orders for the creation, in the Winter Palace, of a Museum of Porcelain and Silver Objects from the Highest Court, commonly known as the "Muzeum [sic] of Alexander III," in which he gathered from all the various imperial residences the most important items of porcelain and silver. The museum was housed in the Winter Palace itself; it had no official staff and saw few visitors, since special permission was required to enter. In 1910 a decision was made to transfer the porcelain to the Imperial Hermitage, where a Porcelain Gallery opened in 1911. Imperial porcelain finally became part of an official collection—an object of study and preservation.

L.L

Tapestry

In keeping with the other decorative arts and lavish furnishings collected by the tsars for their various residences, imperial tapestries adhered to the Westernizing mission set forth by Peter I to raise Russia's cultural and political profile, and often depicted religious subjects or reflected the European Rococo taste for idyllic country life.

Peter I received several tapestries from the royal Gobelins factory as gifts from Louis XV when the tsar visited France in 1717, including a series of New Testament scenes by Jean Jouvenet and another set of eight tapestries of the flora and fauna of South America. When she rose to power, Catherine II directed Russian textile manufacturers to emulate the distinguished and rigorous weaving standards set in the West at the Gobelins and Aubusson tapestry works, among others. Catherine's son Paul I, and his wife, Maria, acquired a set of four fashionable Gobelins tapestries from Louis XVI when they traveled to Europe in 1781–82.

As imperial lifestyles became more intimate and more expensive to maintain in the mid to late nineteenth century, tapestry production declined, and the Russian Imperial Tapestry Factory closed in 1859.

S.R.

Furniture

The imperial family's ever-changing tastes can be seen in the furniture with which they lived. Pieces were often

adorned with 1222 unique topographical views of Britain (although the service was made from the famous Wedgwood Queen's Ware rather than porcelain). In 1778 Catherine ordered the magnificent Cameo Service from Sèvres (cat. 93). But she also encouraged Russian production: after her visit to the St. Petersburg Porcelain Factory in 1765 it was reorganized as the Imperial Porcelain Factory, and marked its products with Catherine's monogram or, later, with the mark of the then reigning monarch. It was under Catherine's patronage that a second Russian porcelain factory made its appearance in Moscow in 1766, founded by the Englishman Francis Gardner.

Important pieces and whole porcelain ensembles were also associated with Paul I and his sons Alexander I and Nicholas I; these items too were added to the imperial storerooms. Nicholas was the first to introduce some order into the way porcelain was stored, organizing new storage areas and modernizing the old ones, moving several services to country palaces in the city's environs, and ordering additional pieces for the more important services from the Imperial Porcelain Factory. This reorganization was useful, but essentially boiled down to mere housekeeping. It had no element of a scholarly system and made no attempt to study the history of porcelain. In no way could it be said to reflect a new collector's attitude toward porcelain: services were still perceived simply as beautiful utensils.

replaced without a second thought as fashions changed and new styles emerged. Contemporaries were amazed by the striking luxury of the interiors of the St. Petersburg palaces. The chambers of the Kremlin—the ruler's residence in Moscow—had not been notable for any variety and were certainly not taste-making. Peter I's interest in shipbuilding led to the development of carpentry as more a craft than simply a trade, and his policy of inviting foreign masters to work in Russia brought with it a knowledge of Western style and culture. Peter preferred his furniture in the Dutch and English styles, and a writing desk in the Hermitage was produced to designs he had made during his stay in London in 1698. Empress Elizabeth introduced the elegant Rococo style to the imperial palaces, exemplified by the mid-eighteenth-century *cartonnier* (a filing cabinet with pigeonholes) by the celebrated French masters Bernard van Risamburgh II and Joseph Baumhauer.

Most furniture, however, was purchased during the reign of Catherine II, partly due to the fact that the large, new Winter Palace was completed as she came to power, and with her accession she also gained the responsibility to furnish it. At this key period for the formation of the collections in the Winter Palace, Catherine turned her attention to German furniture, and the name David Roentgen will forever be linked with Russia. To draw attention to his work, Roentgen created a large bureau adorned with a figure of Apollo, fitted with numerous internal mechanisms allowing it to change shape and appearance, to the accompaniment of music. Over time more than a hundred objects—bureaus, tables, lecterns, and toilet tables—by this celebrated master were acquired to adorn the Empress's palace. She further commissioned from Roentgen five cabinets to house her beloved collection of cameos. These were found worthy of mention, alongside her paintings, by Johann Georgi in his description of the Winter Palace in 1794: "… cupboards and cabinets in which are stored gems and other precious objects … the most elegant work of Roentgen, Meyer and other celebrated masters of this art form." Christian Meyer was head of the court furniture workshop in St. Petersburg, working exclusively on commissions for the imperial court. One other cabinetmaker in Russia rivaled Roentgen in fame: Heinrich Gambs, whose firm in St. Petersburg existed for some seventy years, producing furniture that stood in Russian palaces alongside the finest imported objects.

It is to Catherine's love of cameos that we owe the appearance of a series of Neo-classical cabinets commissioned in England in 1781. They were intended specially to house a collection of casts made by James

Tassie from cameos and intaglios in Europe's most famous collections (cat. 100).

During his travels in Europe Catherine's son Grand Duke Paul disguised himself as the "Comte du Nord" and visited Paris in 1782, making numerous purchases of applied art to decorate his own summer residence, the palace at Pavlovsk, near St. Petersburg. His taste for all things French was most strongly manifested in the adornment of the Mikhail Palace, built for him when he came to power in 1796. Bronzes and furniture were acquired from dealers in Paris, and signed works by Pierre-Philippe Thomire, Adam Weisweiler, and Guillaume Benneman appeared in Russia.

During the reign of Paul's son Alexander I, the Empire style was introduced to the Winter Palace, in the form of objects influenced by the designs of the French ornamentalists Charles Percier and Pierre-François-Léonard Fontaine. Adorned with fasces and military trophies, they sat naturally alongside furniture by Russian masters, elaborately decorated with swans' heads and dolphins.

Numerous new objects were required to adorn the interior of the Winter Palace in the wake of a huge fire that tore through it in 1837, and then more to fill the New Hermitage (opened to the public in 1852). By this time, however, there was almost no need to send large commissions abroad, since craftsmen in Russia were producing furniture equal in quality to that in the West. A series of watercolors commissioned by Nicholas I and produced by Edward Hau, Luigi Premazzi, and Konstantin Ukhtomsky shows rooms in the Winter Palace and the Hermitage from this period.

During the last quarter of the nineteenth century the first historicist-style furniture arrived in the Hermitage, the result of Alexander III's purchase of a collection of medieval applied art from Alexandre Basiliewski. At last furniture had come to be seen as worthy of collecting and not merely as functional. Still, furniture—unlike other forms of applied art—was rarely presented as a gift.

Today the Hermitage rooms are still filled with the furniture that was once used every day by inhabitants of the Winter Palace, but now these pieces are prized alongside the museum's greatest masterpieces.

T.R.

Notes

1 I.G. Georgi: *Opisanie rossiisko-imperatorskogo stolichnogo goroda Sankt-Peterburga i dostopamiatnostei v okrestnostiakh onogo, 1794–1796* [A Description of the Russian Imperial Capital City of St. Petersburg and the Sights in its Environs, 1794–1796], St. Petersburg, 1794, vol. 1, p. 77 [reprinted 1996, St. Petersburg].

2 William Coxe: *Travels into Poland, Russia, Sweden, and Denmark. Interspersed with historical relations and political inquiries, illustrated with charts and engravings*, 2 vols., London 1784, vol. 1, pp. 491–92.

79
Cane of Pale Yellow Reed
With Gold Knob, Inset Watch
and Miniatures
Friedrich Fabritius
(Danish) 1770s–1780s; 1791
Gold, silver, diamonds, garnets,
enamel, miniatures, glass, metal
alloys; chased, polished, guilloche,
painted
Length 128 cm (50³⁄₈ in.)
Inscribed on the inside of clock
mechanism: *Gregson à Paris 1791*
Inscribed on the third miniature:
*Representation des glorieuses Conquêtes que
L'Invincible Catherina Alexievna a
remportes sur les Turcs en 1769 et 1770*
(Representation of the glorious
conquests won by the Invincible
Catherina Alexievna against the
Turks in 1769 and 1770)

Inscribed on the last miniature: *dedié
à sa Majesté Catherine Alexievna II
Impératrice de tout les Russies. Par son
très humble et très obéisant Serviteur Frid.
Fabritius Jouaillia de la cour de
Dannemark* (dedicated to Her Majesty
Catherine Alexievna II, Empress of
all the Russias. By her humble and
very obedient servant Frid. Fabritius
Jeweler to the court of Denmark)
Inv. No. E 4411

PROVENANCE
In the Gallery of Objets de Vertu of
the Hermitage Museum from the
mid-nineteenth century; in the
Winter Palace from the late
eighteenth century

On the head of this cane is a
diamond monogram of Catherine II
beneath a crown, surrounded by
laurel leaves, and below this an inset

watch mechanism by the Paris
master Gregson. But for its technical
innovation, the piece might have
been considered typical of its time,
but the cane's head is decorated
with three medallions, and when
that showing Minerva is opened it
reveals miniatures of events in the
first Russo-Turkish War (early
1770s). The first painting reveals how
to use the mechanism correctly,
which can be revolved to show
twenty-one miniature insets. Here
are images of Catherine II, a two-
headed eagle with a mace and
scepter, seascapes, and battle scenes,
clearly intended to reflect Russian
military victories. The last, more
intricate, miniatures show the
signing of the Kuchuk Kainardzhi
Peace Treaty on 10 July 1774.
 There are few known works
by the Danish master Friedrich

Fabritius, who may have worked
exclusively on diplomatic gifts,
which would mean that he would
only rarely have put his mark on his
products. The quality of every detail
of this cane is witness to his great
professionalism and excellent taste.
 The question of date remains
unresolved since the paintings reflect
events of the 1770s, the iconography
of Catherine II derives from
portraits by Alexander Roslin of the
1770s and 1780s, and the watch
mechanism is dated 1791. It is
possible that the cane was specially
made as a gift and later had the
French watch mechanism set into it.
There are other examples of such
compilations in the Hermitage
collection.

O.K.

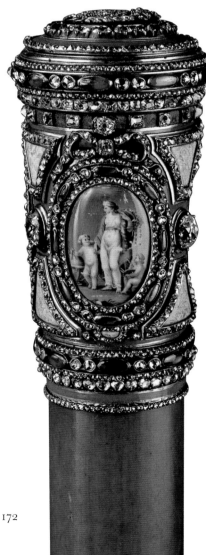
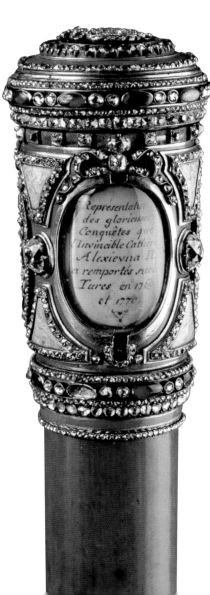
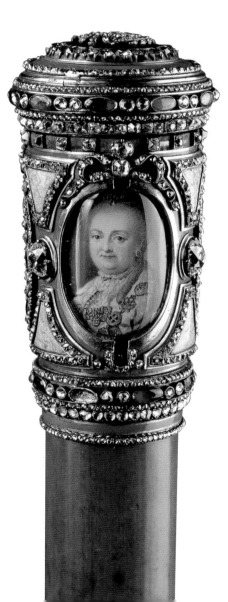

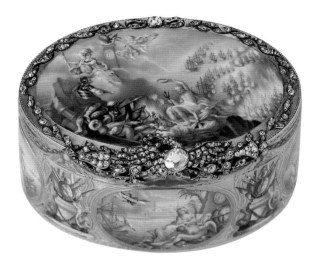

80
**Snuffbox: The Victory
at Chesme**
Jean-Pierre Ador
(Swiss, 1724–1784)
St. Petersburg
1771
Gold, silver, diamonds, rubies,
enamel; chased and painted
4.2 × 7.5 × 6.1 cm (1⅝ × 3 × 2⅜ in.)
Inscription: *ADOR – A – ST –
PETERSBOURG*
Inv. No. E 6239

PROVENANCE
Transferred to Gallery of Objets de
Vertu of the Imperial Hermitage,
1876; presented by Empress
Alexandra Fedorovna to the Duke
of Mecklenburg-Strelitz (who
bequeathed it to the Hermitage),
1854; sold to the Hermitage by the
Yuriev Monastery; bequeathed to
the Yuriev Monastery in Novgorod
by Orlov's daughter; presented by
Count Alexei Orlov to Catherine II

Jean-Pierre Ador was one of
St. Petersburg's leading jewelers. He
arrived in Russia in the early 1760s
and worked independently in his
own workshop, without joining the
guild of foreign jewelers. He
produced decorative vases, fans,
clocks, insignia, and weapons, but
his work is represented in most
collections by snuffboxes. The
master frequently signed his works
with one of two marks, *IA* in a
crown, or *IA* beneath a crown.
 Painted enamel compositions
symbolize the victory of the Russian
fleet (commanded by Alexei Orlov)
over the Turks at Chesme on
24–26 June 1770 (Old Style). The
figures of Chronos and History set
into the central medallion on the
edge record the date 24 June 1771,
indicating that the snuffbox was
made to celebrate the first
anniversary. All the decorative
elements—the laurel wreaths,
Hercules with his club, Minerva
by the obelisk with the inscription
"Patrie," the sacrificial altar with
the inscription "Monument
éternel"—are part of the box's
commemorative nature. The bottom
of the snuffbox bears an enamel
miniature with an allegorical image
of the Turkish fleet pulled by
Neptune and Nereids to the shore,
where they are met by Mars. In the
central miniature on the lid,
surrounded with a garland of
diamonds, Neptune leads the fleet,
and Minerva (with a spear) leans on
a shield with the monogram
"AO"—for Alexei Orlov, whose
armored figure is shown below. The
clasp has a diamond eagle holding a
laurel branch in its beak: possibly
not merely a symbol of peace, but
also an allegorical hint at the
owner's name (Orlov comes from
oriol, Russian for eagle).
 Typical of Ador's early works,
this snuffbox finds analogies with a
work in the Louvre that shows
Susanna and a Chesme snuffbox in
the Philips Collection, both of which
are also dated to the early 1770s. We
do not know of any signed works by
Ador in enamel, although some
works and documents indicate that
he collaborated with enamelers. The
authorship of the enamels on this
snuffbox thus remains unclear.
Kenneth Snowman suggested that
they might be by Bernabé Auguste
de Mailly, author of enamel
paintings on a Chesme inkpot that
was also commissioned in honor of
the famous battle and is now in the
Hermitage. A comparison, however,
reveals clear differences in the
painting style, and from the
correspondence between Catherine
the Great and Baron Melchior
Grimm (Catherine–Grimm
Correspondence 1878, pp. 105, 109)
we know that the enameler arrived
in Russia no earlier than 1775, while
the snuffbox dates from 1771. The
painting of the enamels directly on
to the gold setting excludes the
possibility that they were later set
into the snuffbox. These enamels are
of great artistic merit. The master
worked daringly with contrasting
colors, making active use of varied
color combinations. Particular skill
was required in producing the
medallions, which are placed on the
uneven surface of the border and
lower edge of the lid.

EXHIBITIONS
Cologne 1981, No. 43; Paris
1986–87, No. 530; Leningrad 1987,
No. 449; London 2000–01, No. 102

BIBLIOGRAPHY
Lieven 1902, p. 118; Ivanov 1904,
p. 116; Snowman 1966, p. 107;
Kuznetsova 1980, p. 47; Kostiuk 1987,
pp. 158–60; Kaliazina 1987, p. 31

O.K.

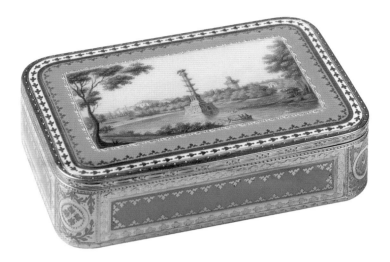

81

Snuffbox with the Chesme Column

Workshop of the Thérémin Brothers: François-Claude and Pierre (Peter)-Étienne Thérémin (French)
St. Petersburg
1795
Gold, enamel; chased, engraved and painting
1.5 × 4.8 × 6.5 cm (⅝ × 1⅞ × 2½ in.)
Marks: workshop – *FT*;
St. Petersburg 1795; Russian fineness mark: 80; letter for gold: Ч
Inv. No. E 4065

PROVENANCE
In the Gallery of Objets de Vertu of the Hermitage Museum from the mid-nineteenth century; listed in the inventory of the Court Office in 1837

Opaque turquoise enamel covers the gold surface of this elegant snuffbox, with ornament composed of tiny gold leaves along the edges and at the corners.

G. Lieven (1902) first published the snuffbox, dating it to 1795 on the basis of the St. Petersburg mark. A. Foelkersam (1907) related it to the works of the St. Petersburg master Tashner, but M. Torneus interpreted the marks and surviving inscriptions on other items and identified (unpublished) the snuffbox as the work of the Thérémin brothers.

François-Claude and Pierre-Étienne Thérémin were active in St. Petersburg for only a relatively short time. Pierre-Étienne moved to

Russia in 1793, being joined by his brother two years later. Before this they had both practiced as jewelers in Paris, London, and Geneva, and immediately before their arrival in Russia they had been living and working in Berlin, where they formed part of the French expatriate community. The Thérémin brothers are represented in art collections exclusively by snuffboxes, but archive documents permit a greater understanding of the scale and variety of their work, since these record that they produced church plate, a crown and scepter, sabers, and numerous decorative and religious items. The brothers were members of the guild of foreign jewelers in St. Petersburg, and from 1800 to 1801 Pierre-Étienne was Alderman of the guild. In St. Petersburg the brothers founded a jewelry factory, using engraved signatures or marks, *F C T*, *P T* or *F T*.

This snuffbox differs from the majority of known works by the Thérémin brothers. It was commissioned by Catherine II as a gift for Alexei Orlov, the military commander who had brought success in the Battle of Chesme (1770) in the Russo-Turkish war. The lid is decorated with a painted enamel miniature, not inset like a medallion but applied directly to the gold surface. It shows the park at Catherine's summer residence at Tsarskoe Selo, near St. Petersburg, with the Chesme Column erected there by Antonio Rinaldi in 1771–78

to mark the great naval victory. The whole of the composition is unusually harmonious and fine in color, and the enameler had clearly mastered the whole repertoire of painterly devices; each color had to be applied in turn, taking into account the melting point for each of the metal oxides used to make them. The painting is marked by its use of fine dots, a love of details, and the composition's stage-like construction, complete with "wings." This virtuoso miniature indicates a master of great professional skill, although the question of that author's identity remains open.

EXHIBITIONS
Lugano 1986, No. 82; Memphis–Los Angeles–Dallas 1991–92, p. 143; St. Petersburg 1993, No. 105; Amsterdam 1996–97, No. 236; Florence 1998, No. 130; Stockholm 1998–99, No. 200

BIBLIOGRAPHY
Lieven 1902, p. 32; Foelkersam 1907, p. 52; Kuznetsova 1980, p. 58; Kaliazina 1987, p. 97; Kostiuk 1993, p. 16

O.K.

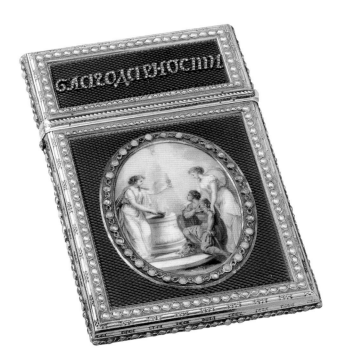

82

Carnet of Gold and Enamel with Diamond Inscription
Anonymous French artist
Paris
1770s
Gold, silver, enamel, diamonds, rose diamonds, pearls, emeralds, opals; chased, guilloche, painted
8.5 × 5.7 × 0.9 cm (3⅜ × 2¼ × ⅜ in.)
Marks: Paris 177(?) (rubbed)
Inscribed: *NAPOMINANIE* (Reminder); *BLAGODARNOST'* (Gratitude); *toboiu voskhozhu* (Through Thee I Rise)
Inv. No. E 4453

PROVENANCE
In the Gallery of Objets de Vertu of the Hermitage Museum from the mid-nineteenth century; in the Winter Palace from the late eighteenth century

Covered with blue enamel over a guilloche ground and decorated with split pearls, opals and emeralds, this carnet, which was a gift to Catherine II from Prince Grigory Potemkin (primary favorite of Catherine's after 1771, and influential strategically and politically during her reign), has diamond inscriptions on both sides: *Reminder* and *Gratitude*. On front and back of the case are allegorical enamel medallions. One of these shows Minerva crowning with laurels a portrait of Catherine II supported by the kneeling Chronos, while the muse of History holds an open book. On the other are a soldier and a *genius* before an altar with the inscription *Through Thee I Rise*. These were probably intended to symbolize Potemkin's military successes and his gratitude to the empress.

EXHIBITIONS
Amsterdam 1996–97, No. 243; Florence 1998, No. 133; London 2000–01, No. 118

BIBLIOGRAPHY
Benois 1902, No. 138; Ivanov 1904, p. 162

O.K.

83

Silver centerpiece: Knight on Horseback

R. & S. Garrard, master Robert Garrard II
(British, 1793–1881)
London
1844–45
Silver, cast, wrought, and chased
50 × 47 cm (19⅝ × 18½ in.)
Marks: England, London, yearmark 1844–45, master
Inscription: *R. & S. Garrard. Panton St. London*
Inv. No. E 7672

PROVENANCE
Transferred to the Hermitage from the Cottage Palace, Peterhof, 1925; commissioned, 1844

Produced according to a design and model by Edmund Cotterill, this group formed part of the London Service.

There were extremely active contacts between the Russian court and leading British jewelry firms in the mid-nineteenth century. Most demonstrative of this are two major commissions, one for a large table service, which was to be known as the London Service, and the other a service produced for Grand Duchess Ekaterina Mikhailovna. The stimulus behind such commissions may have been Nicholas I's visit to London, with his suite, in early June 1844. Archival documents record that Nicholas found time to go over the workshops and the retail outlets of the firms Mortimer & Hunt and Garrard, both Jewellers by Royal Appointment, and that he greatly admired their work. Such admiration soon bore fruit.

The London Service was housed at the Cottage Palace at Peterhof—built specially for Nicholas and his wife, Alexandra Fedorovna, in neo-Gothic style by the Scottish architect Adam Menelaws. Several pages were devoted to the service by Baron A. von Foelkersam, Keeper of the Gallery of Objets de Vertu in the Imperial Hermitage, in his two-volume *Inventories of the Silver at the Court of His Imperial Majesty* (St. Petersburg, 1907). Although after the October Revolution of 1917

many items from the service were sold by the state, and all trace of them has now been lost, a document in the Hermitage Archives entitled "The Journal of the London Service" allows us to trace the general history of the commission and to identify those few items remaining.

The service was intended to serve fifty people (some sources mistakenly put this number at forty), and included some 1680 items. Among these were seven sculptural groups, numerous candelabra, *epergnes*, salt pots in the form of sculptural compositions, *girandoles*, and ewers. Glass, crystal, porcelain, stands for the sculptural groups, and a number of other pieces were made in St. Petersburg, at the English Shop of Nichols & Plinke, at the factory of I. Sazikov, and at the Imperial Porcelain and Glass Factories. The Journal opens on

8 July 1844 (Old Style), and states: "Pedestals to be ordered from the English Shop according to the chosen design for the three silver groups brought from London and similar two which are to be delivered from there." The description of the first two groups accords with one of those in the Hermitage, the "Knight on a horse with a chalice in his hands; a figure standing before the knight."

From 1830 Garrard had the right to use the description "By Royal Appointment." The founder, Robert Garrard I, registered his first mark in 1802, although he had been practicing since 1792, and after his death in 1818 his sons, Robert II, James, and Sebastian, took over the business. A talented businessman, Robert II ran the firm for sixty-three years, achieving the very highest quality production of silverware and successfully winning important

commissions from high-ranking clients (in 1816, for instance, he produced the Portugal Service for the Duke of Wellington). His success was such that some of the items for such commissions had to be made out of house, in the studio of Paul Storr.

The Hermitage has another notable work by Garrard, a repetition of the Queen's Cup made for Ascot in 1844 to a design and model by Cotterill, which appeared in St. Petersburg that same year. Of the original, the correspondent of the *Illustrated London News* (1844, pp. 369–370) wrote: "This marvellous cup … was widely admired when seen at Ascot," and indeed it would seem to have appealed to Nicholas.

EXHIBITIONS
St. Petersburg 1996b, p. 238, No. 4; New Haven–Toledo–St. Louis 1996–97, p. 247, No. 72.

M.L.

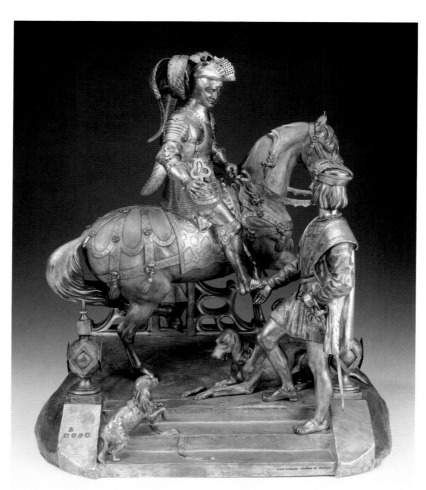

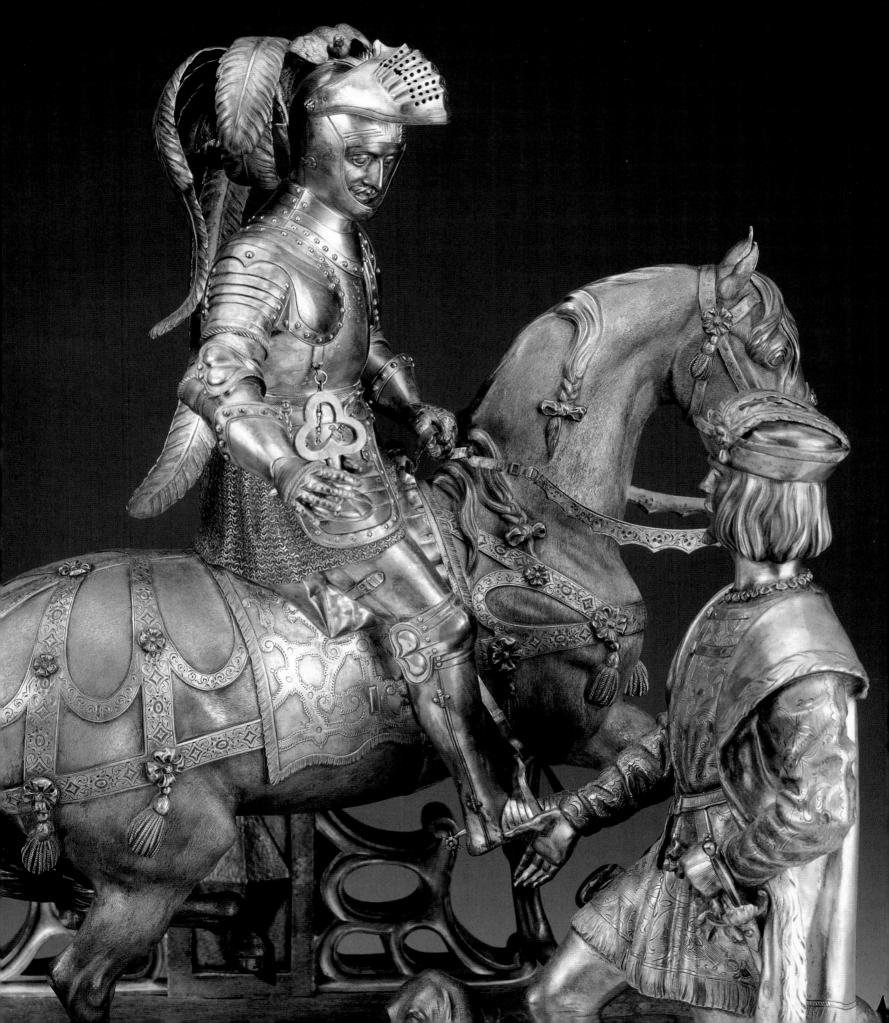

84

Lavabo Set with Imperial Arms

Master Louis Aucoc fils
(French)
Paris
1870s
Silver, wrought, cast, chased, and gilded
Jug, height 32.7 cm (12⅞ in.); bowl 9 × 38.2 × 26.5 cm (3½ × 15 × 10⅜ in.)
Marks: master Louis Aucoc (Aucoc aîné), French export 1840–79, and the imperial arms
Inv. Nos. E 11821, E 11822

PROVENANCE
Transferred from the collection of Princess Elena of Sachsen-Altenburg, 1924

This jug and bowl formed part of a toilet set composed of forty items, among which the mirror bears the engraved inscription *Aucoc aine Feur du Roi a de la Flle Royale, a Paris*. Louis Aucoc inherited his father's business in 1854 and continued to produce a large quantity of silver goods, including all kinds of services (tea, dinner, and toilet). The main trend of Aucoc's work is manifested in his interpretation of the Rococo style of Louis XV, as can be seen in this set, which in many ways recalls a lavabo set of 1748–49 produced for the Louvre Palace by the Parisian master Nicolas Outrebon II.

The Hermitage toilet service would seem to have been commissioned to mark some important event in the life of the Grand Duchess Ekaterina Mikhailovna, mother of Princess Elena and granddaughter of Paul I, which explains the imperial arms on the items.

EXHIBITIONS
St. Petersburg 1996b, p. 245, Nos. 70, 71

M.L.

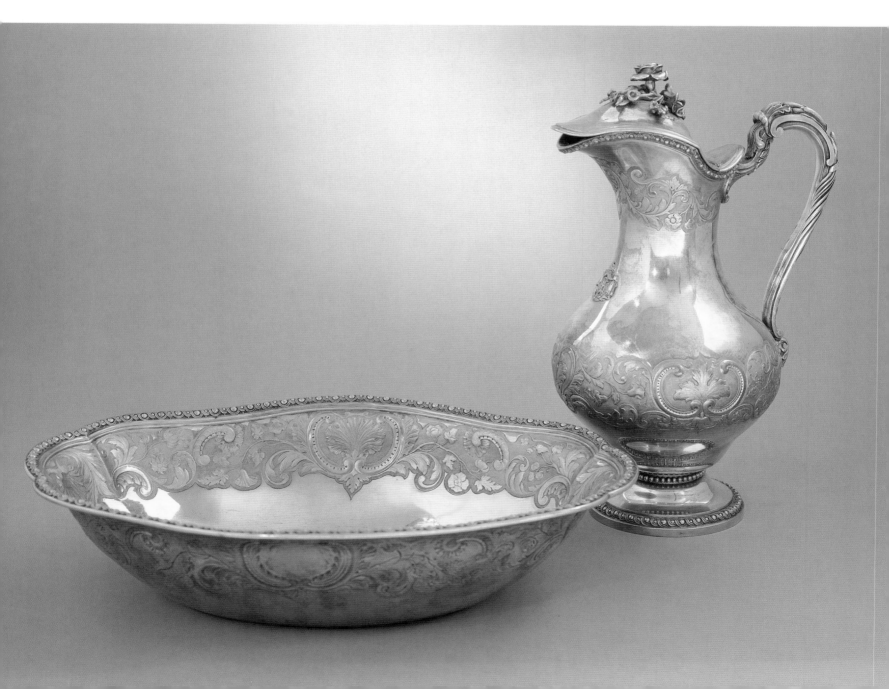

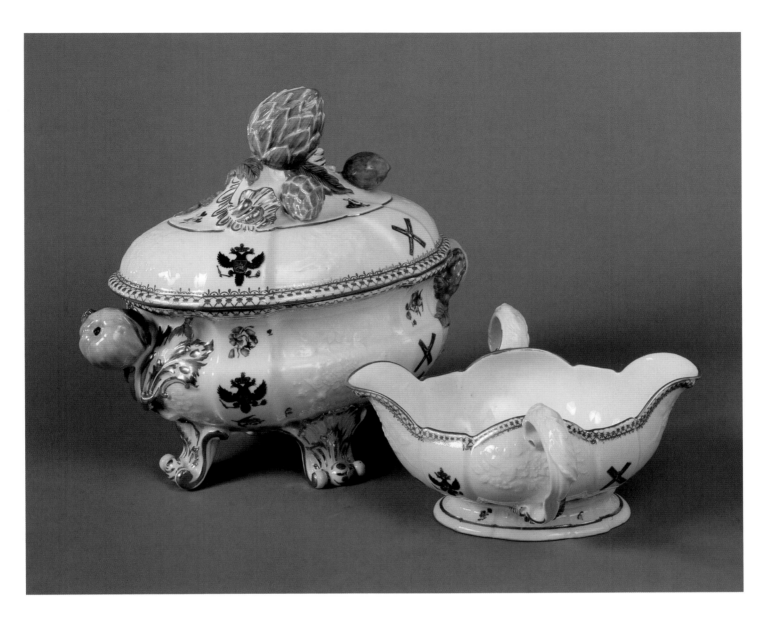

PORCELAIN

85
Table Service of the Order of St. Andrew
Meissen, Germany
1744–45
Models by Johann-Joachim Kändler (German, 1706–1775) and Johann-Friedrich Eberlein (German, 1693/6–1749)
Porcelain, overglaze painting, gilding
Marks: underglaze cobalt crossed swords

Tureen with Lid, height 27.5 cm (10⅞ in.)
Inv. No. GCh 1426

Sauce-boat, height 9 cm (3½ in.)
Inv. No. GCh 1451

Candlestick, height 28.5 cm (11¼ in.)
Inv. No. GCh 1441

Cup and Saucer for Hot Chocolate, height of cup 7.8 cm (3 in.), diameter of saucer 15 cm (5⅞ in.)
Inv. No. GCh 1497

Coffee Spoon, length 12 cm (4¾ in.)
Inv. No. GCh 1535

PROVENANCE
Porcelain Gallery of the Imperial Hermitage, 1910; presented to Empress Elizabeth by Augustus III,

Elector of Saxony and King of Poland, and kept in the Winter Palace, St. Petersburg, 1745

This table service was sent to Empress Elizabeth of Russia by Augustus III, Elector of Saxony and King of Poland, in the summer of 1745 on the occasion of the marriage of her nephew, the heir to the throne Grand Duke Peter, and Princess Sophia Augusta Frederika of Anhalt-Zerbst (who took the name Catherine on joining the Russian Orthodox church). These were the future Emperor Peter III and Empress Catherine II. The ensemble, combining a dinner and

coffee/chocolate service, consisted of more than four hundred items and was the first porcelain service on such a scale in Russia.

All the objects in the dinner service were decorated with the Russian arms (the two-headed eagle charged with an image of St. George) and the cross of the Order of St. Andrew, the first and most important of the Russian Orders, founded by Peter the Great at the end of the seventeenth century. St. Andrew is nailed to his cross, with the letters "S(anctus) A(ndreas) P(atronus) R(ussiae)" at the four corners. The choice of protector for this Order was

explained by a legend that it was St. Andrew who had preached Christianity in Russia. The items in the coffee/chocolate part of the service were decorated with Peter I's monogram in a shield composed of a link of the Order chain surrounded by flags. At the center of the table was a *plat-de-ménage* composed of a large openwork shell (destroyed) surrounded by four small salt pots in the form of shells, with the same number of cruet pots for oil and vinegar.

Accompanying the St. Andrew Service were two series of figures to adorn the table, made of glazed but unpainted porcelain. The author of the models of figures in one series, *Apollo and the Nine Muses*, was the head of the sculpture workshop, Johann-Joachim Kändler (Butler 1977, Nos. 30–36). Another series, the *Ovidian Gods* (from motifs in Ovid's *Metamorphoses*), were produced to models by the sculptor Johann-Friedrich Eberlein (Butler 1977, Nos. 37–47). Also included in the gift were three fireplace sets, each of seven vases. Time has left its mark and only two of these vases survive, while of some hundred-odd figures (several examples of each figure were made to protect against loss by accident) just eighteen survive from the two series combined.

Kändler was responsible for the greater number of the forms for items in the St. Andrew Service, although his colleague Eberlein also played an important role. For instance, the latter produced the model for fourteen candlesticks—unlike many of the other forms this model was not created specifically for the St. Andrew Service. Eberlein had designed the candlestick with figures of two putti earlier, for the famous Swan Service of Count von Brühl in 1739, his visual source being an engraving by Louis Deplace after a drawing by Juste Aurèle Meissonier, a copy of which was in the possession of the manufactory. When asked to produce items for the service for the Russian Empress, he introduced certain alterations to the model.

The type of flat flower relief which decorates the items in the service is known as "Gotzkowski Flowers," since Eberlein first

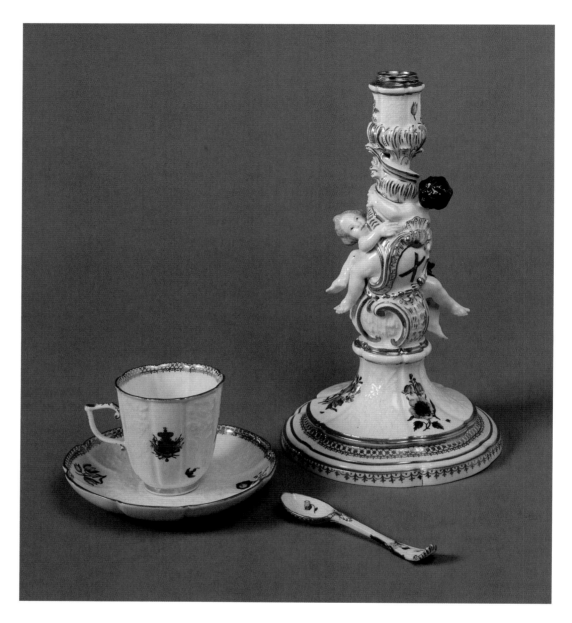

developed this ornamental motif in 1741 to decorate a service commissioned by the merchant Johann Ernst Gotzkowski. (This was that same Gotzkowski who, in 1764, sold Catherine II the collection of 225 paintings originally intended for Frederick the Great (Friedrich II) of Prussia, the purchase of which is considered to mark the foundation of the Hermitage.)

The service was used at the Russian court each year on 30 November, the day of the Order of St. Andrew the First-Called, when a reception was held for knights of the Order in the Winter Palace.

In 1885 Alexander III ordered the transfer of six items from the service to the Museum of Porcelain and Silver Objects of the Highest Court in the Winter Palace, but the wider public was able to see this masterpiece of Meissen porcelain only in 1904, at an historical exhibition organized in St. Petersburg under the patronage of Empress Alexandra Fedorovna to raise money for wounded soldiers. The objects were exhibited in the cases of "Their Imperial Highnesses" (1904 St. Petersburg, p. 44). In 1910 the whole service was transferred to the Porcelain Gallery

of the Imperial Hermitage, and at the present time the museum has some two hundred items from the ensemble.

EXHIBITIONS
St. Petersburg 1904, p. 44;
St. Petersburg 1995a; 1985 Dresden,
Cat. 28–70

BIBLIOGRAPHY
Troinitsky 1911, p. 26; Boltz 1977,
pp. 12–14; Butler 1977, Nos. 30–47;
Pietsch 2000, No. 135

L.L.

86
Berlin Dessert Service
Berlin
1770–72
Models by Friedrich-Elias Meyer
(German, 1723–1785) and
Wilhelm-Christian Meyer
(German, 1726–1786)
Plates painted by Johann-Baptist-
Balthasar Borrmann
(German, 1725–1784)
Porcelain, overglaze painting, gilding
Marks: underglaze cobalt scepter

Compotier in the Form of a Leaf,
30 × 23 cm (11¾ × 9 in.)
Inv. No. GCh 2992

Ice-cream Cup, height 6.5 cm
(2½ in.)
Inv. No. GCh 3136

Flower Vase, height 10.5 cm (4⅛ in.)
Inv. No. GCh 3169

Plate, diameter 25.5 cm (10 in.)
Inv. No. GCh 3013

Plate, diameter 25.5 cm (10 in.)
Inv. No. GCh 3014

Trophy group, h. 49 cm (19¼ in.)
Inv. No. GCh 2761

PROVENANCE
Porcelain Gallery of the Imperial
Hermitage, 1910; in the Museum of
Porcelain and Silver Objects of the
Highest Court, Winter Palace,
1885–1910; at the Great Palace,
Peterhof, near St. Petersburg,
1827–85; in the Winter Palace,
St. Petersburg, 1772–1827; presented
by Frederick the Great (Friedrich II)
of Prussia to Catherine II, 1772

The Berlin Dessert Service,
presented in 1772 to Empress
Catherine II by the Prussian King
Frederick the Great (Friedrich II),
offers a sweeping reflection of the
historical and cultural context of
European diplomatic relations
during the last third of the
eighteenth century.

The most important element
in the service, in terms of both
ideology and composition, was
the luxurious multi-figure table
decoration, at the center of which
was a white figure of the Russian
empress seated on her throne. This
throne is set on a stepped pedestal
rising up beneath a baldachin
supported by round columns. The
model for the figure was the work
of Friedrich-Elias Meyer after a
painted portrait by Vigilius Eriksen,
sent by Catherine as a gift to the
Prussian king. Ranged on either side
of the throne were Justice and
Themis, and behind stood the
goddess of Fame, Fama, holding the
Russian coat of arms. Below were
Minerva, Mars, Bellona, and
Hercules, symbolizing wisdom,
military success, and the strength
of the Russian empress's rule. This
majestic Parnassus was surrounded
on all four sides by kneeling figures
of representatives of different
peoples and classes in Russia,
arranged in compact groups. Freely
arranged at some distance from the
throne were graceful standing female
figures as allegories of the seven free
arts. The ensemble was
complemented by twelve standing
male figures dressed in various
national costumes. The table
decoration also included twelve large
decorative groups composed of
military trophies and captive Turks
(as well as black-skinned figures
who, like the Turks, were meant
to represent non-Christian peoples).

Friedrich-Elias Meyer, the main
modeler at the manufactory, was the
author of a relatively small number
of sculptures. In addition to the
portrait of Catherine II he created
models for Themis, Justice, and the
twelve standing male figures in
national costumes, the remaining
sculptures being the work of his
brother Wilhelm-Christian Meyer.
As main model master, however,
Friedrich-Elias was the author of all
the models for crockery, whether
created specially for this service or
created earlier. The most unusual
pieces are the tureens in the form of
a melon and the *compotiers* of two
types: in the form of leaves with the
stems as handles, and in the form of
round flat gilded baskets almost
totally covered with vine leaves.
There were 120 plates in the service,
their openwork edges of palm leaves
adorned with four repetitions of the
monogram "C" (for Catherine)
beneath a crown. The plates were
accompanied by gilded silver spoons,
knives, and forks, all with porcelain
handles. The cups for ice-cream or
fruit jelly, the bodies almost covered
by relief leaves, would have been
presented on special stands in the
form of cauliflower leaves (the only
form not to have survived today).
Each such leaf-tray was adorned
with little vases for flowers.

Of particular ideological
importance in the overall concept
were the images on the plates and
partly (because they were so small
and therefore fragmentary) on the
cutlery. All the plates and cutlery
were painted with battle and
bivouac scenes from the last
successful Russo-Turkish war by
Johann-Baptist-Balthasar Borrmann.
The majority of the scenes were
taken from prints after paintings
by David Teniers the Younger and
Philips Wouwerman, whose figures
the artist re-dressed in contemporary
Russian army uniform (we know
that the Berlin Porcelain
Manufactory had colored images
of uniforms for different kinds of
troops. Use was also made of prints
by contemporary German artists
such as Christian-Wilhelm-Ernst
Dietrich and Daniel-Nikolaus

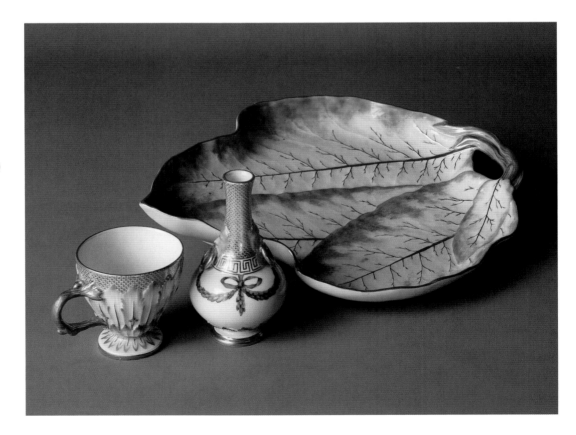

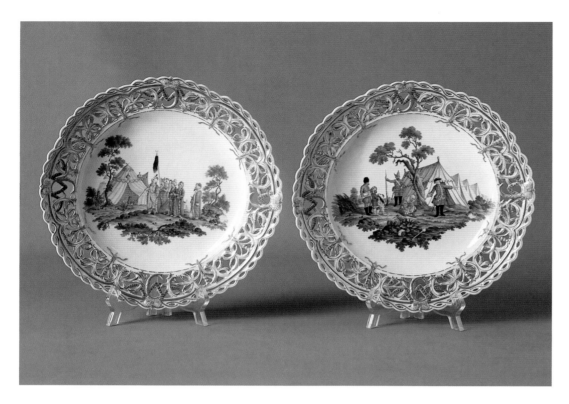

Chodowiecki. The latter, in his turn, left an interesting record of the Berlin Dessert Service in his diary (when the service was completed, in April 1772, the grandiose ensemble was put on display to the Berlin public at the manufactory for two weeks). His comments on this new porcelain wonder were not so very complimentary: "The whole is done with much intelligence and invention, but the throne and the Empress could have been larger, the arts in a grander style … . The best things are the figures prostrated around the throne. The painting of the plates, representing country subjects, is very mediocre … ." (Volz 1908, p. 53). Chodowiecki had in mind the procession that appears in his print *Die Gleichheit aller Stände im Grabe* (Jacoby: *Chodowiecki's Werke. Oder: Verzeichniss sämtlicher Kupferstiche, welche der verstorbene Herr. Daniel Chodowiecki, Direktor der Königl. Preuss. Academie der Künste, von 1758 bis zu seinem Tode 1800 verfertigt, und nach der Zeitfolge geordnet hat*, Berlin, 1814, No. 60), produced for Baron von Labes in 1770. The plate with that particular motif is included in this exhibition, but we should note that

Chodowiecki was a somewhat inattentive viewer, for the painting on the plates includes several figures from his prints. The standing figure of a Russian officer (in the foreground to left) on the second plate with a camp scene is taken from Chodowiecki's print *Action près de Choczim le 18 Sept. 1769* (Jacoby 1814, No. 55), while four other figures are taken from motifs in Dietrich's print *Die Taufe des Eunuchen* (J.F. Link: *Monographie der von dem vormals K. Poln. und Churfürstl. Sächs, Hofmaler und Professor etc. C.W.E. Dietrich radirten, geschabten und in Holz geschnittenen malerischen Vorstellungen*, Berlin, 1846, No. 31).

The Berlin Dessert Service was delivered to Russia in the summer of 1772, and on 3 August (Old Style) the royal command came to enter it in the Service Stores of the Winter Palace (Kazakevich 1994, p. 110). Together with the service came presents for Grand Duke Paul, the empress's favorite Count Grigory Orlov, the hero of the Seven Years War Zakhar Chernyshov, and Catherine's chief counselor on foreign affairs, Count Nikita Panin, a supporter of Prussia and author of the idea of a

"Northern Alliance" against the Bourbons and the Habsburgs.

Frederick the Great's sweeping diplomatic gesture was suitably received by Catherine, on the one hand sincerely pleased at so grandiose a gift, expressed in her letter of thanks to the Prussian king, on the other struck with the sober comprehension that Frederick's action was intended to emphasize not so much her as his own political might. This latter circumstance gave rise to the need for a diplomatic response, and Catherine embarked on a series of demonstrative commissions for new porcelain ensembles further glorifying her, an act that was noted through Europe. As early as August 1772 she had admired the table decoration of the Berlin Dessert Service, which showed her as the wise ruler and successful commander, and in the autumn of that same year she commissioned from Meissen a new decorative series of forty allegorical and mythological porcelain figures and groups that were also intended to glorify her state and military talents, which had brought her empire to victory in the East. This was to be known as the

Oranienbaum Series after the palace complex at Oranienbaum, near St. Petersburg, where it adorned a special room in the Sliding Hill Pavilion.

Then, in early 1773, the firm of Josiah Wedgwood received a commission from the empress to produce a faience service decorated with various view of Britain, the Green Frog Service. Wedgwood wrote to his partner Thomas Bentley: "I suppose this service is order'd upon the idea of the two services getting up by the King of Prussia which I suppose, have taken, or will take many years to complete. One with all the battles between the Russians & the Turks, drawn under his Majestys inspection & intended as a present you know to the Empress—& the other with all the remarkable views & Landskips in his Dominions, for his own use" (Williamson 1909, p. 8).

The striking forms of the items in the Berlin Dessert Service found a response in Russian porcelain. One example might be the Order Services produced by the firm of Francis Gardner near Moscow. The ethnographical theme of the service was also further developed in the creation of numerous series of "Peoples of Russia." At the present time the Hermitage has some five hundred items in all from the celebrated Berlin Dessert Service.

EXHIBITIONS
Kolding 1994, Cat. 160–259; Potsdam-Sanssouci 1994, Cat. 19.1; St. Petersburg 1995b

BIBLIOGRAPHY
Kazakevich 1994, S. 110; Köllmann 1966, vol. I, pp. 123–24; Lenz 1913, vol. I, pp. 24–27; Pachomova-Göres 1994, pp. 22–33; Volz 1908, pp. 49–61, Williamson 1909, p. 8

L.L.

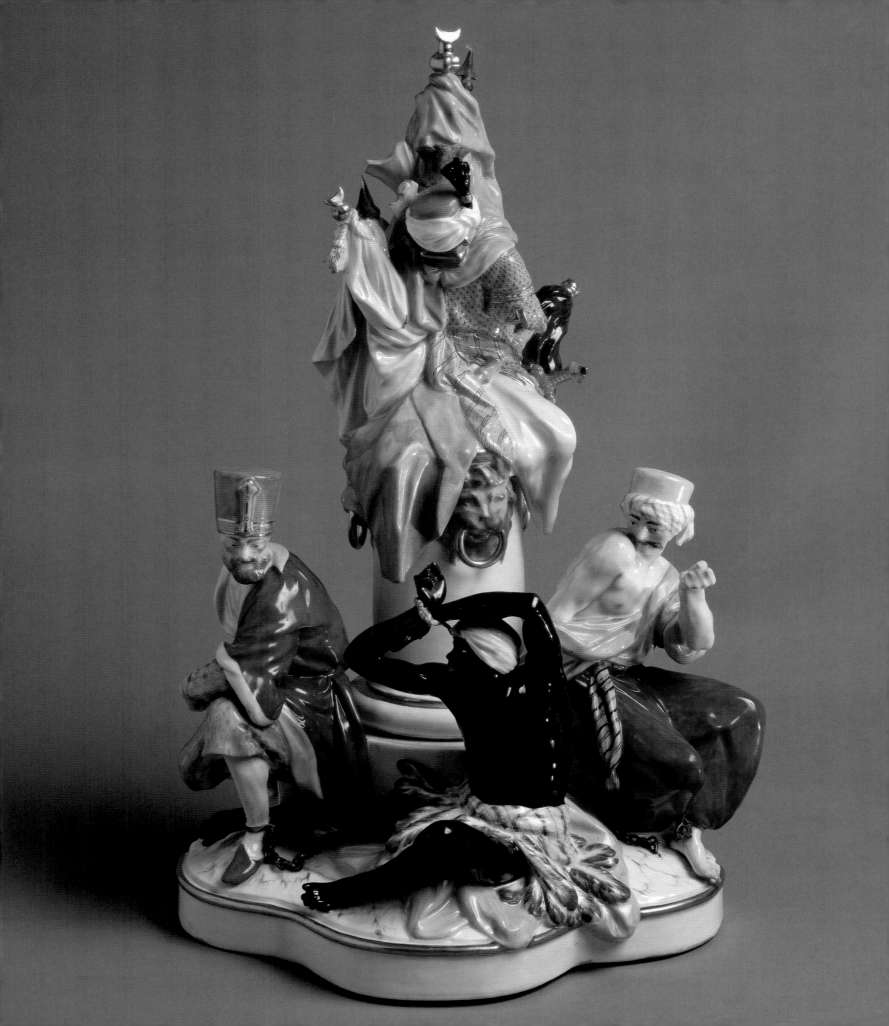

90

Dessert Service Presented to Nicholas I by Queen Victoria
1845
Coalport, England
Painting attributed to William Cook (1800/01–1876)
Porcelain, underglaze and overglaze painting, gilding
Gold overglaze marks in the form of a circle with inscriptions: *A.B. & R.P. DANIELL. To Her MAJESTY & The Royal FAMILY. MANUFACTURERS. 129. NEW BOND ST. & 18. WIGMORE ST.*

Oval *compotier*, 39.2 × 29.1 cm (15³⁄₈ × 11½ in.)
Inv. No. 21668

Plate, diameter 25.3 cm (10 in.)
Inv. No. 21669

PROVENANCE
Transferred to the Hermitage from the Service Stores of the Winter Palace, 1922; presented by Queen Victoria of Great Britain to Emperor Nicholas I and housed in the Winter Palace, St. Petersburg, 1845

Fruit Bowl
Additional item made for the

Dessert Service presented to Nicholas I by Queen Victoria
Imperial Porcelain Factory, St. Petersburg, Russia 1847
Porcelain, underglaze and overglaze painting, gilding
Height 31 cm (12¼ in.)
Cobalt underglaze mark: monogram of Nicholas I beneath a crown
Inv. No. 21689

PROVENANCE
Transferred to the Hermitage from the Service Stores of the Winter Palace, 1922; entered the Service Stores of the Winter Palace, St. Petersburg, 1847

During Nicholas I's official visit to Great Britain in 1844, the Russian emperor met Queen Victoria for the first time. Among the many events to mark his visit was a gift from the British queen of a porcelain "Order" dessert service, made after Nicholas had returned to Russia and delivered to Russia in 1845. Commissioned by Victoria through the London firm of Alfred and Richard Daniell, the service was made at Coalport and consisted of two ice-cream pails, eight round and four oval *compotiers*, and forty-eight dessert plates.

In the center of each object stands the cross of the Order of St. Andrew—the Russian Empire's most important Order—with other important Russian awards and honors along the edges in reserved areas on the dark-blue cobalt background: the crosses of the Orders of St. George, St. Anne, St. Alexander Nevsky, St. Vladimir, St. Stanislaus, and the White Eagle of Poland. Victoria's elegant diplomatic gesture was remarked in the British press. *The Times* for 26 March 1845 published a notice in which the author, perhaps somewhat excessive in his praise, described the luxury and artistic quality of the gift to the emperor. Nicholas's tendency to exaggerate led him to state that the service was intended to serve sixty whereas it actually consisted of just sixty-two items in all.

One plate was produced superfluous to requirements, not intended for inclusion in the service, and this remained with the firm as a model, and was shown at the Great Exhibition of 1851 (*Great Exhibition of the Works of Industry of All Nations, 1851. Official Description and illustrated catalogue, by authority of the Royal Commission*, London, 1851, vol. II, Class XXV, No. 23, p. 724, pl. 132).

Nicholas was highly pleased with the gift and desired that it be used along with the other "Order" services during large banquets at the royal table. This led to an order for sufficient additional pieces from the Imperial Porcelain Factory to make the service large enough to serve forty persons (Znamenova 1991, p. 76). The imperial confectioners compiled a list of additional items that they thought necessary, and examples of the English ware were sent to the Imperial Porcelain Factory. In accordance with the confectioners' list, six oval and six round dishes and another forty-eight plates were made according to the English models, but totally new forms were also introduced: two flat round dishes and three pairs of fruit bowls. Although made according to a single model, the fruit bowls came in three sizes: large, medium (on display in this exhibition), and small.

From the time it arrived in Russia the service was kept in the Service Stores of the Winter Palace, but when this was finally dismantled in 1922 it was transferred to the Hermitage Museum. It suffered seriously from the vagaries of Russian history during the Soviet period, and in 1934 alone thirteen items of English production and two of Russian production were transferred to the People's Commissariat for Foreign Trade to be sold abroad. At the present time the Hermitage has just thirteen items from the dessert service presented by Queen Victoria and seventeen additions made in Russia. Items from the service still appear occasionally at auction (e.g. Christie's London, 21 April 1988, lots 153–56; Christie's London, 14 June 1995, lot 264).

EXHIBITIONS
St. Petersburg 1996b, Nos. 191–99; Ironbridge 1996

BIBLIOGRAPHY
Znamenova 1991, pp. 75–80; Messenger 1995, pp. 220–22; Liackhova 2001, pp. 23–24, fig. 4 on p. 22

L.L.

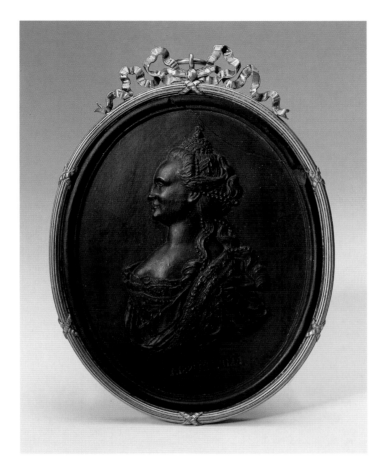

91

Medallion with a Portrait of Catherine II

Wedgwood, England
c. 1780
Black basalt ware, silver frame
11.5 × 9.5 cm (4½ × 3¾ in.)
Beneath the portrait a stamped
inscription: *EMP RUSSIA*; on the
reverse the stamped mark: *Wedgwood*
Inv. No. 19813

PROVENANCE
Transferred to the Hermitage via
the Museums Fund from the Art
Historical Museum of Everyday
Life (former Mansion of Countess
Elizaveta Shuvalova), Leningrad
(St. Petersburg), 1925; formerly
collection of Princess Maria
Shakhovskaia

Mention of a medallion portrait
of Catherine II appears in the
first publication of Wedgwood's
Ornamental Ware Catalogue in 1773, by
which time the Russian empress was
one of the firm's most important

regular clients. The first examples
of Wedgwood products had been
shown at the Russian court in 1769,
and the following year Catherine
commissioned a table service for
twenty-four persons, the so-called
Husk Service (now Great Palace,
Peterhof), and in 1773 she
commissioned a service for fifty
persons, each item of which was to
be decorated with one or several
unique views of the British Isles and
the image of a frog on a shield (it
was intended for her wayside palace
built on a marsh)—the celebrated
Green Frog Service.

R. Reilly and G. Savage consider
that the first portrait medallion of
Catherine, mentioned in 1773, was
of modest dimensions and perhaps
of modest merits, since on 15 May
1776 Josiah Wedgwood wrote to his
partner Thomas Bentley: "We want
a good Head of the Empress of
Russia" (Reilly, Savage 1973, p. 85).
By 1779 Wedgwood was putting out
two versions of medallions with
portraits of the empress, both based

on medals by Timofei Ivanov,
dating from 1762 and 1774. The
medallion here is based on Ivanov's
Coronation Medal of Catherine II
of 1762. In the opinion of the
leading Russian scholar Evgenia
Shchukina, Ivanov's source was a
painted portrait of Catherine before
a mirror by the court painter
Vigilius Eriksen. It was the reflection
in the mirror that would seem to
have determined the iconography of
the Coronation Medal (Shchukina
1962, p. 86).

This medallion was among works
in the collection of Princess Maria
Shakhovskaia exhibited in 1912 in
the retrospective section of a show
of works by Wedgood held, as
was noted in an advertisement
to St. Petersburg's cultural elite,
"under the patronage of Her
Imperial Majesty Grand Duchess
Maria Pavlovna in the Rooms of
the Imperial Academy of Arts"
(Liackhova 1992, p. 21). This was
the first monographic exhibition of
works from Wedgwood held outside
Britain. The high-ranking patron
was daughter of the Grand Duke of
Mecklenburg-Schwerin, and before
adopting Russian Orthodoxy she
was known as Princess Maria
Alexandrina Elizabeth Eleonora;
the wife of Grand Duke Vladimir
Alexandrovich, third son of
Alexander II, she was, in accordance
with court hierarchy, the third lady
in the empire after the reigning and
dowager Empresses. The very highest
society, both Russian and foreign,
gathered in her St. Petersburg salon.

Wedgwood produced this
portrait of Catherine II after
Ivanov's coronation medal in
various materials (not just black
basalt but also jasper ware), and
there seems to have been an
unlimited number of them.

EXHIBITIONS
St. Petersburg 1912, p. 46; New
Haven–Toledo–St. Louis 1996–97,
No. 103

BIBLIOGRAPHY
Shchukina 1962, p. 86; Reilly,
Savage 1973, p. 85; Liackhova 1992,
pp. 21–26

L.L.

92

Dessert Service with Maps and Plans

Berlin

1776

Diameter 24.5 cm (9⅝ in.)

Porcelain, overglaze painting, gilding

Marks: underglaze cobalt scepter

Plate with the inscription *CHISME*
Inv. No. GCh 3677

Plate with the inscription *NATOLIE*
Inv. No. GCh 3674

Plate with the inscription *ATHENE*
Inv. No. 17163

This dessert service bears maps and plans of fortresses that were the sites of the most important battles in the Russo-Turkish War of 1768–74. It was presented by Frederick the Great (Friedrich II) of Prussia to Grand Duke Paul, heir to the Russian throne, during Paul's visit to Berlin in the summer of 1776. It was at Frederick's court in Berlin, and with the monarch's aid, that Paul, who had in April lost his wife (Grand Duchess Natalia Alexeevna, née Princess Wilhelmina Luisa of Hesse-Darmstadt), met Princess Sophia Dorothea Augusta Luisa of Württemberg, who was to be his second wife (upon her marriage she adopted the Orthodox faith and took the name Maria Fedorovna).

Among the many sights of the Prussian capital, Paul visited the Royal Porcelain Manufactory, his interest in the production being so great that he was even permitted to see the firing kilns, usually forbidden to visitors. The heir was accompanied by Prince Heinrich of Prussia, Frederick's brother, and by Count Petr Rumiantsev-Zadunaisky, Field Marshal-General of the Russian army and hero of the last Russo-Turkish War.

It was with some reason that the porcelain service presented to Paul was specifically devoted to Russia's naval battles: by 1776 Paul had been Admiral-General of the Russian Fleet for twelve years. In Russia there were four ranks of admiral—Admiral-General, Admiral, Vice-Admiral, and Rear-Admiral—but although all successes at sea would formally be attributed to the highest command, in reality the command of the Russian squadron in the Mediterranean was entrusted to Count Alexei Orlov, brother of the empress's favorite, Grigory Orlov. One dish in the service, which for some unknown reason remained in Prussia (until 1945 it was in the Kunstgewerbemuseum in Berlin but has since disappeared), bore an image of Grand Duke Paul led by Minerva, with Count Alexei Orlov (Volz 1908, p. 60). With his marshal's baton Paul points to a map with the inscription *Natolie* in Orlov's hands—it was there that the Russian fleet defeated the Turks on 5 July 1770, two days before the famous battle at Chesme. The goddess of victory, floating in the clouds above, shades the heir to the throne with a palm branch and a laurel wreath.

The graphic sources for the paintings on the plates were colored engravings, maps, and plans of the battles produced by order of Alexei Orlov as a gift when he visited the castle of Rheinsberg in 1771 (2002 Schloss Rheinsberg, No. V. 52).

In 1885 the nine plates then surviving from the service were moved to the Museum of Porcelain and Silver Objects of the Highest Court, but in 1910 only eight of the plates were then transferred to the Porcelain Gallery of the Imperial Hermitage. There is no information to record how the ninth disappeared. It was possibly the plate with a stereometric plan of the Acropolis in Athens (included here) that entered the Hermitage in 1918 from the nationalized collection of Prince A.S. Dolgoruky, Ober-Hofmarschall of the Court and Member of the State Council.

BIBLIOGRAPHY

Troinitsky 1911, p. 48; Lenz 1913, vol. I, p. 41; Pachomova-Göres 1994, pp. 33–35; Volz 1908, pp. 59–60

L.L.

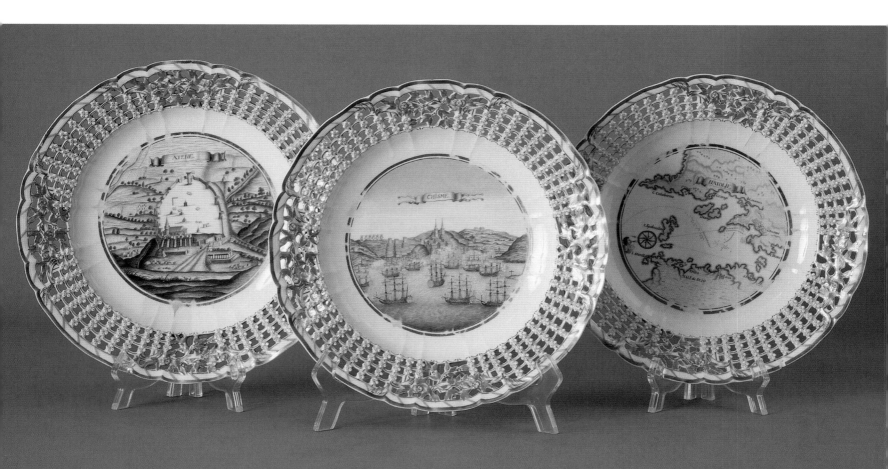

93
Cameo Service

Sèvres Manufactory, France
1778–79
Soft-paste porcelain, overglaze
painting, gilding
Marks: interlaced "L" and "AA"
for the year 1778

Flat Plate, diameter 26.2 cm
(10⅜ in.)
Inv. No. GCh 49

Flat Plate, diameter 26 cm (10¼ in.)
Inv. No. GCh. 264

Square *Compotier* or Dish,
25 × 25 cm (9⅞ × 9⅞ in.)
Inv. No. GCh. 361

Round Fruit Bowl, diameter 21 cm
(8¼ in.)
Inv. No. GCh. 379

Four-part Dish, 22.3 × 20 cm
(8¾ × 7⅞ in.)
Inv. No. GCh. 373

Wine Cooler, height 20 cm (7⅞ in.)
Inv. No. GCh. 621

Wine Cooler, height 20 cm (7⅞ in.)
Inv. No. GCh. 619

PROVENANCE
In the Porcelain Gallery of the
Imperial Hermitage from 1911; in
the Winter Palace from 1782; in the
Tauride Palace, St. Petersburg,
1779–1782; commissioned by
Catherine II for Prince Grigory
Potemkin (*c.* 1739–1791), 1777

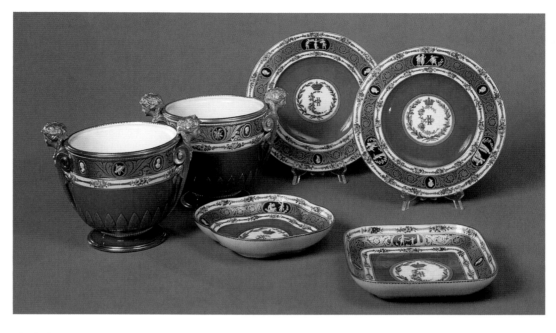

Over the course of two years,
between 1777 and 1779, most of
the employees at the Sèvres
Manufactory were employed in
making what they called the
"Russian service," a vast porcelain
service to serve sixty persons that
had been commissioned by
Catherine II as a gift for Prince
Grigory Potemkin. Composed of
some 744 items in all, the service
cost the Russian treasury the vast
sum of 328,188 *livres*.

The ground "d'un bleu céleste
imitant le turquoise" (of a celestial
blue imitating turquoise), cartouches
coloured like the lees of wine, the
flowered monogram "E" of the
Russian Empress (in Russian

"Catherine" is spelled "Ekaterina")
with a crown, and the thick, noble
hue of the gilding united to create
a rich coloring of the kind possible
only on soft-paste porcelain.
Although by the 1770s outstanding
success had been achieved in
working with soft paste or *pâte tendre*
(which contains no kaolin), the new
forms and wealth of decoration on
this service demanded numerous,
expensive experiments at all stages
of the complex process of porcelain
production.

Surviving drawings and sketches
provide evidence of just how
carefully the decoration was
conceived for each object in the
dinner, dessert, and coffee parts of
the service. The majority of the
forms were conceived specifically
for this service and used here for
the first time.

It was the increasing widespread
interest in the art of Ancient Greece
and Rome, as well as the Russian
empress's well-known passion for
engraved gems (her collection
included some ten thousand items),
that provided the inspiration behind
the key decorative motif: the
imitation cameos copied from
Antique originals that gave the
service its name. The images, oval
cartouches or round medallions with
subjects from Greek and Roman
history and mythology, were applied
using the transfer-printing technique

invented by N.P. Berthevin and
never before used at Sèvres. Large
objects, such as the wine coolers and
ice-cream bowls, had their "cameos"
made separately from polished
biscuit imitating agate or onyx,
which were then set into nests
specially carved for them in the
body. The Cameo Service formed
an encyclopedia of Antique art, with
over two thousand images on the
plates alone. Some of the subjects
are linked by mythological themes,
while some motifs were taken from
the decoration of the Theater of
Marcellus [Teatro di Marcello] in
Rome, including the design for the
gilded frieze that adorns every
single item.

By the summer of 1779 the
service had arrived in St. Petersburg
aboard a Dutch ship. As a mark of
his gratitude for so rich a gift,
Prince Potemkin presented
Catherine with an Angora cat.

Until 26 July 1782 the service
was kept at Potemkin's residence,
the Tauride Palace, but after his
death it was returned to the treasury
and moved to the stores of the
Winter Palace. More than 160 items
were stolen during the fire that
raged through the Winter Palace in
1837, and in 1856 the French
Embassy in St. Petersburg informed
the court that more than a hundred
pieces were in London in the
possession of a merchant, John

Webb. By order of Emperor
Alexander II these were acquired for
Russia and returned to the Service
Stores of the Winter Palace. Six of
the best items in the service
remained in the possession of Lord
Hertford, and are today part of the
Wallace Collection in London. The
service was first shown publicly in
1904 at a historical exhibition in
St. Petersburg, and in 1910 the
Cameo Service was moved from the
stores of usable services to the newly
created Porcelain Gallery of the
Imperial Hermitage. The Hermitage
today has more than six hundred
items, with examples of all the
different forms that originally went
to make up the service.

EXHIBITIONS
Kolding 1994, Nos. 269–94; London
2000–01, pp. 128–29, Nos. 198–208;
Versailles 1993, Nos. 232–48

BIBLIOGRAPHY
Troinitsky 1911, pp. 35–36;
Kazakevich 1995; Kazakevich 1996,
pp. 462–77; Butler 1975, pp. 452–57;
Brunet, Préaud 1978, passim;
Eriksen, Bellaigne 1987, pp. 127, 156;
Gautier 1964, p. 162; Lechevallier-
Chevignard 1908, vol. I, pp. 88–89;
Savill 1982, pp. 304–11

J.V.

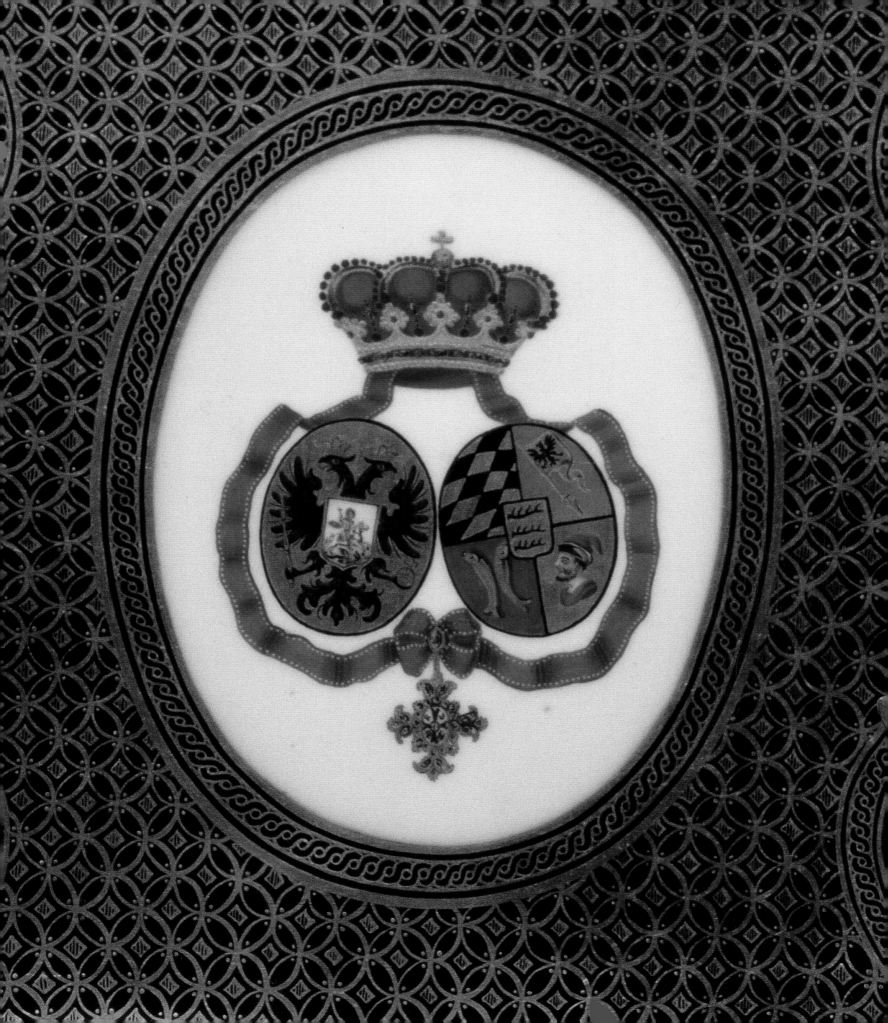

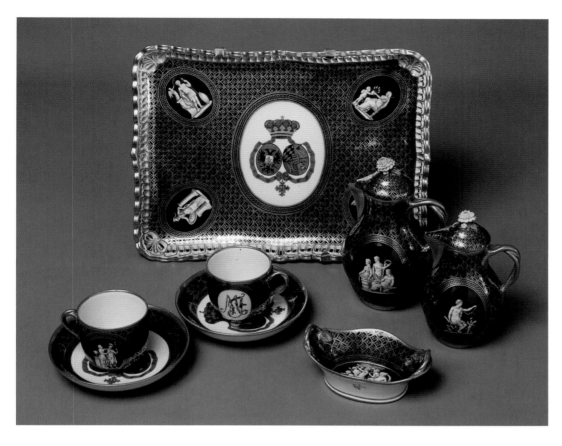

94
**Tête-à-tête Service
(Service for Two)**
Vienna Porcelain Manufactory,
Austria
c. 1776–81
Porcelain, gilding, overglaze painting

Tray, 33 × 24 cm (13 × 9½ in.)
Cobalt overglaze mark: striped
shield beneath a crown
Inv. No. 23586

Coffee Pot, height 17 cm (6¾ in.)
Cobalt overglaze mark: striped
shield
Inv. No. 23587

Cream Jug, height 15 cm (5⅞ in.)
Cobalt overglaze mark: striped
shield
Inv. No. 23588

Sugar Bowl, height 5 cm (2 in.)
Inv. No. 23589

Cups, height 6 cm (2⅜ in.)
Cobalt overglaze mark: striped
shield with a dot at its base
Inv. Nos. 23590 a, 23591 a

Saucers, diameter 13.5 cm (5⅜ in.)
Cobalt overglaze mark: striped
shield with a dot at its base
Inv. Nos. 23590 b, 23591 b

PROVENANCE
Transferred to the Hermitage via
the Museums Fund, 1934; removed
from Gatchina Palace, near
St. Petersburg, and given to
Antikvariat for sale abroad, 1930s;
at Gatchina Palace from 1823;
Pavlovsk Palace, near St. Petersburg;
presented to Maria Fedorovna on
the occasion of her marriage to the
heir to the throne, Grand Duke
Paul, 1776?

In the wedding arms on the tray
and saucers, evidence is found to
support the theory that this service
was presented to Sophia Dorothea
Augusta Luisa, Princess of
Württemberg, on the occasion of
her marriage in September 1776
to Grand Duke Paul, heir to the
Russian throne. In accordance with
tradition, the German princess
adopted the Russian Orthodox faith
and took the name Maria
Fedorovna. The arms beneath a
grand ducal crown are framed with
the ribbon of the "female" Order of
St. Catherine bearing the device on
the bow "For Love and the
Fatherland"— Princess Sophia
Dorothea received this Order from
Catherine II herself upon taking the
name Maria Fedorovna, and this is
another indication of the identify of
the intended recipient. Natalia
Kazakevich suggests, however, that
this gift was made in 1781 during the
young couple's travels through
Europe under the pseudonyms of
the "Comte et comtesse du Nord"
(Kazakevich 1995).

Until 1823 the service was kept
at Pavlovsk Palace, outside
St. Petersburg, Maria Fedorovna's
favorite country residence, but it was
moved to Gatchina Palace at her
own request to be used there during
the reign of her son, Nicholas I. The
Tête-à-tête Service was kept there
and was listed in the inventory until
the 1930s, when it was removed by
the state authorities from the
palace—by now turned into a
museum—with the intention of

selling it abroad. For various reasons
the sale did not take place, and in
1934 the state-run organization
responsible for the sales, Antikvariat,
gave it to the Hermitage Museum.

The influence of Sèvres porcelain
can be felt in the decoration of this
service, and the coffee pot and
cream jug repeat a Sèvres model
of 1754.

All items in the Tête-à-tête
Service bear medallions (the coffee
pot and cream jug have them on
both sides of the body) with figures
of mythological and historical
characters from Antiquity, executed
in grisaille on a brown ground. The
tray with its openwork edge is
decorated with four such medallions:
*Minerva, Venus and Cupid, Plutus
Presenting Ears of Wheat to Ceres,* and
Sergius Sipius. On the coffee pot are
Mars with Venus Being Crowned by Love,
the second subject unidentified. On
the cream jug are *Leda and the Swan*
and *Cupid Begging his Bow from Venus.*
The cups have not only medallions
with figures—*Mars and Venus* and
Vulcan in his Forge —but also reserved
areas with the initials "PP" (Paul
Petrovich) and "MF" (Maria
Fedorovna) wound in garlands of
flowers on a white ground. On the
bottom of the sugar bowl is the
composition *The Triumph of Silenus*
(Reinach 1895, pls 28, 31, 35, 36, 43,
57, 62, 83).

BIBLIOGRAPHY
Kazakevich 1995, pp. 45–52

M.L.

95–97
**Three Tapestries from a Series
of Pastoral Scenes**
Aubusson, France, branch of the
Belgian Braquenie et Co.
1880–1900
Wool and silk
All three have a woven mark in the
bottom-left corner: *Braquenie et Co.*

Les charmes de la vie champêtre
(The Charms of Rural Life),
245 × 206 cm (96½ × 81⅛ in.)
Inv. No. T 15906

Le berger récompencé (The Shepherd
Rewarded), 251 × 204 cm
(98⅞ × 80⅜ in.)
Inv. No. T 15905

Les dénicheurs (The Birdsnesters),
240 × 204 cm (94½ × 80⅜ in.)
Inv. No. T 15911

PROVENANCE
In the Winter Palace from 1900;
commissioned by Alexander II

The fourteen tapestries in this series
of pastoral scenes were woven
between 1880 and 1900 specifically
for the Saltykov Staircase in the
Winter Palace. The series had
originally been commissioned by
Alexander II from the Braquenie
brothers, who owned tapestry
manufactories in Aubusson and
Felletin, and, from 1870, another at
Mechelen (Malines). The cartoons
for the tapestries were free
interpretations of eighteenth-century
French paintings by artists such as
Boucher and Fragonard. The
tapestries were completed in 1900
at Aubusson and were hung on the
staircase leading to the private
apartments of Nicholas II.
 Created during a period of
general decline in tapestry-making,
the series of Pastoral Scenes is
worthy of some interest since it
reflects the tendencies of French
weaving during the last quarter of
the nineteenth century, in which
forms and subjects were specifically
adapted to be subordinate to interiors
in an attempt to revive the art form.
 The model for *The Charms of
Rural Life* was an engraving by Jean
Daullé after Boucher's painting of

95

the same title (*Les charmes de la vie
champêtre*), although some details in
the landscape underwent significant
alteration.
 The source for the cartoon to
The Shepherd Rewarded was an
engraving by Robert Gaillards after
Boucher's *Le berger récompencé*. The
author of the cartoon altered the
landscape and introduced figures of
dancing children, omitting the cow
and goat.

The cartoon for *Les dénicheurs*
derives from a painting by François
Boucher.

EXHIBITIONS
St. Petersburg 1996b, No. 780;
Speyer 1994, p. 124

BIBLIOGRAPHY
Biriukova 1994, p. 30

N.B.

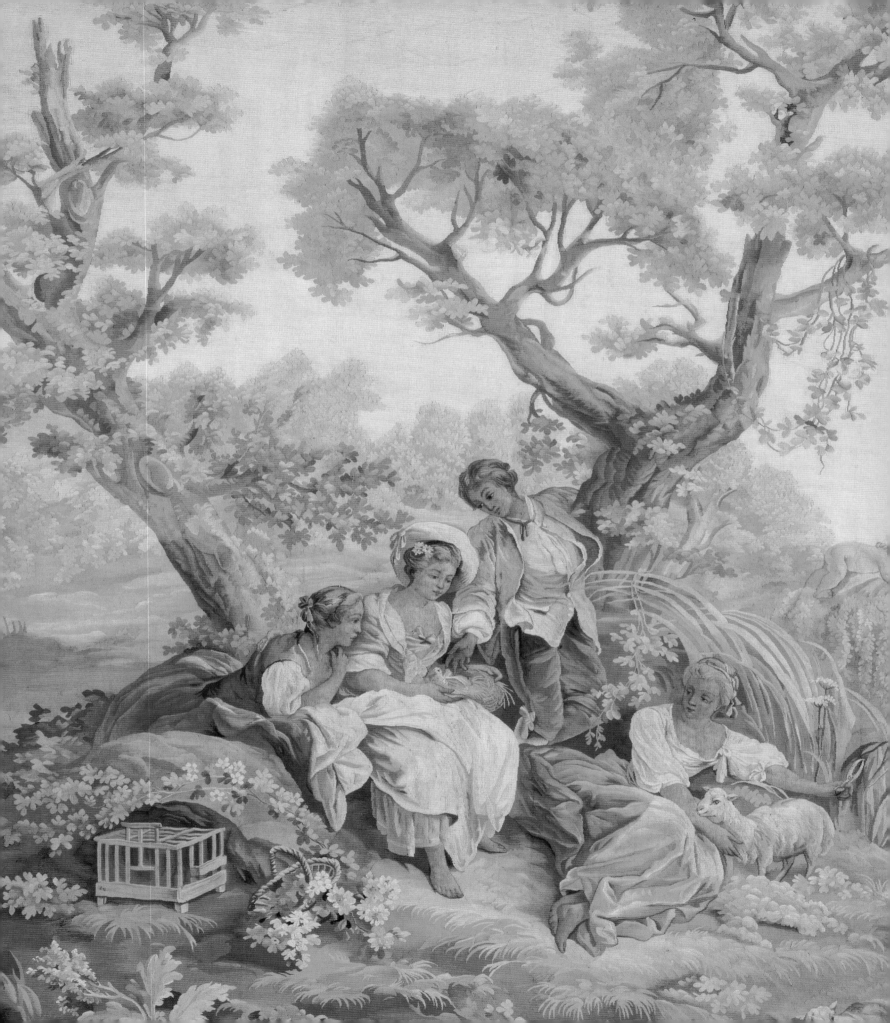

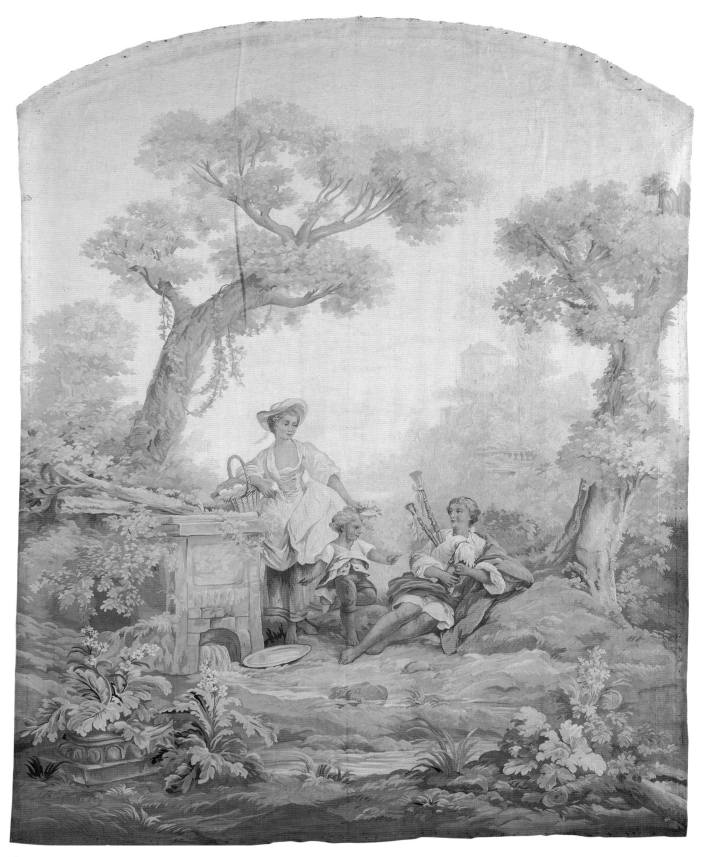

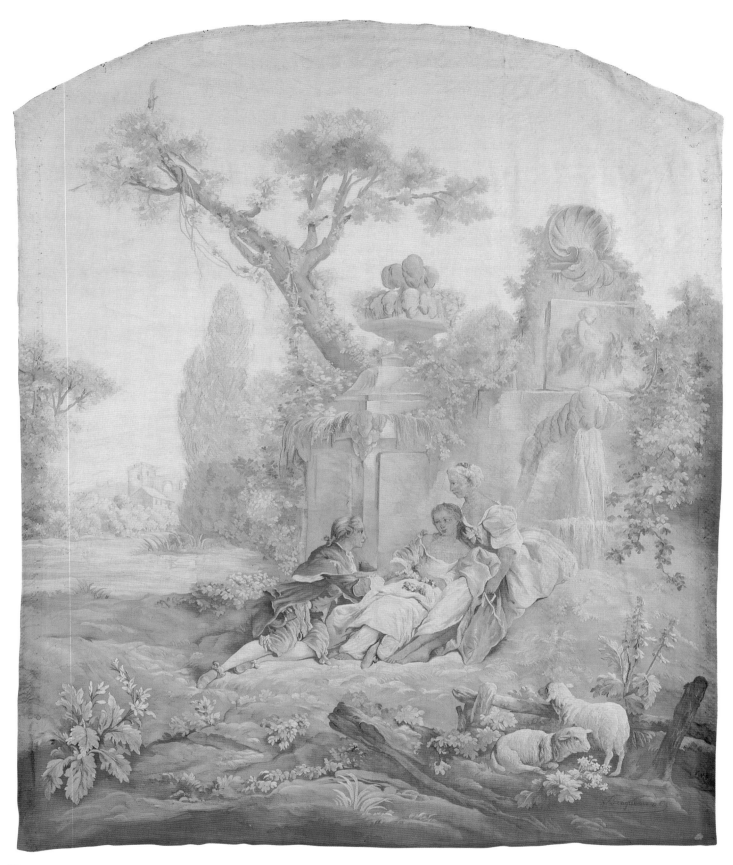

97

FURNITURE

98
Cylindrical Bureau
Workshop of David Roentgen
(German, 1743–1807)
Neuwied, Germany
1785–86
Mahogany, gilded bronze and brass
118 × 133 × 87 cm (46½ × 52⅜ × 34¼
in.)
Inv. No. MB 478

PROVENANCE
Acquired through the Purchasing
Commission, 1930

The celebrated German
cabinetmaker David Roentgen was
active in the second half of the
eighteenth century, gaining fame for
his furniture with complex internal
and musical mechanisms. His
workshop was located in Neuwied
on the Rhine, but the master's fame
soon spread far beyond his native
land and he came to supply items to
many European courts; from 1784
he was working in the Russian
capital. In his correspondence with
Catherine II, her Paris friend Baron
Grimm describes Roentgen as "the
first furniture-maker and mechanic
of the century." Today the
Hermitage has more than twenty
items by the master, all of which
demonstrate the development of
"Roentgen Neo-classicism." This
furniture is of strict form, veneered
with mahogany and decorated with
bronze. Just such a piece is this
cylindrical bureau on pyramidal legs
with bronze fluted insets, a sliding
writing surface, and a cylindrical lid
framed with beading.

EXHIBITIONS
Leningrad 1980, No. 6; Lipetsk
2001–02, Cat. 3.109

T.R.

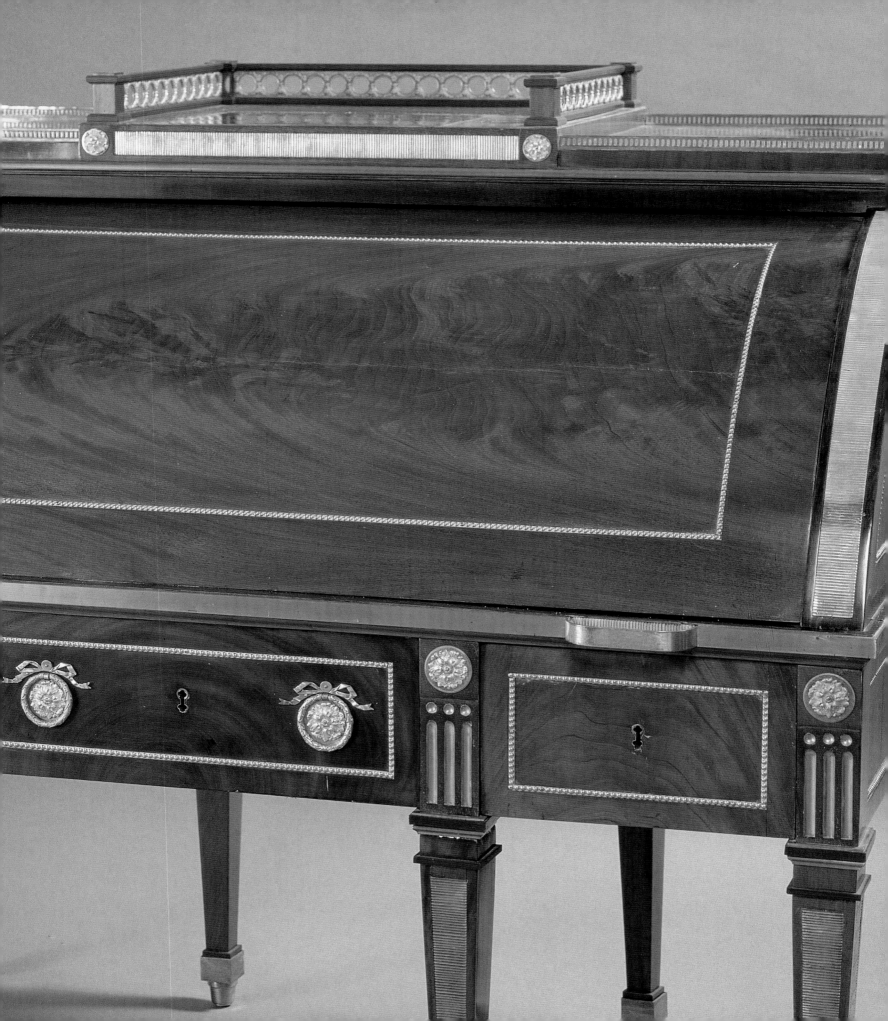

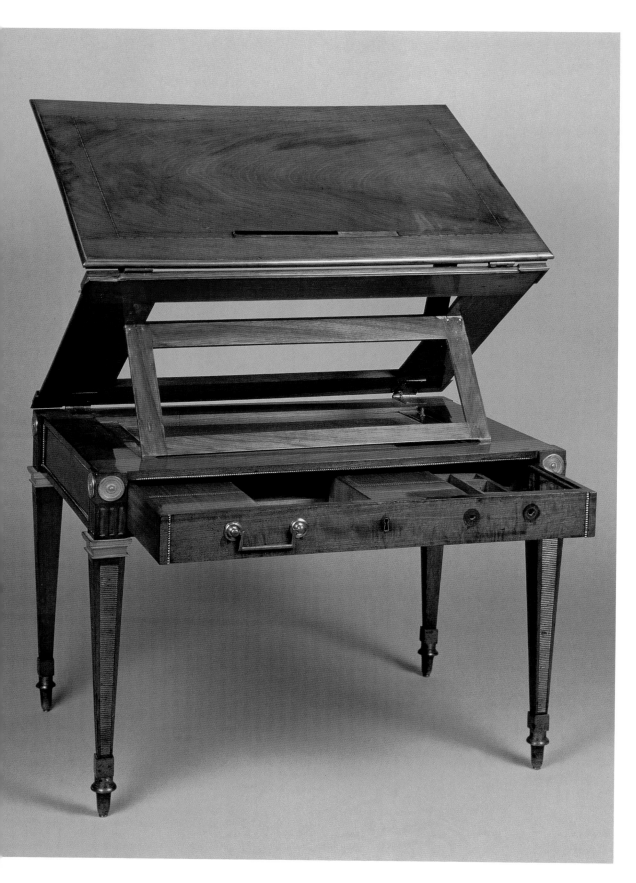

99
Desk-Lectern
Workshop of David Roentgen
(German, 1743–1807)
Neuwied, Germany
1783
Mahogany, oak, gilded bronze and
brass, leather with gold stamping
61 × 68 × 46 cm (24 × 26¾ × 18⅛ in.)
Inv. No. E 48

PROVENANCE
Transferred from the Anichkov
Palace (residence of the heir to the
throne), St. Petersburg, 1922; in
Russia from 1784

This unusually small reading desk
correlates to the large desks that
were being supplied to Russia in
large quantities by the German
furniture workshop of David
Roentgen. It is supported by
rectangular legs with bronze feet
and the case is decorated with
handles in the form of folded cloth,
a characteristic of Roentgen's
furniture. Pulling out the central
drawer turns it into a writing desk,
with several pigeonholes on the right
to hold writing materials. The outer
lid of the desk can be lifted to
transform the table into a lectern.
 It is thought that this table was
produced by Roentgen for
Catherine II's grandsons Alexander
and Constantine, and Burckhardt
Göres dates the appearance of this
type of furniture to 1783.

EXHIBITIONS
Leningrad 1980, No. 24; Stockholm
1998–99, No. 505

T.R.

100
Cabinet for Casts of Engraved Gems

Attributed to master J. Roach
London
1783–90
Frame of oak, pine, and fir, marquetry veneer with engraving of satinwood, maple, ebony, and rosewood, bronze, white paste medallions imitating porcelain
128 × 117 × 41 cm (50³⁄₈ × 46 × 16¹⁄₈ in.)
Inv. No. E 342

PROVENANCE
Commissioned by Catherine II

This cabinet belongs to a group of such items specially made to store a collection of casts and pastes of engraved gems, created using a technique newly invented by James Tassie in the period 1783–90. These pastes were commissioned in England by Catherine II in 1781, and one specific condition was that the collection should be housed in suitable cabinets (Kagan 173, p. 87). The "Tassies," as they were known, and their cabinets arrived in several groups and R.E. Raspe, author of the catalogue of the pastes, records that the cabinets were made to designs by the English architect James Wyatt (Raspe 1786, p. 25). It is known that Wyatt worked in a similar manner to Robert Adam, developing the principles of Neo-classicism in architecture and interior decoration.

It is thought that the Hermitage cabinets were made by a cabinetmaker of the name of Roach, since one of the other pieces in this group still bears an ivory plaque with the words "Cabinet Maker Roach" (Inv. No. E 58). Unfortunately, almost no information is available about Roach, who is mentioned by British scholars solely in connection with these cabinets for Catherine II (Edwards, Jordain 1955, p. 66; Macquoid 1904, p. 220). There are in all thirteen cabinets of varied form and dimensions, each employing the same kinds of wood for construction and marquetry. The cabinet presented in this exhibition differs from the others in the group in its more refined proportions, and in the marquetry decoration on the doors and sides, which consists of tendrils and vases. It is also decorated with white oval medallions in bronze settings made after Tassie's casts of cameos. Julia Kagan has suggested that the cabinet was intended by Catherine as a gift for Count Alexander Lanskoi, and that it returned to her possession after his untimely death in 1784.

EXHIBITIONS
1976 Leningrad; 1999 St. Petersburg, 56

BIBLIOGRAPHY
Kagan 1973; Edwards, Jourdain 1955, p. 66; Macquoid 1904, p. 220; Raspe 1786, p. 25

T.R.

CONTRIBUTORS

JAMES CHRISTEN STEWARD is Director of the University of Michigan Museum of Art and Professor of the History of Art at the University of Michigan. A specialist in the art of eighteenth-century Europe, he previously served as Curator and then Chief Curator at the Berkeley Art Museum, University of California. The organizer and curator of a wide range of exhibitions, Dr. Steward is author of *The New Child: British Art and the Origins of Modern Childhood, 1730–1830* (1995), and the editor of and contributor to numerous exhibition catalogues, including *When Time Began to Rant and Rage: Figurative Painting from Twentieth-Century Ireland* (1998).

KATIA DIANINA is Assistant Professor of Russian at Amherst College. Her dissertation, "A Nation on Display: Russian Museums and Print Culture in the Age of the Great Reforms" (Harvard University, 2002), is a study in Russian cultural nationalism as it evolved in the visual arts and the press. Among her recent publications are the journal articles "Passage to Europe: Dostoevskii in the St. Petersburg Arcade" (*Slavic Review*, Summer 2003) and the forthcoming "Art and Authority: the Hermitage of Catherine the Great" (*Russian Review*, 2004).

ALEXEY LEPORC is Curator in the Western European Department at the State Hermitage Museum and Assistant Professor in the Department of Art History at the European University, St. Petersburg. He is the author of articles on such figures as Oskar Kokoschka, George Minne, Francis Bacon, and Alois Riegl, and he was the editor of the first complete Russian translations of Erwin Panofsky's *Meaning in the Visual Arts*, Jacob Burckhardt's *Rubens* (annotated edition), and Max Dvorak's *Kunstgeschichte als Geistesgeschichte* (The History of Art as the History of Spirit).

WENDY SALMOND is Associate Professor in the Department of Art at Chapman University in Orange, California. A specialist in Russian and European art and architecture, she has been a guest curator at Hillwood Museum and Gardens in Washington, D.C. In addition to serving as editor, contributor, and translator for a number of publications and articles, Dr. Salmond is the author of *Arts and Crafts in Late Imperial Russia: Reviving the Kustar Art Industries 1870–1917* (1996) and *Russian Icons at Hillwood* (1998).

CONTRIBUTORS OF CATALOGUE TEXTS

S.A.	Sergey Androsov
I.A.	Ira Artemieva
B.A.	Boris Asvarishch
A.B.	Alexander Babin
N.B.	Nina Birjukova
T.B.	Tatyana Bushmina
M.D.	Mikhail Dedinkin
E.D.	Ekaterina Deryabina
M.G.	Maria Garlova
R.G.	Roman Grigoriev
N.G.	Natalya Gritsay
A.I.	Arkady Ippolitov
J.K.	Julia Kagan
A.K.-G.	Asya Kantor-Gukovskaya
E.K.	Elena Karceva
O.K.	Olga Kostiuk
O.L.	Alexey Larionov
M.L.	Maria Lerman
L.L.	Lydia Liackhova
M.L.	Marina Lopato
G.P.	Galina Printseva
T.R.	Tamara Rappe
E.R.	Elizaveta Renne
I.S.	Irina Sokolova
S.S.	Sergey Stroganov
J.V.	Jan Vilensky
G.V.	Georgy Vilinbakhov

SELECTED BIBLIOGRAPHY

This is a selected listing of sources referred to in the essay notes and recommended for background reading and information. A full list of the sources cited in the catalogue entries can be found on the website of the University of Michigan Museum of Art (www.umma.umich.edu/hermitage).

B. Alfieri, *San Pietroburgo, 1703–1825: Arte di corte dal museo dell'Ermitage*, Milan (Berenice) 1991

B. Allen and L.A. Dukelskaia, *British Art Treasures from Russian Imperial Collections in the Hermitage*, New Haven CT (Yale University Press) 1996

M.V. Alpatov, "Znachenie Ermitazha V Russkoi I Mirovoi Kul'ture" (The Importance of the Hermitage in Russian and World Cultures), in *Etiudy Po Vseobshchei Istorii Iskusstv*, Moscow 1979

S. Androsov, *Pietro il Grande: Collezionista d'arte veneta*, Venice (Saggi Canal) 1999

S. Androsov and M. Bertozzi, *Sotto il cielo di Roma: scultori europei dal Barocco al Verismo nelle collezioni dell'Ermitage*, Massa (Maschietto & Musolino) 2000

S. Androsov and G. Nepi Scirâe, *Alle origini di Canova: le terrecotte della collezione Farsetti*, Venice (Marsilio) 1991

S. Androsov and O. Neverov, *Istoriia Ermitazha I Ego Kollekcii: Sbornik Nauchnykh Trudov* (The History of the Hermitage and Its Collections: Selected Papers), Leningrad (Gosudarstvennyi Ermitazh) 1989

Art Institute of Chicago, Metropolitan Museum of Art, Gosudarstvennyi Ermitazh (Russia), and Gosudarstvennyi Muzei Izobrazitel'nykh Iskusstv Imeni A.S. Pushkina, *From Poussin to Matisse: The Russian Taste for French Painting: A Loan Exhibition from the USSR*, exhib. cat., Chicago (Art Institute of Chicago) and New York (Metropolitan Museum of Art); distributed by Abrams; 1990

M.I. Artamonov, V.F. Levinson-Lessing, and Gosudarstvennyi Ermitazh (Russia), *Splendeurs de l'Ermitage; Écoles flamandes et hollandaise*, Paris (Hachette) 1964

I. Artemieva and G. Pavanello, *Masterpieces from the Hermitage*, Milan (Electa), Brussels (Art Media), and St. Petersburg (Hermitage State Museum) 1998

I. Artemieva and P. Strozzi, *Caterina Di Russia: L'imperatrice e le arti*, Milan (Electa) 1998

Association française d'action artistique and Galeries nationales du Grand Palais (France), *La France et la Russie au siècle ses lumières: Relations culturelles et artistiques de la France et de la Russie Au XVIIIe siècle* (exhibition held at Galeries nationales du Grand Palais, 20 November 1986 – 9 February 1987), Paris (Association française d'action artistique) 1986

B. Asvarishch (ed.), *German Art for Russian Imperial Palaces 1800–1850: Hermitage Rooms at Somerset House*, exhib. cat., London 2002

B. Asvarishch, *German and Austrian Painting, Nineteenth and Twentieth Centuries*, 1st edn, Florence (Giunti) 1988

B. Asvarishch, *Western European Art: Paintings, Drawings, Sculptures*, Leningrad (Aurora Art Publishers) 1984

J. Baehrend, R. MacLeish, Public Media Incorporated (Wilmette IL), Gosudarstvennyi Ermitazh (Russia), and Daniel Wilson Productions, *Catherine the Great: A Lust for Art*, Public Media Home Vision 1994 (videocassette, 53 min.)

A.G. Barskaia and A.N. Izergina, *French Painting, Second Half of the 19th to Early 20th Century: The Hermitage Museum, Leningrad: A Complete Publication of the Collection, with 358 Colour Plates, Including 44 Details*, Leningrad (Aurora Art Publishers) 1975

G. Bazin, *The Museum Age*, New York (Universe Books) 1967

Z. Beliakova, L. Bogdanov, and M. Clayton, *The Romanov Legacy: The Palaces of St. Petersburg*, New York (Viking Studio Books) 1994

T. Bennett, *The Birth of the Museum: History, Theory, Politics*, London and New York (Routledge) 1995

A. Benois, *Putevoditel' Po Kartinnoi Galeree Imperatorskago Ermitazha* (A Guidebook for the Paintings Gallery of the Imperial Hermitage), St. Petersburg (Izd. Obshchiny sv. Evgenii) 1910

A. Benois and N. Lanceray, "Dvortsovoe Stroitel'stvo Pri Imperatore Nikolae I" (Palace Construction under Emperor Nicholas I), in *Starye gody* (Days of Old), July–September 1913

V. Berezina, *French Painting: Early and Mid-Nineteenth Century*, 1st edn, New York (Johnson Reprint/Harcourt Brace Jovanovich) 1983

W. Bernt, *Die Niederländischen Maler Des 17. Jahrhunderts. 800 Künstler Mit 1470 Abbildungen*, Munich 1960

M. Bertozzi and S. Androsov, *I Marmi degli Zar: gli scultori carraresi all'Ermitage e a Petergof*, Milan (Charta) 1996

N. Biriukova, *Decorative Arts in the Hermitage: The East, Classical Antiquity, Western Europe, Russia*, Leningrad (Aurora Art Publishers) 1986

N. Biriukova, W. Forman, and B. Forman, *The Hermitage, Leningrad: Gothic & Renaissance Tapestries*, London (Hamlyn) 1966

W.H. Bond, *Eighteenth-Century Studies in Honor of Donald F. Hyde*, New York (Grolier Club) 1970

P. Bourdieu, A. Darbel, and D. Schnapper, *The Love of Art: European Art Museums and Their Public*, Stanford CA (Stanford University Press) 1990

K. Butler, *Meissener Porzellan-Manufaktur*, Dresden (Meissen) 1985

D. Chevalier, P. Chevalier, and P.F. Bertrand, *Les Tapisseries d'Aubusson et de Felletin: 1457–1791*, Paris (S. Thierry: Bibliothèque des arts) 1988

T. Clifford and I. Novoselskaia, *French Drawings and Paintings from the Hermitage: Poussin to Picasso*, London (Thames & Hudson) 2001

M.D.B. Corberon and L.H. Labande, *Un Diplomate français à la cour de Catherine II*, Paris (Plon-Nourrit) 1901

C.S. Corsiglia and Art Gallery of Ontario, *Rubens and His Age: Treasures from the Hermitage Museum, Russia*, London (Merrell Publishers) and Toronto (Art Gallery of Ontario) 2001

W. Coxe, *Travels into Poland, Russia, Sweden, and Denmark. Interspersed with Historical Relations and Political Inquiries*, Dublin (printed for S. Price) 1784

A. Cross, *Catherine the Great and the British: A Pot-Pourri of Essays*, Keyworth (Astra Press) 2001

A.G. Cross, *Engraved in the Memory: James Walker, Engraver to the Empress Catherine the Great, and His Russian Anecdotes*, Oxford and Providence RI (Berg) 1993

I. De Madariaga, *Russia in the Age of Catherine the Great*, London (Weidenfeld & Nicolson) 1981

P. Descargues, *Art Treasures of the Hermitage*, New York (Abrams) 1976

G.V. Diatleva and K.A. Liackhova, *Mastera Istoricheskoi Zhivopisi* (Masters of Historic Painting), *Magistri Artium*, Moscow (Veche) 2001

M.V. Dobroklonsky, *Dessins des maîtres anciens*, Leningrad 1926

L.A. Dukelskaia, *The Hermitage: English Art, Sixteenth to Nineteenth Century: Paintings, Sculpture, Prints and Drawings, Minor Arts*, Leningrad (Aurora Art Publishers) 1979

L.A. Dukelskaia and E.P. Renne, *British Painting, Sixteenth to Nineteenth Centuries*, Florence (Giunti) 1990

S. Ebert-Schifferer and B. Asvarishch, *Von Lucas Cranach Bis Caspar David Friedrich: Deutsche Malerei Aus Der Ermitage*, Munich (Hirmer) 1991

C.T. Eisler, *Paintings in the Hermitage*, 1st edn, New York (Stewart) 1990

R. Enggass, *Early Eighteenth-Century Sculpture in Rome: An Illustrated Catalogue Raisonné*, University Park (Pennsylvania State University Press) 1976

T.D. Fomicheva, *Venetian Painting, Fourteenth to Eighteenth Centuries*, Florence (Giunti) 1992

I. Forbes and W. Underhill, *Catherine the Great: Treasures of Imperial Russia from the State Hermitage Museum, Leningrad*, London (Booth-Clibborn) 1990

K. Gallwitz, C.W. Schümann, and H.J. Ziehmke, *Deutsche Malerei Im 19. Jahrhundert: Eine Ausstellung Für Moskau Und Leningrad: Städtische Galerie Im Städelschen Kunstinstitut Frankfurt Am Main, 14.2–20.4.1975: Katalog*, Frankfurt-am-Main (Die Galerie) 1975

I.P. Georgi, *A Description of the Russian Imperial Capital City of St. Petersburg and the Sights in Its Environs*, St. Petersburg 1794

F. Gille, *Musée de l'Ermitage Impérial. Notice sur la formation de ce musée et description des diverses collections qu'il referme avec une introduction historique sur l'Ermitage de Catherine II*, St. Petersburg (Imprimerie de l'Académie impériale des sciences) 1860

Gosudarstvennyi Ermitazh (Russia), *The Hermitage, Leningrad: Western European Painting*, Leningrad (Aurora Art Publishers) 1988

Gosudarstvennyi Ermitazh (Russia), *The Hermitage: Selected Treasures from One of the World's Great Museums*, V. Matveyev (ed.), 1st edn. in US, New York (Doubleday) 1991

Gosudarstvennyi Ermitazh (Russia), Gosudarstvennyi Muzei Izobrazitelnykh Iskusstv Imeni A.S. Pushkina, and Pierpont Morgan Library, *Master Drawings from the Hermitage and Pushkin Museums*, New York (Pierpont Morgan Library) 1998

Gosudarstvennyi Ermitazh (Russia), Kulturstiftung Ruhr, and V. Hügel, *St. Petersburg um 1800: Ein goldenes Zeitalter des Russischen Zarenreichs: Meisterwerke und authentischen Zeugnisse der Zeit aus der Staatlichen Ermitage, Leningrad* (exhibition held at Kulturstiftung Ruhr, Villa Hügel, Essen, 9 June–4 November 1990), Rechlinghausen (Aurel Bongers) 1990

Gosudarstvennyi Ermitazh (Russia), Metropolitan Museum of Art (New York), and the Art Institute of Chicago, *Dutch and Flemish Paintings from the Hermitage*, New York (Metropolitan Museum of Art) and Chicago (Art Institute of Chicago); distributed by Abrams; 1988

Gosudarstvennyi Ermitazh (Russia) and Museum Boymans-Van Beuningen, *Meesterwerken Uit De Hermitage, Leningrad: Hollandse En Vlaamse Schilderkunst Van De 17e Eeuw* (Masterpieces from the Hermitage, Leningrad: Dutch and Flemish Paintings of the Seventeenth Century) (exhibition held 19 May–14 July 1985 at Museum Boymans-Van Beuningen, Rotterdam), Leningrad (Ministry of Culture) 1985

Gosudarstvennyi Ermitazh (Russia), Städtische Galerie Karlsruhe, and E. Rèodiger-Diruf, *Vom Glück des Lebens: Französische Kunst des 18. Jahrhunderts aus der Staatlichen Ermitage St. Petersburg*, Stuttgart (Verlag G. Hatje) 1996

Gosudarstvennyi Ermitazh (Russia) and Whitworth Art Gallery, *Drawings by West European and Russian Masters from the Collections of the State Hermitage and the Russian Museums in Leningrad* (exhibition held 8 October–7 December 1974, Whitworth Art Gallery, University of Manchester), Manchester (Whitworth Art Gallery) 1974

M.M. Grewenig, O. Letze, and Historisches Museum der Pfalz (Speyer, Germany), *Der Zarenschatz der Romanow: Meisterwerke aus der Eremitage St. Petersburg*, Stuttgart (Verlag G. Hatje) 1994

I.S. Grigorieva, *Zeichnungen Alter Meister aus der Ermitage zu Leningrad. Die Sammlung Brühl*, Dresden (Staatliche Kunstsammlungen. Kupferstichkabinett) 1972

I.S. Grigorieva, I.U. Kuznetsov, and I.N. Novoselskaia, *Disegni dell'Europa occidentale dall'Ermitage di Leningrado*, exhib. cat., Florence (L.S. Olschki) 1982

F.M. Grimm, D. Diderot, Raynal, J.H. Meister, and M. Tourneux, *La Correspondance littéraire, philosophique et critique de Grimm, Diderot, Raynal, Meister, etc.*, Paris (Garnier Frères) 1877

J.O. Hand, *The Age of Bruegel: Netherlandish Drawings in the Sixteenth Century*, Washington, D.C. (National Gallery of Art) and Cambridge, UK (Cambridge University Press) 1986

A. Heal, *The London Furniture Makers, from the Restoration to the Victorian Era, 1660–1840; a Record of 2500 Cabinet-Makers, Upholsterers, Carvers and Gilders, with Their Addresses and Working Dates*, London (Batsford) 1953

Hermitage Museum, *Nikolai I i Novyi Ermitazh* (Nicholas I and the New Hermitage), exhib. cat., St. Petersburg (Hermitage Museum) 2002

L. Hughes, *Russia in the Age of Peter the Great*, New Haven CT (Yale University Press) 1998

H. Huth, *Roentgen Furniture: Abraham and David Roentgen, European Cabinet-Makers*, London and New York (Sotheby Parke Bernet) 1974

A.N. Izergina and A.G. Barskaia, *La Peinture française, seconde moitié du XIXe–début du XXe siècle: Musée de l'Ermitage, Léningrad*, Leningrad (Aurora Art Publishers) 1975

I. Karp and S. Lavine, *Exhibiting Cultures: The Poetics and Politics of Museum Display*, Washington, D.C. (Smithsonian Institution Press) 1991

S.A. Kasparinskaia, *Muzei I Vlast'* (Museums and Authority), Moscow (Nauchno-issl. in-t kultury) 1991

H.E. Kiewe, *The Marriage of the Medieval and Modern in Aubusson Tapestry Design, Craftsman and Designer Guide, No. 7*, Oxford (Art Needlework Industries) 1958

G.N. Komelova, "Catherine the Great and Her Age", in *Catherine the Great: Treasures of Imperial Russia from the State Hermitage Museum, Leningrad*, I. Forbes and W. Underhill (eds.), London (Booth-Clibborn) 1990, pp. xviii, 206

A.G. Kostenevich, *French Art Treasures at the Hermitage: Splendid Masterpieces, New Discoveries*, New York (Abrams) 1999

A.G. Kostenevich, *West-Europäische Malerei Des 19. Und 20. Jahrhunderts in Der Ermitage*, Leningrad (Aurora Art Publishers) 1987

A.G. Kostenevich, *Western European Painting of the Nineteenth and Twentieth Centuries*, Leningrad (Aurora Art Publishers) 1976

E.F. Kozhina, *Western European Painting of the Thirteenth to Eighteenth Centuries*, Leningrad (Aurora Art Publishers) 1978

A.E. Krol, *Angliiskaia Zhivopis' XVI–XIX Vekov V Ermitazhe* (English Paintings from the 16th–19th Centuries at the Hermitage), Leningrad (Gosudarstvennyi Ermitazh) 1961

I.U. Kuznetsov and I.S. Grigorieva, *Izbrannye Risunki Iz Sobraniia Gosudarstvennogo Ermitazha. Kollektsiia G. Briulia* (Select Drawings from the Collection of the State Hermitage. The G. Brühl Collection), Leningrad (Hermitage Museum) 1971

I.U. Kuznetsov and I.S. Grigorieva, *Izbrannye Risunki Iz Sobraniia*

Gosudarstvennogo Ermitazha. K 200-Letiiu Osnovaniia Otdeleniia Risunkov: Kollekstiia K. Kobentslia. Katalog Vystavki (Selected Drawings from the Collection of the State Hermitage. On the 200th Anniversary of the Foundation of the Department of Drawings: The Collection of C. Cobenzl); exhib. cat, essays by Yury Kuznetsov and Irina Grigorieva, Leningrad (Hermitage Museum) and Moscow (Pushkin Museum of Fine Arts) 1969

I.U. Kuznetsov and I.V. Linnik, *Dutch Paintings in Soviet Museums*, New York (Abrams) and Leningrad (Aurora Art Publishers) 1982

I.U. Kuznetsov and T.A. Tseshkovskaia, *Dessins flamands et hollandais du dix-septième siècle. Collections de l'Ermitage, Leningrad et du Musée Pouchkine, Moscou*, Brussels (Bibliothèque royale Albert Ier) 1972

I. Kuznetsov, "Introduction: European Drawings," in *Drawings by West European and Russian Masters from the Collections of the State Hermitage and the Russian Museums in Leningrad* (exhibition held 8 October–7 December 1974, Whitworth Art Gallery, University of Manchester), Manchester (Whitworth Art Gallery) 1974

M.T. Lemoyne de Forges, *Chefs d'Œuvre de la peinture française dans les musées de Leningrad et de Moscou* (exhibition held September 1965–January 1966, Paris), Paris 1965

V.F. Levinson-Lessing, *Istoriia Kartinnoi Galerei Ermitazha (1764–1917)* (The History of the Paintings Gallery at the Hermitage [1764–1917]), Leningrad (Iskusstvo Publishers) 1985

V.F. Levinson-Lessing, P. Paul, and K. Neubert, *Splendeurs de l'Ermitage: Baroque et Rococo*, Paris (Hachette) 1964

V.F. Levinson-Lessing and M. Varshavskaia, *The Hermitage, Leningrad: Dutch & Flemish Masters*, London (Hamlyn) 1964

V.F. Levinson-Lessing, S.N. Vsevolozhskaia, P. Paul, and K. Neubert, *The Hermitage, Leningrad: Baroque & Rococo Masters*, London (Hamlyn) 1966

I.V. Linnik, *Western European Painting*, Leningrad (Aurora Art Publishers) 1977

G.K. Lukomsky and N. De Gren, *Charles Cameron (1740–1812): an Illustrated Monograph on His Life and Work in Russia, Particularly at Tsarskoe Selo and Pavlovsk, in Architecture, Interior Decoration, Furniture Design and Landscape Gardening*, London (Nicholson & Watson) 1943

D. Maroger, *The Memoirs of Catherine the Great*, New York (Macmillan) 1955

S. Massie, *Pavlovsk: The Life of a Russian Palace*. 1st edn, Boston (Little, Brown) 1990

M. Messenger, *Coalport 1795–1926: An Introduction to the History and Porcelains of John Rose and Company*, Woodbridge, UK (Antique Collectors' Club) 1995

J. Montagu, *Roman Baroque Sculpture: The Industry of Art*, New Haven CT (Yale University Press) 1989

A. Moore, *Houghton Hall: The Prime Minister, the Empress and the Heritage*, London (Philip Wilson) 1996

A. Moore and L. Dukelskaia, *A Capital Collection: Houghton Hall and the Hermitage: With a Modern Edition of "Aedes Walpolianae": Horace Walpole's Catalogue of Sir Robert Walpole's Collection*, New Haven CT (Yale University Press) 2002

H. Moulin, *Hubert Robert (1733–1808) et Saint-Pétersbourg: Les Commandes de la famille impériale et des princes russes entre 1773 et 1802*, Paris (Réunion des musées nationaux) and Valence (Musée de Valence) 1999

I. Nemilova, *French Painting, Eighteenth Century*, 1st edn, Florence (Giunti) and Moscow (Iskusstvo Publishers) 1986

N.N. Nikulin, *German and Austrian Painting, Fifteenth to Eighteenth Centuries*, Florence (Giunti) 1987

N.N. Nikulin, *Nemetskaia I Avstriiskaia Zhivopis' XV–XVIII Veka: Katalog* (German and Austrian Paintings from the 15th–18th Centuries: Catalogue), exhib. cat., Leningrad (Iskusstvo Publishers) 1987

N.N. Nikulin, O.N. Nechipurenko, Y.S. Pamfilov, M.L. Strocchi, and

A. Brierley, *Netherlandish Painting, Fifteenth and Sixteenth Centuries*, 1st edn, Florence (Giunti) and Moscow (Iskusstvo Publishers) 1989

G. Norman, *The Hermitage: The Biography of a Great Museum*, 1st edn, New York (Fromm International) 1998

Rossiiskoe Imperatorskoe Istoricheskoe Obshchestvo, *Sbornik Rossiiskogo Imperatorskogo Istoricheskogo Obshchestva* (Anthology of the Russian Imperial Historical Society), vol. XXIII, 1878

A. Odom, *The Art of the Russian North*, Washington, D.C. (Hillwood Museum) 2001

A. Odom, *Russian Imperial Porcelain at Hillwood*, Washington, D.C. (Hillwood Museum) 1999

A. Odom and L.P. Arend, *A Taste for Splendor: Russian Imperial and European Treasures from the Hillwood Museum*, Alexandria VA (Art Service International) 1998

T.L. Pashkov, *Zal Van Deika* (The Van Dyck Room), St. Petersburg 2002

N.B. Petrusevich, Y.S. Pamfilov, L. Brylenko, and E.B. Georgievskaia, *Five Hundred Years of French Painting: The Hermitage, Leningrad, the Pushkin Museum of Fine Arts, Moscow*, 2 vols., Leningrad (Aurora Art Publishers) 1990

B.B. Piotrovsky, *Treasures of Catherine the Great*, London (Thames & Hudson) and New York (Abrams) 2000

B.B. Piotrovsky and G.C. Argan, *The Hermitage: Its History and Collections*, 1st edn, New York (Johnson Reprint Corporation: Harcourt Brace Jovanovich) 1982

A.V. Prakhov, "Imperator Aleksandr Iii Kak Deyatel' Russkogo Khudozhestvennogo Prosveshcheniya" (Emperor Alexander III as a Proponent of Russian Artistic Education), in *Khudozhestvennye Sokrovishcha Rossii* (Art Treasures of Russia), St. Petersburg, 1903

L. Réau, *Catalogue de l'art français dans les musées russes*, Paris (A. Colin) 1929

W.F. Reddaway (ed.), *Documents of Catherine the Great: the Correspondence with Voltaire and the Instruction of 1767 in the English Text of 1768*, New York (Russell & Russell) 1971

R. Reilly, *Wedgwood: The New Illustrated Dictionary*, Woodbridge, UK (Antique Collectors' Club) 1995

R. Reilly and National Portrait Gallery, London, *Wedgwood Portrait Medallions: an Introduction*, London (Barrie and Jenkins) 1973

J. Richardson and E. Zafran, *Master Paintings from the Hermitage and the State Russian Museum, Leningrad* (exhibition at National Gallery of Art, Washington, D.C.; M. Knoedler & Co., Inc., New York; the Detroit Institute of Arts, Detroit; Los Angeles County Museum of Art, Los Angeles; and the Museum of Fine Arts, Houston; 1975–1976), New York (M. Knoedler) 1975

S.M. Soloviev, *Imperator Aleksandr I: Politika, Diplomatiia* (Emperor Alexander I: Politics, Diplomacy), Moscow (Mysl') 1995

F. Souchal, *Les Slodtz: sculpteurs et décorateurs du Roi (1685–1764)*, Paris (E. de Boccard) 1967

A. Stange, *Malerei Der Donauschule* Munich (Bruckmann) 1971

T.G. Stavrou, *Art and Culture in Nineteenth-Century Russia*, Bloomington IN (Indiana University Press) 1983

C. Sterling, *Great French Painting in the Hermitage*, Library of Great Museums, New York (Abrams) 1958

G.Y. Sternin, *Khudozhestvennye Protsessy V Russkoi Kul'ture Vtoroi Poloviny XIX Veka* (Art Developments in the Russian Culture of the Second Half of the 19th Century), Moscow (Izd-vo "Nauka") 1984

M. Stuffmann, "Les Tableaux de la collection de Pierre Crozat: historique et destinée d'un célèbre, établis en parlant d'un inventaire apres décès inédits (1740)," *Gazette des Beaux-Arts*, July–September 1968, pp. 5–144

V.A. Suslov, *Die Ermitage: Westeuropäische Und Russische Kunst*, Leipzig (E.A. Seeman) 1988

V.A. Suslov, *Great Art Treasures of the Hermitage Museum, St. Petersburg*, New York (Abrams) 1994

V.A. Suslov, *The State Hermitage: Masterpieces from the Museum's Collections*, London (Booth-Clibborn) 2001

V.A. Suslov, *Treasures of the Hermitage*, New York (Newsweek) 1980

S.S. Tatishchev, *Imperator Nikolai I i Inostrannye Dvory: Istoricheskie Ocherki* (The Emperor Nicholas and Foreign Courts: Essays on History), St. Peterburg (Tip. I.N. Skorokhodova) 1889

S. Varshavskii, B. Rest, and I.A. Orbeli, *Ermitazh, 1764–1939. Ocherki Iz Istorii Gosudarstvennogo Ermitazha* (The Hermitage, 1764–1939. Essays on the History of the State Hermitage), Leningrad (Tip. "Leningradskaia pravda," 1939

Vorontsov, *Arkhiv Kniazia Vorontsova* (Archive of Prince Vorontsov), vol. XXVIII, Moscow 1888

J. Vrieze, *Catharina: De Keizerin En De Kunsten: Uit De Schatkamers Van De Hermitage*, Zwolle (Waanders) 1996

S.N. Vsevolozhskaia, *Italian Painting from the Hermitage Museum, 13th to 18th Centuries*, New York (Abrams) 1981

I. Wardropper, S. Androsov, and D. Walker, *From the Sculptor's Hand: Italian Baroque Terracottas from the State Hermitage Museum*, 1st edn, Chicago (Art Institute of Chicago) 1998

F.C. Weber, *The Present State of Russia ... Being the Journal of a Foreign Minister Who Resided in Russia at That Time ...Translated from the High-Dutch*, London (printed for W. Taylor., W. and J. Innys, and J. Osborn) 1722

J. Wedgwood, R. Reilly, and G. Savage, *Wedgwood: The Portrait Medallions*, London (Barrie & Jenkins) 1973

N. Wrangell (Vrangel'), *Iskusstvo I Gosudar' Nikolai Pavlovich* (Art and Emperor Nikolai Pavlovich), Petrograd (Tip. Sirius) 1915

H. Young, *The Genius of Wedgwood*, London (Victoria & Albert Museum) 1995

Z.V. Zaretskaia and N. Kosareva, *Zapadnoevropeiskaia Skulptura V Ermitazhe* (West European Sculpture at the Hermitage), Leningrad (Aurora Art Publishers) 1970

B.A. Zernov and T.A. Ilatovskaia, *Risunki, Akvareli, Pechatnaia Grafika Nemetskikh Khudozhnikov Xix-Xx Vv. Iz Sobraniia Ermitazha* (Drawings, Watercolors and Prints by German Artists of the 19th and 20th Centuries from the Hermitage Collection), Leningrad 1990

PICTURE ACKNOWLEDGMENTS

Page 16: courtesy of The Royal Collection © 2003 Her Majesty Queen Elizabeth II. Page 30: Inv. Nr. ZV 3084. 1929, aus dem Besitz des Grafen Medem, Dresden, erworben; courtesy Staatliche Kunstsammlungen Dresden. Page 31: © Bildarchiv Preussischer Kulturbesitz, Berlin, 2004. Page 32: photo Jens Weber, Munich. Page 48: I.639, courtesy Bob Jones University Museum and Gallery, Inc. Page 49: Russkoe narodnoe iskusstvo na Vtoroi vserossiiskoi kustarnoi vystavke v Petrograde v 1913. Petrograd (Golike i Vil'borg) 1914, plate VIII. Photo courtesy Wendy Salmond.

INDEX